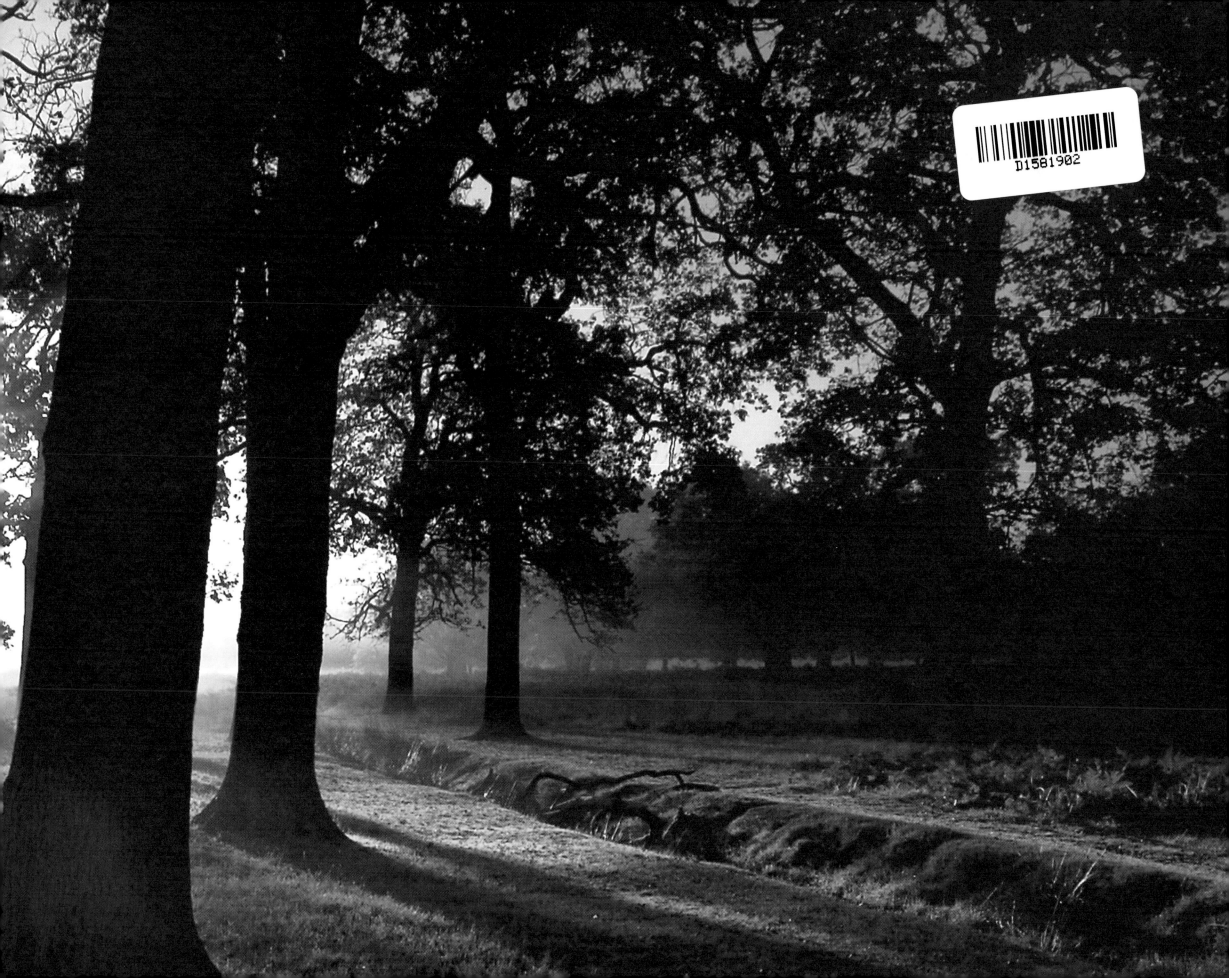

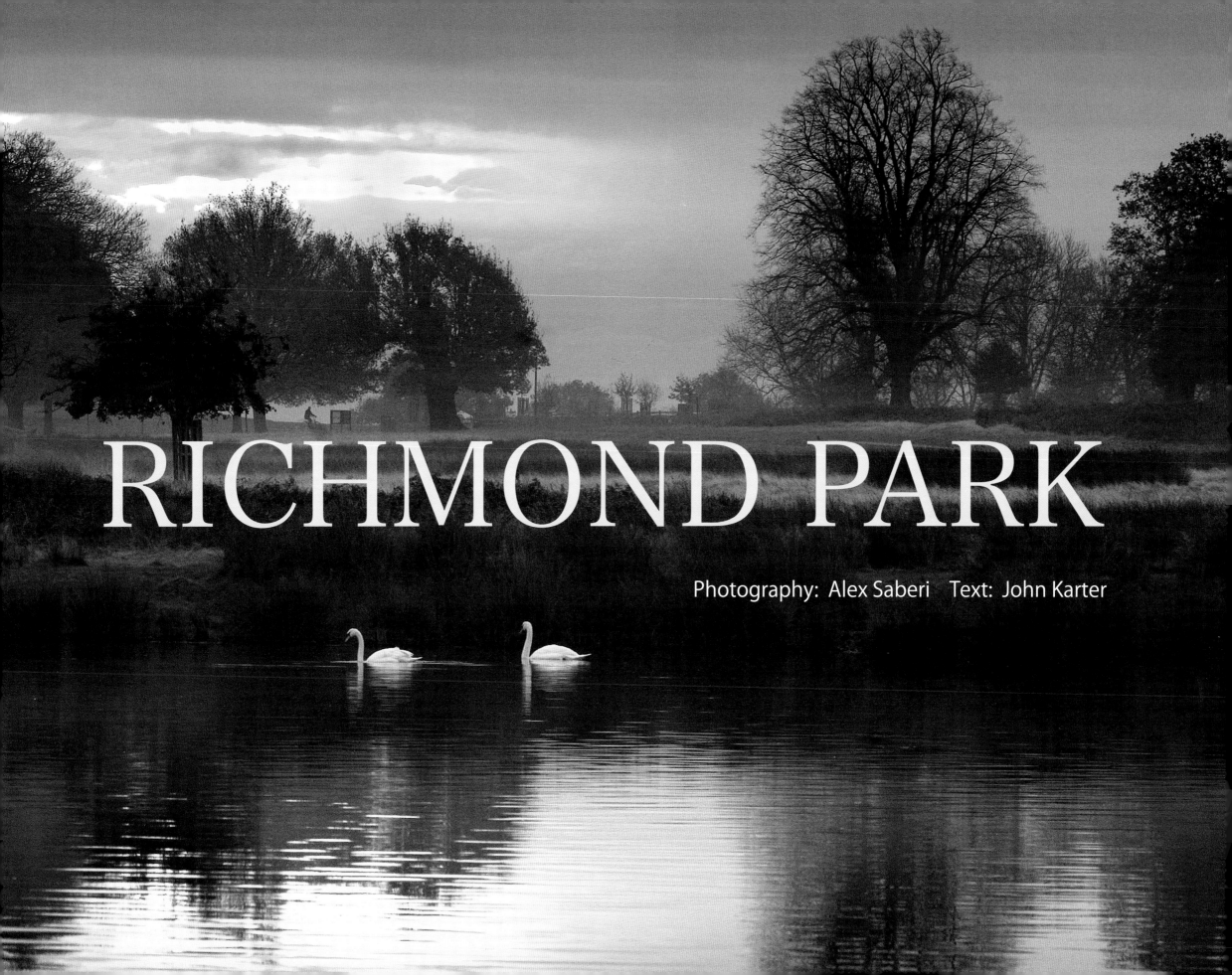

RICHMOND PARK

Photography: Alex Saberi Text: John Karter

A roaring stag stands silhouetted against the dappled morning sky, sounding out a bellicose warning to any rival foolish enough to enter its domain; antlers a lethal weapon primed for combat; formidable presence dominating the landscape. This is nature at its most awe-inspiring, within a setting steeped in history; a moment to watch and wonder at, and store forever in the memory.

Across the way, a circle of ancient Oak trees, their gnarled trunks and grotesquely twisted boughs forming the perfect setting for a witches' coven, stand sentinel over a group of hinds huddling nervously together: the females of the species, dewy-eyed, with delicate, velveteen ears twitching, listening out for danger; a fetching contrast to the macho posturing of the big guy on the hill.

The sun's rays filter through the branches, illuminating the clearing with an eerie glow; a pair of bob-tailed rabbits, dead ringers for Fiver and Bigwig from *Watership Down*, skip lightly across the carpet of leaves and acorns, pausing now and then to gather a morsel or glance anxiously around, before scuttling off into the sanctuary of the undergrowth. High up above, a sinister shape amongst the scudding clouds, a kestrel hovers menacingly, its eyes like laser beams homing in on the merest hint of movement below, ready to arrow down mercilessly on its hapless prey.

In the shadow of a copse, lurking conspicuously amidst the broad sweep of grassland, yet keeping a discreet distance from the older male, a group of young stags are desperate to make their presence felt, but betraying the callow uncertainty of youth. Gangly and weak-framed, their unformed antlers more adornments than weapons, they are immature youths in a man's world. Their time will come, but for now there is plenty to be said for just hanging out with the boys.

In a distant corner of the rolling landscape below, a golden pond shimmers like an oasis. As the sun burns away the last of the lingering morning mist, a swan rises regally from the water as if on water skis, flapping its enormous wings like a cape; as with the big old stag, it too marks out its territory in a way that brooks no argument. A foolhardy Labrador, breaking impatiently away from its owner, rushes towards the water's edge, dips its paws in ready for a random splash-about, then thinks better of it as the feathered giant approaches with a look that says 'Not on my watch, sonny boy!'

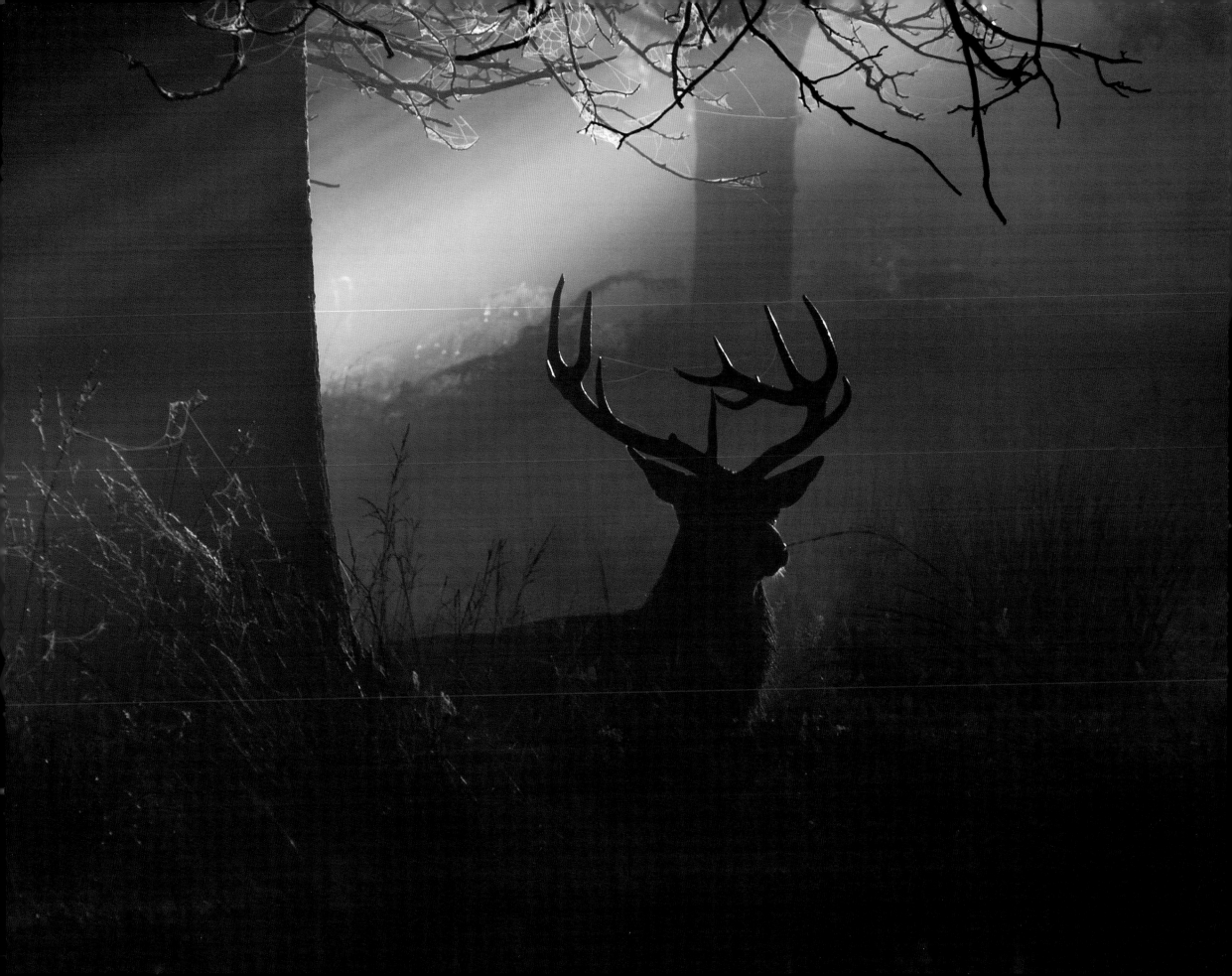

Our cowardly canine is the first clue. But if transported here with no prior knowledge of your surroundings, where might your imagination take you? Recalling the bellowing stag, a remote Highland location evoking Landseer's *Monarch of the Glen*, perhaps; or, gazing out across the savannah-like grasslands to the gleaming expanses of open water, the epic beauty of the Lake District. If allowing your mind's eye totally free rein, maybe even the Serengeti.

Make a short climb to a vantage point high above the fields of green and gold, with a skylark circling and ring-necked parakeets screeching overhead, and enlightenment begins to dawn. Through a narrowly focussed gap in the foliage, where a robin redbreast offers you its chirpy greeting, you gaze out across a sprawl of hazy urbanisation to the domed magnificence of St Paul's Cathedral, a view that is as unexpected as it is breathtaking. Incredible though it might seem, you are just eight miles from the centre of London, standing on a Bronze Age artefact known as King Henry's mound, one of the many and varied features of Richmond Park's treasure trove of history and, more obviously, natural history.

When we talk of natural history, one name leaps to mind: Sir David Attenborough, doyen of wildlife documentary makers. His celebrated professional odysseys have taken him to the most exotic, inaccessible and beautiful locations on our planet, and yet he is still entranced by this corner of suburban England. In his foreword to the *Guide to Richmond Park* (produced by the Friends of Richmond Park), he revealed: 'Richmond Park is a very special place for me. My regular walks in the Park, with its peace and tranquillity, have always provided me with an invaluable respite from the strains of daily life. The Park's wildlife is exceptional, particularly for somewhere so close to a major urban centre'.

Sir David's very personal tribute will come as no surprise to anyone who has passed even fleetingly through Richmond Park's wondrously diverse and picturesque terrain. For those who like their instinctive appreciation to be underpinned by hard fact, the Park comprises 2,350 acres of serene yet rugged beauty, with a meandering perimeter of eight miles, making it Europe's largest enclosed urban park, more than equal to London's seven other Royal Parks combined.

A handsome beast of a park, you might say; and on the subject of handsome beasts, our formidable friend the roaring stag in all his magnificence represents the most familiar, iconic image of Richmond Park, and rightly so. If asked to name the Park's primary attraction, it is fairly certain that the vast majority of people would plump for the deer, some of whom roam its lush and varied habitats untamed and relatively unapproachable; others more like lovable characters from a Disney movie.

The herd blends red deer (the slightly more wild-looking, deeply tanned individuals) with fallow deer (the spotted, Bambi-like ones), and is maintained at a figure of around 630 to ensure their health and well-being in an environment that is to a great extent tailored to meet their needs. Their cousins in the wild do not usually live to the age of 10, but in the more cosseted environment of the Park it is not unusual for them to survive well into double figures. Deer have mythical and even super-natural associations in many cultures, and these elegant superstars of the Park have that kind of mystical aura, too, ensuring that they will continue to draw visitors from all around the country, and from overseas, as long as the sun continues to rise over nearby Richmond Hill.

However, you do not have to be a wax-coated, wellie-wearing deer fanatic, with your binoculars, dedicated to seeking out the merest twitch of an antler or the flash of a spotted flank, to be excited, inspired, and occasionally awed, by the natural wonders of Richmond Park. Whether you are a bird watcher, a beetle- or butterfly buff seeking rare species, a serious or casual walker (with or without a dog), a family looking for a day out that is stimulating and educational as well as fun, or just a lover and observer of natural beauty, the Park will find a way of serving up precisely what you are looking for – and more. With its unique blend of wildlife and plant life, beautiful and historic buildings, sweeping landscapes and formal gardens, Richmond Park is a jewel among parks. And for many it is more than that; it is a way of life.

The downside of the deer, if there is one, is that they can sometimes seduce the visitor into overlooking the richness of the other Park life, which, for the record, includes 119 species of birds, 730 species of butterfly and moth, over 1,350 species of beetle, at least nine of the UK's 17 species of bat, as well as other mammals such as foxes, rabbits and shrews. For those who are prepared to leave their beds early, or simply wait and watch, there are opportunities to witness nature at its most unguarded and spectacular, and, on occasion, to savour those rare moments of wildlife action and majesty that usually yield themselves only to the most avid and patient of observers.

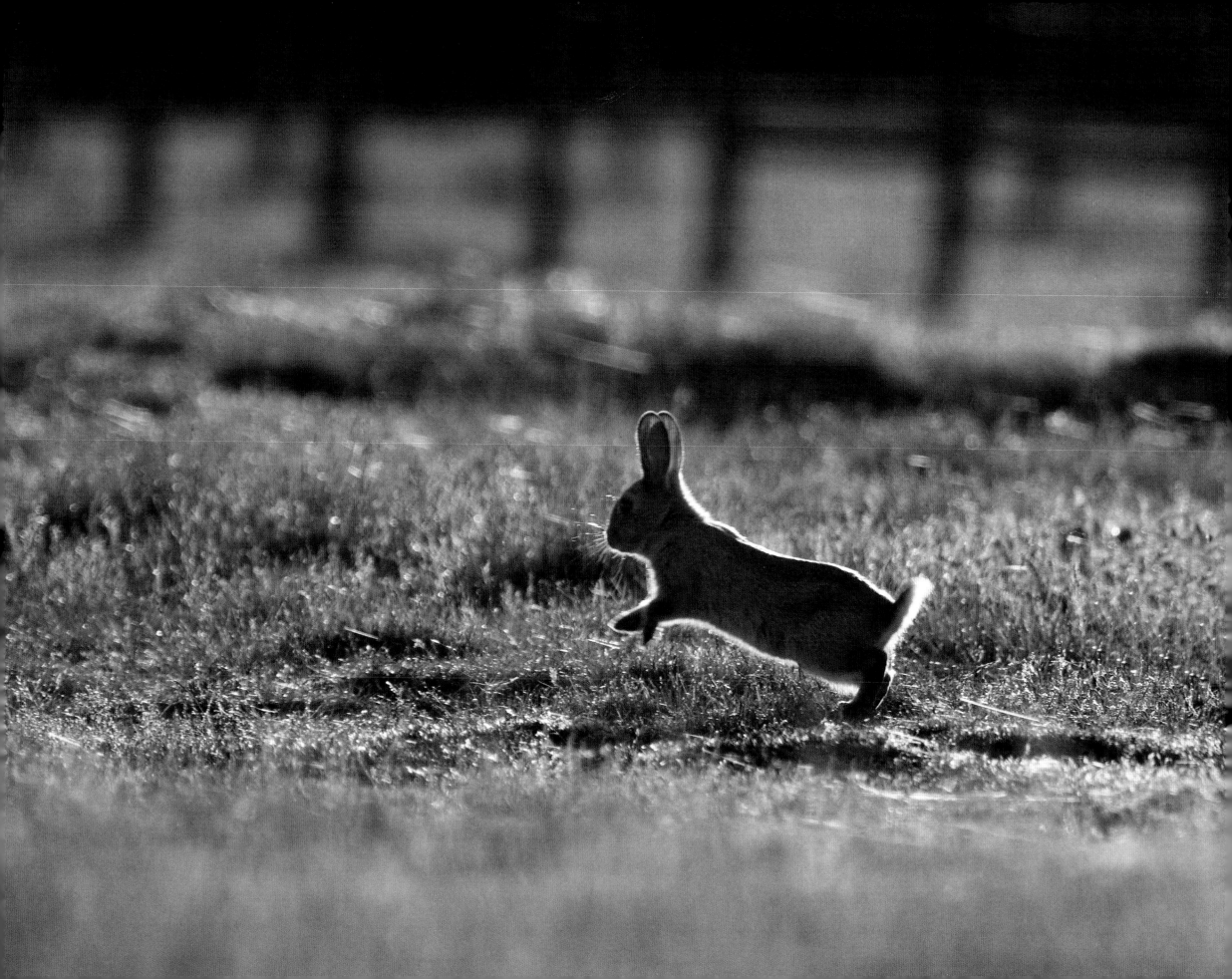

You might, for example, be lucky enough to spot a great crested grebe, with its extraordinary punk-like head feathers, performing its intricate courtship ritual or carrying its stripe-headed youngsters on its back; a pair of rampant stags, with antlers seemingly superglued together in combat during the rutting (mating) season; or a Canada goose, massive wings outstretched in perfect symmetry, landing spectacularly on the water like an aquatic jumbo jet.

Less rare, but equally captivating in its way, you might catch a glimpse of an exquisitely fragile, China-blue damselfly resting regally atop a plume of purple moor grass; a flash of peacock blue as a kingfisher speed-dives into a pond to snap up minnow; a spider's web transformed into a stunning silvery work of art by the morning dew; a burnet moth, with its garish red blotches, fluttering purposefully around a thistle; or a laddish-looking crow perching languidly on a bench in the morning haze. The permutations of wildlife and scenery in the Park are as limitless as they are mesmerising.

If it is trees that move your spirit, the stunning array totalling some 130,000 in all, includes several varieties of oaks, as well as beeches, field maples, hornbeam, cedars, crack and weeping willows, horse chestnut, and rare black poplar and handkerchief tree. This is complemented by the 450 species of plants that illuminate the landscape in a glorious patchwork of colours throughout the seasons, as well as the many ponds, pools and streams that sparkle like iridescent jewels in the landscape, often springing up before you in places where you might least expect to find them.

As regular Park users will affirm, every visit offers a new experience, as if seeing it fresh for the first time. There is a myriad of 'mix and match' ways of enjoying its many features that captivate first-timers and 'hardy annuals' alike and draw them back time and again. For example, taking tea on the terrace at Pembroke Lodge, a beautiful 18th–century house redolent with history, followed by a stroll through the veteran oak trees of Sidmouth Wood and Queen Elizabeth's Plantation, some of which are between 500 and 700 years old, to view the exotic collection of waterfowl disporting themselves in and around Pen Ponds; ambling leisurely around Pembroke Lodge gardens, a haven of tranquillity and colour, with Bambi's cousins as enchanting companions; or meandering through Isabella Plantation, savouring the rich mix of flora and fauna, and the alluring water features.

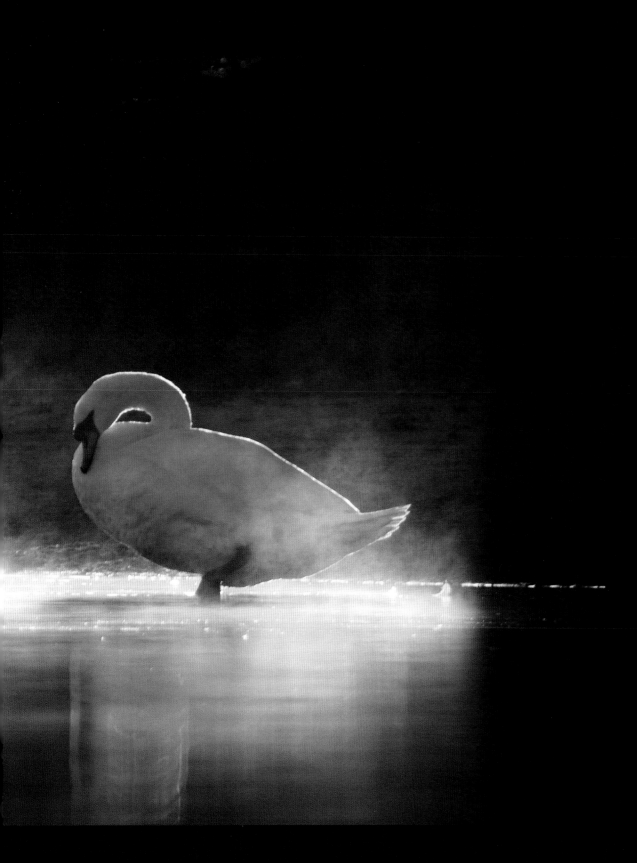

For the architectural *cognoscenti* and the casual visitor alike, there are many fine buildings, including White Lodge, where Nelson sketched out his battle plans for Trafalgar in red wine during a dinner in 1805, and now home to the Royal Ballet School; and Thatched House Lodge, an 18th–century mansion used by Britain's first *de facto* Prime Minister Sir Robert Walpole – and, it is believed, King George II, as a hunting lodge – and now the private home of Princess Alexandra.

However, it is not just the treasure trove of visible attributes that make the Park such a special place; a magnet for photographers, film crews, artists and writers seeking to capture something of its Mona Lisa-like charms to disseminate to a wider audience. In many ways the things that are unseen are at least as important in producing and maintaining the Park's public face; and it is here that we confront an apparent paradox.

Despite the incongruous presence of an established commuter route snaking through the Park, disgorging its flow of traffic into the mayhem of suburbia at several different points, visitors are often struck by an inherent stillness and tranquillity that one does not find in other parks. This state of ordered but certainly not stifling calm and serenity, underpinned by an ethos of restraint and reverence, has not come about by accident.

On one level this is because the Park's commanding presence automatically engenders respect; but there is more to this special relationship between Park and public than attitude. A newcomer might notice that the usual range of fun and games one expects to find in a park are conspicuous by their scarcity and, in some cases their absence. For example, kite and model aircraft flying, cycling and roller skating, are restricted to certain dedicated areas; and dogs must be under control at all times and on leads in some places. If you want to lead a parade or put on a display, light a fire or a barbecue, climb a tree, land a helicopter, or, for that matter, frolic in a pond, discharge a firearm, or do your washing *al fresco*, the message is simple: "Don't".

So why the need for a 'rule book' approach to a very public asset, which on one level is so accessible and user-friendly? The short answer: ecology. Maintaining the healthy condition of its many and varied habitats – woodland, grasslands, ponds and streams, ancient trees and decaying wood, and formal garden areas – is crucial. This, in turn, ensures the well-being of the diversity of life forms that are dependent on the preservation of the ecological status quo for their survival.

The hard work behind the scenes has paid off handsomely. In 1992 Richmond Park was designated London's largest Site of Special Scientific Interest (SSSI); in 2000, a National Nature Reserve (NNR); and in 2005, a European Special Area of Conservation (SAC). It can also boast the prestigious Green Flag award for outstanding environmental standards.

Sadly, there is no room for complacency. Nature is under threat, not just globally but in the microcosm of Richmond Park, too. Over the last 50 years, the Park has lost many species of wildlife, and half of its trees are threatened by disease and climate change. This is why the Park's management, supported by the Friends of Richmond Park, a charity dedicated to its conservation and protection, continually emphasise the need to respect the natural order of things and refrain from interfering whenever humanly possible. "Tread lightly" is the official message for visitors.

One illustration of this is the prohibition on destroying and removing dead and decaying wood and fungi, which provide homes and food for birds, animals and invertebrates, including the rare cardinal click and rusty click beetles. And when you see a skylark soaring overhead, pouring forth 'in profuse strains of unpremeditated art', as the poet Shelley described the heavenly birdsong of this 'blithe spirit', bear in mind that walkers, dogs and general human usage at one stage threatened its extinction as a breeding bird in the Park. Fortunately, signs placed at strategic points asking people to keep to paths and to control dogs have had a dramatic effect and skylark numbers have increased again.

The story of our nation is illuminated by people of courage and single-mindedness; and had it not been for a local hero epitomising these qualities, the timeless magic of Richmond Park, which nowadays draws two and a half million people through its gates each year, might not have been available for visitors to enjoy in any shape or form. In the mid-18th century, John Lewis, a feisty local brewer, fought a lone battle to open this wondrous place for all to enjoy; not with a sword or a rifle but with a far more powerful weapon: a legal challenge to a royal personage, no less. Lewis dared to take on Princess Amelia, daughter of George II, who had barred all but her highfalutin friends from gaining access to the Park, in a High Court action that proved to be as dramatic as it was audacious.

The official respondent in Lewis's court case was a gatekeeper named Martha Gray, who, acting on the instructions of Princes Amelia in her capacity as Park Ranger, had barred him from entering through Sheen Gate because he was not in possession of a ticket, as dispensed to her carriage driving cronies. Despite all the Princess's machinations, including what appeared to be a rather obvious and clumsy attempt to bribe the jury, Lewis won his case and, given a choice by the court, elected to have a ladder stile erected to allow local people access rather than a door in the boundary wall, which he feared might still represent a barrier to entry.

The Princess still had a trick up her blue-blooded sleeve, however. She had the rungs on the ladder stile spaced so widely that it was impossible for all but the most agile members of the public to use. Lewis complained to the court, stating that "Children and old men are unable to get up it". The judge again found in his favour, commenting: "I have observed it myself; and I desire, Mr Lewis, that you would see it so constructed that not only children and old men, but old women too, may be able to get up." His triumph was commemorated on 16 May, 2008, exactly 250 years after the Park was re-opened to the public, when the Friends of Richmond Park installed a plaque in his honour at Sheen Gate.

It was not merely a peeved Princess Amelia who weaved a royal name in the rich tapestry of the Park's history. Kings, earls, countesses and prime ministers have at some time availed themselves of its spectacular natural features in one way or another, beginning in 1637 with King Charles I, who being 'extremely partial to the sports of the chase', discovered the ideal place, close to the royal palace of Hampton Court, where he could indulge his passion for hunting.

Charles requisitioned the area that now constitutes Richmond Park and, having managed with some difficulty to buy off the local landowners whose territory he annexed, had the site surrounded by an eight-mile boundary wall built from bricks he had specially manufactured (it is now a Grade II listed structure). In those days Richmond Park was known as the King's 'Newe Park' in Richmond as a way of avoiding any confusion with what is now called Old Deer Park close by.

George II also regularly hunted deer in the Park, often with Sir Robert Walpole; but deer were not the only royal prey. During the 18th century, George III would regularly shoot turkeys that had been specially raised in the Park for his sporting pleasure. And folklore has it that Prince Edward, later to become Edward VII, pursued a quarry of an entirely different kind

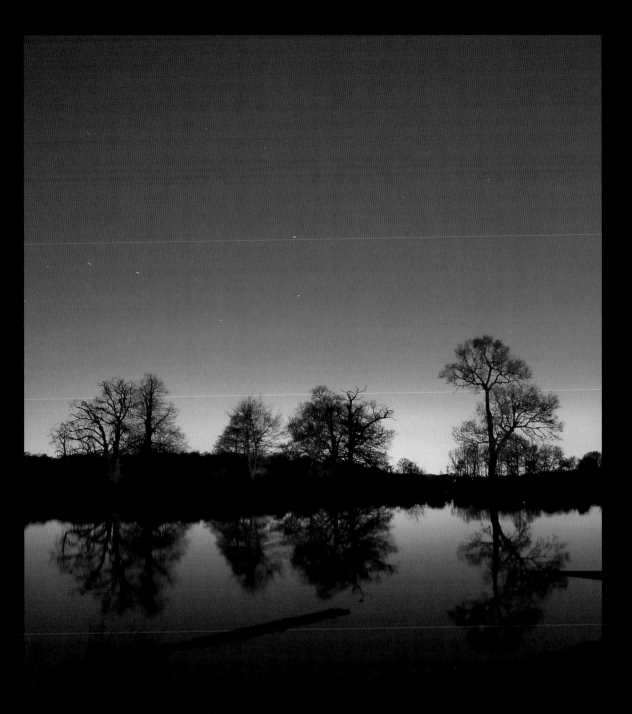

there, namely one of his mistresses, Lillie (or Lily) Langtry. According to certain killjoy historians, however, Edward's assignations with this famous actress in the Park's White House Lodge, were romantic fiction.

Fact or folklore: as you might expect a wealth of tantalising Park tales exist, whose ability to intrigue and captivate depends on whether you buy into the romance of urban legend or the cold fact of the history boys. It is indisputable that three British Prime Ministers – Sir Robert Walpole, Henry Addington and Lord John Russell – the Yugoslav president Marshal Tito, philosopher Bertrand Russell, and actor David Niven were erstwhile residents; an Olympic village (1948) was sited there; and that beavers once frolicked by its streams and ponds – Beverley Brook derives its name from 'bever', meaning 'beaver', and 'ley', an Anglo-Saxon word for 'stream'.

However, the much-chronicled story that Henry VIII waited atop his eponymous mound for a signal that Anne Boleyn had been executed at the Tower of London in 1536 is still open for debate; as is the grisly origin of Gallows Pond, close to Kingston Gate, reputedly so named because it was the site used for executing felons convicted at nearby Kingston Assizes. The actual gallows, it is claimed by those non-romantics who allow detail to spoil a good story, was located just outside the gate.

Legend also has it that there was a magical tree, a shrew ash (destroyed in the storm of 1987) that had supernatural healing properties and was used to cure sick children and animals. That is something maybe even the cynics can live with: a magical tree for a magical setting – Richmond Park is that kind of place.

by John Karter

Spring

A spectacular coming-back-to-life as vibrant hues of green, pink and blue are daubed in sprawling brushstrokes across the Park's stripped canvas. Whilst delightful young deer calves and fawns make their faltering entrance into the world under the gaze of their ever-watchful mothers, the hoary old stags are engaged in a little personal renovation, casting off their bony antlers to make way for velvety new ones. With the backdrops becoming more stunning by the day, you might see the deer family emerging eerily from the morning mist or silhouetted against a blood-red evening sky.

Look up to catch a sparrowhawk showing off his sky dance, wheeling and diving as if auditioning for an aerobatics display; and, less extravagant in flight but equally eye-catching, the unmistakable shape of a serpent-necked cormorant preparing to dive-bomb a fish, then posing with massive wings outstretched. A chorus of birdsong fills the ears: the liquid trill of a willow warbler; the yaffling of a woodpecker; and the cuckoo leading the choir with the distinctive call that has become the traditional harbinger of springtime, whilst its namesake, the delicate cuckoo flower, lights up the glades with bursts of lilac.

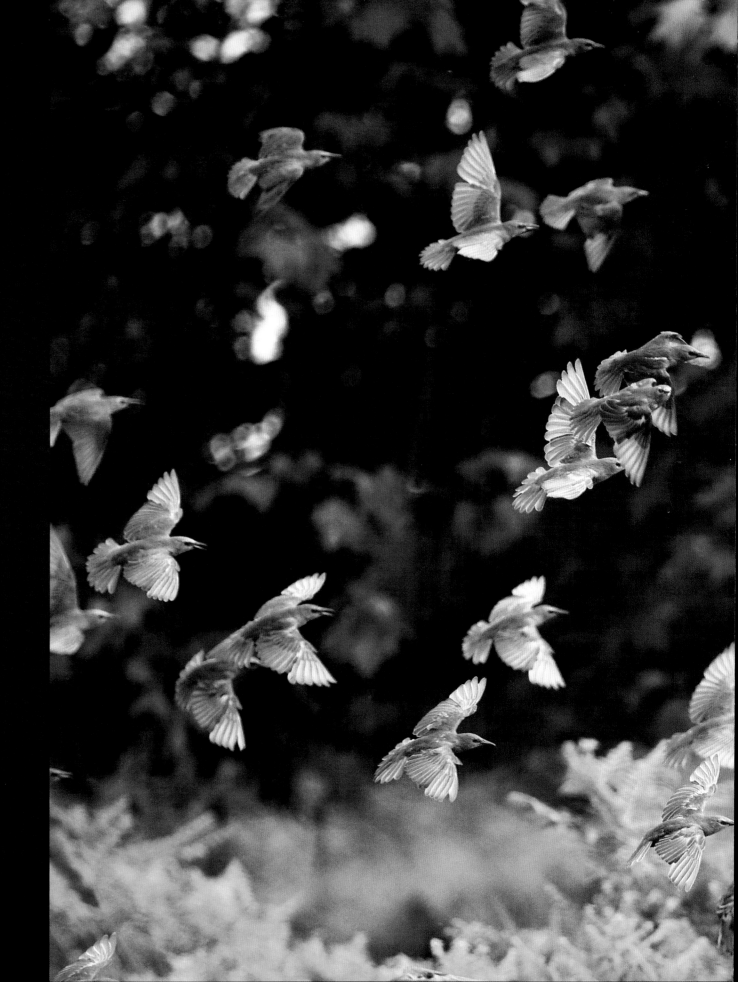

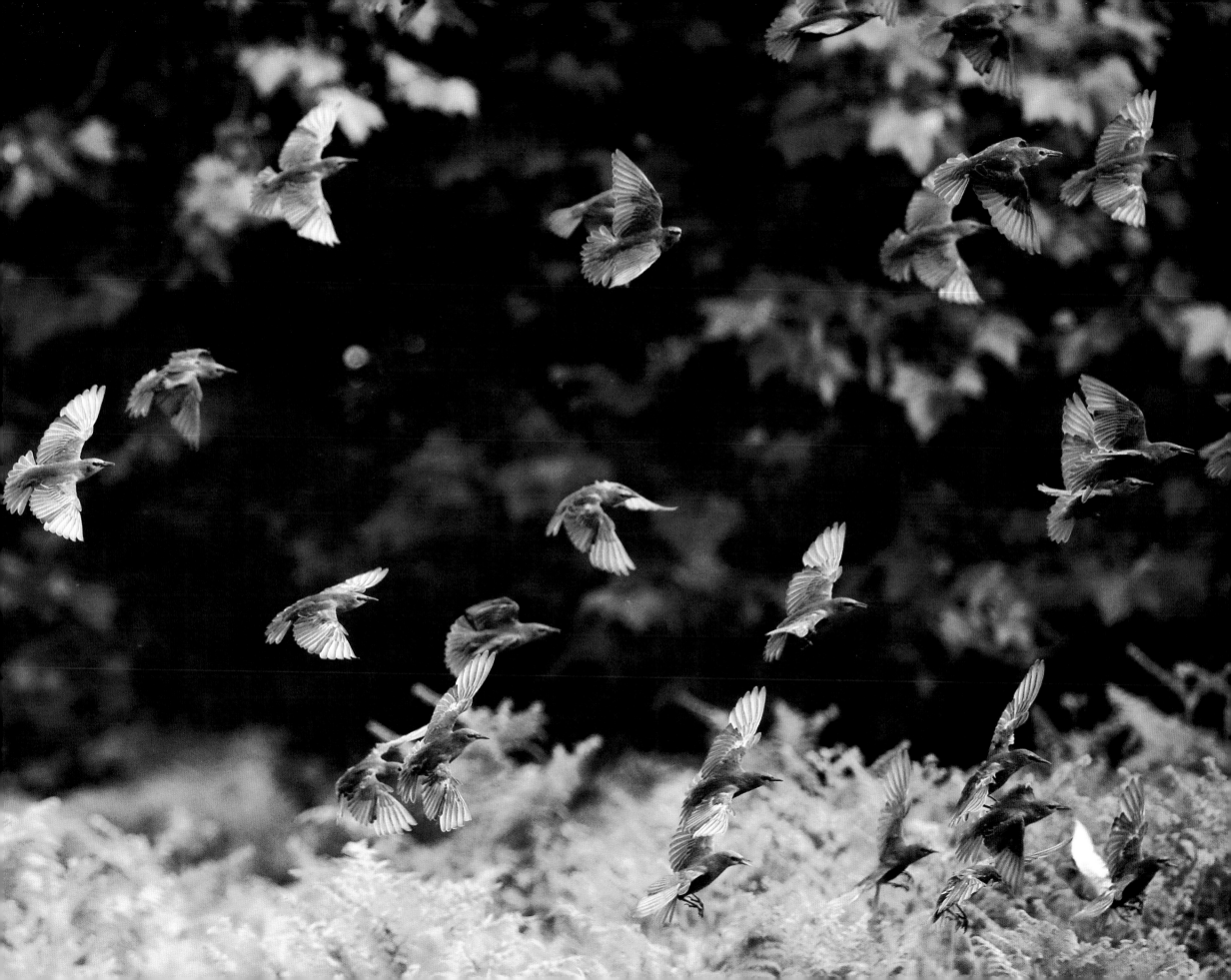

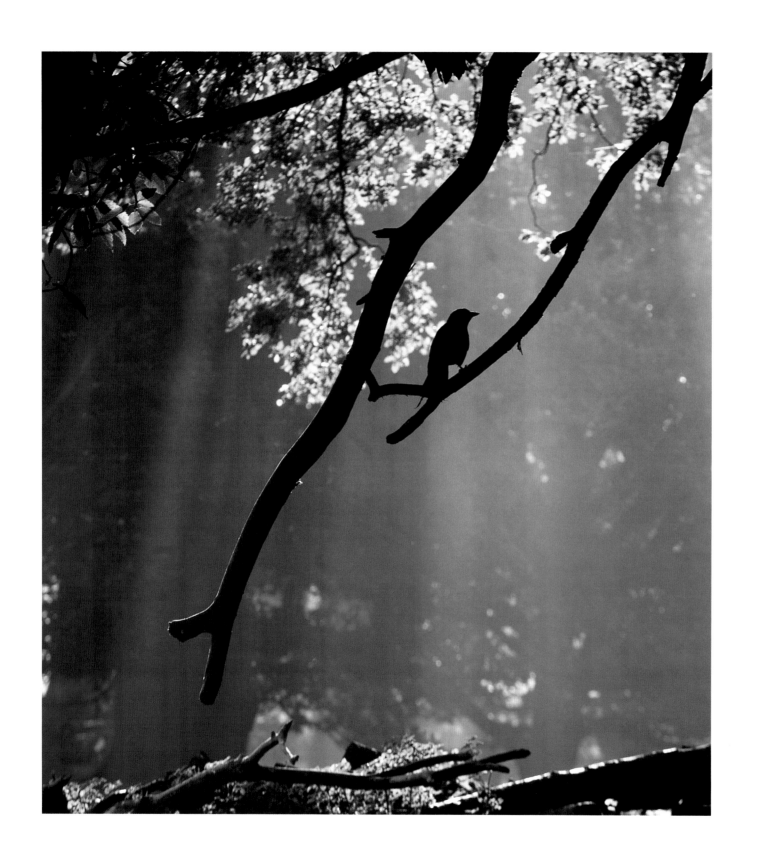
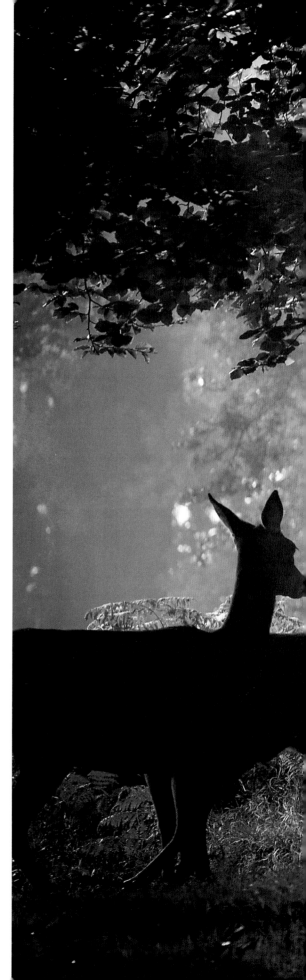

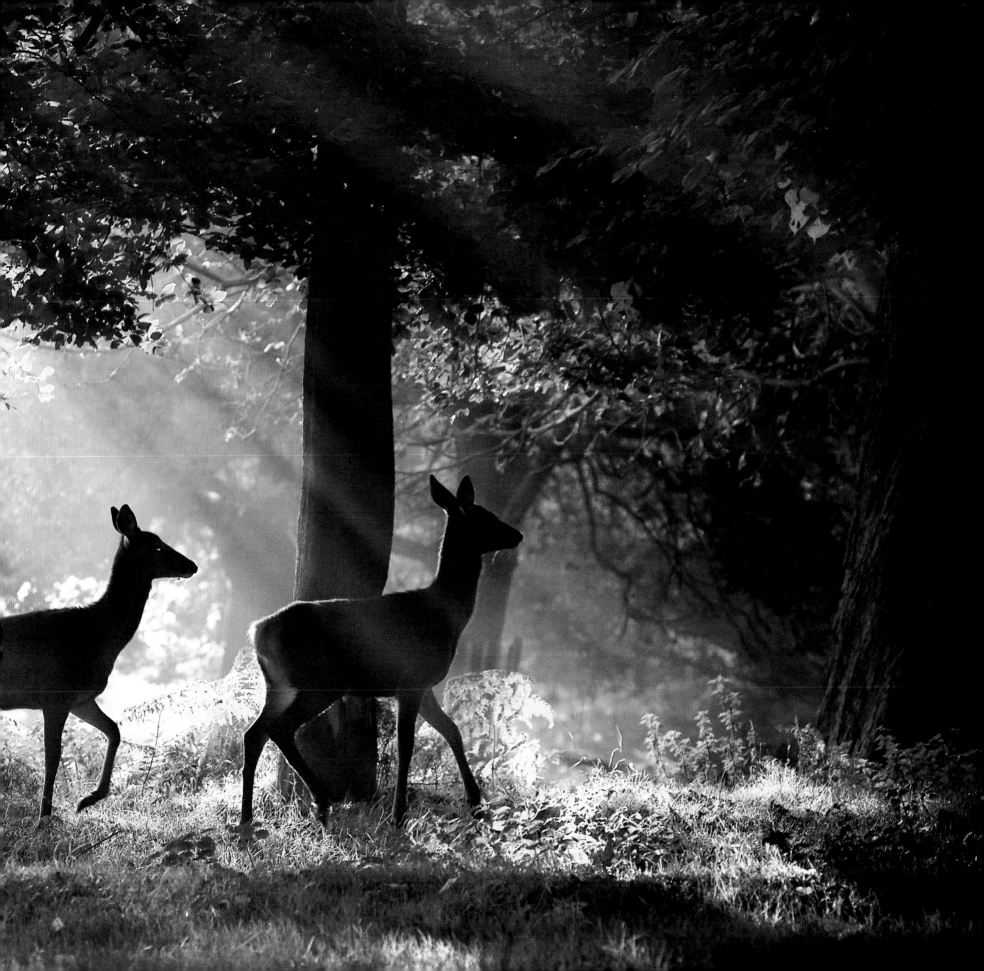

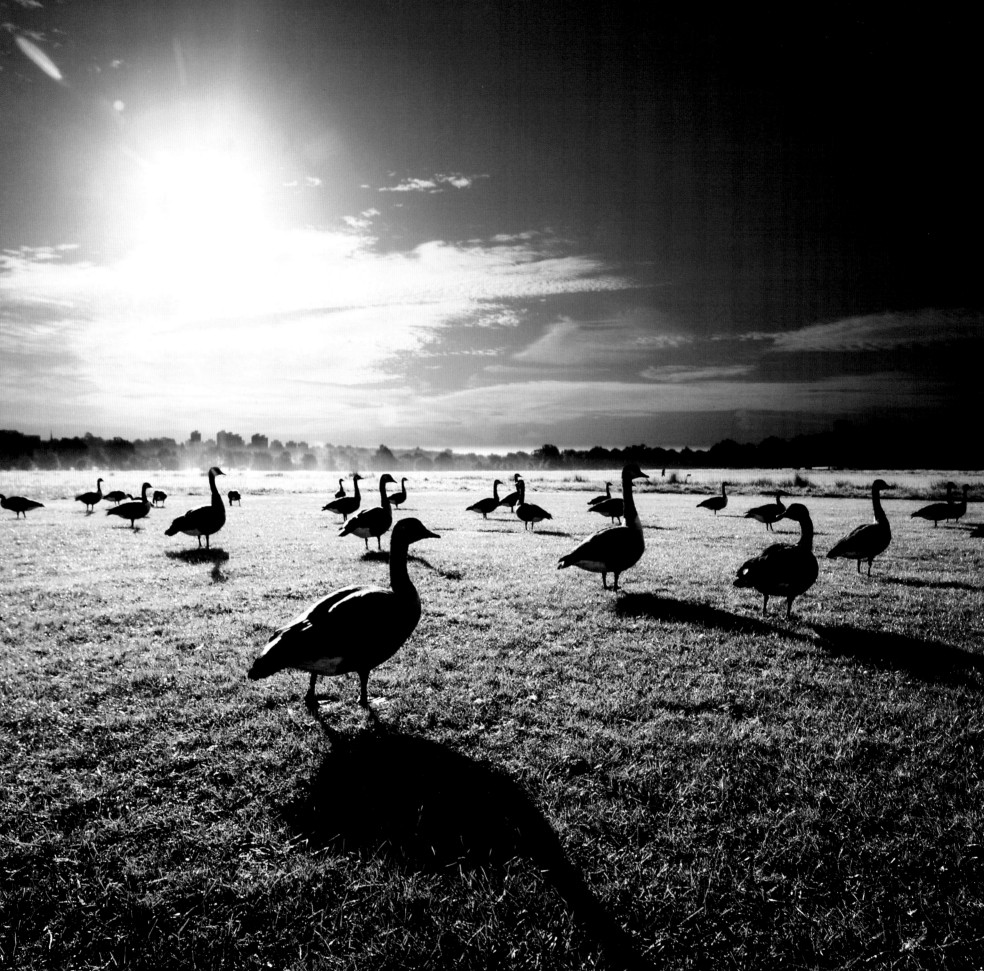

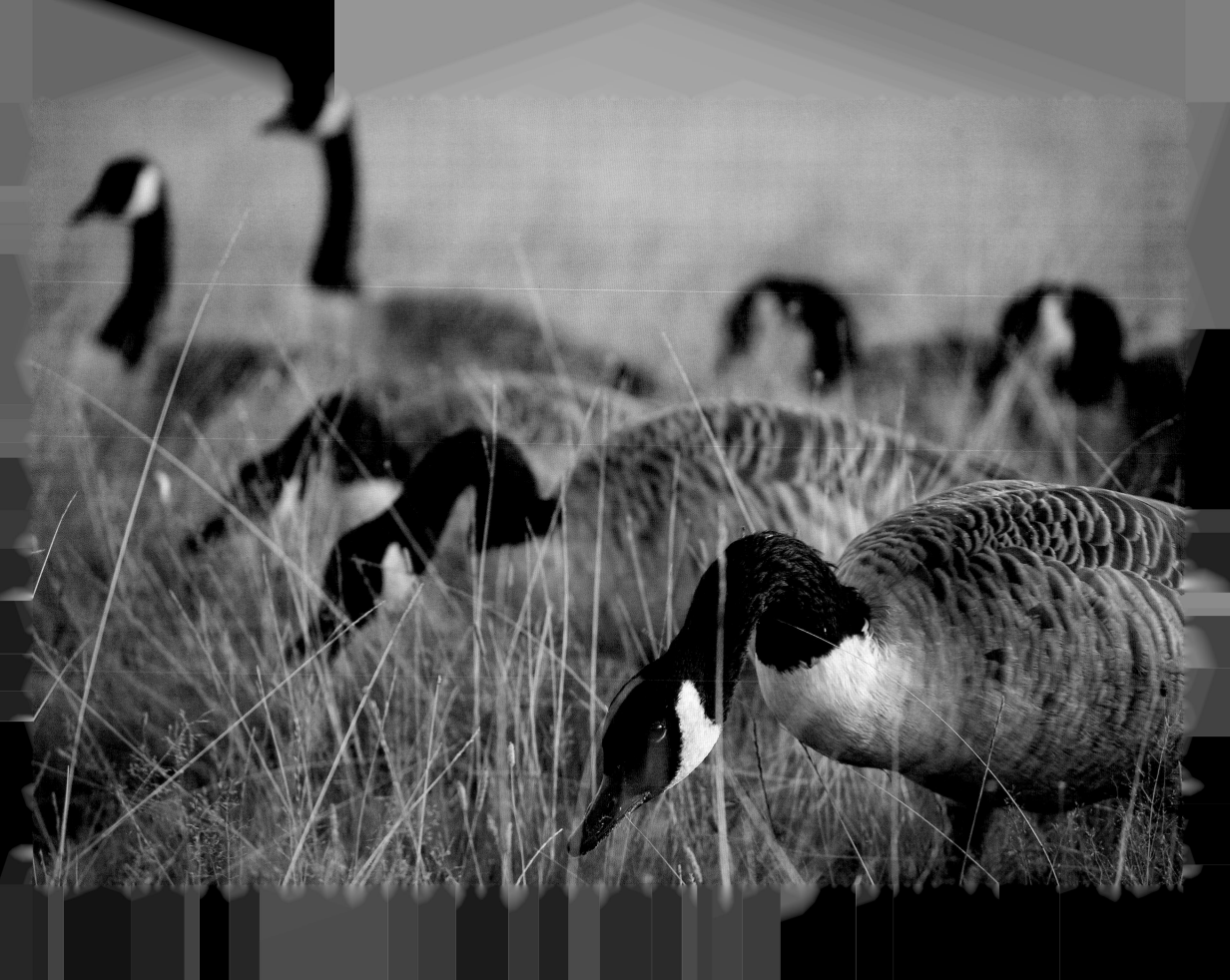

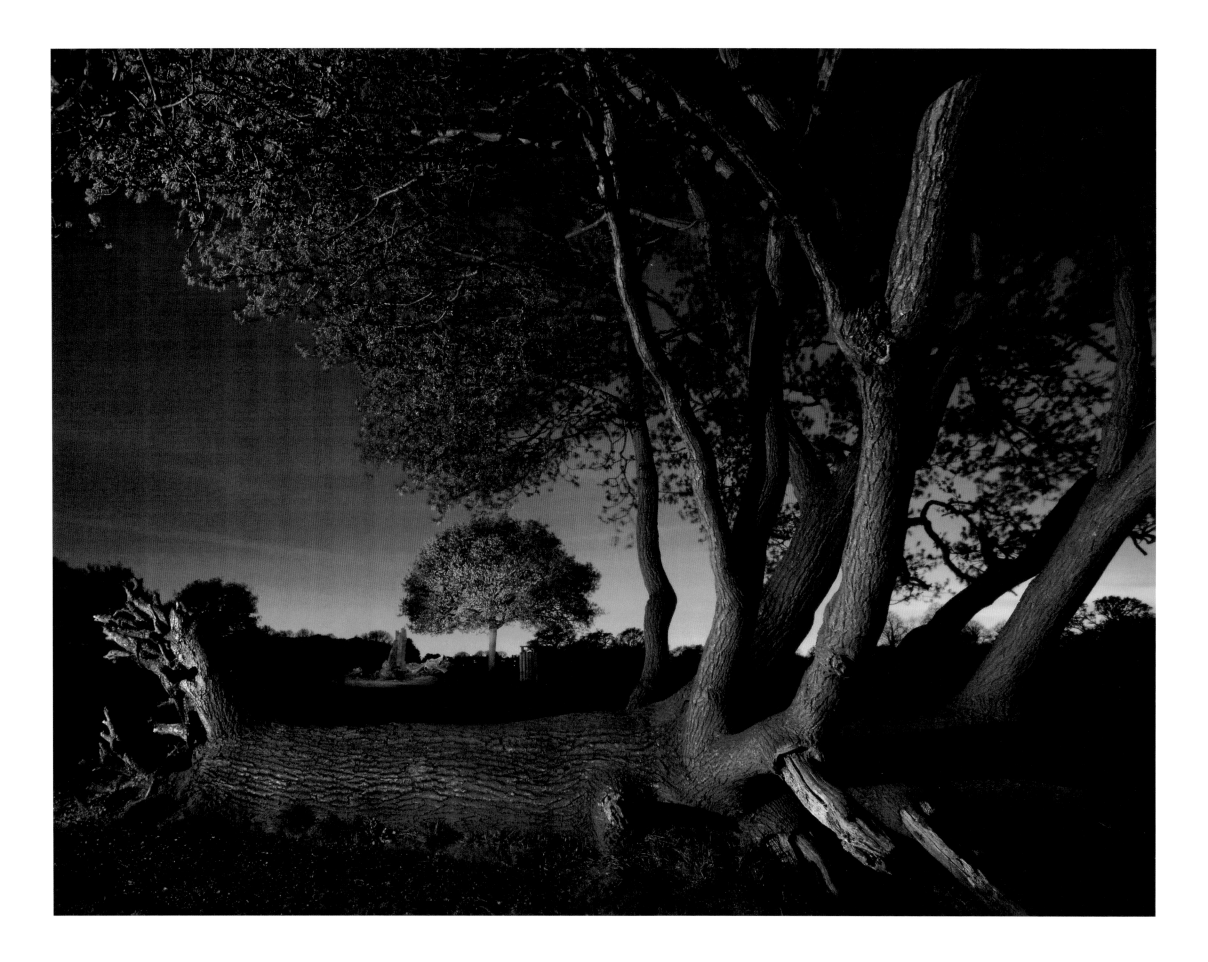

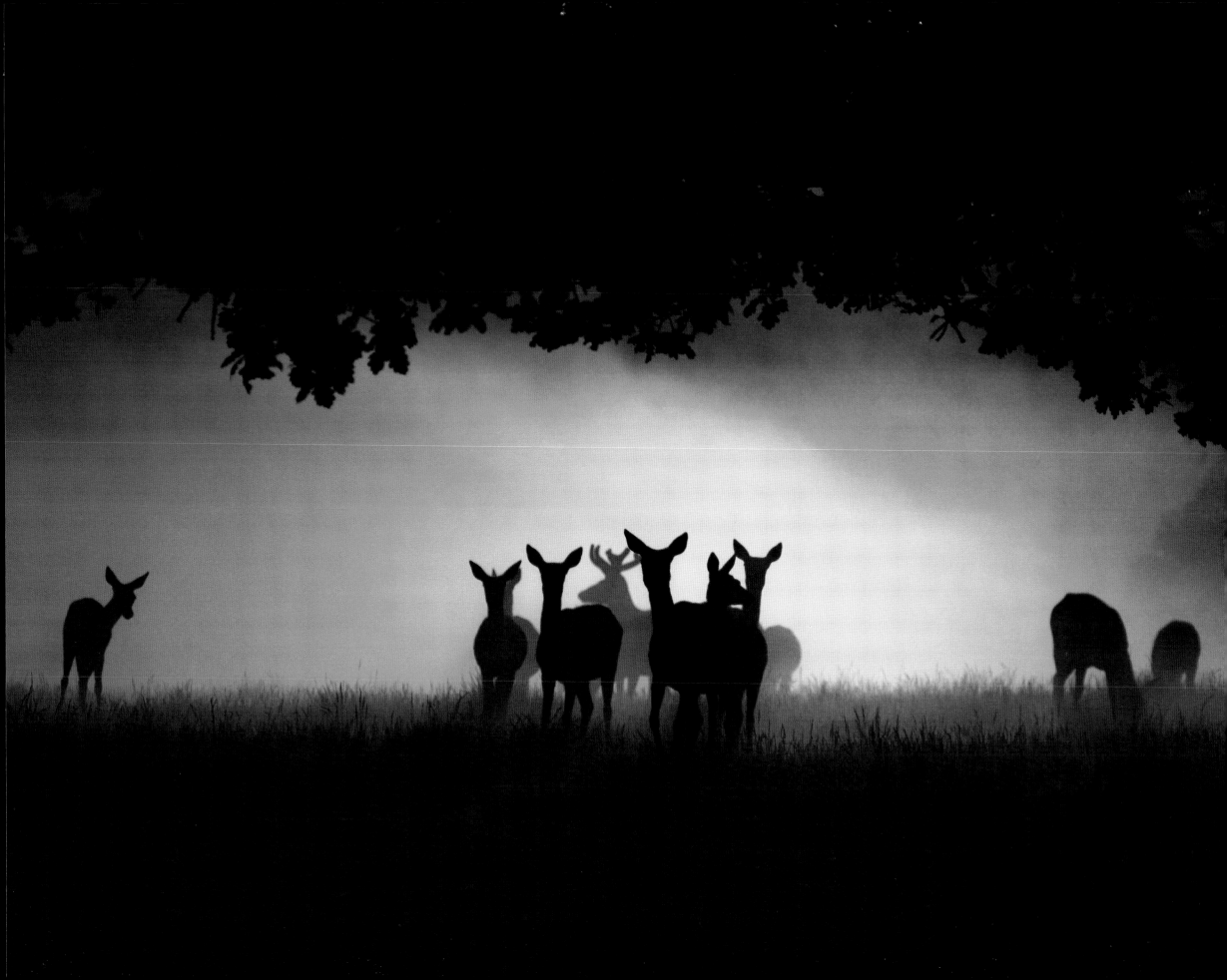

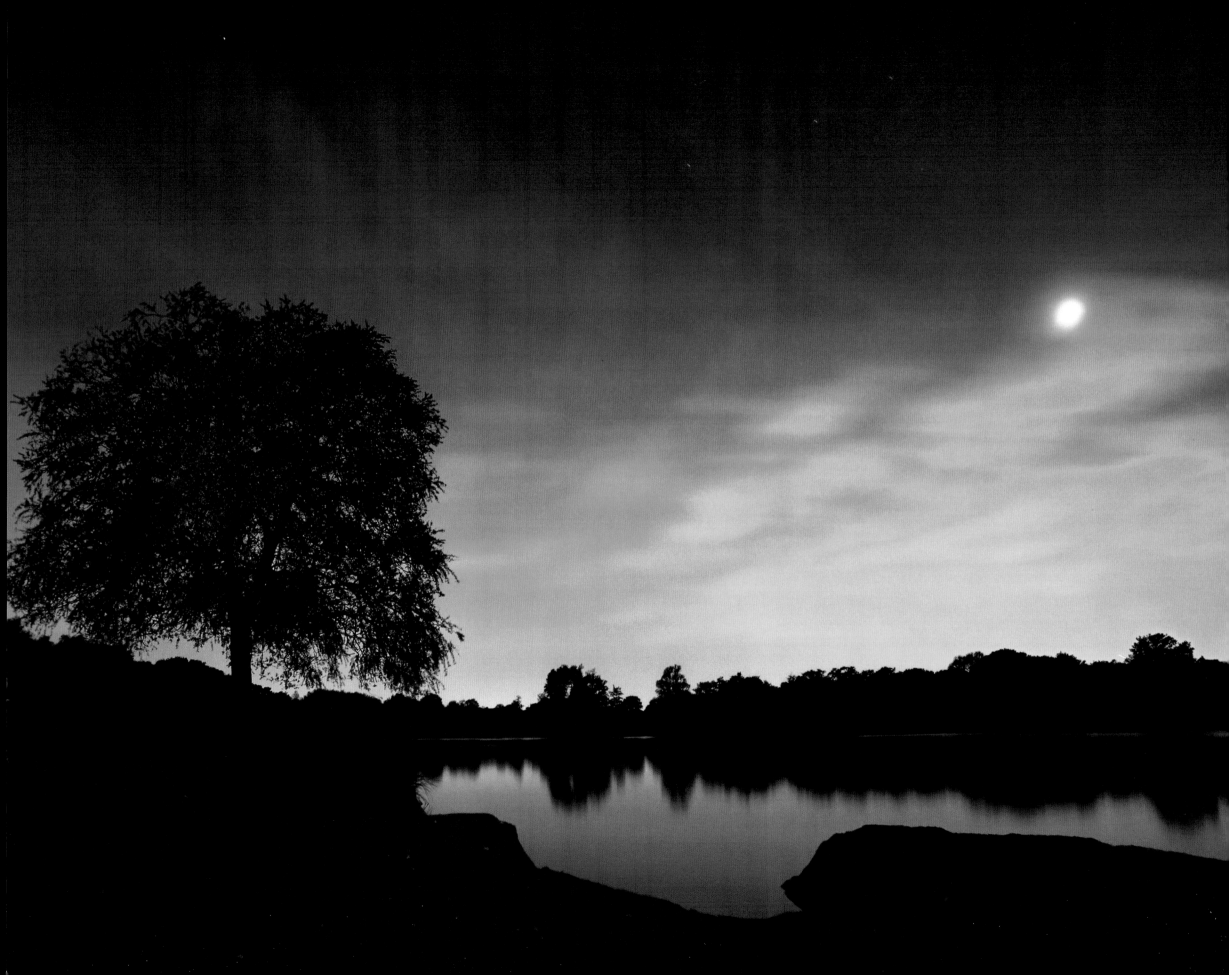

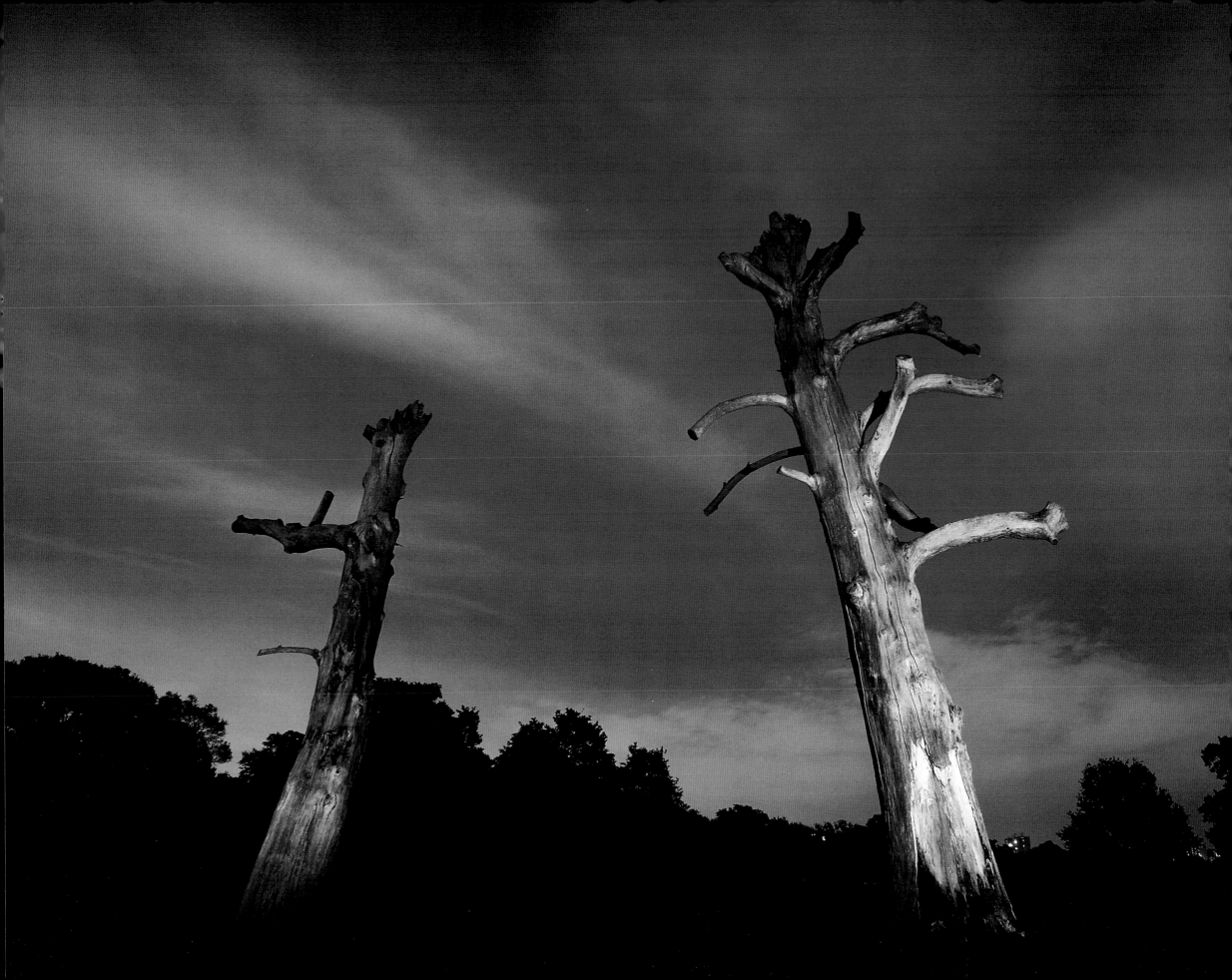

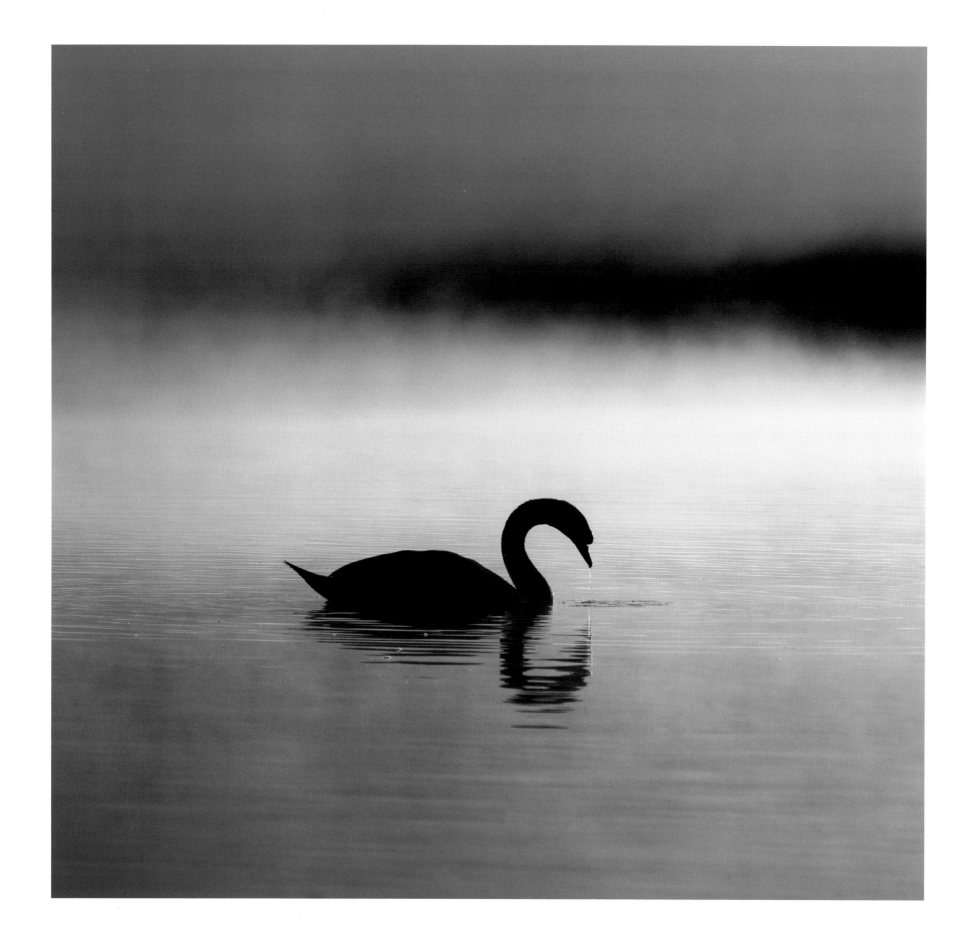

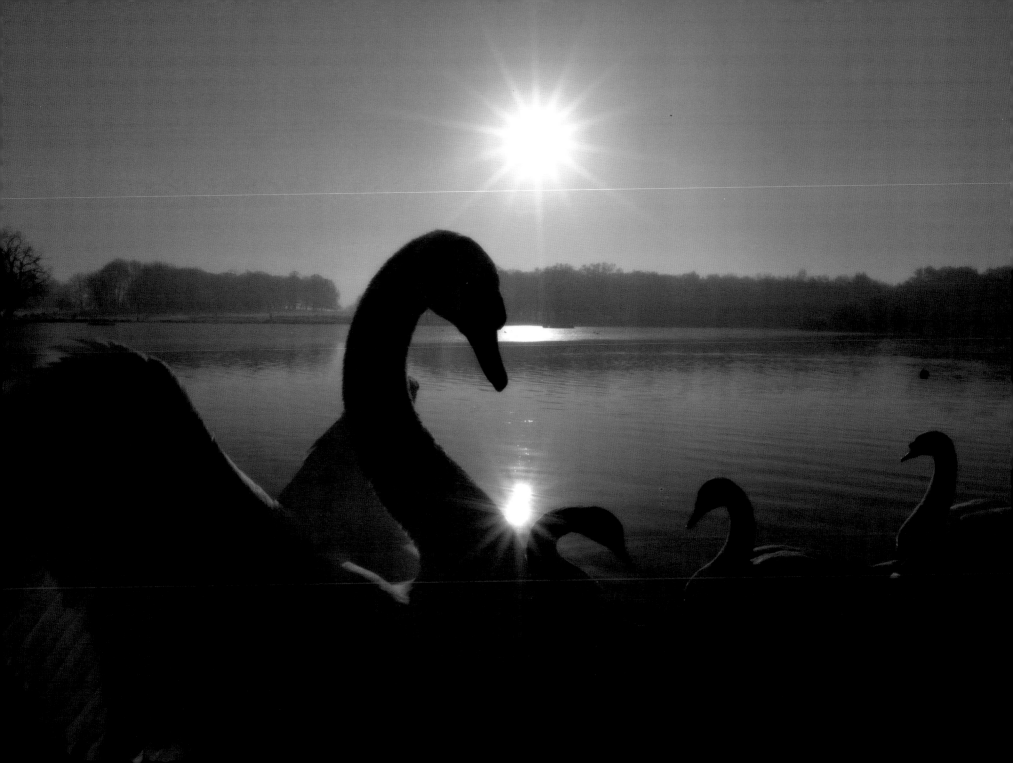

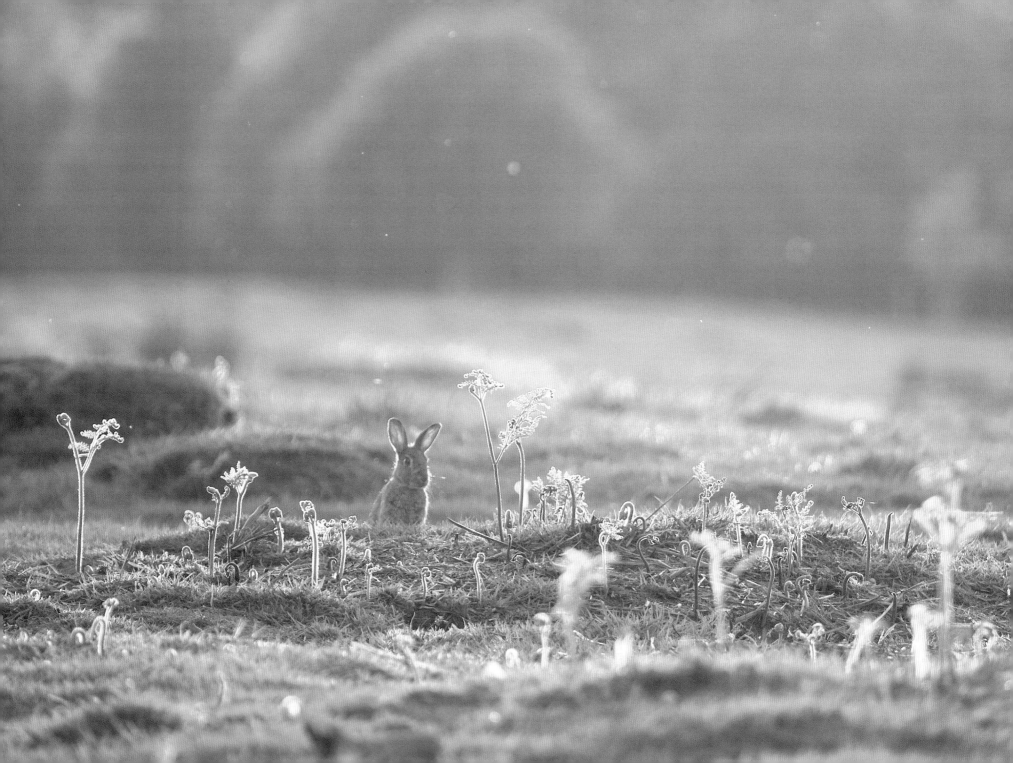

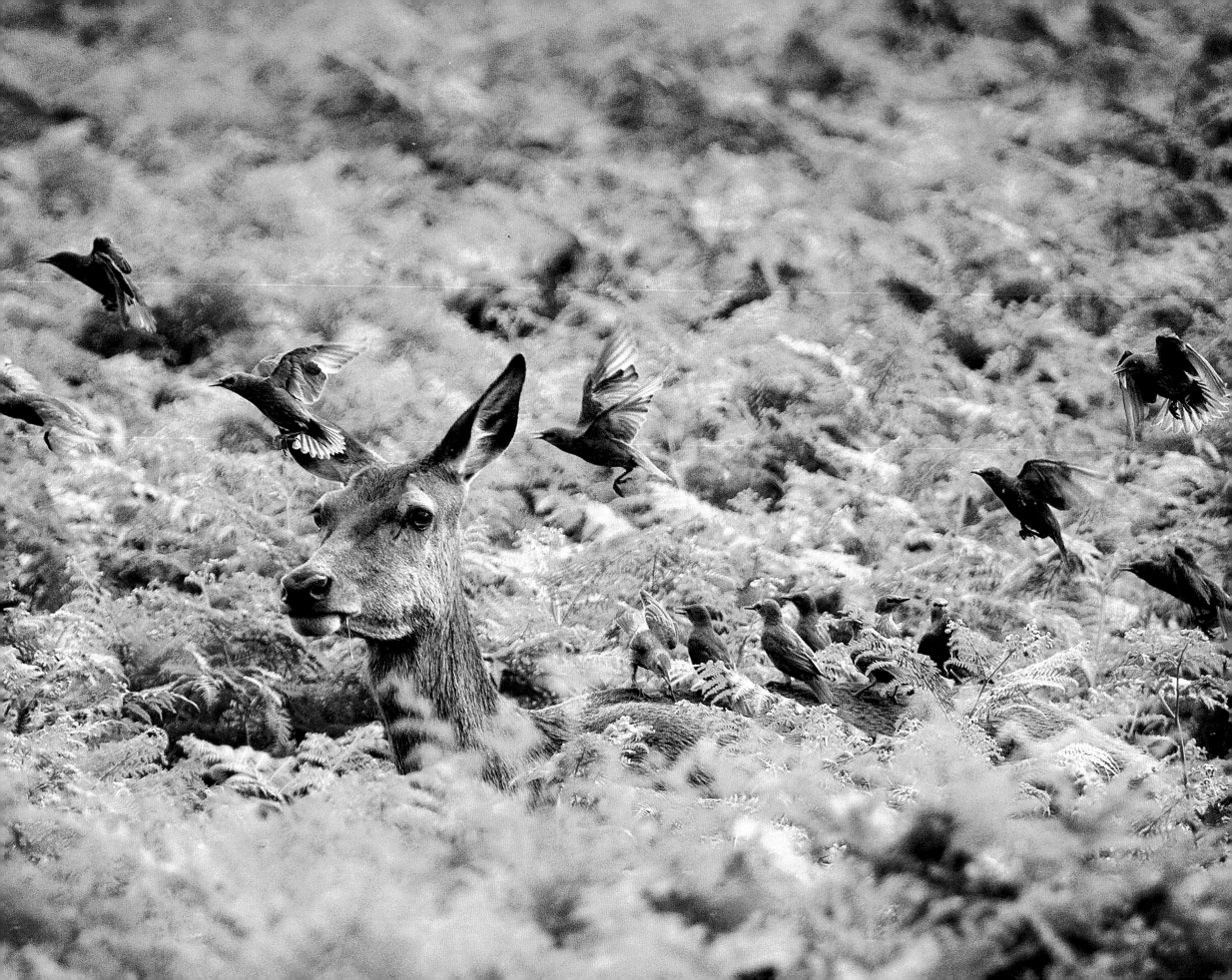

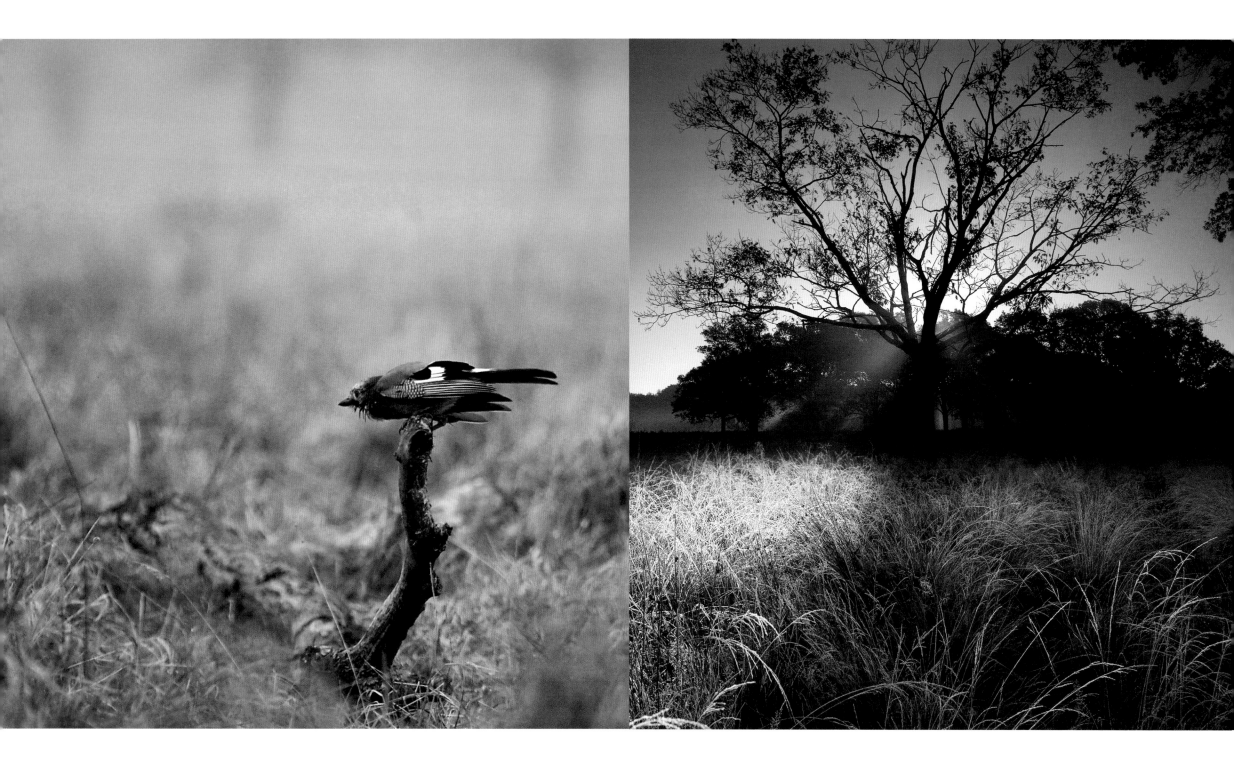

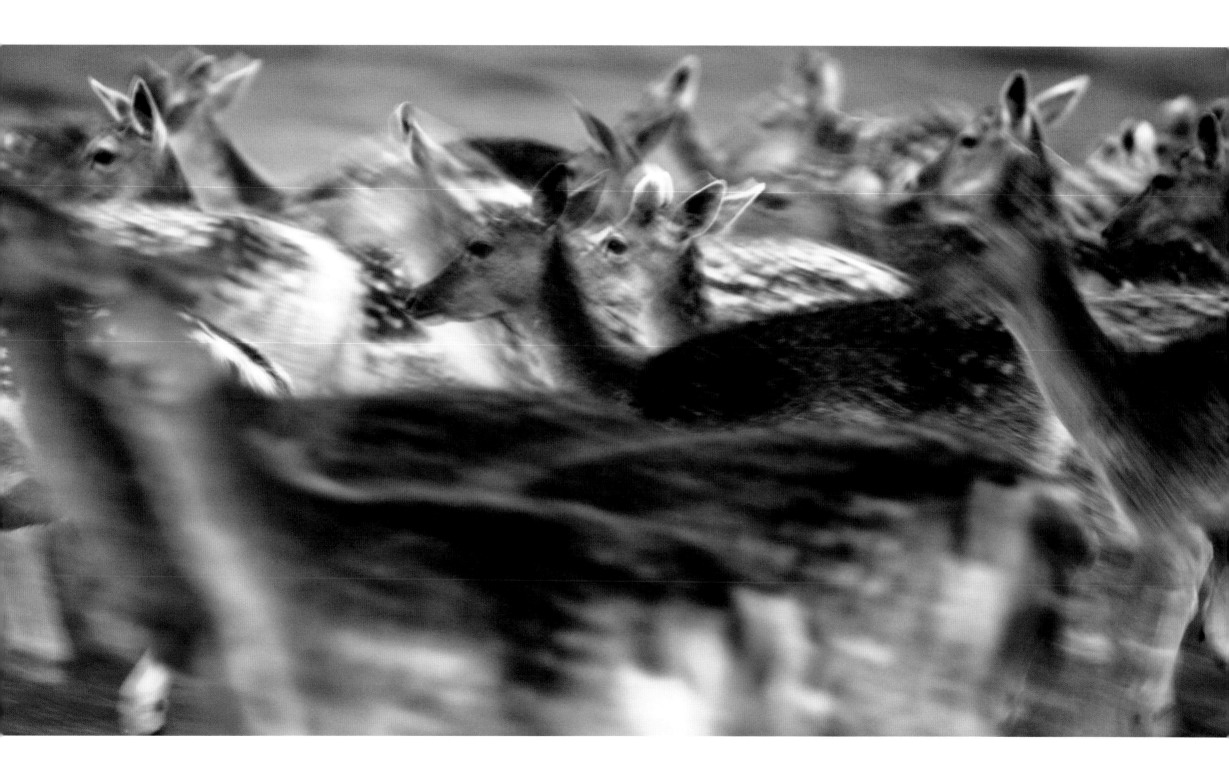

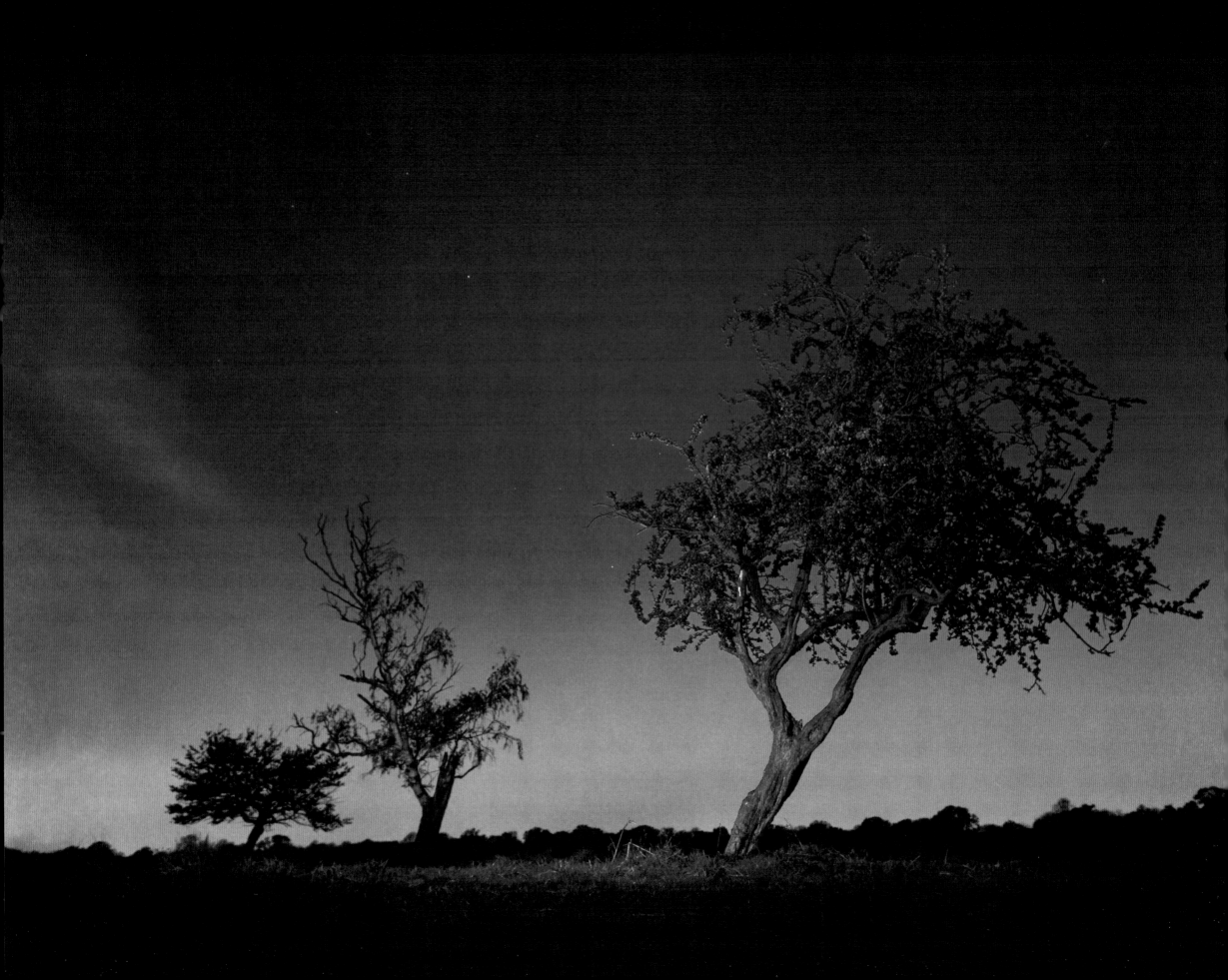

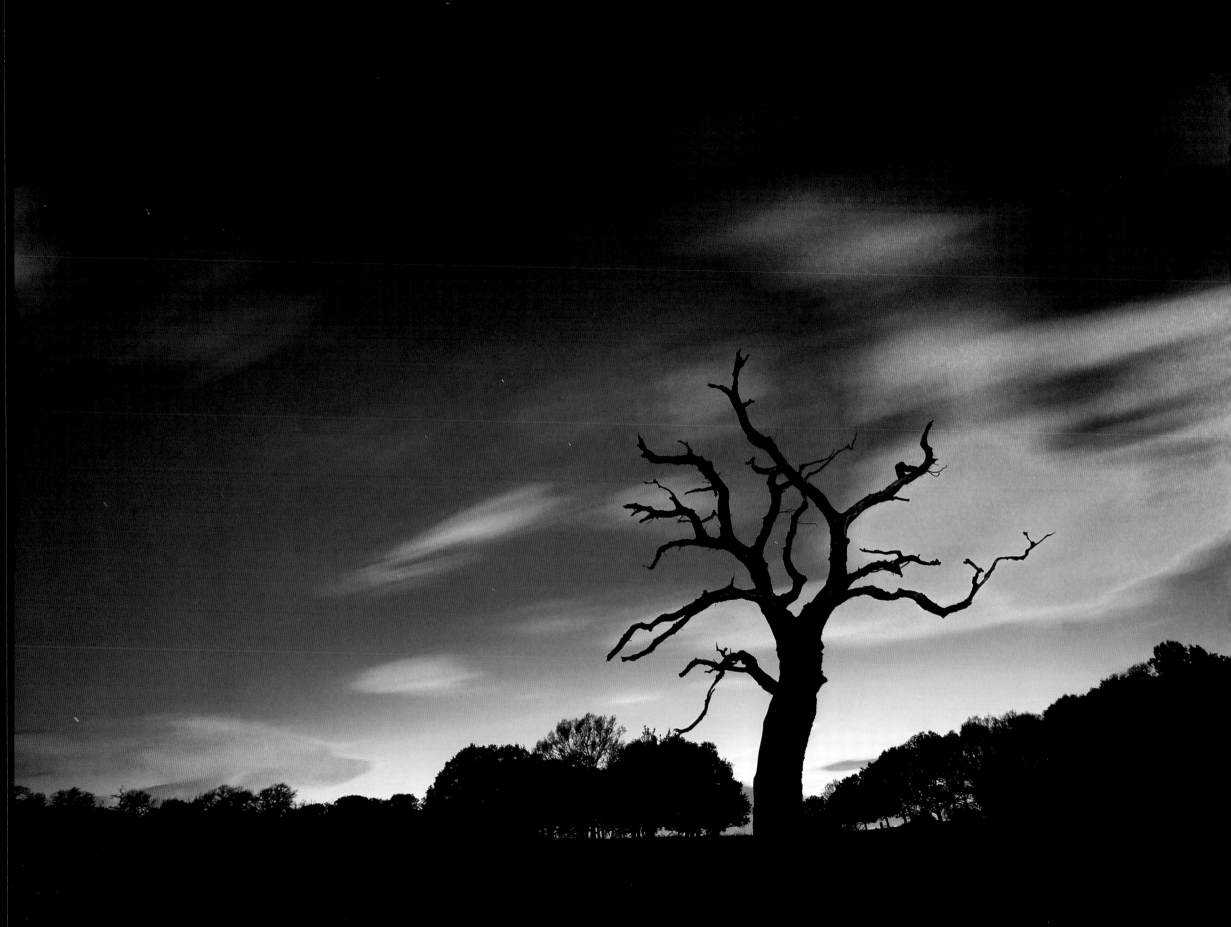

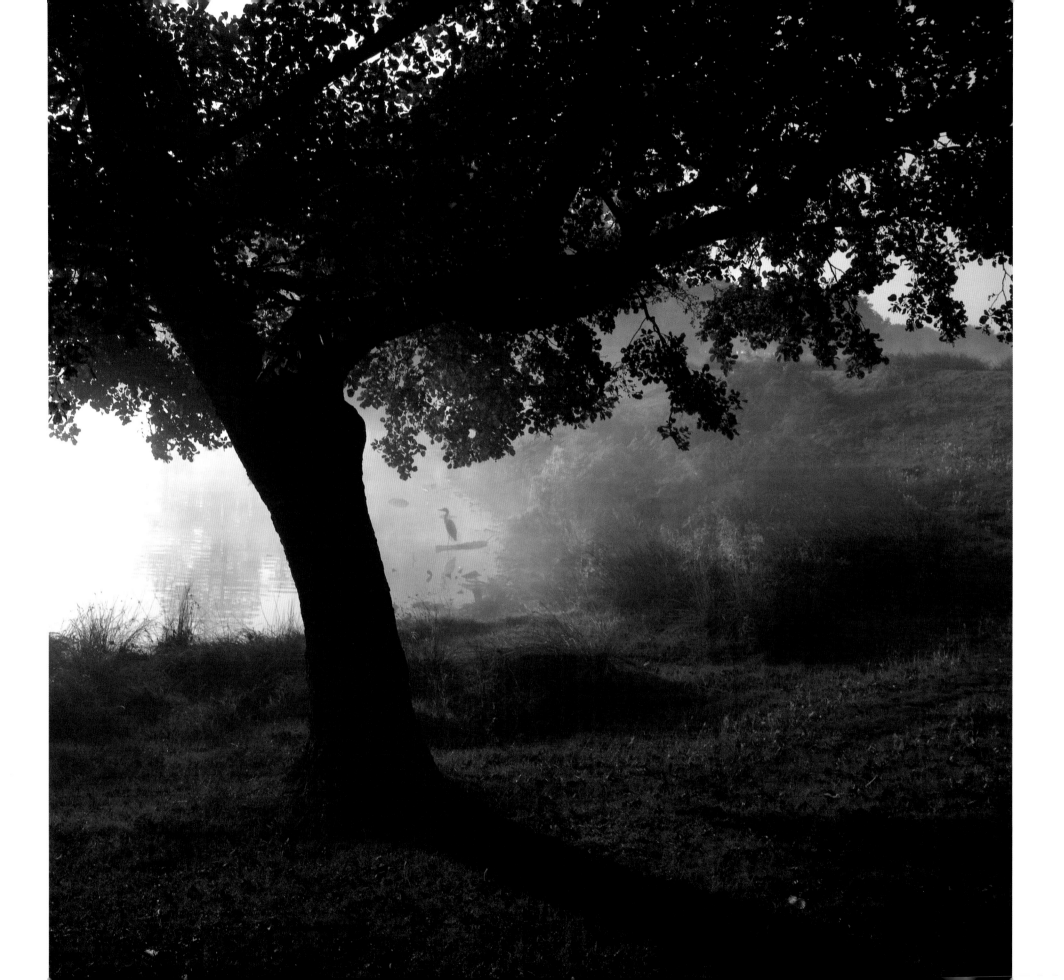

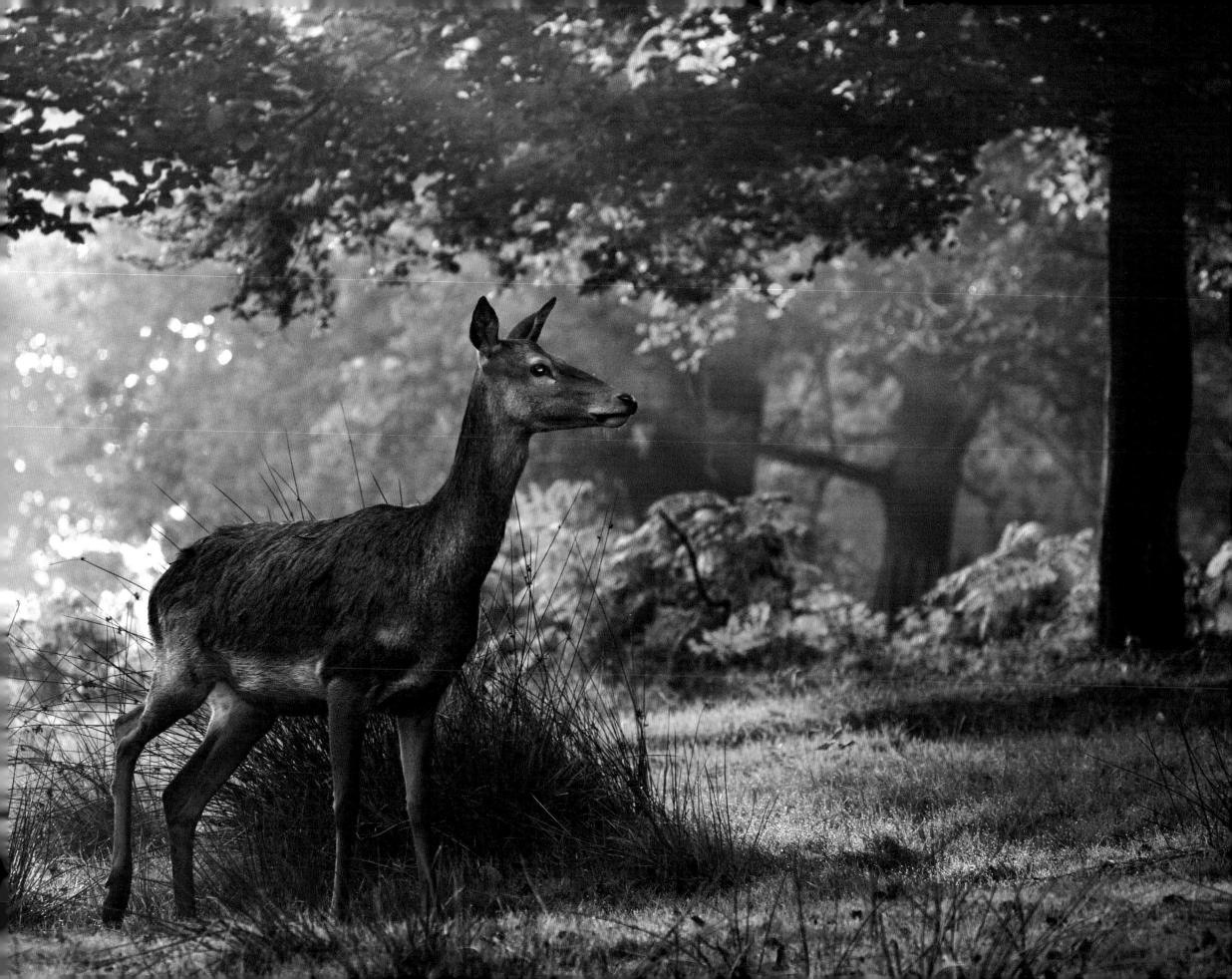

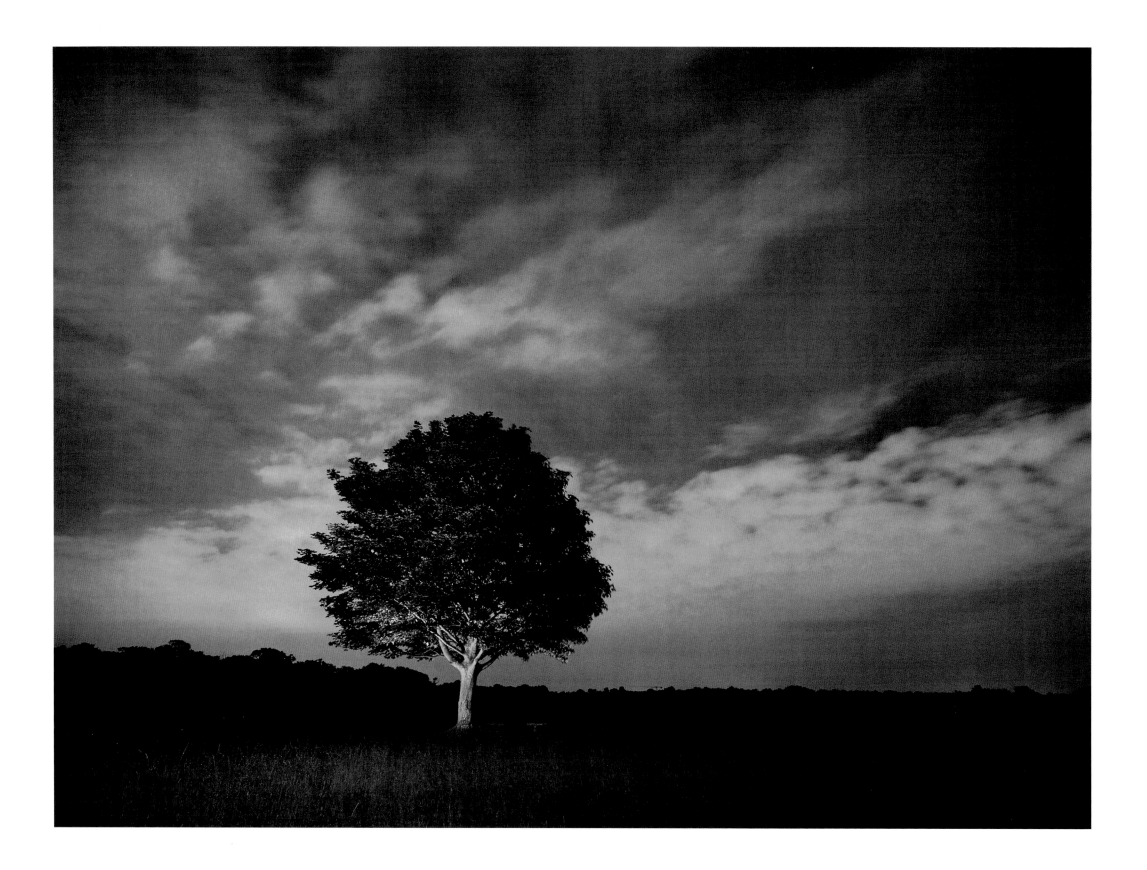

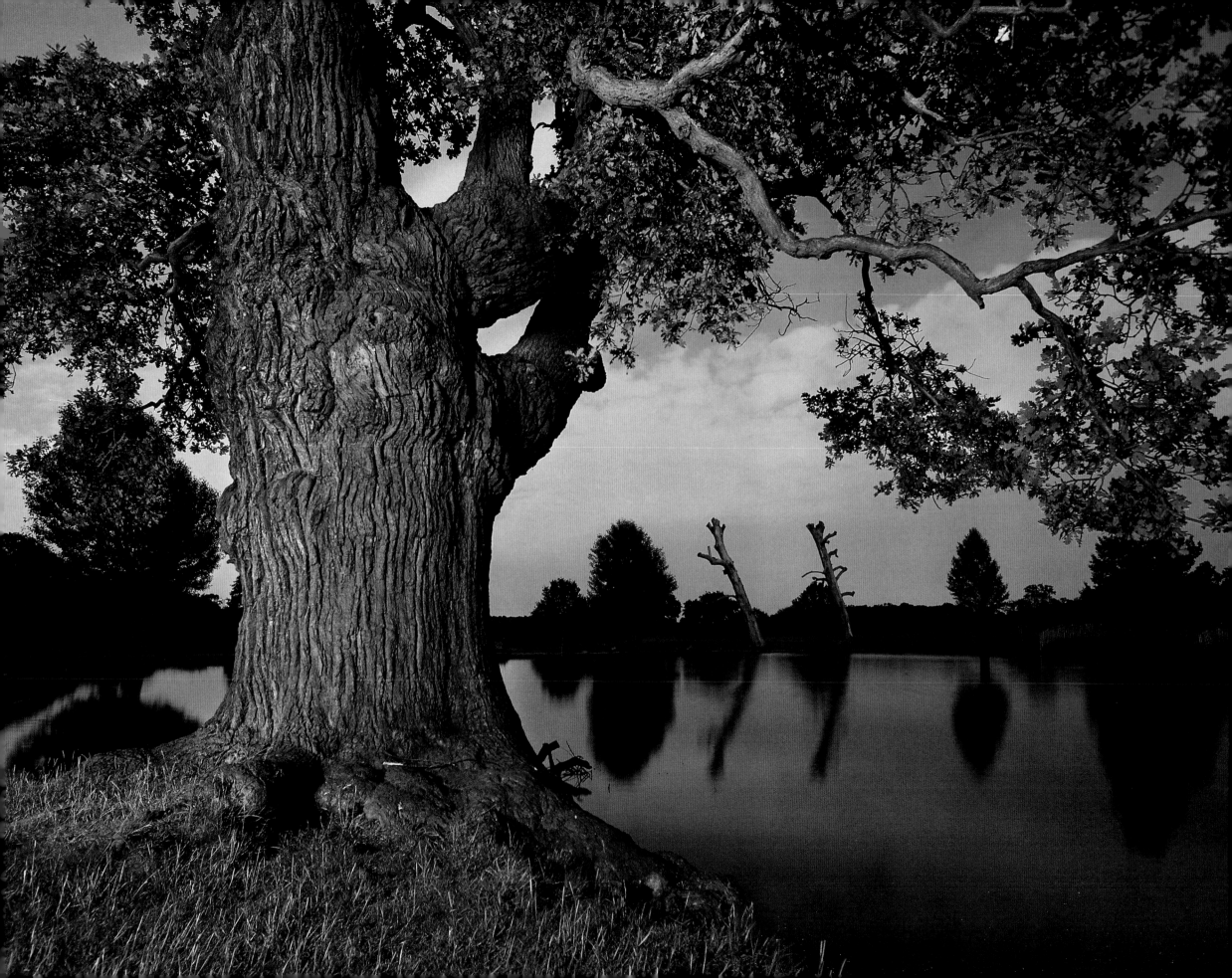

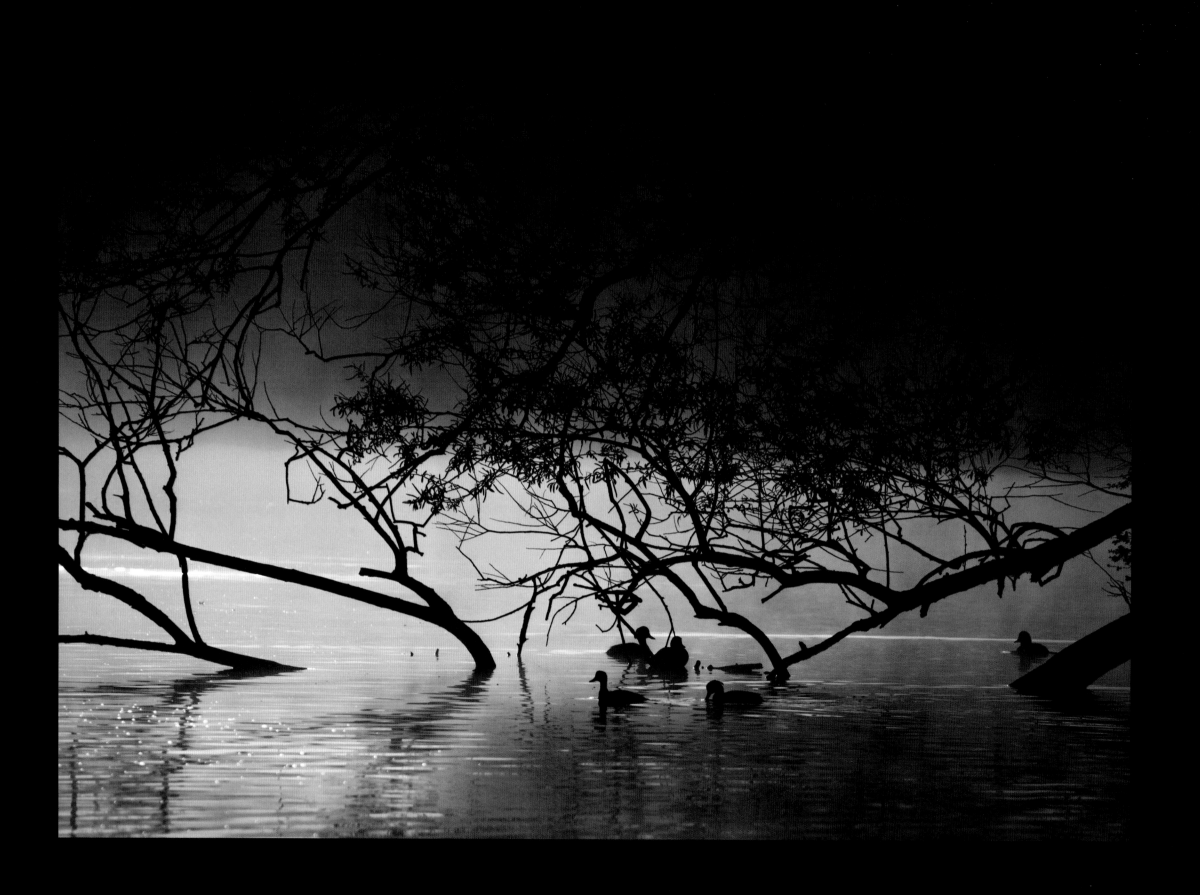

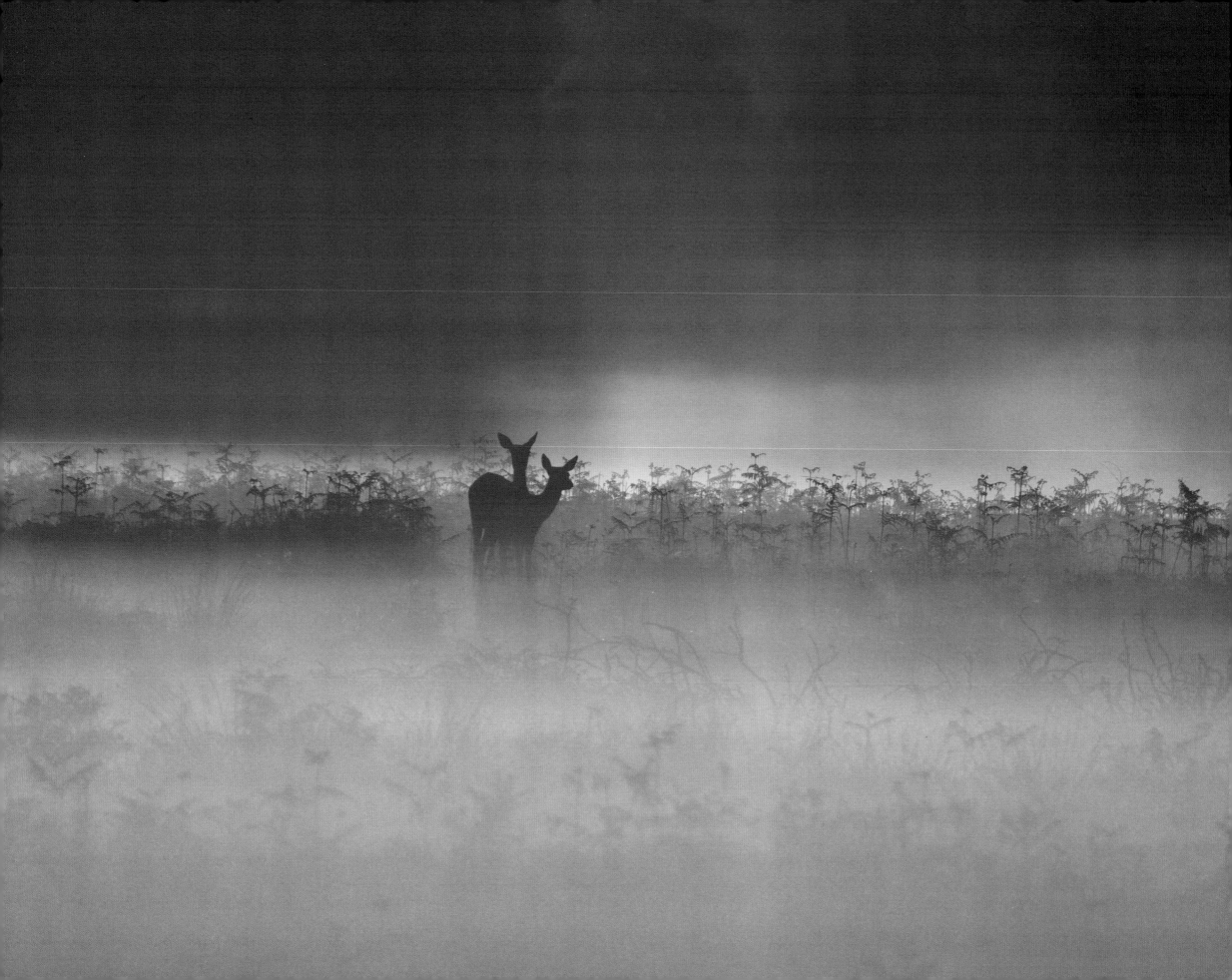

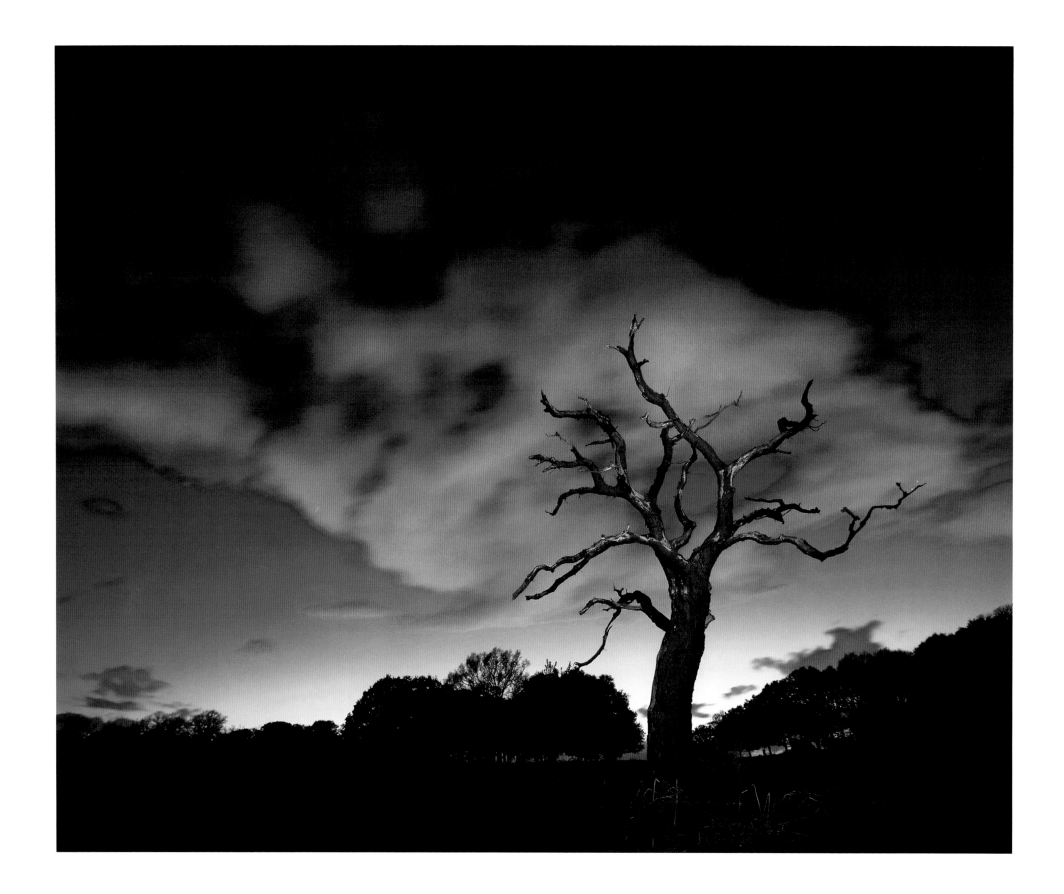

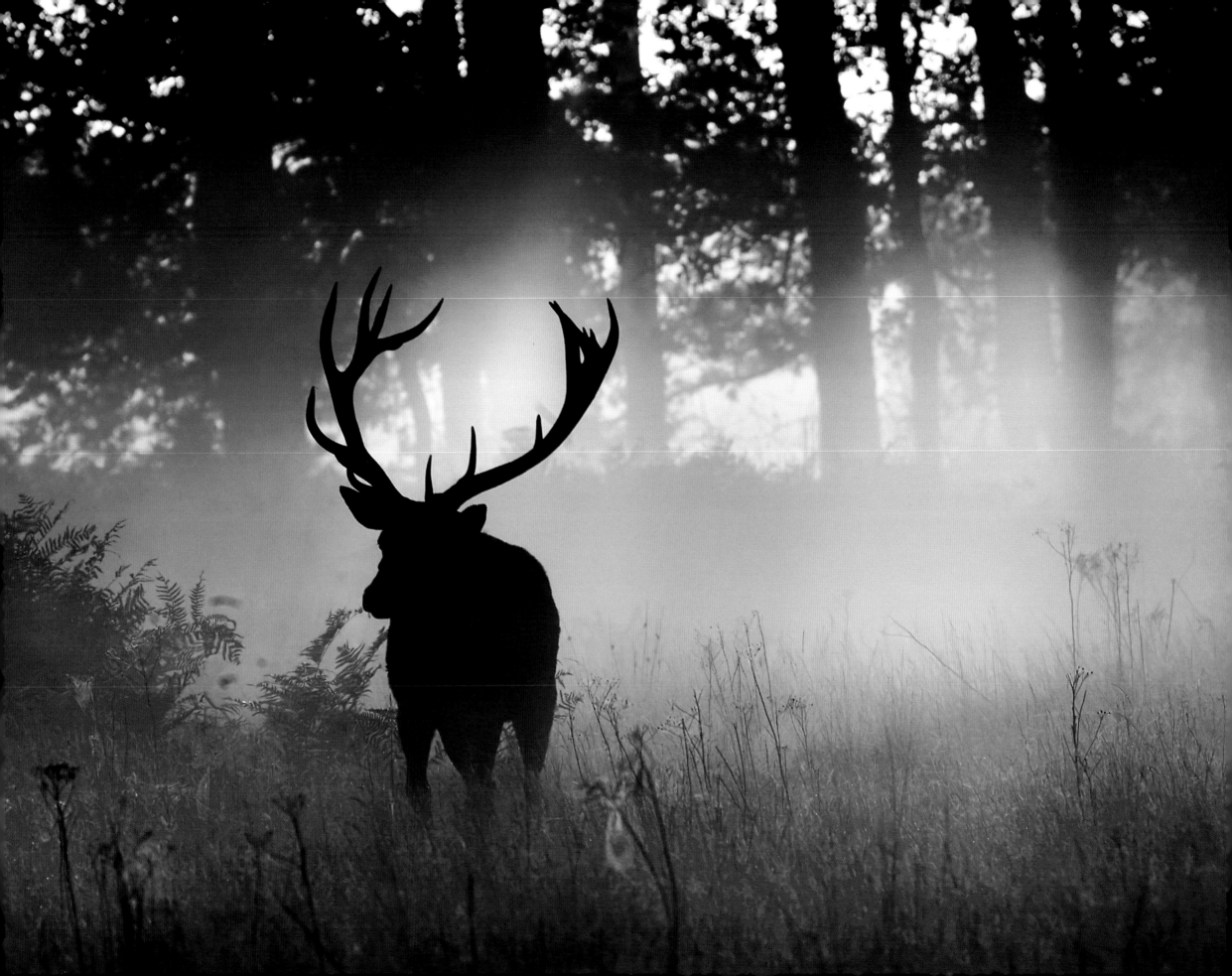

Summer

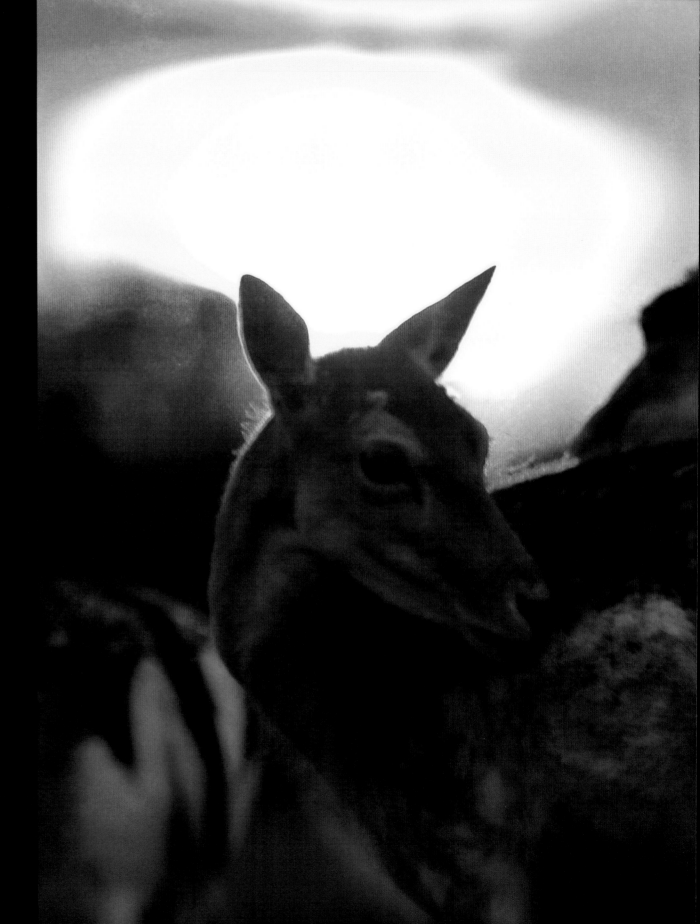

Golds and yellows illuminate the landscape as trees and shrubs, re-clothed in their leafy splendour, dominate every corner of the terrain. A dazzling mix of butterflies, damselflies and dragonflies disport themselves amongst the foliage, settling occasionally on a leaf or a flower for a brief respite from the afternoon heat. Right time, right place, you might catch sight of an exquisitely beautiful azure damselfly, or its more garish red cousin; a charismatic red admiral, with its velvety black wings and striking red bands; or even the rarer white admiral as it glides serenely through the woods.

The sunsets are becoming even more awe-inspiring now, with dazzling swathes of red and orange filling the eye as the sun dips below a row of ancient oaks, bathing the grassland in a flaxen glow. As a rare meadow pipit makes its parachuting descent from high above, and an elegant wheatear scuttles along the ground, deer stand around languidly, seemingly disinterested in the people pointing lenses at them endlessly. This is the season when human activity peaks: a time for families to wander woodland paths, cycle the meandering Tamsin Trail, or revel in the richness and diversity of nature's own family.

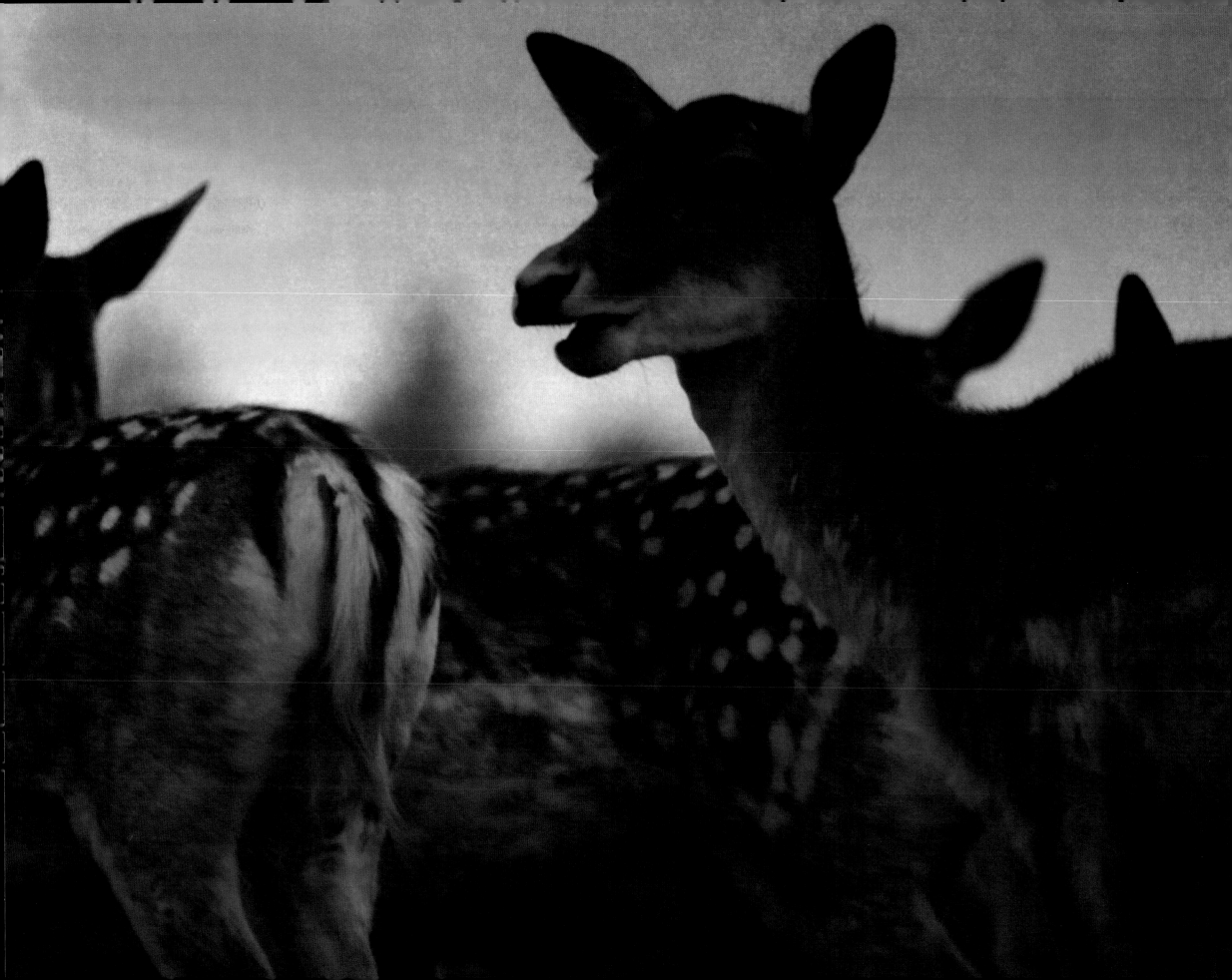

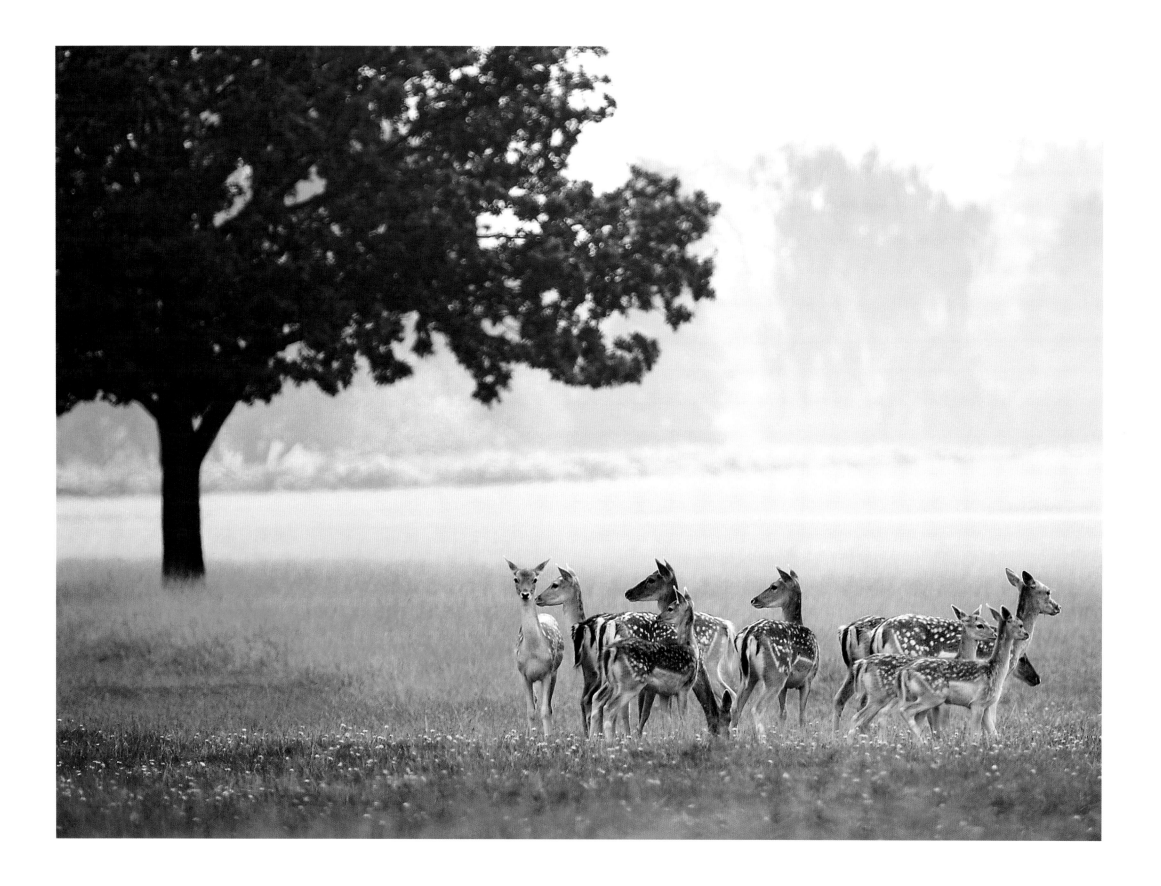

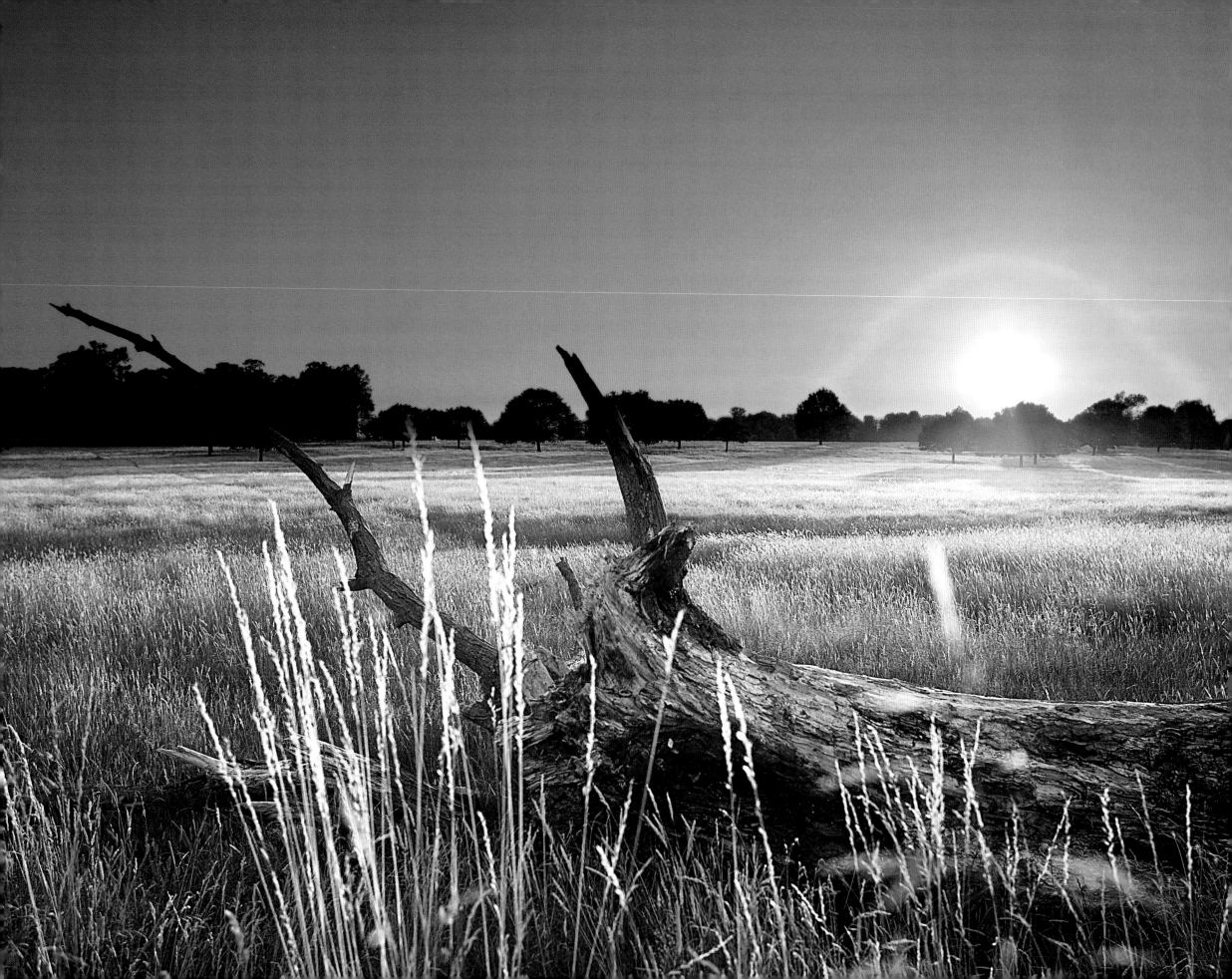

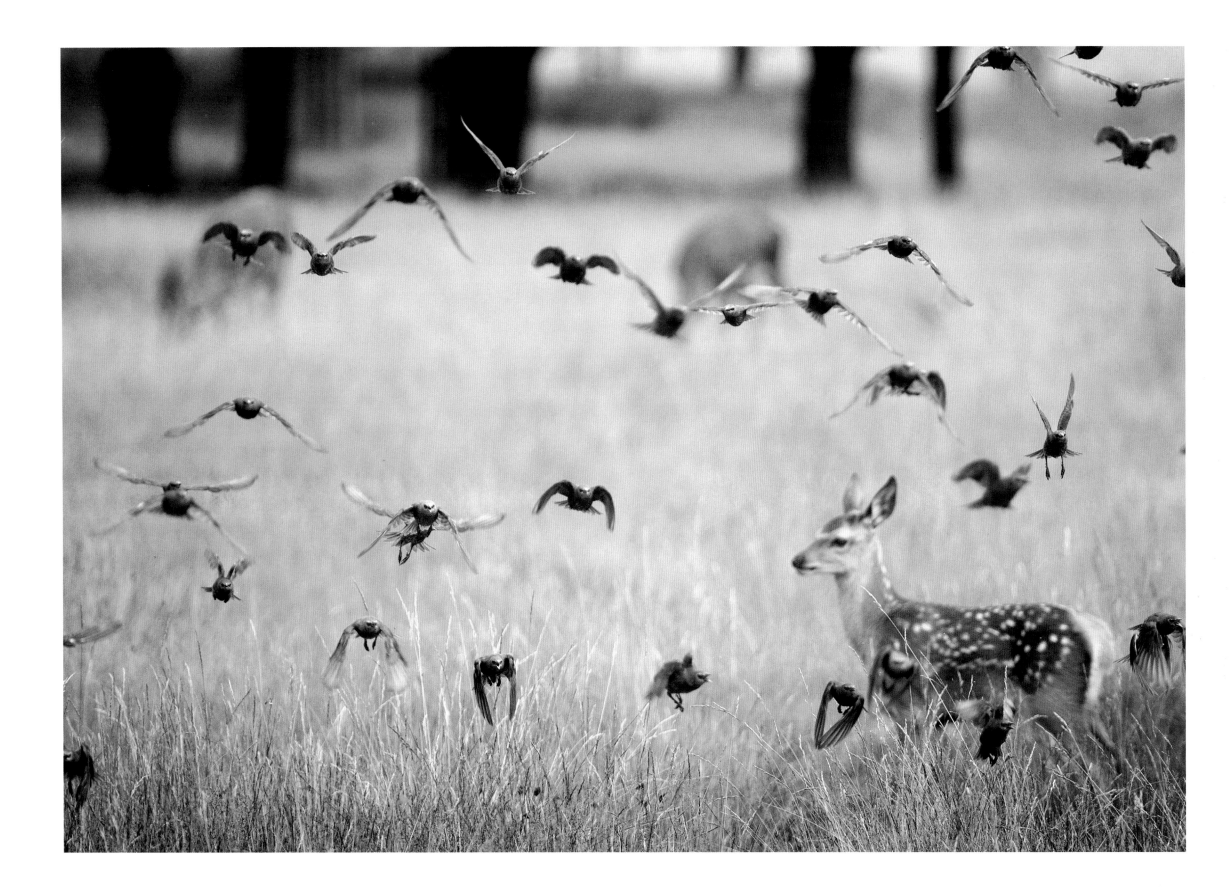

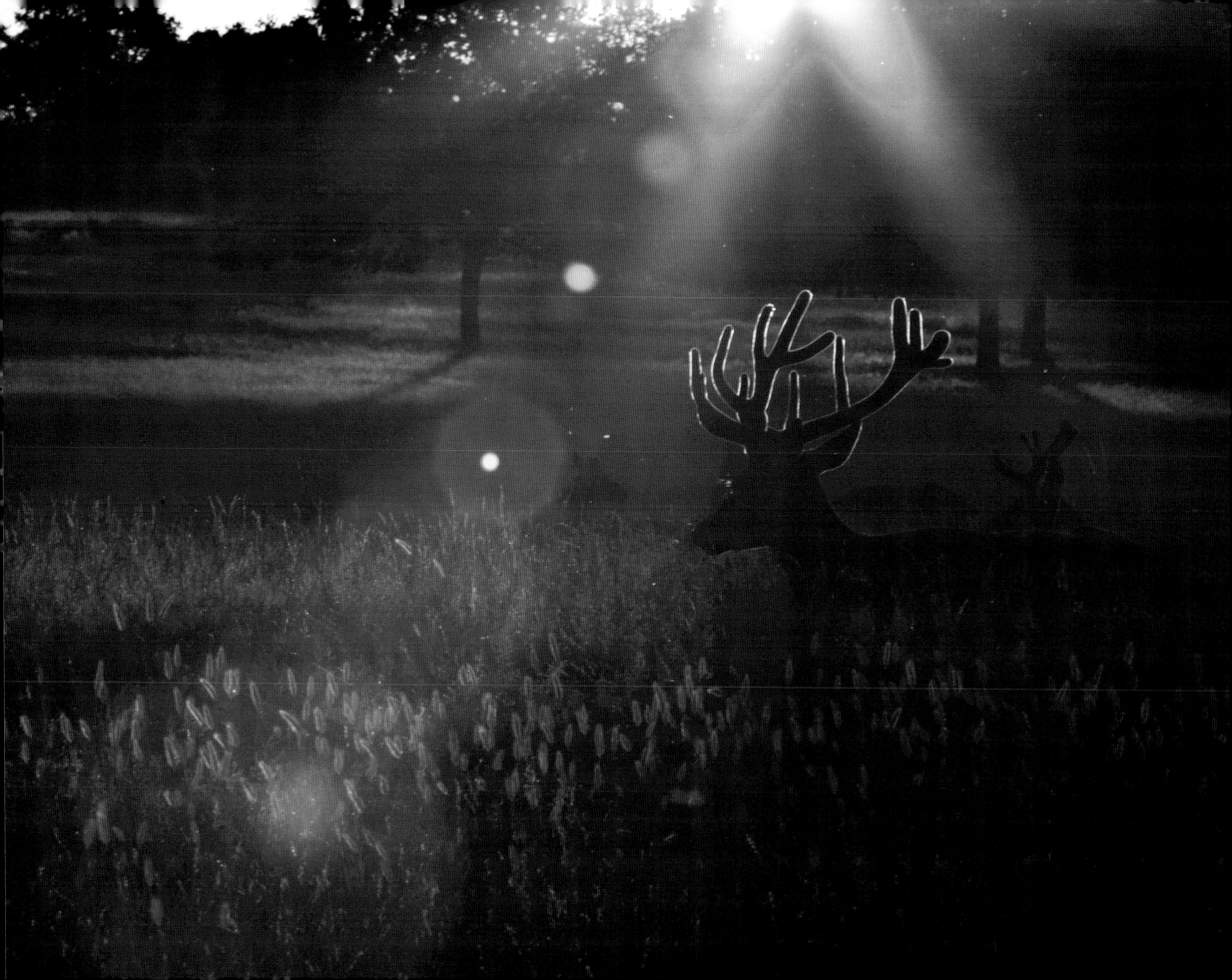

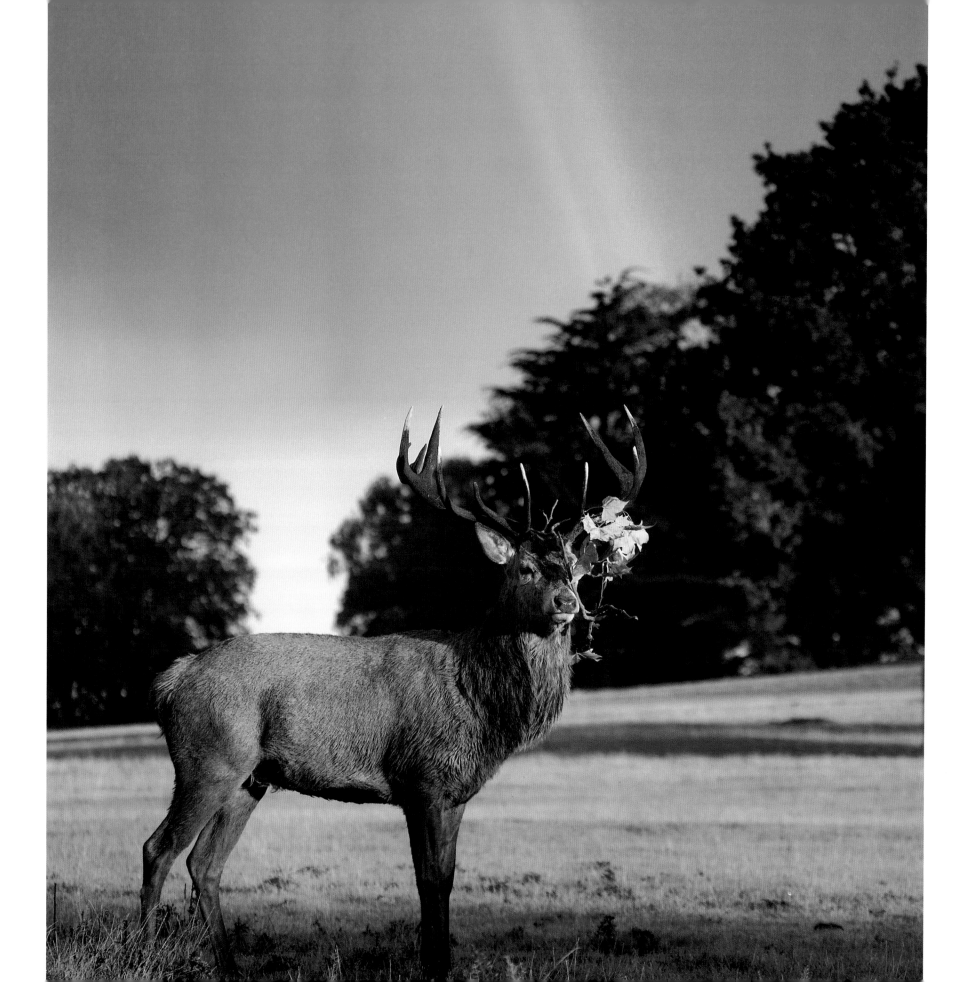

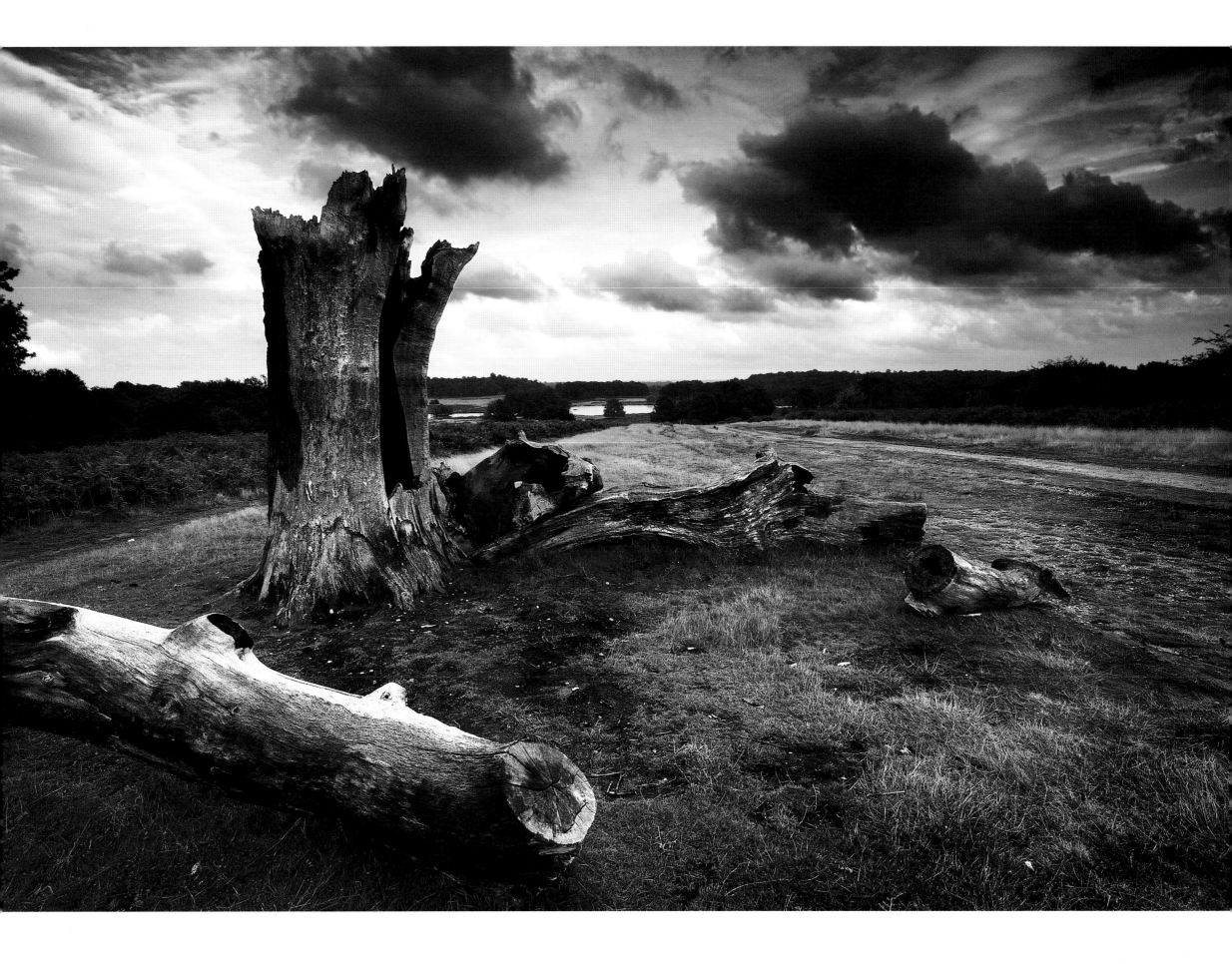

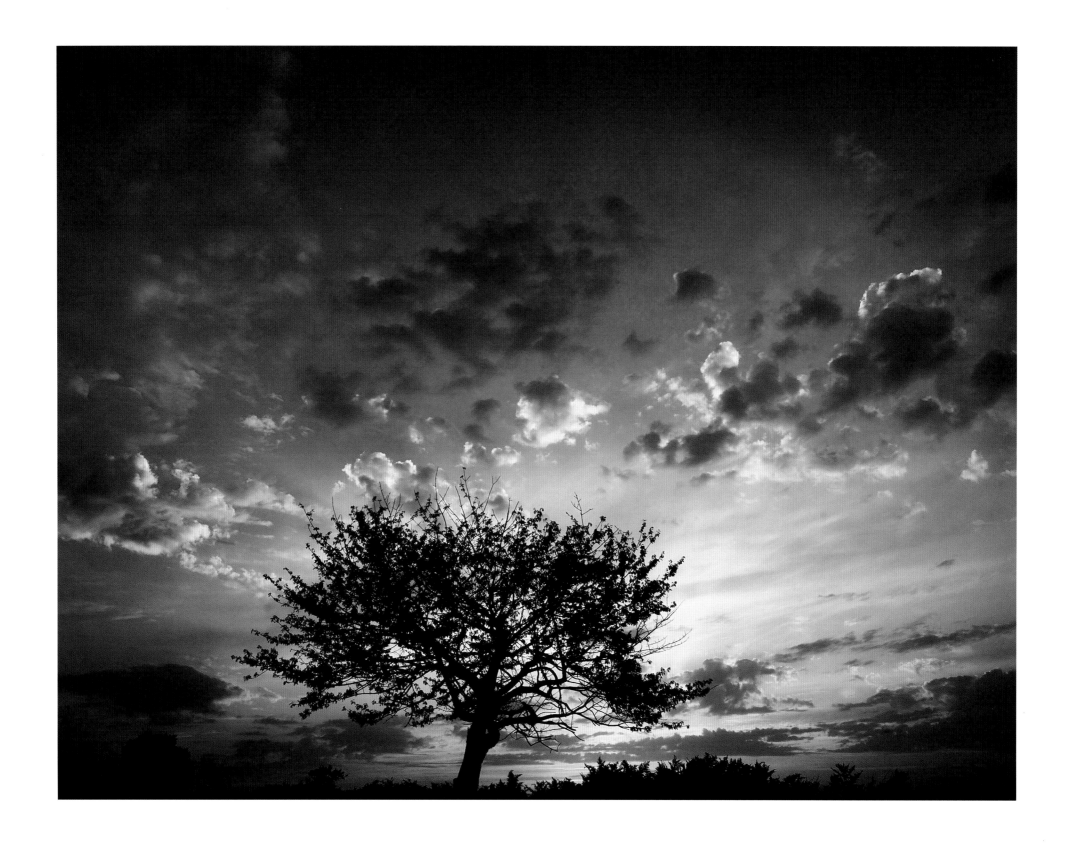

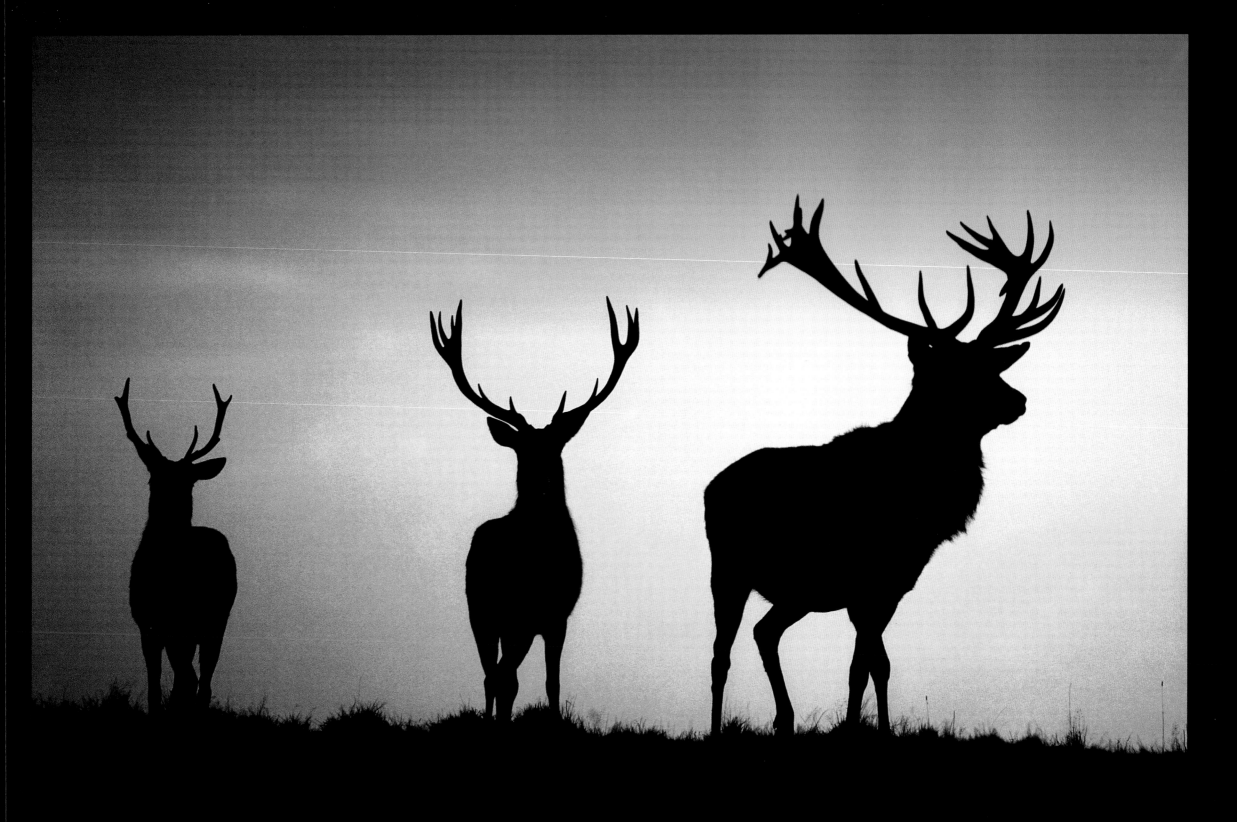

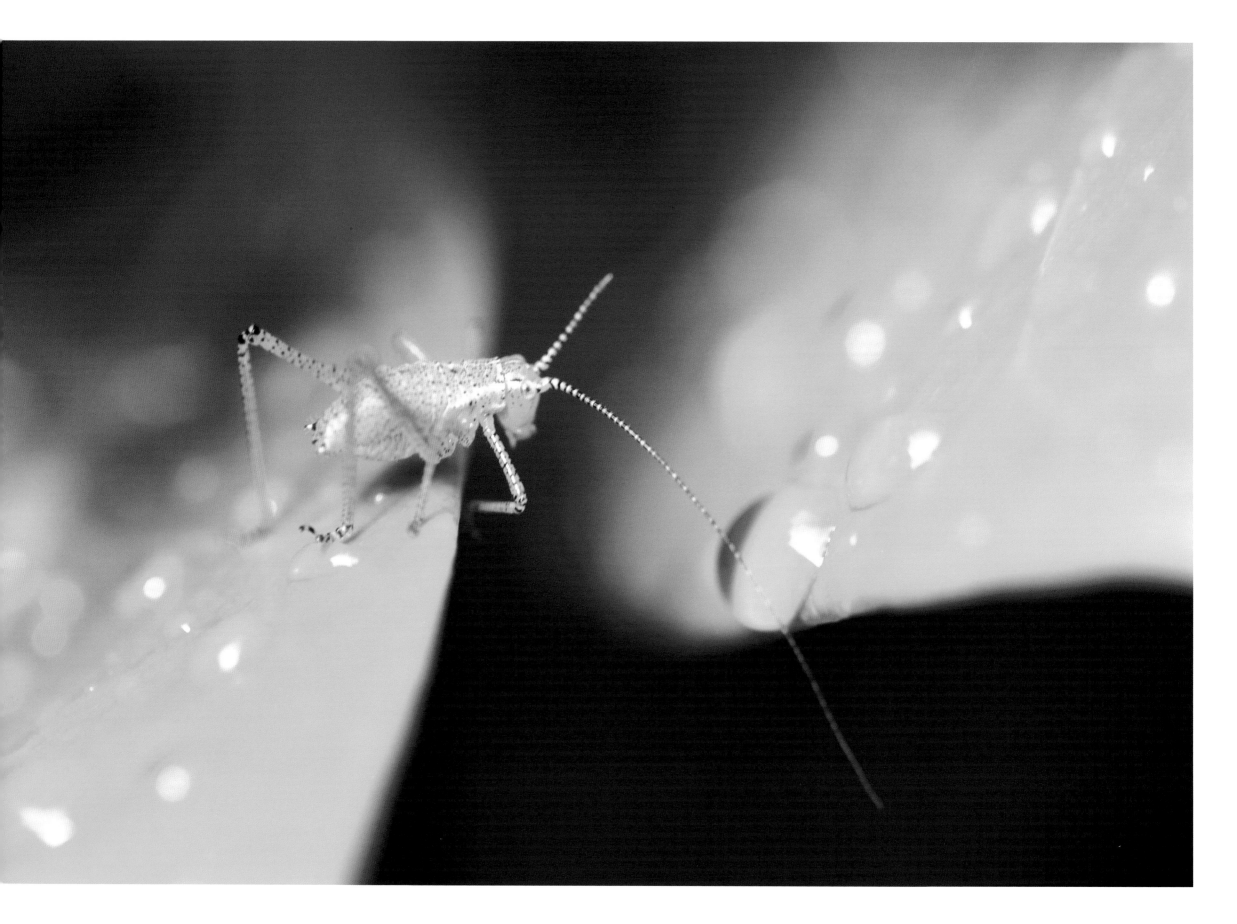

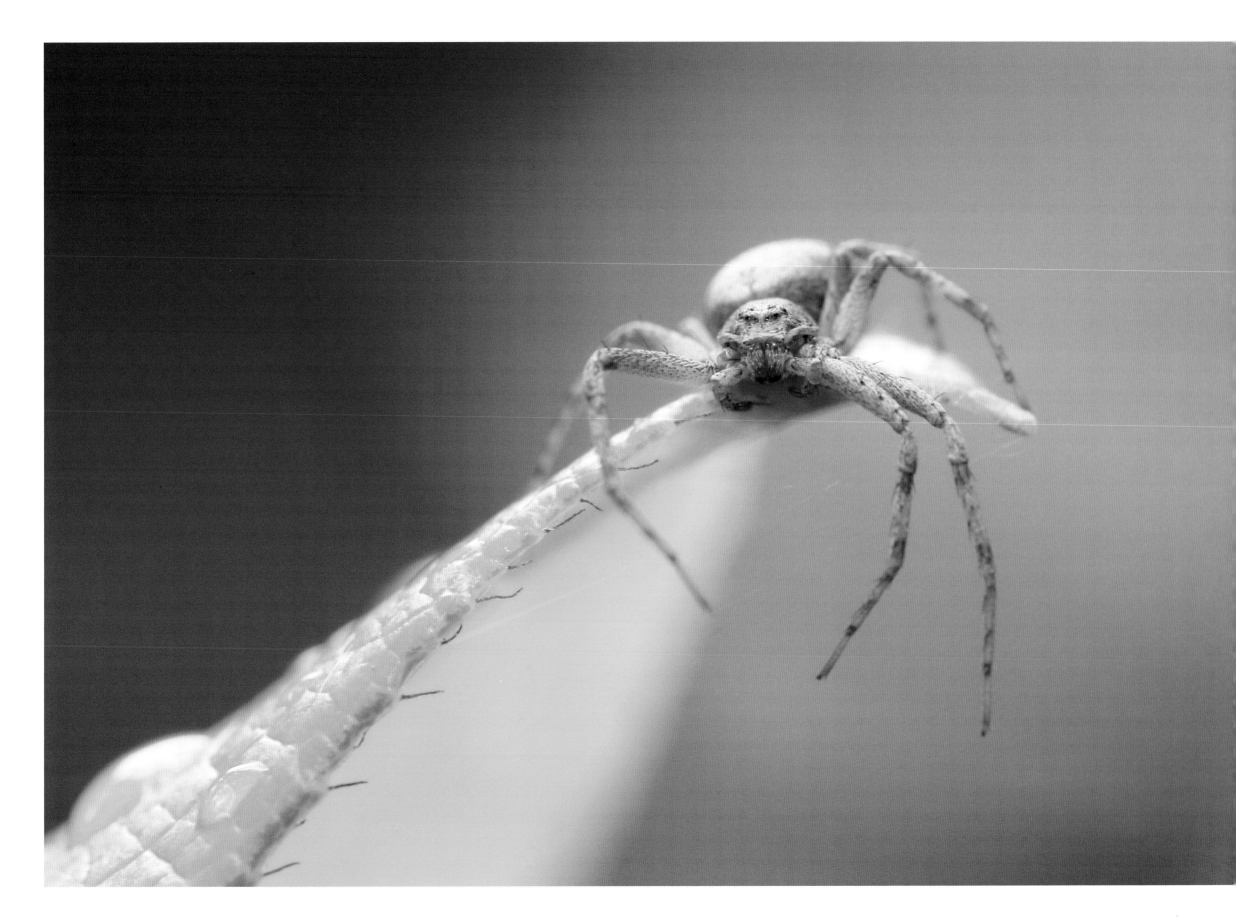

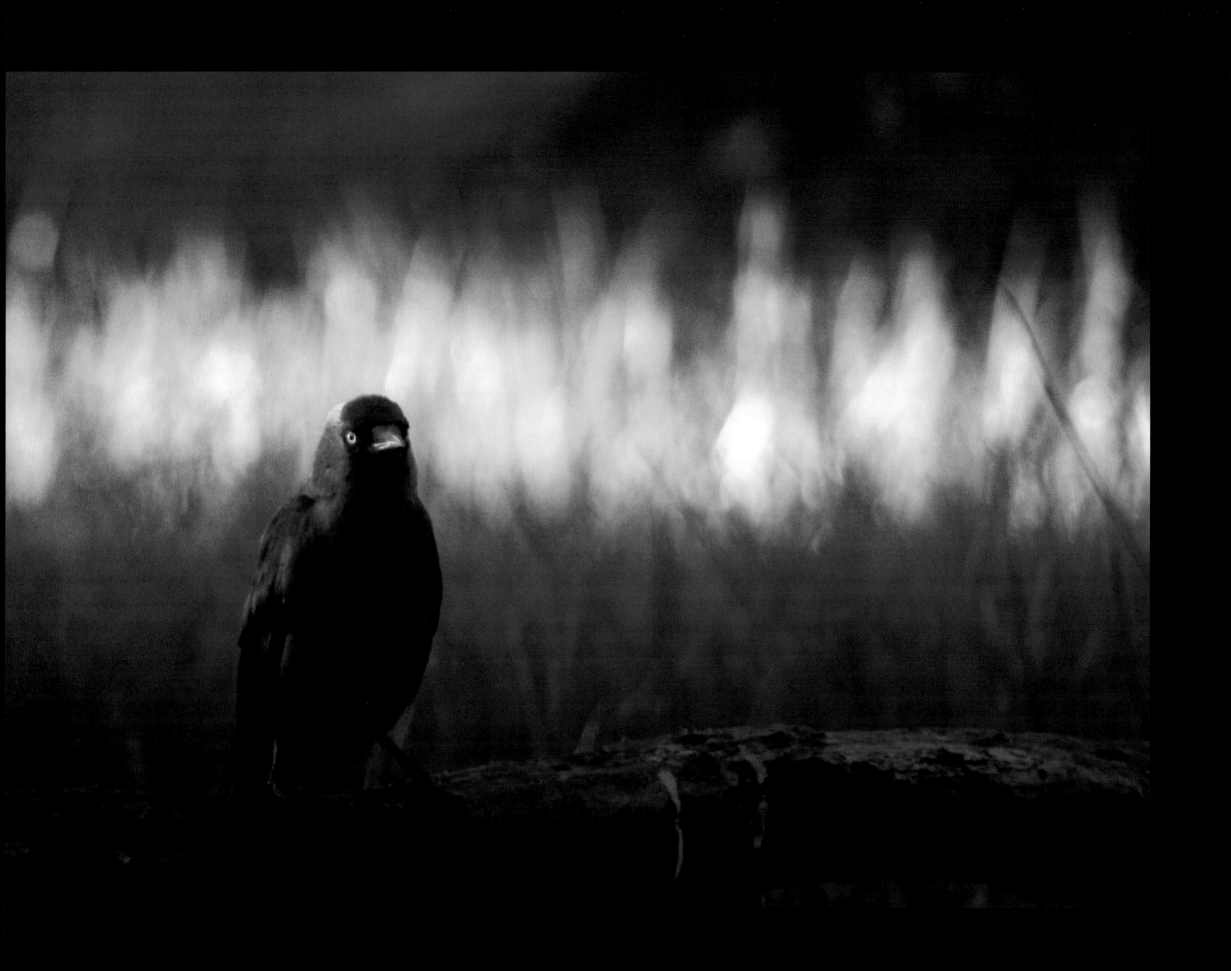

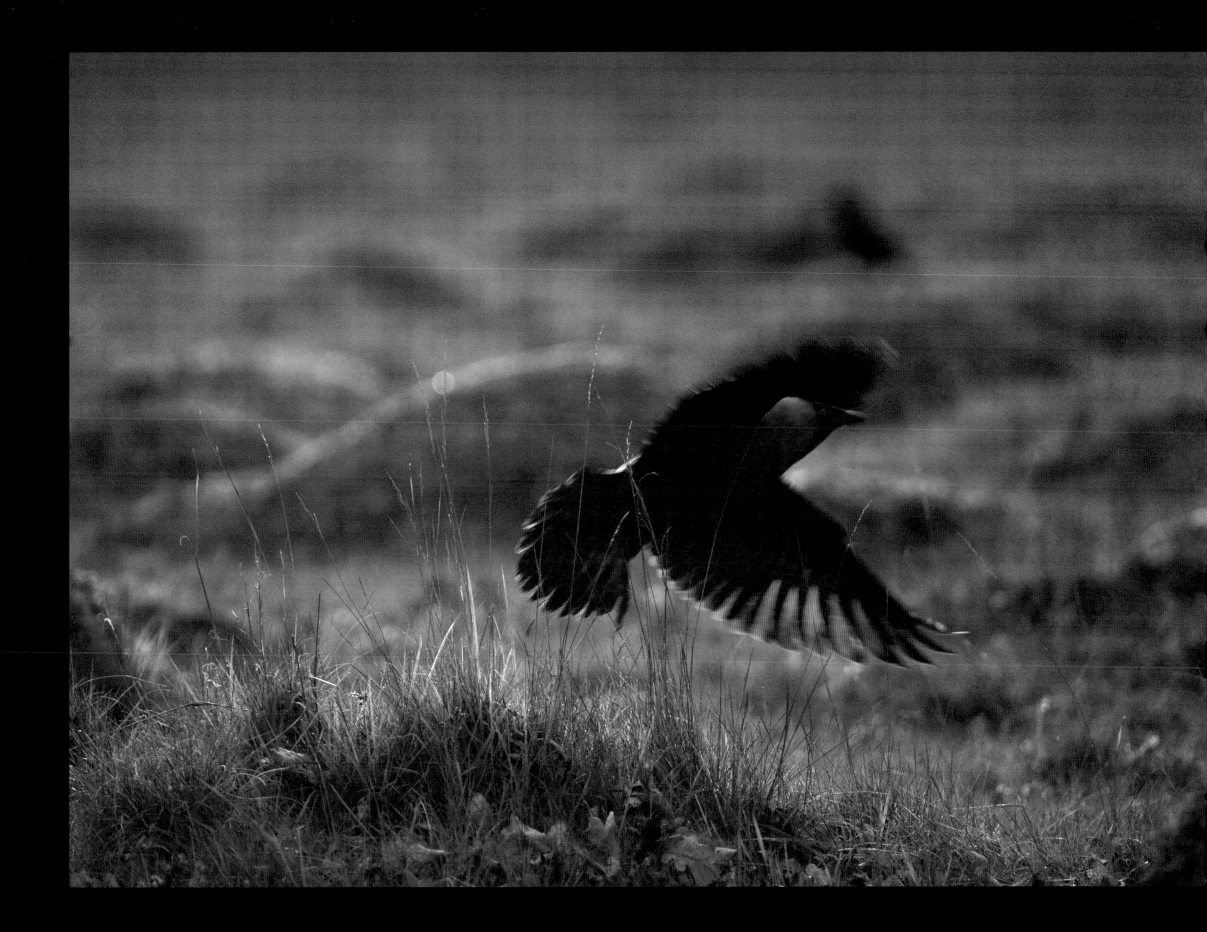

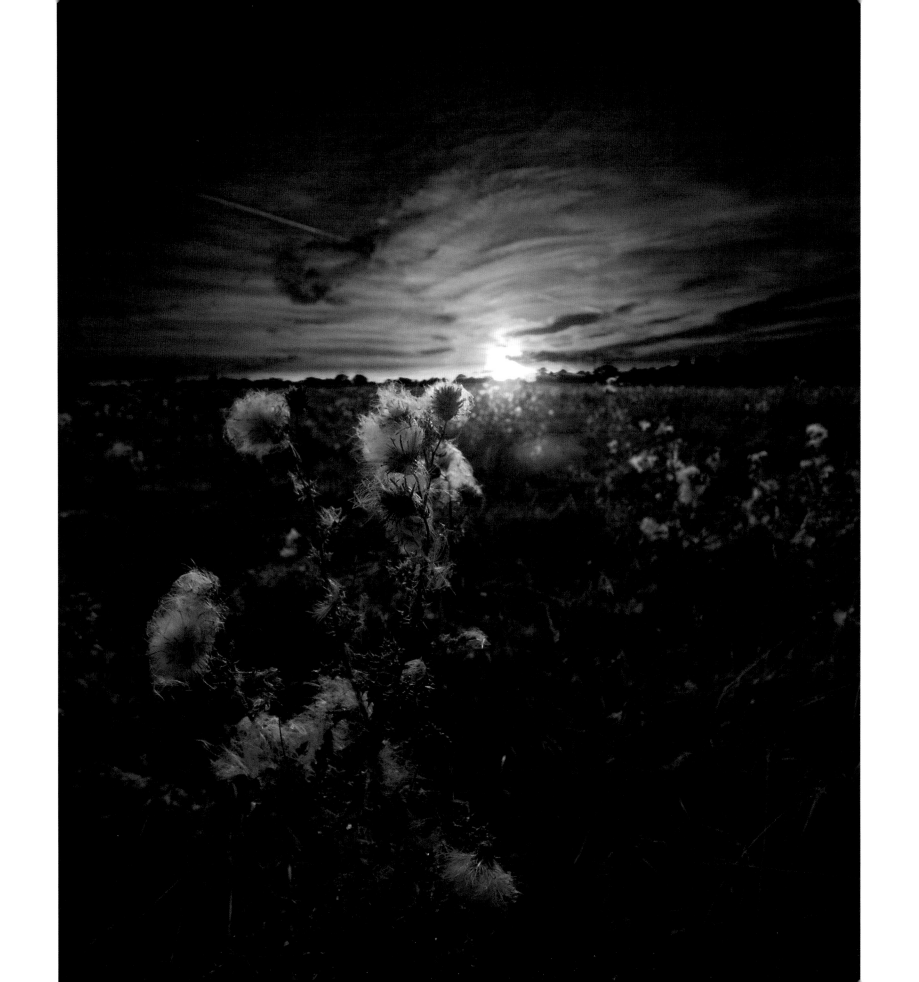

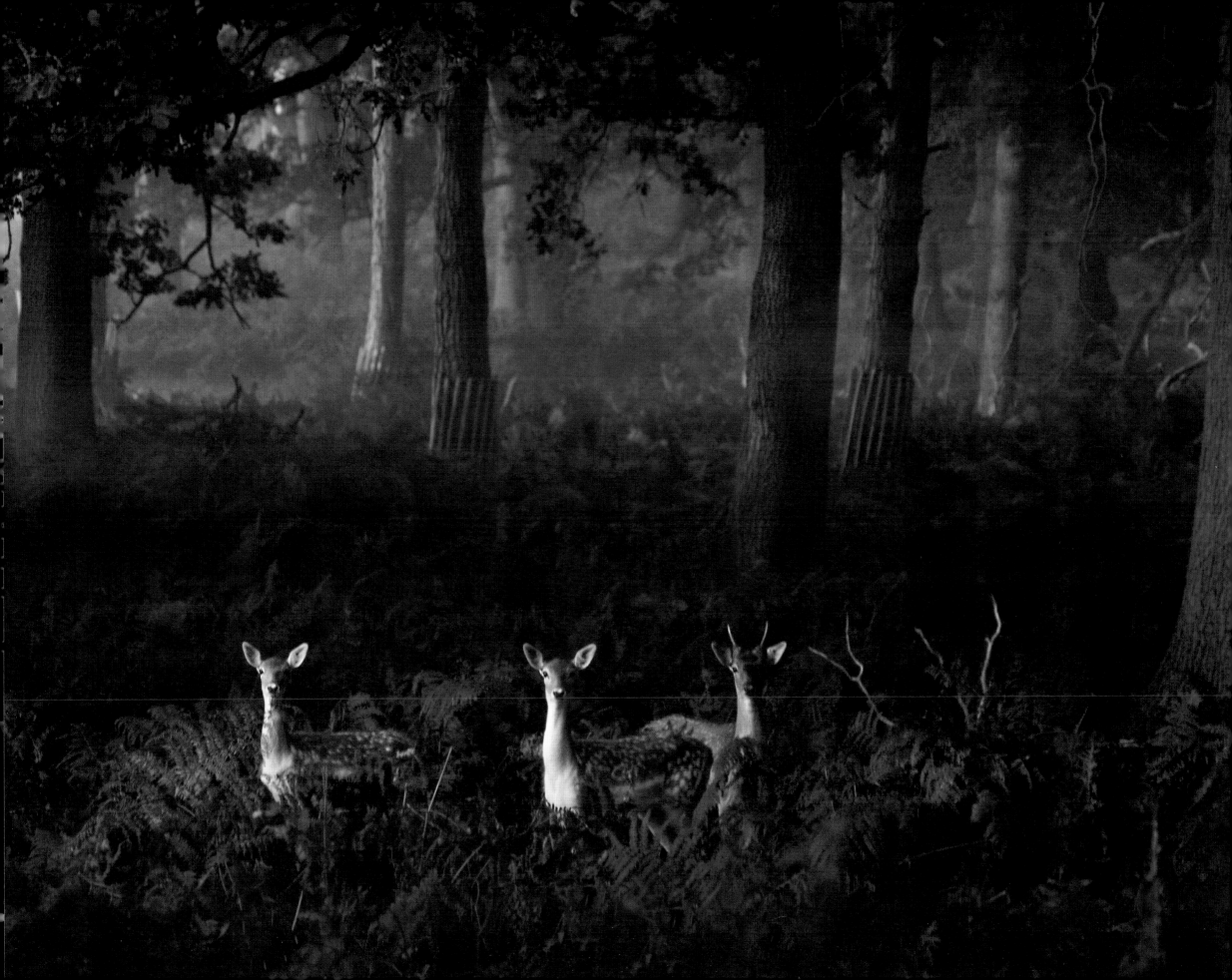

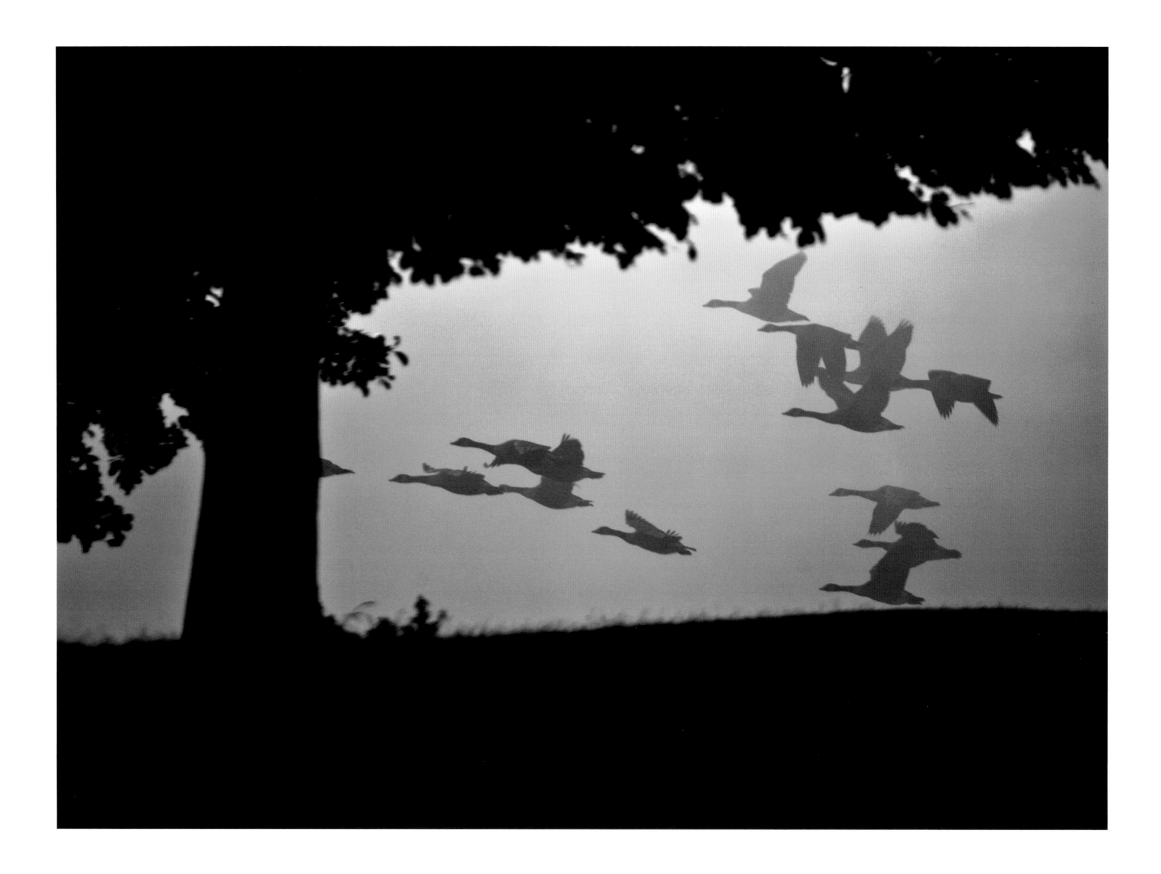

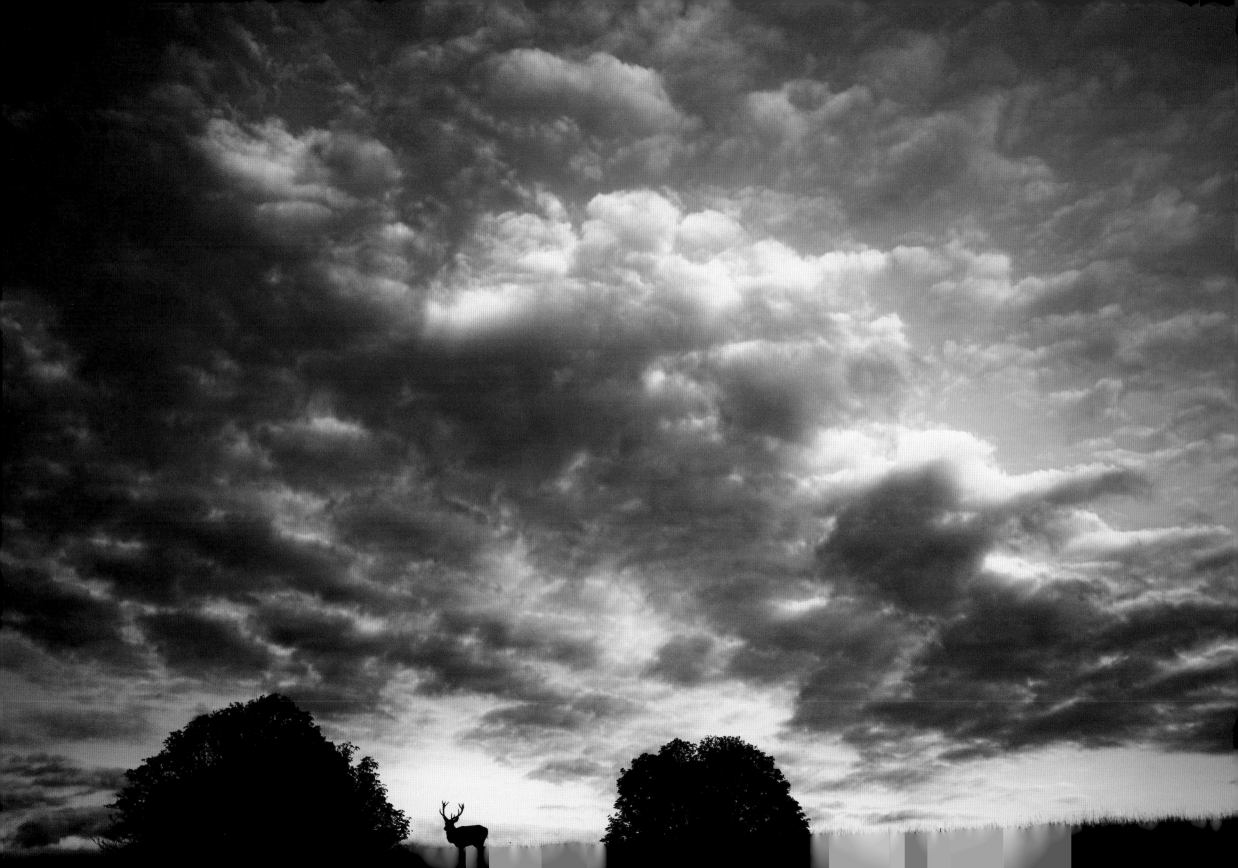

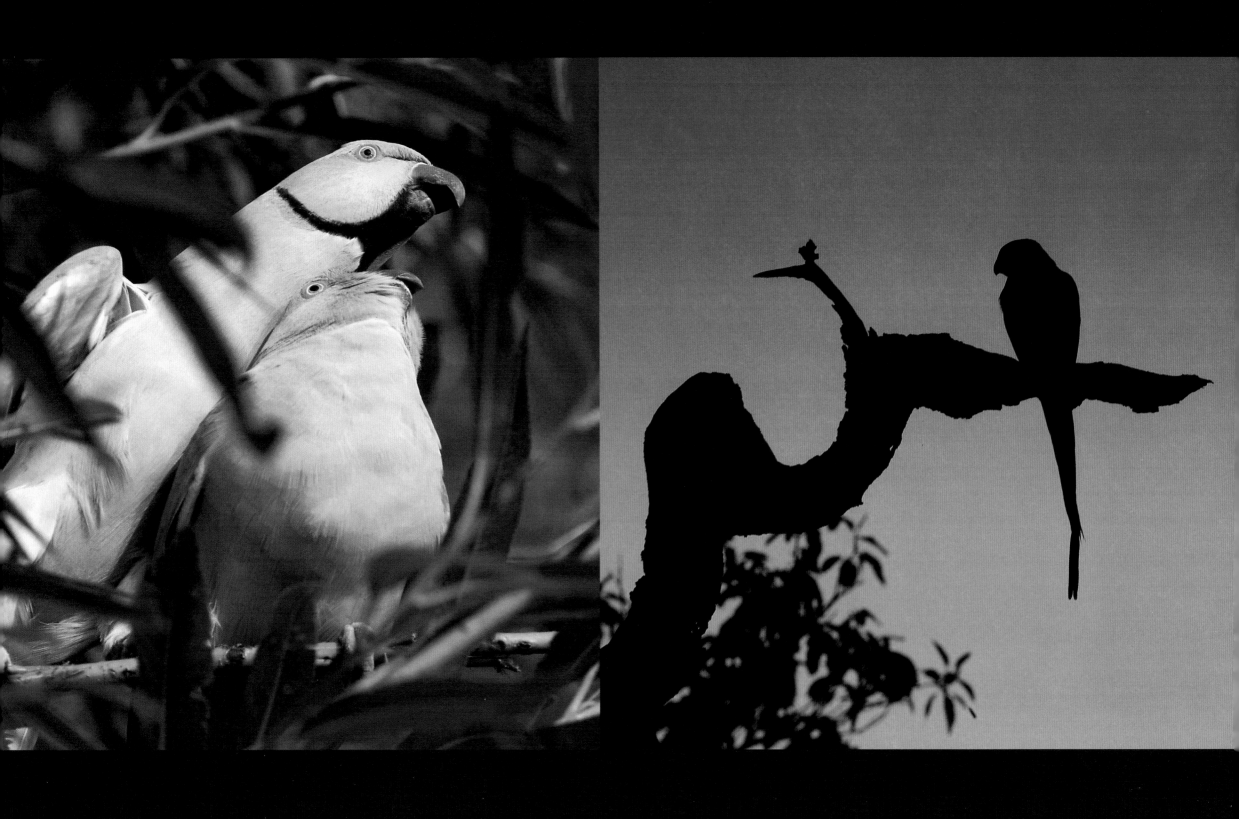

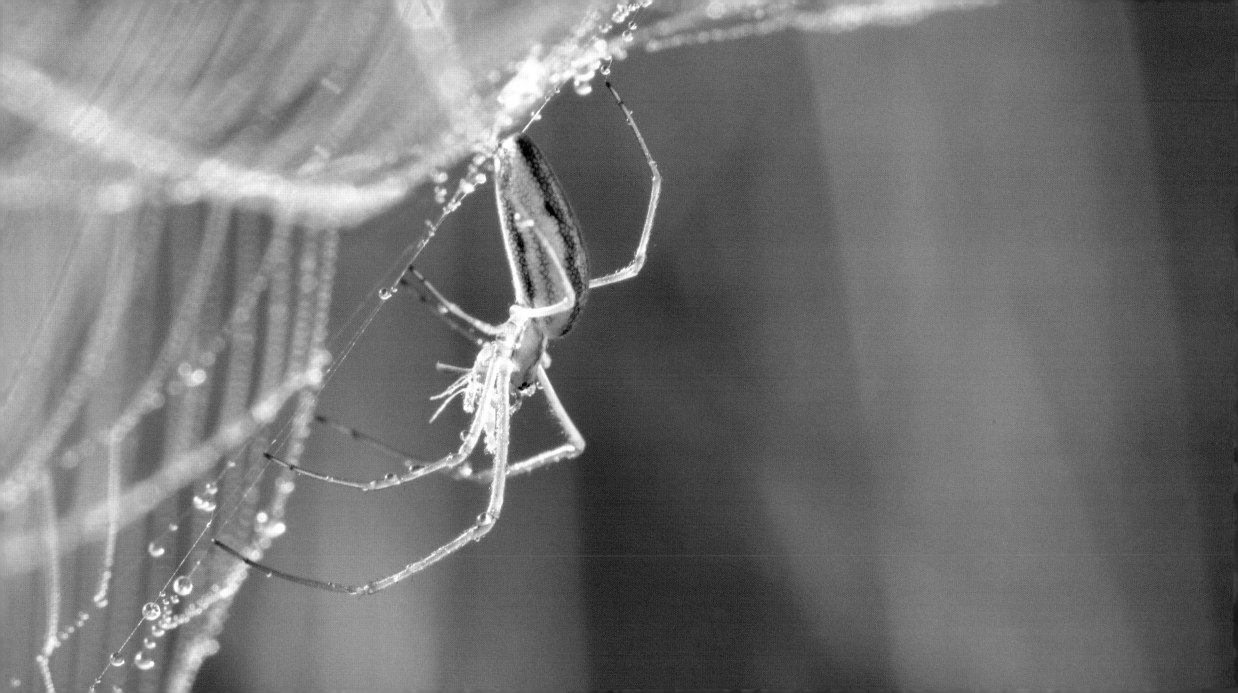

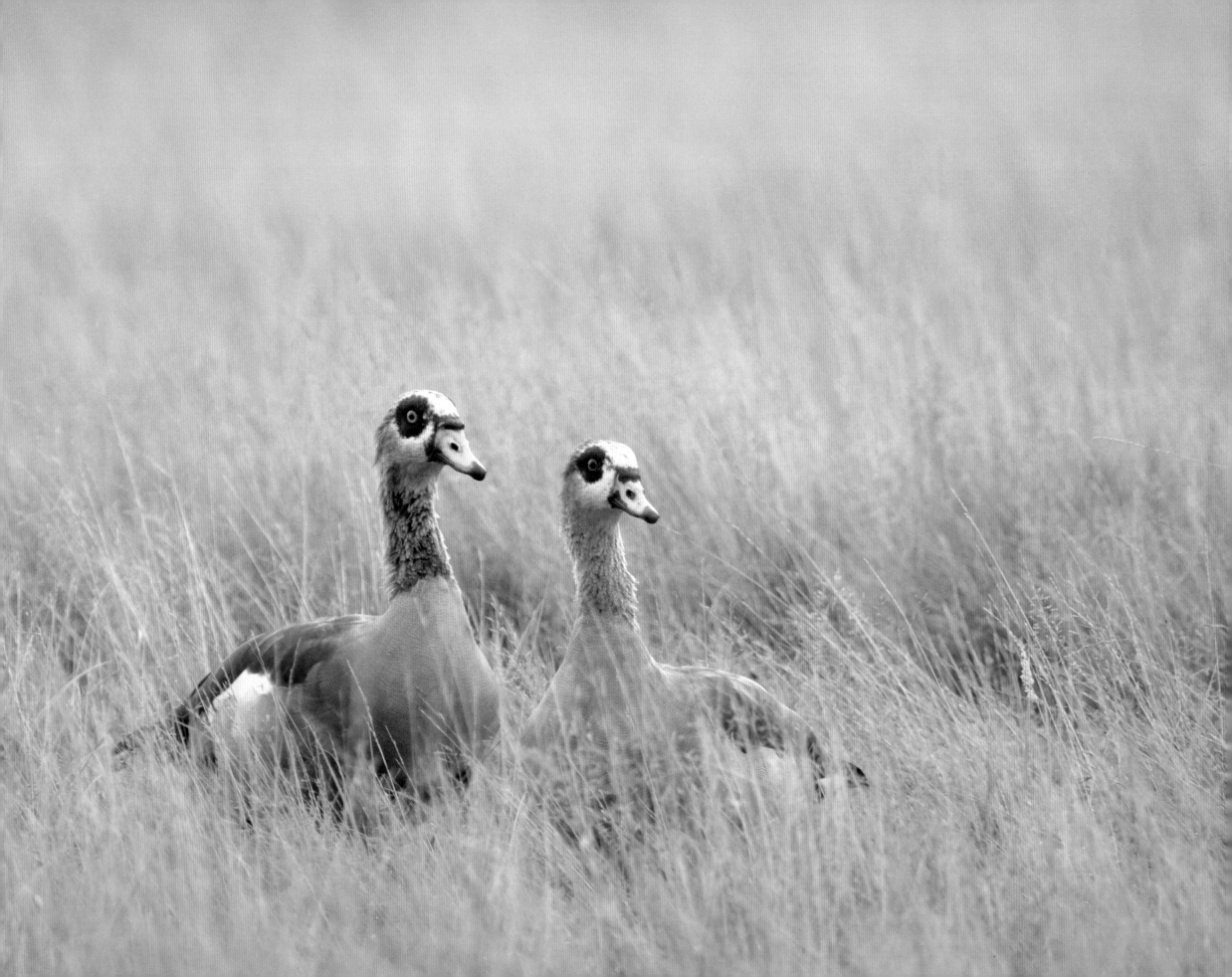

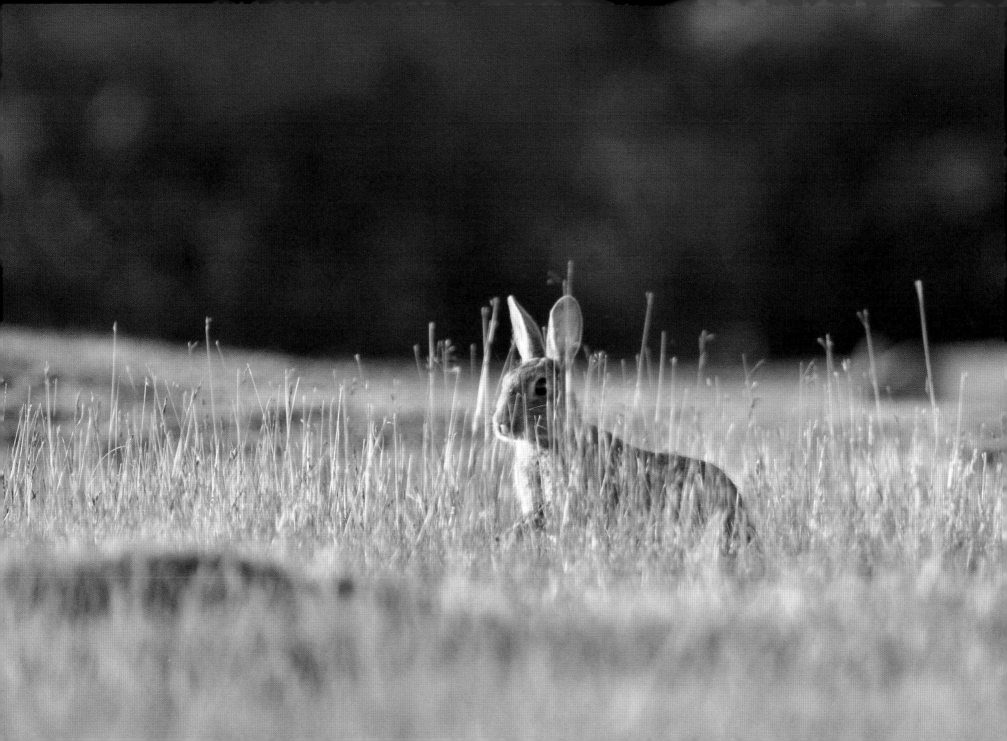

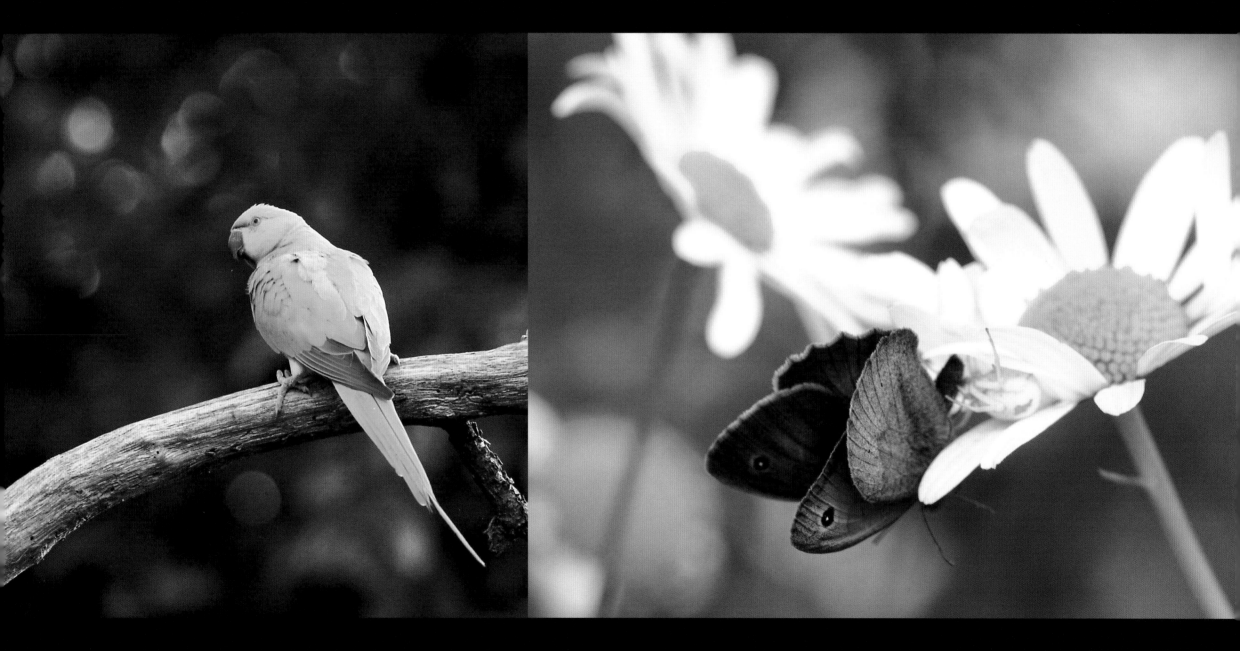

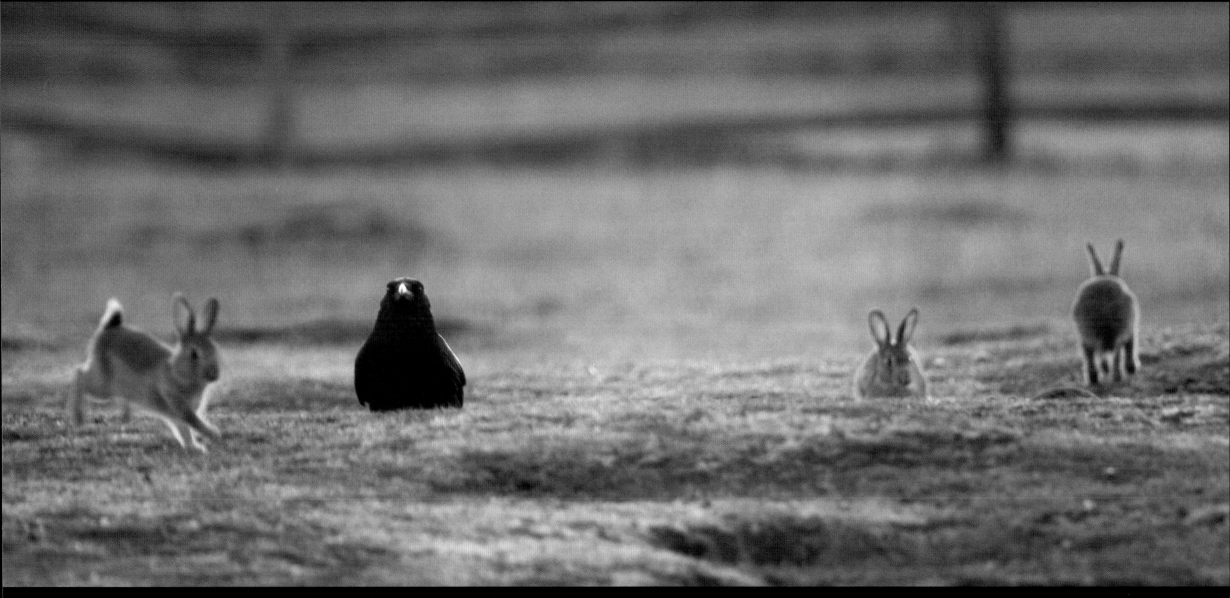

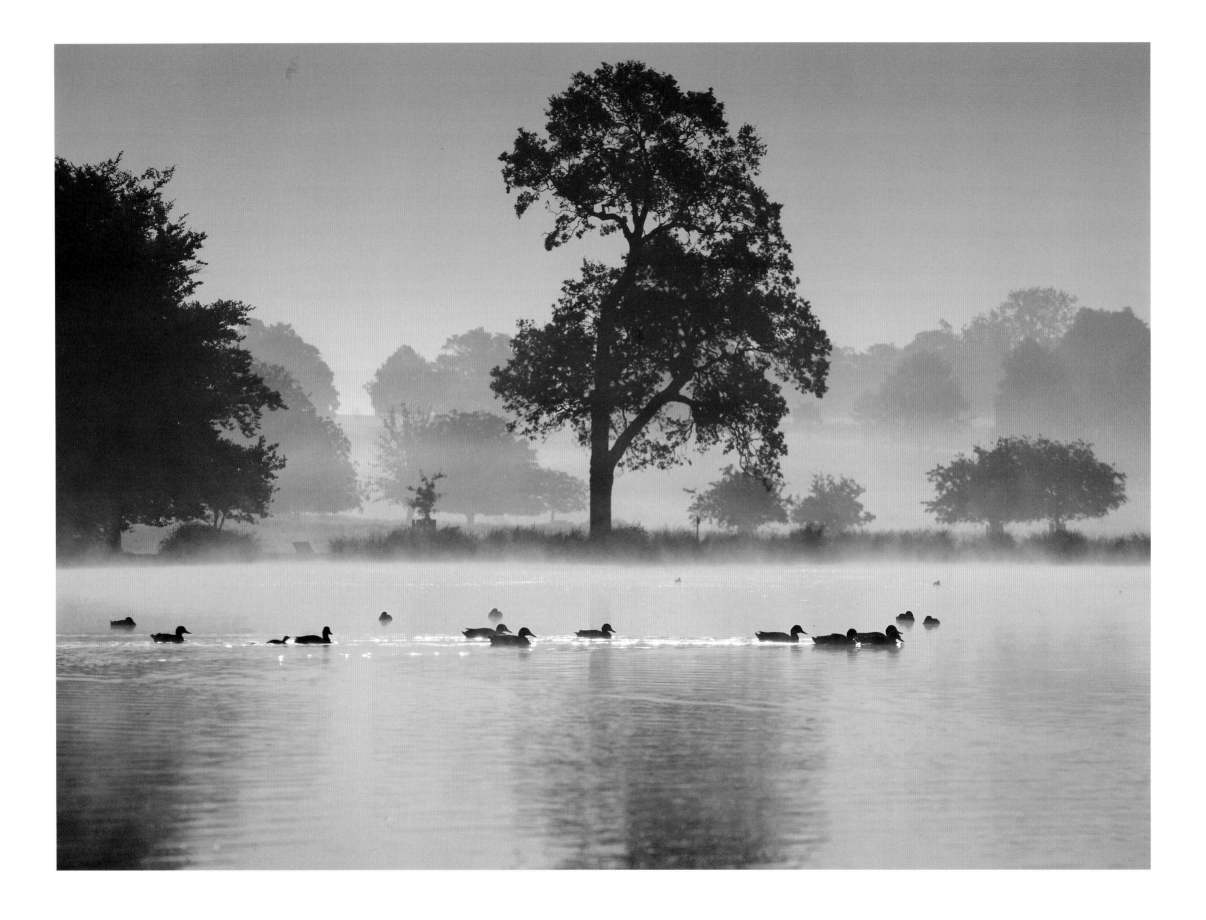

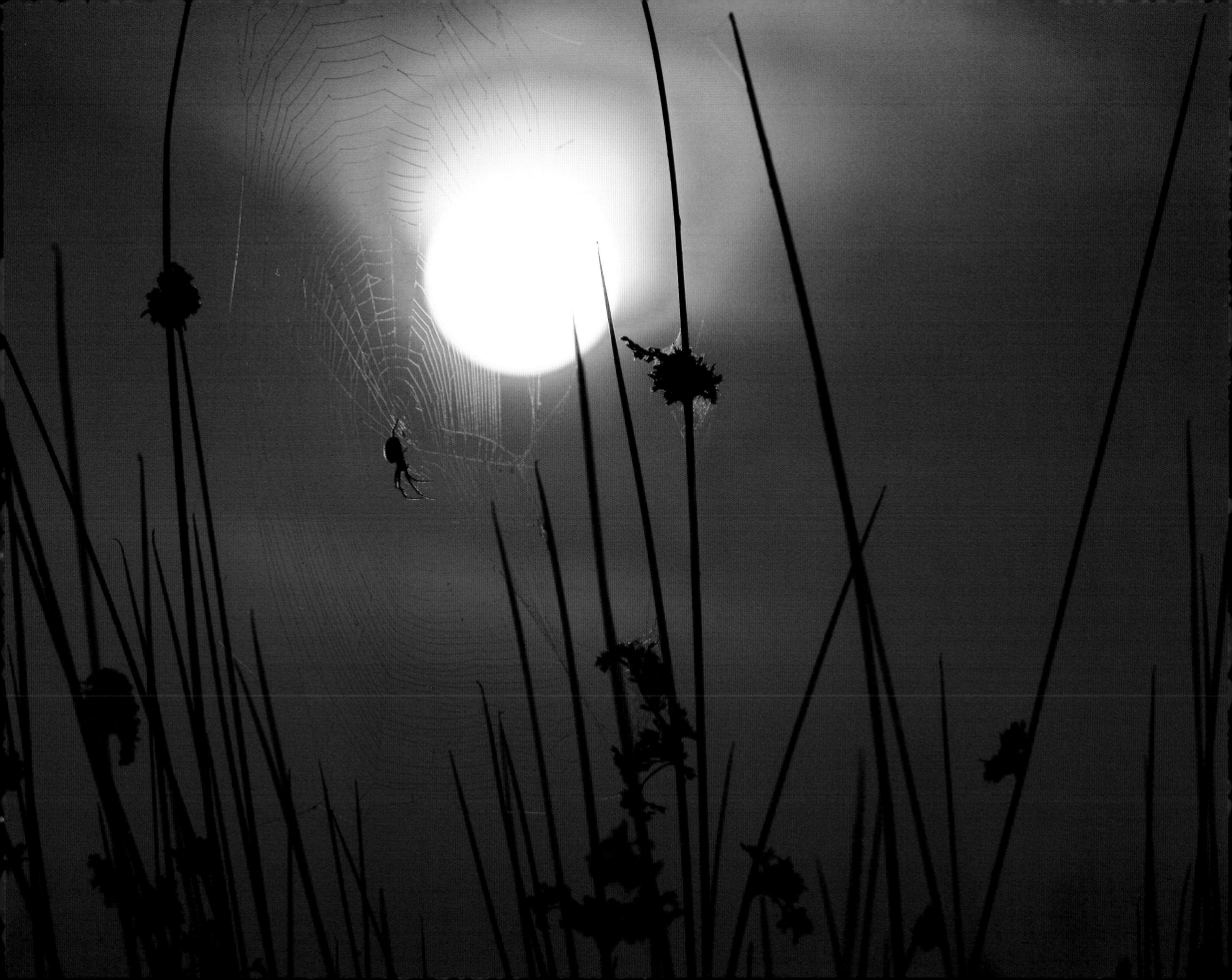

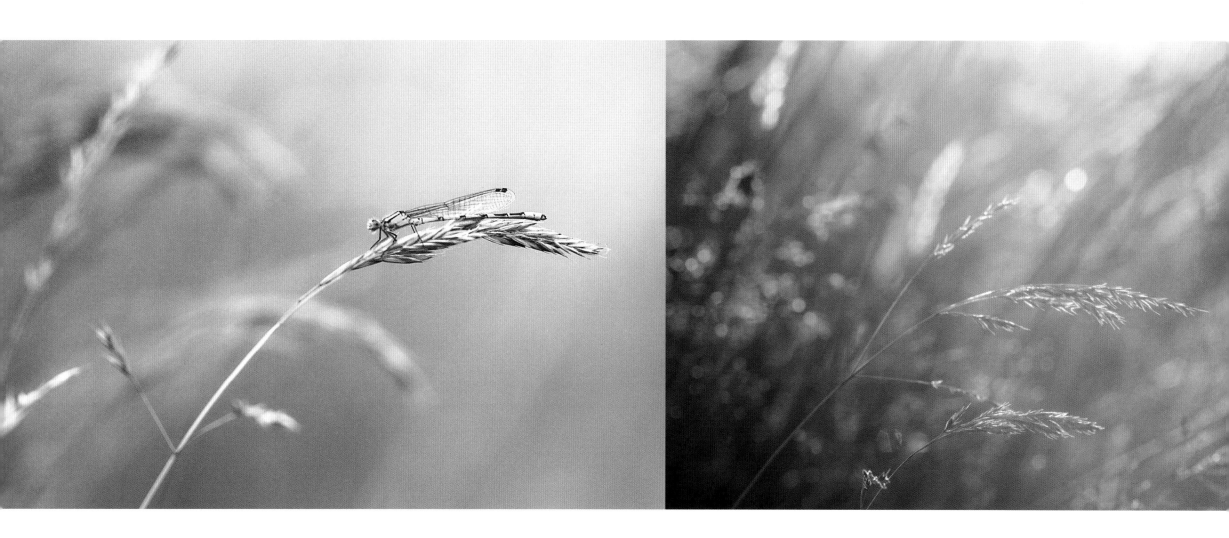

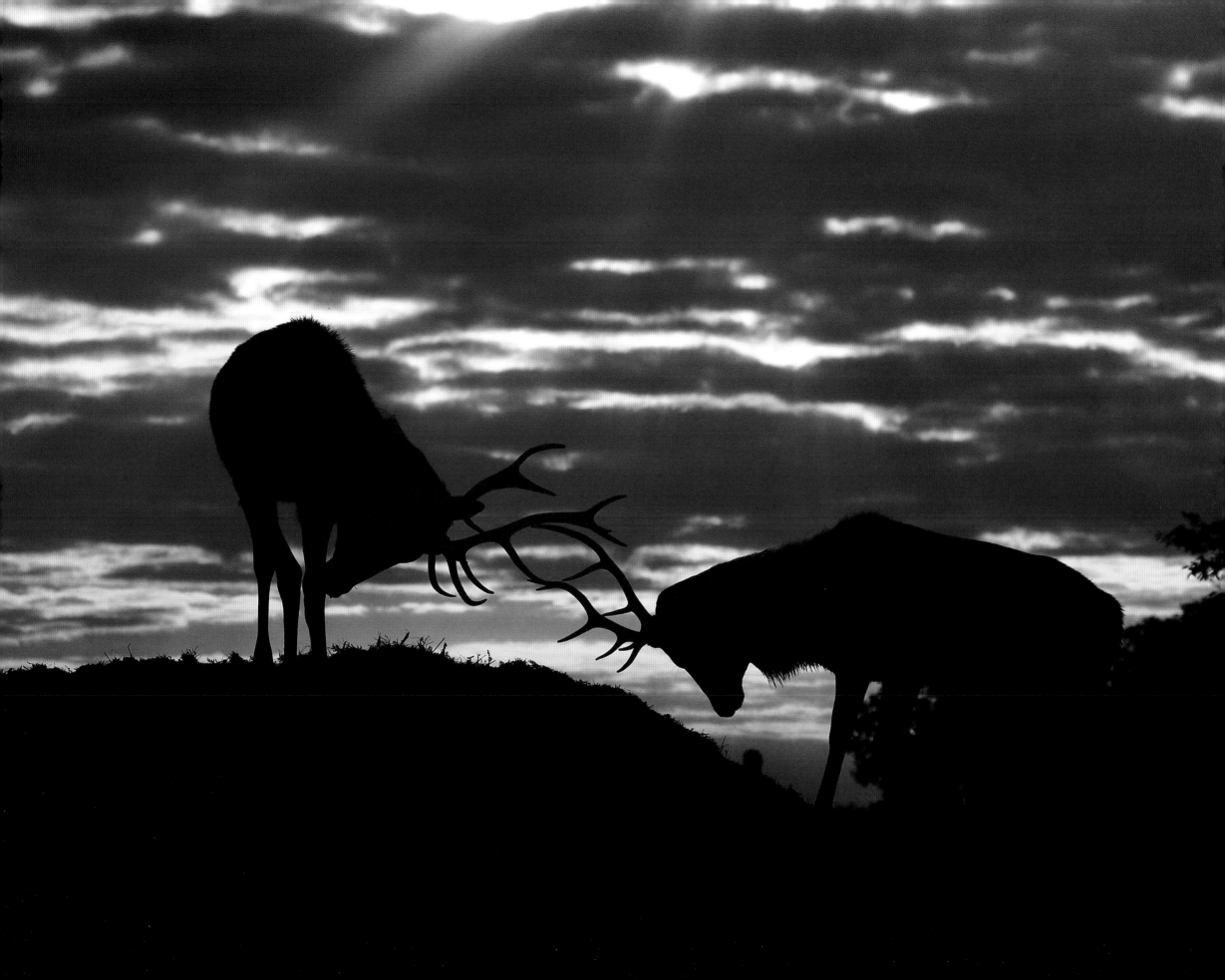

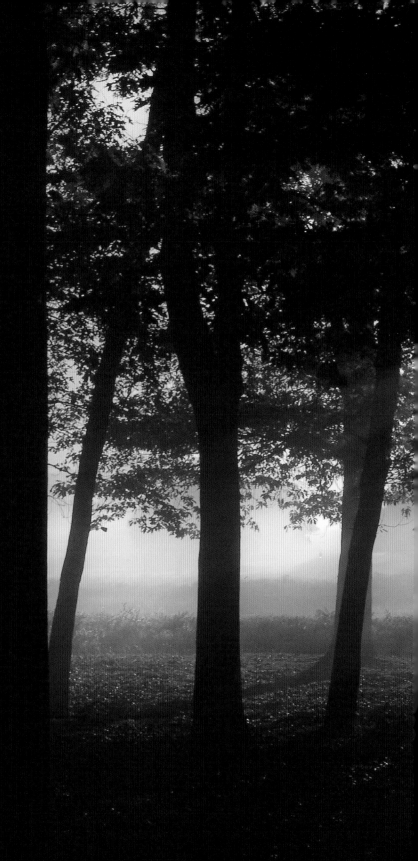

Autumn

This "second spring when every leaf is a flower", as Albert Camus memorably described it, is in many ways the most appealing and certainly the most photogenic segment of the year. The colours are exceptional, featuring every shade of brown, gold and orange that the mind's eye could imagine, splayed liberally across the landscape's changing face. Lingering mists bring a mystical aura, enhanced by the sun's rays flickering through the trees, surrounding deer, rabbits, birds and other creatures great and small with an eerie incandescence that can seem almost supernatural.

Now is the time for winding down, for anticipating bleak midwinter; when hibernation fever sets in, and nuts and nibbles are salted away meticulously in preparation for the big sleep. As black-headed gulls shriek noisily overhead, leaves and acorns are cascading down from the skies, forming a deep pile carpet that scrunches appealingly underfoot. Everything is slowing down except for the deer, for whom the rutting season means courtship and aggression in equal measure. The clash of antlers, the roaring of the stags, and the pungent, musty scent of these symbolic creatures epitomises the unique mix of sounds and smells that herald the passing of the year.

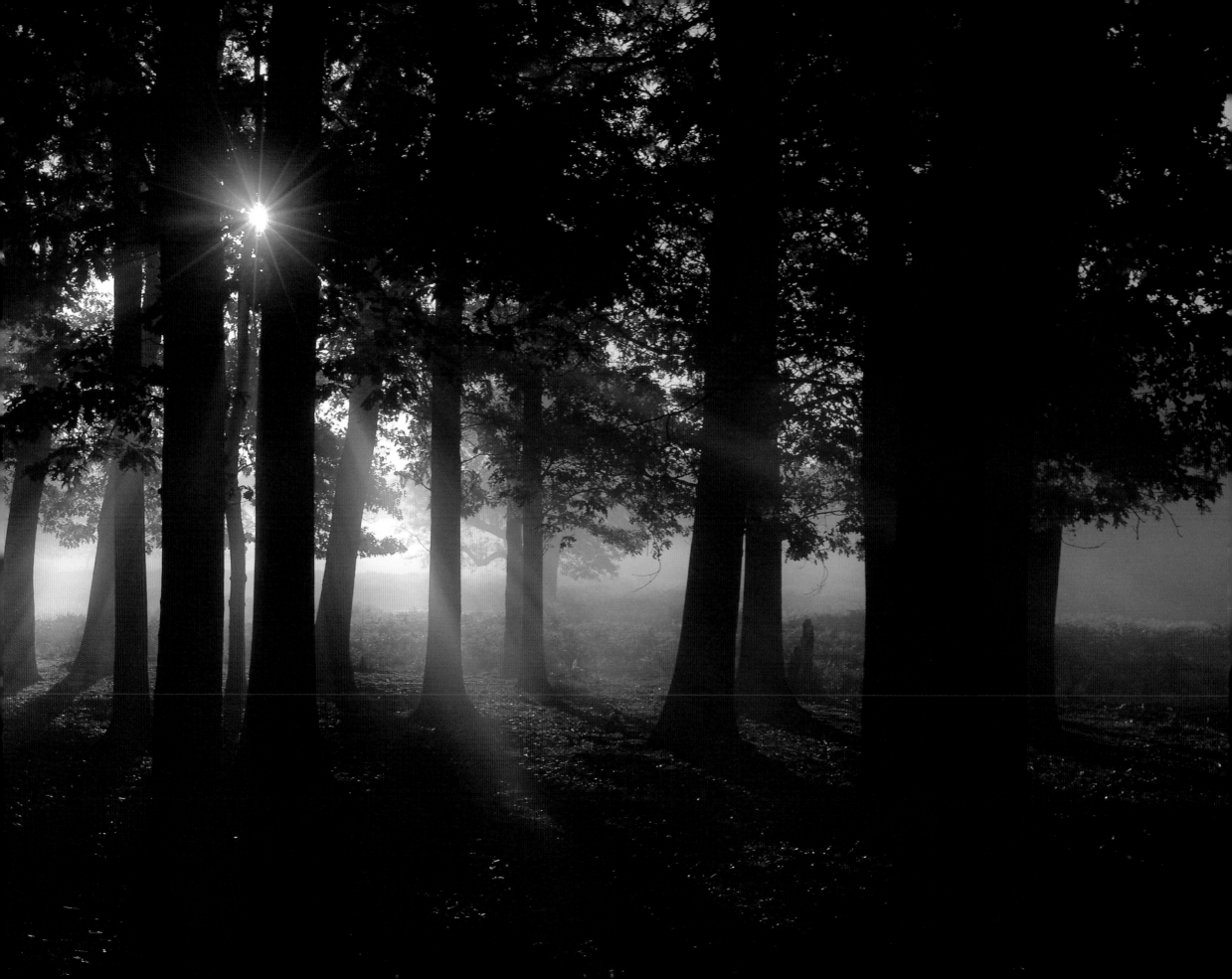

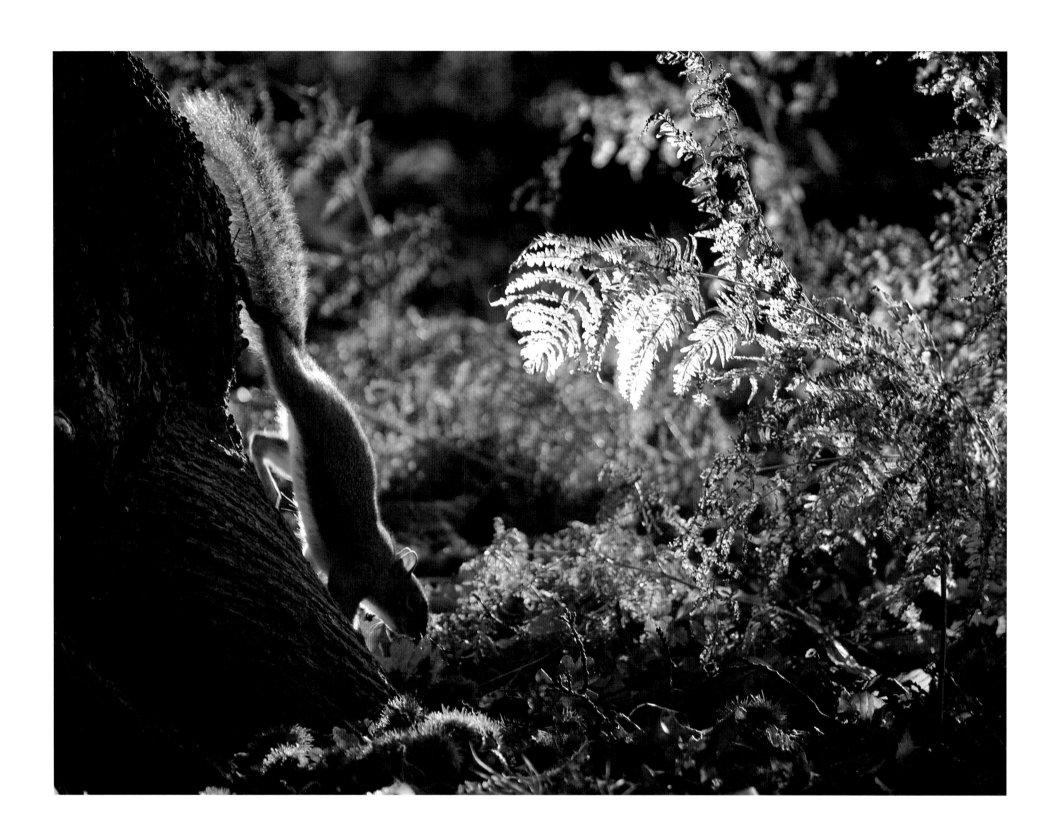

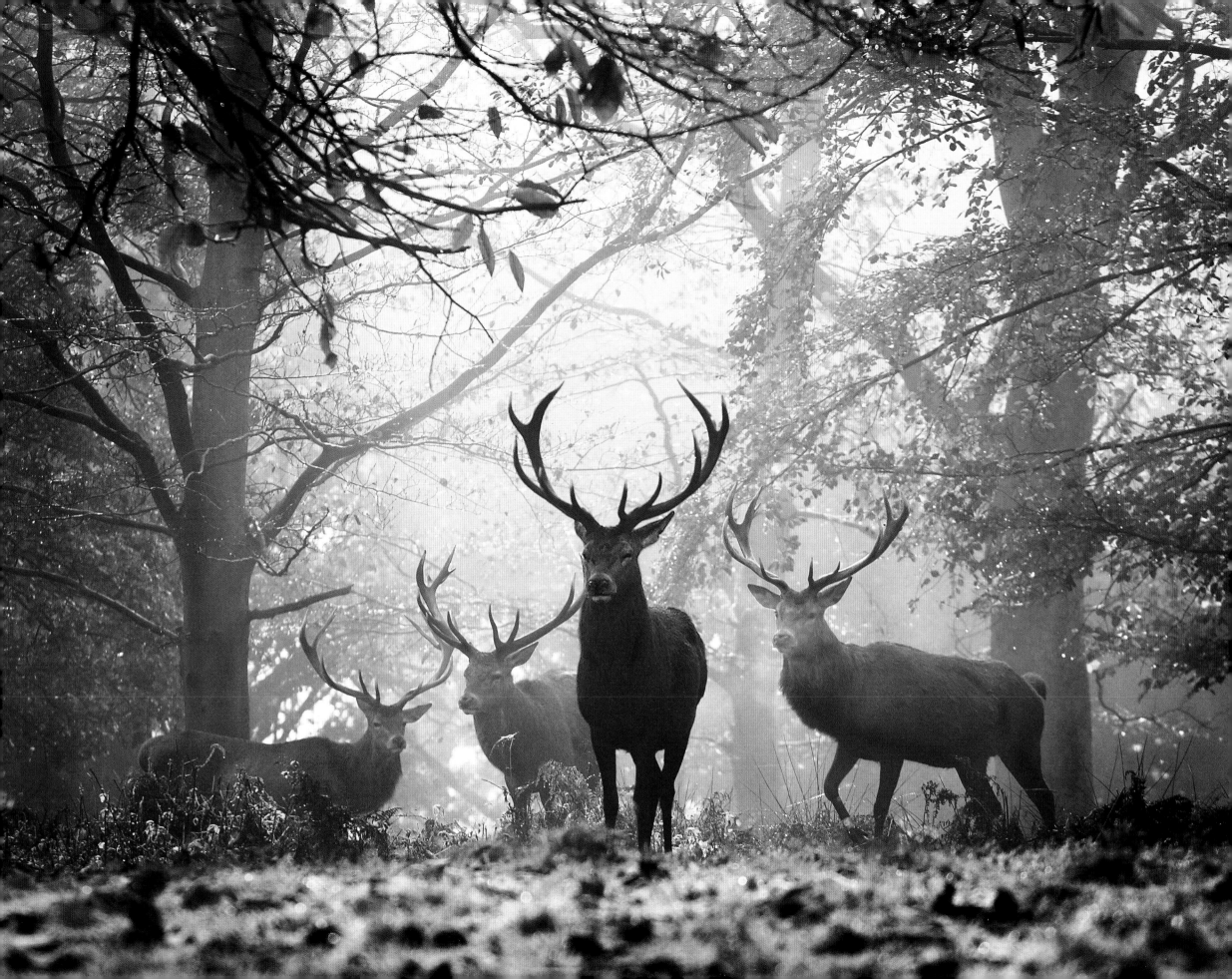

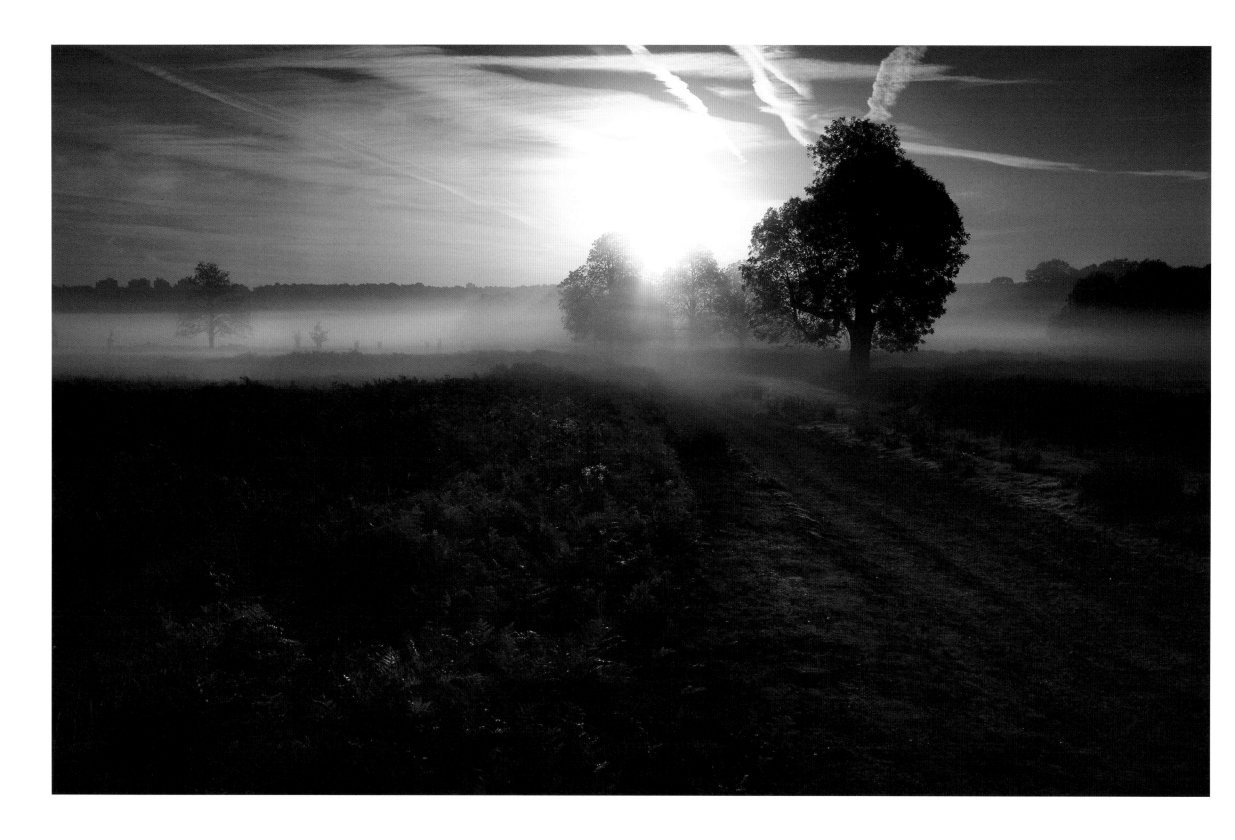

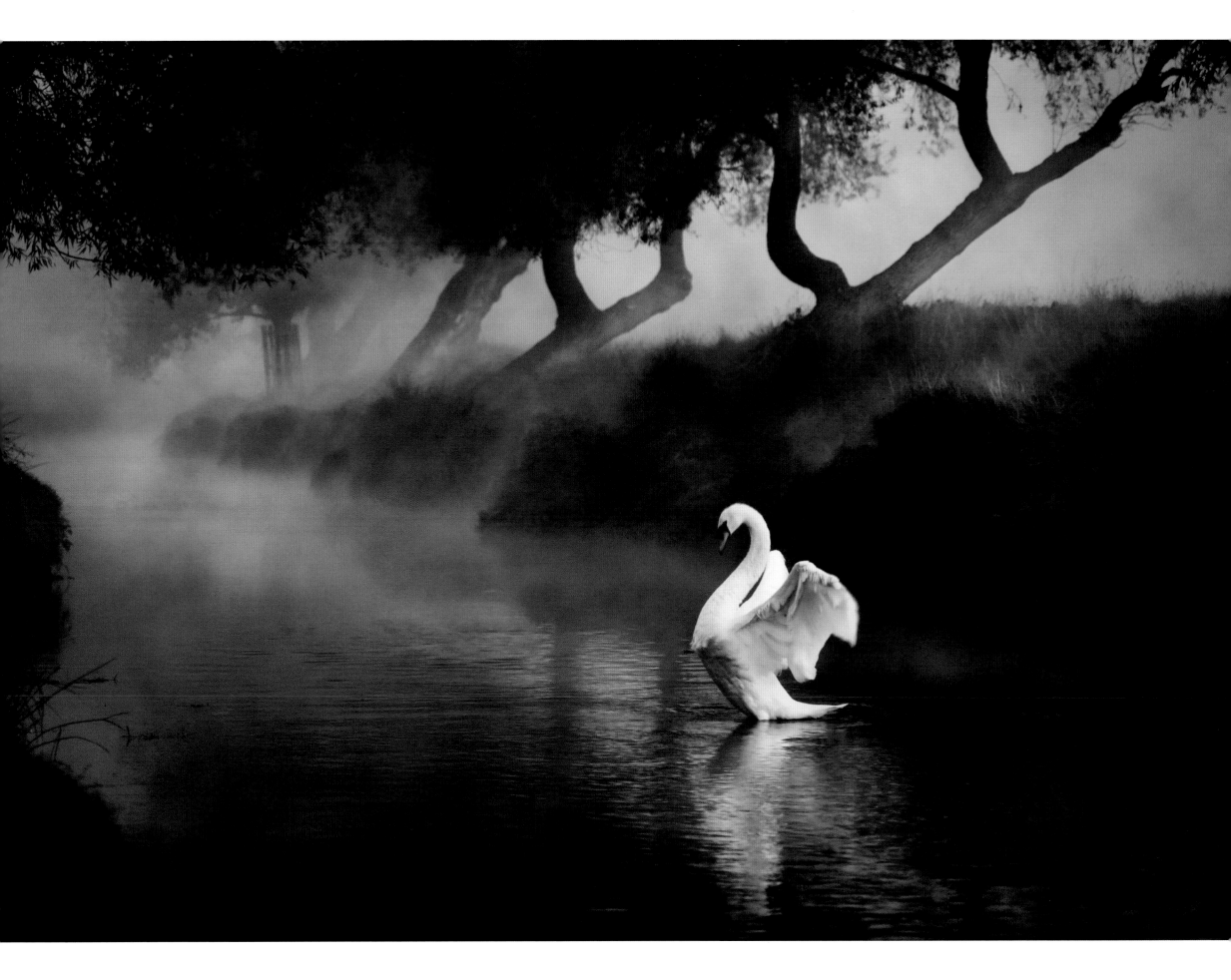

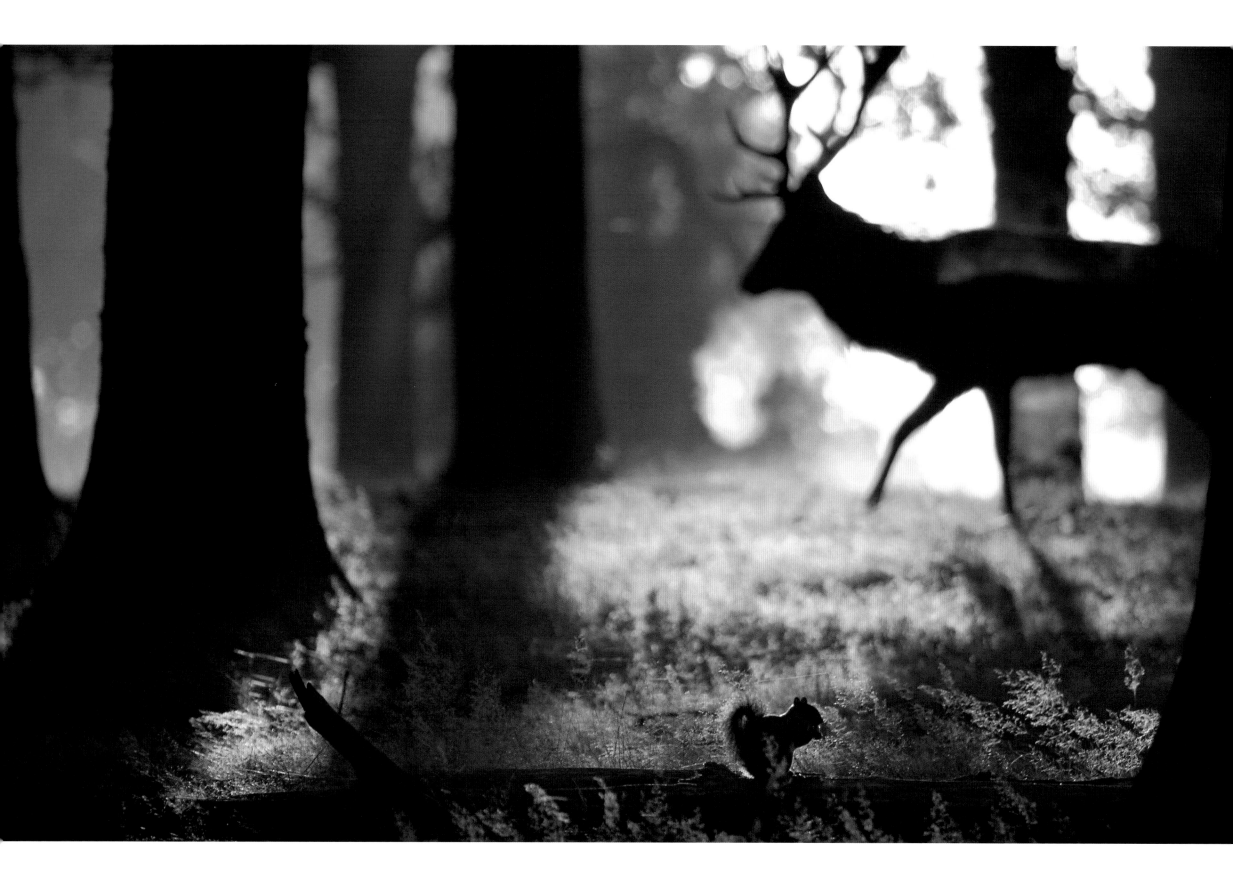

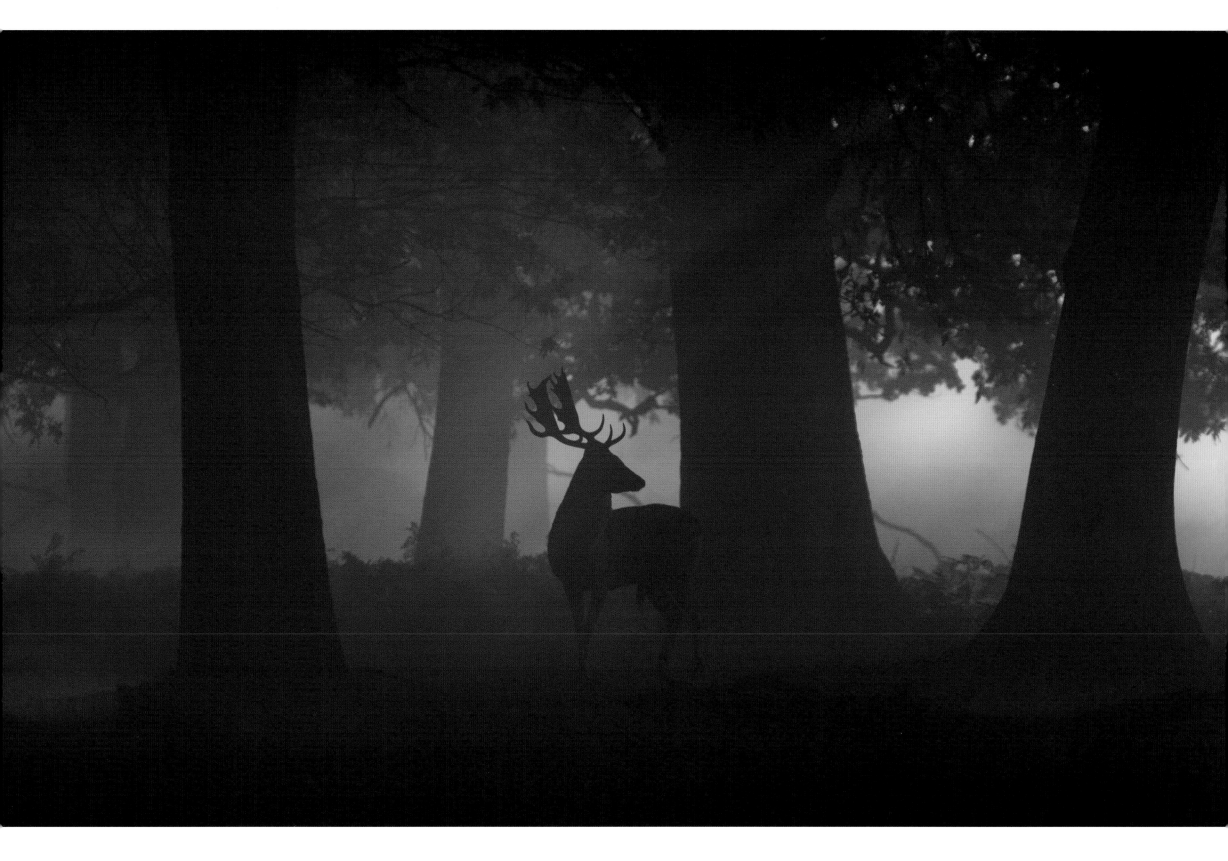

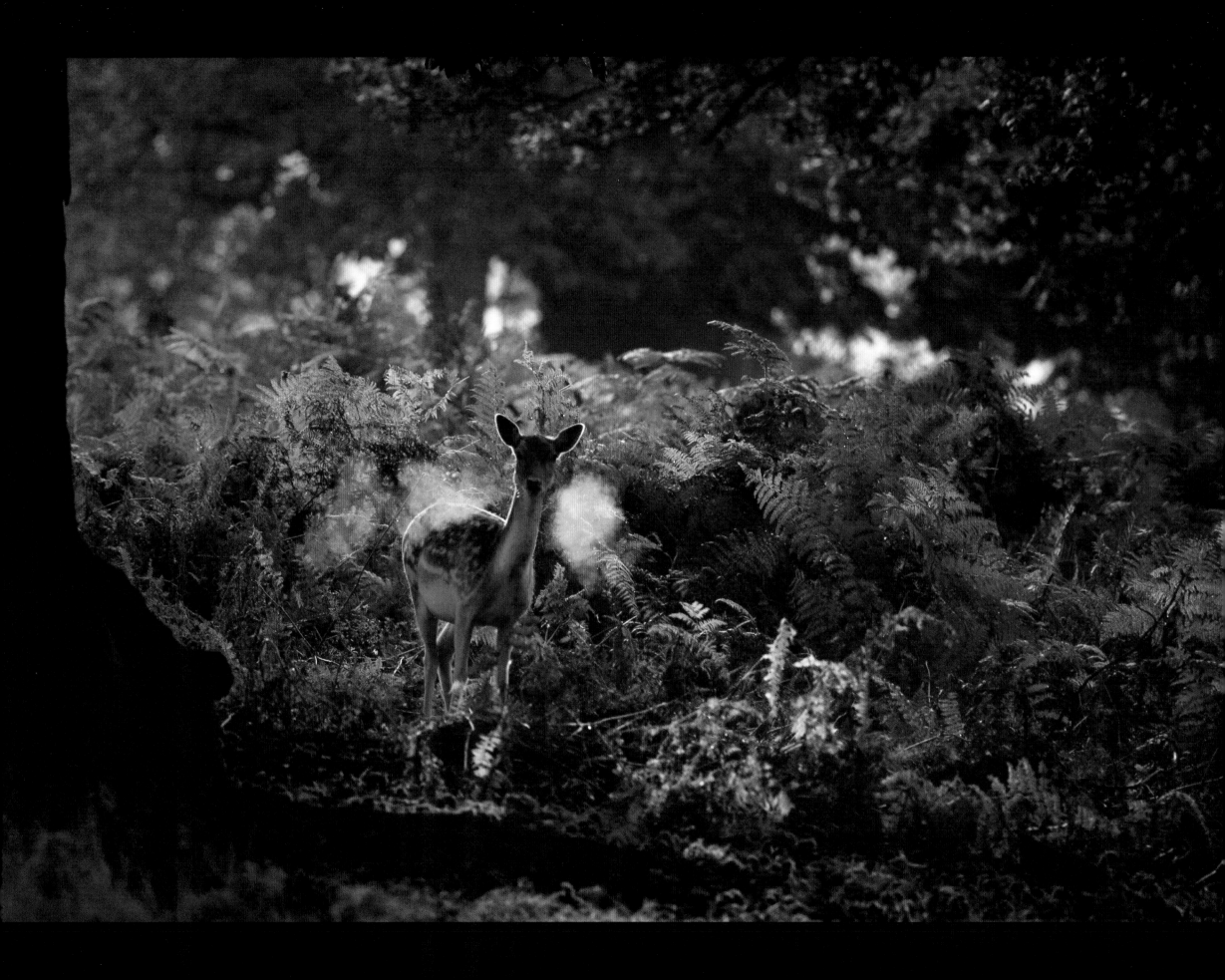

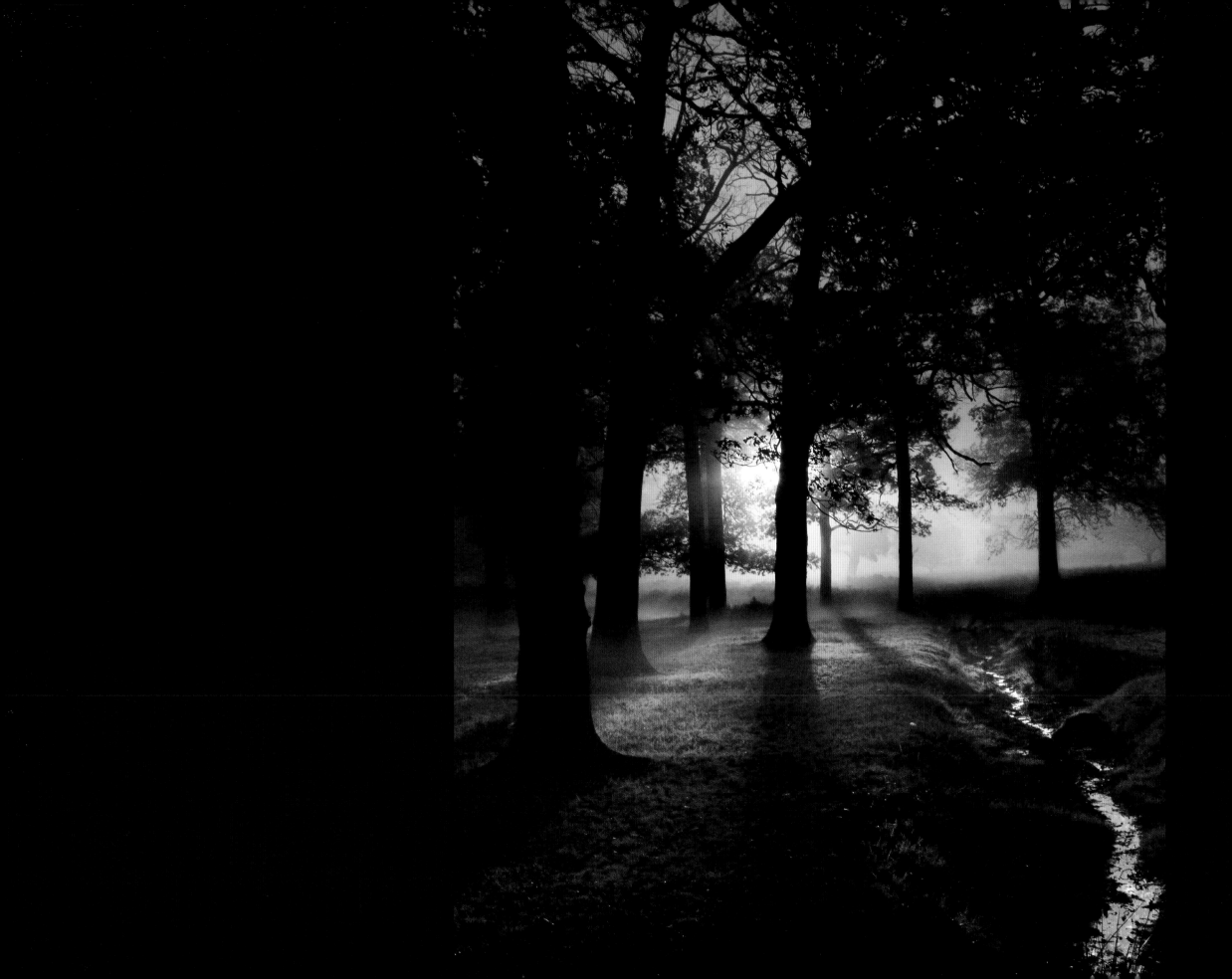

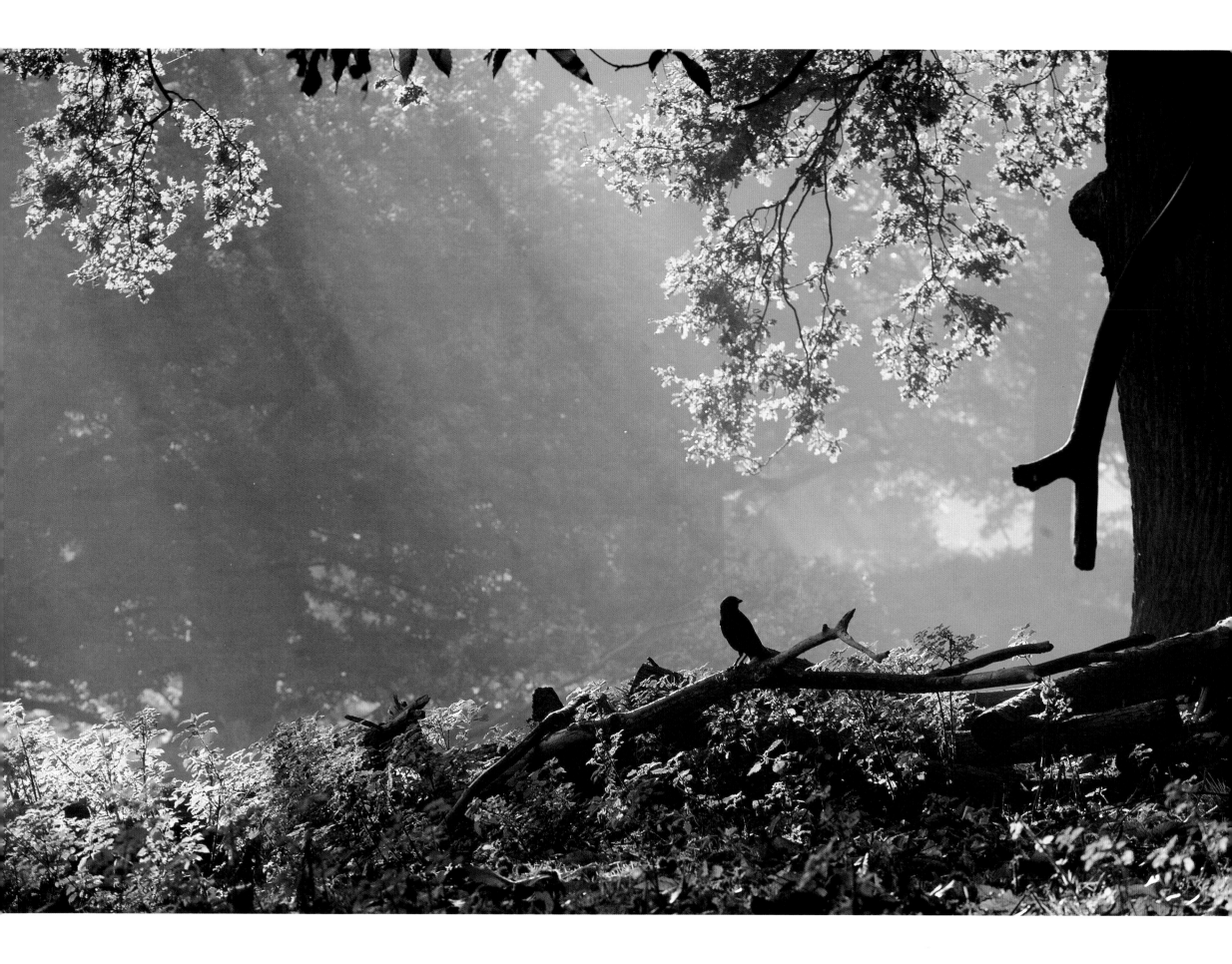

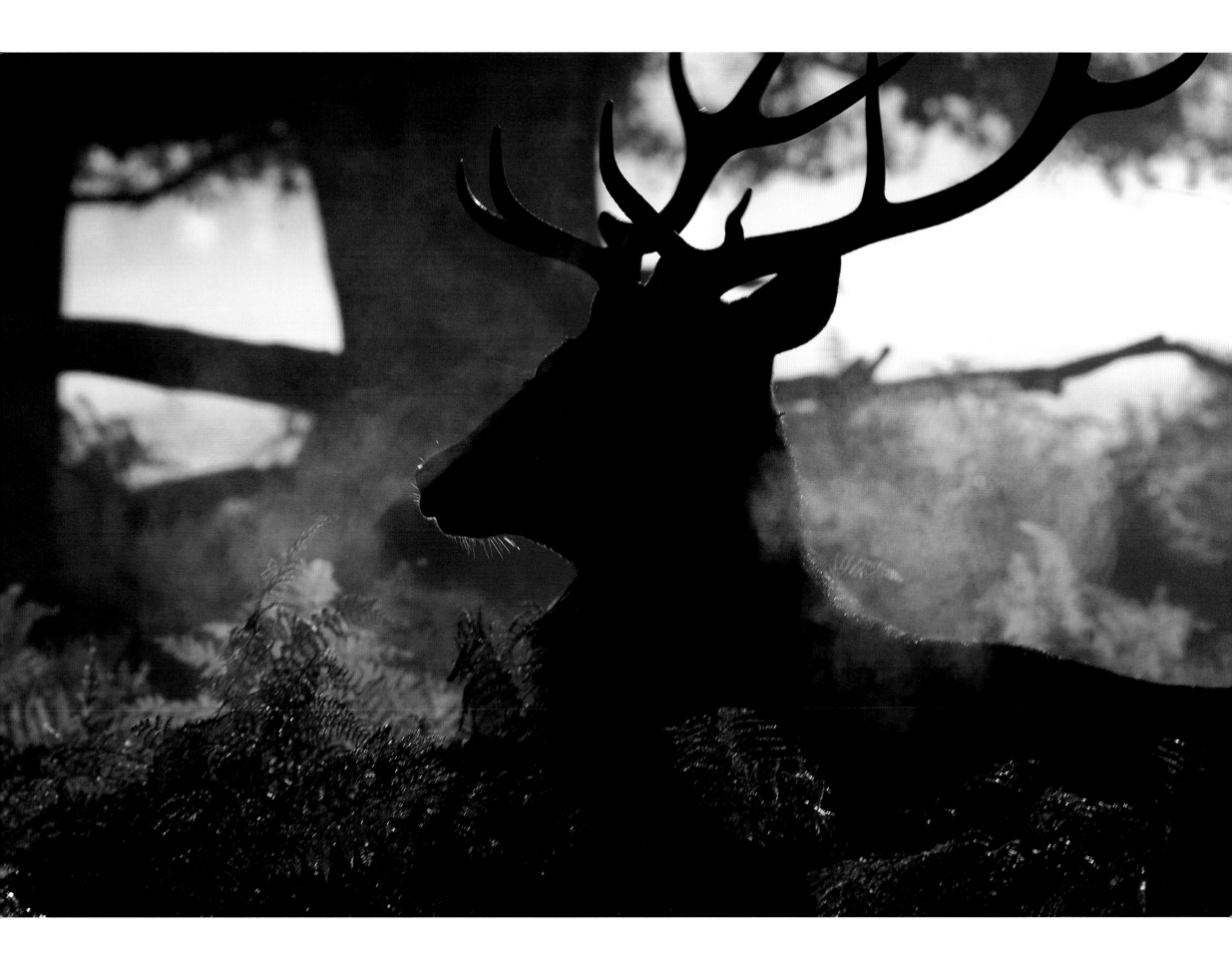

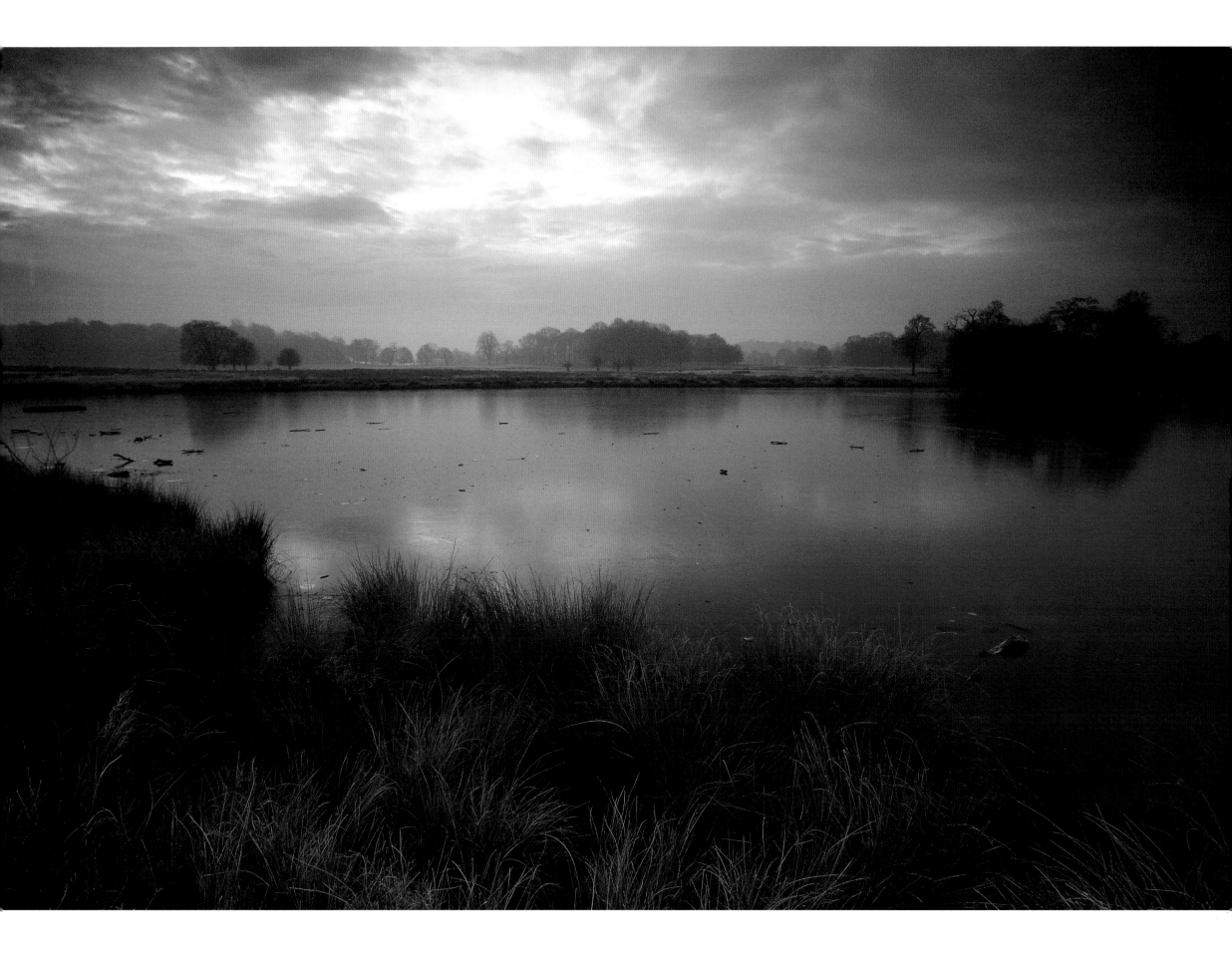

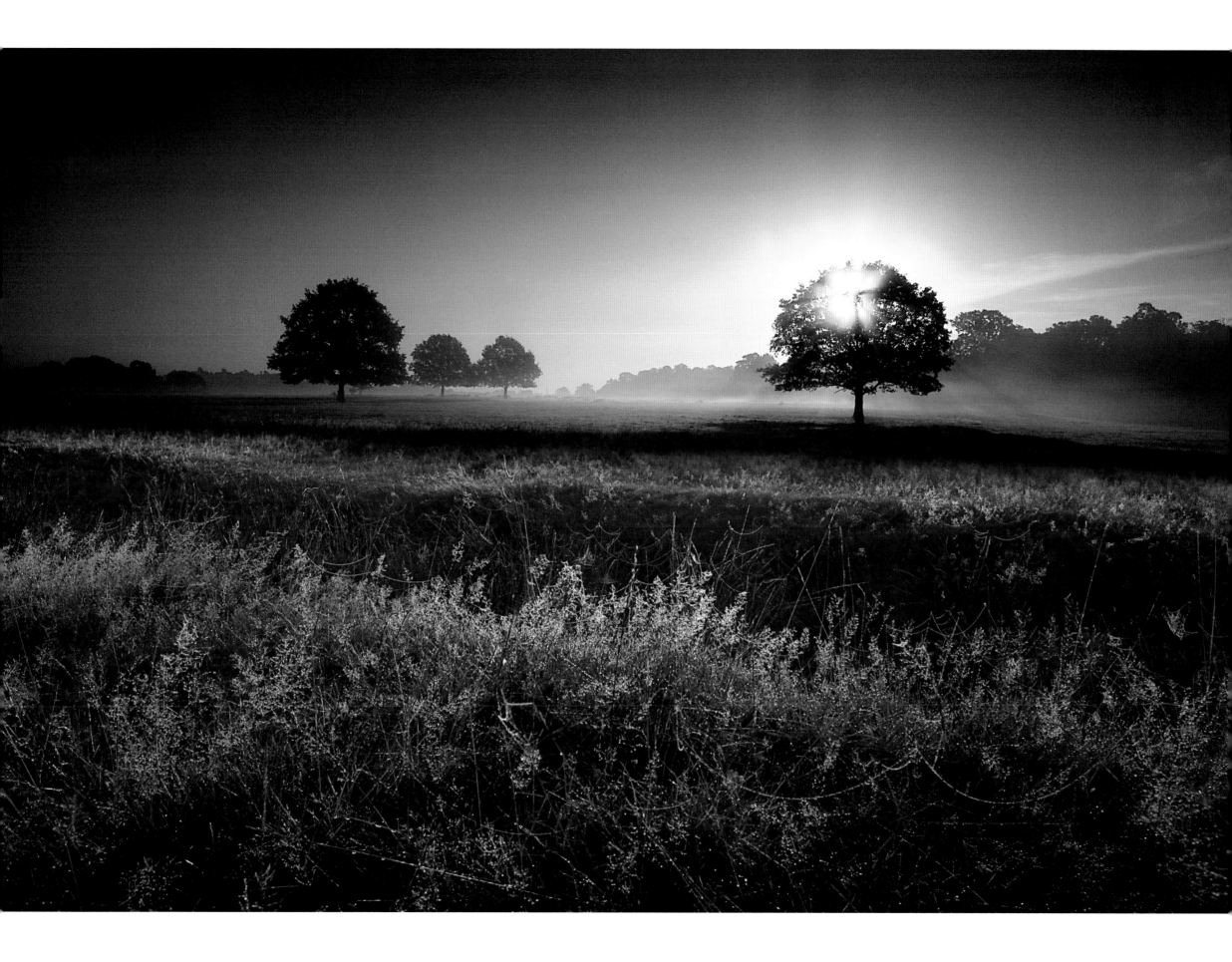

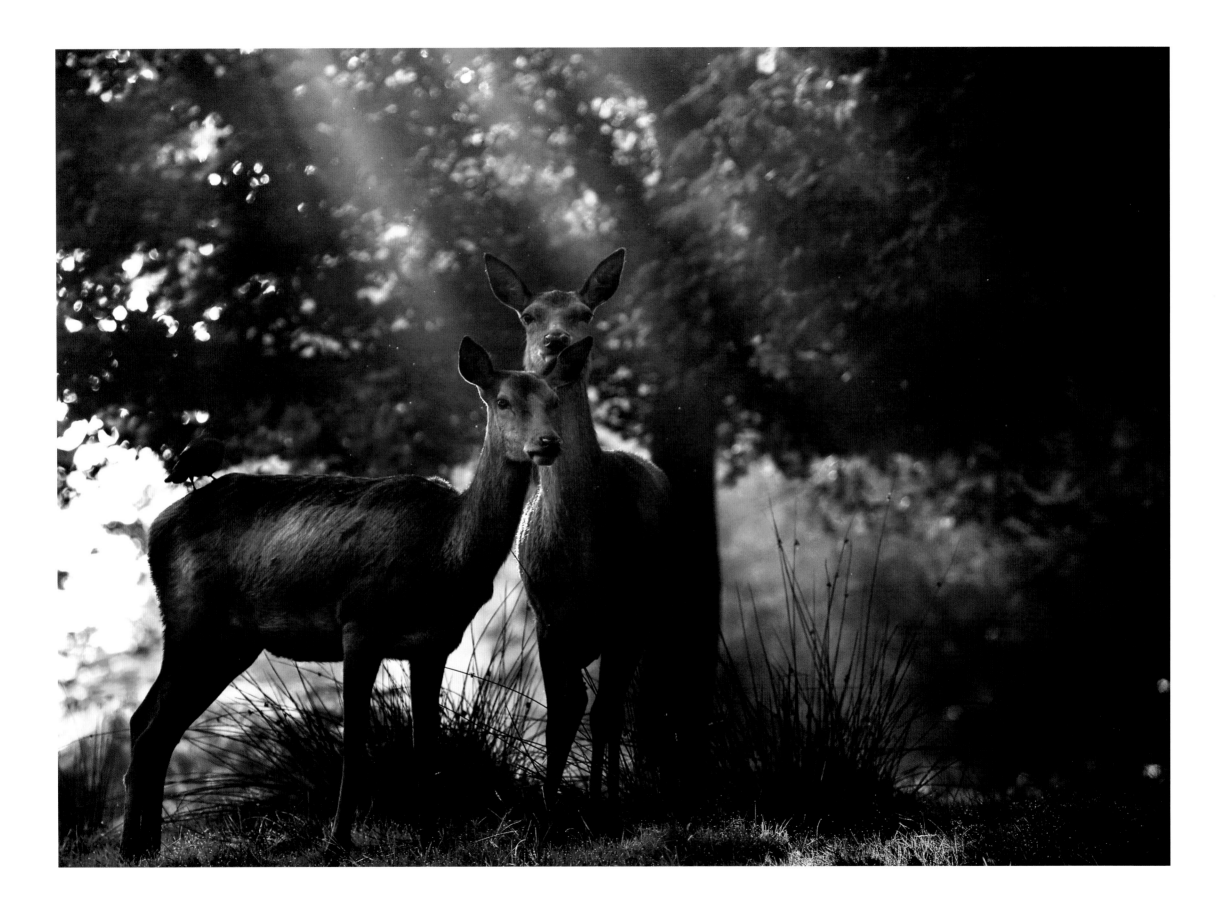

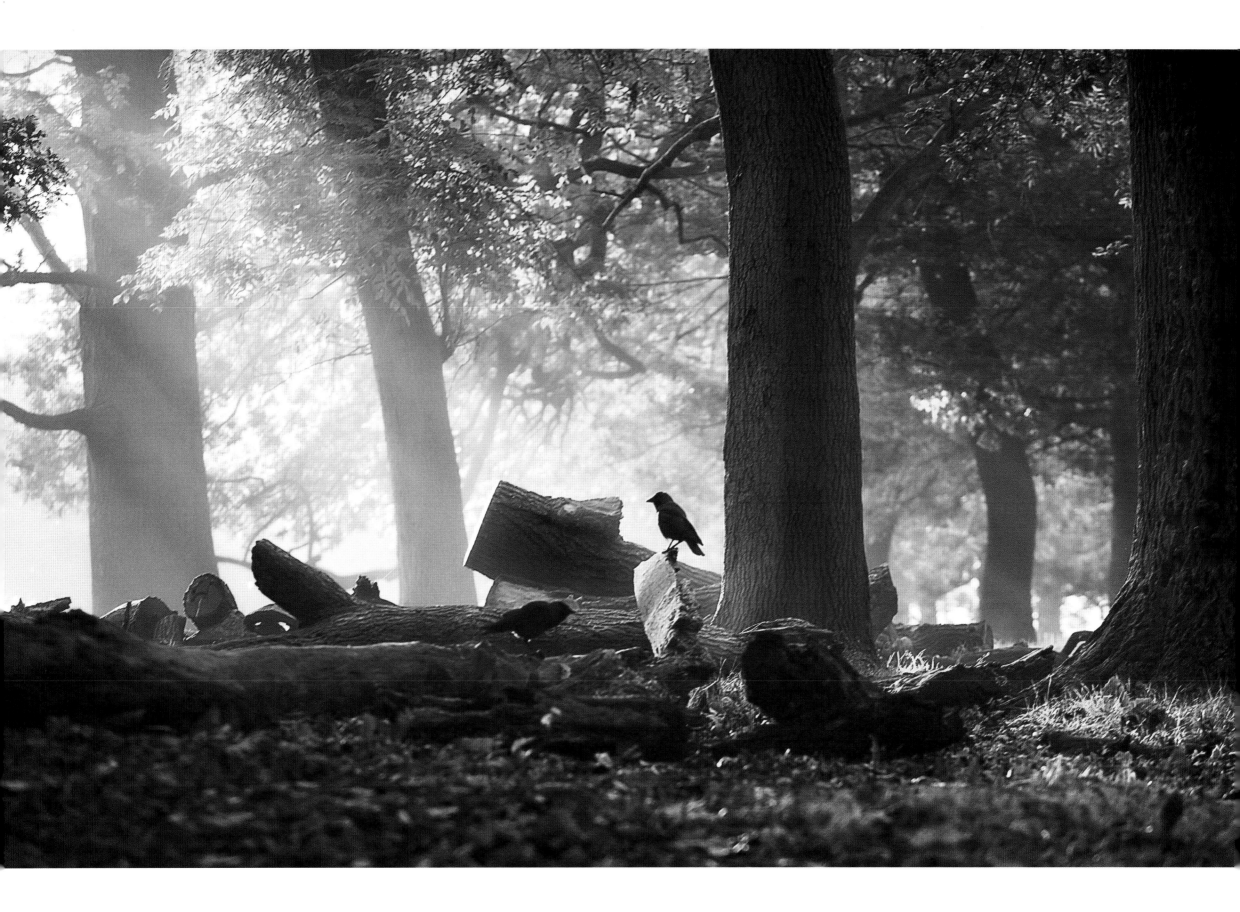

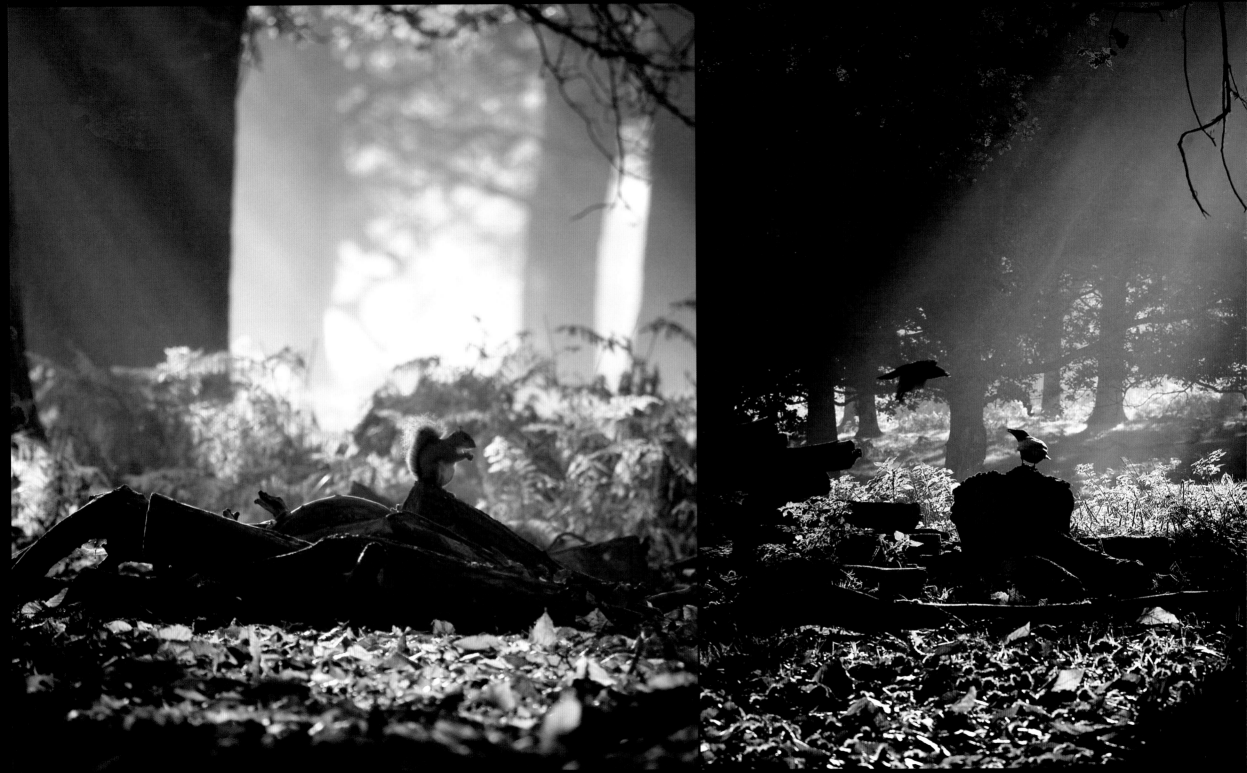

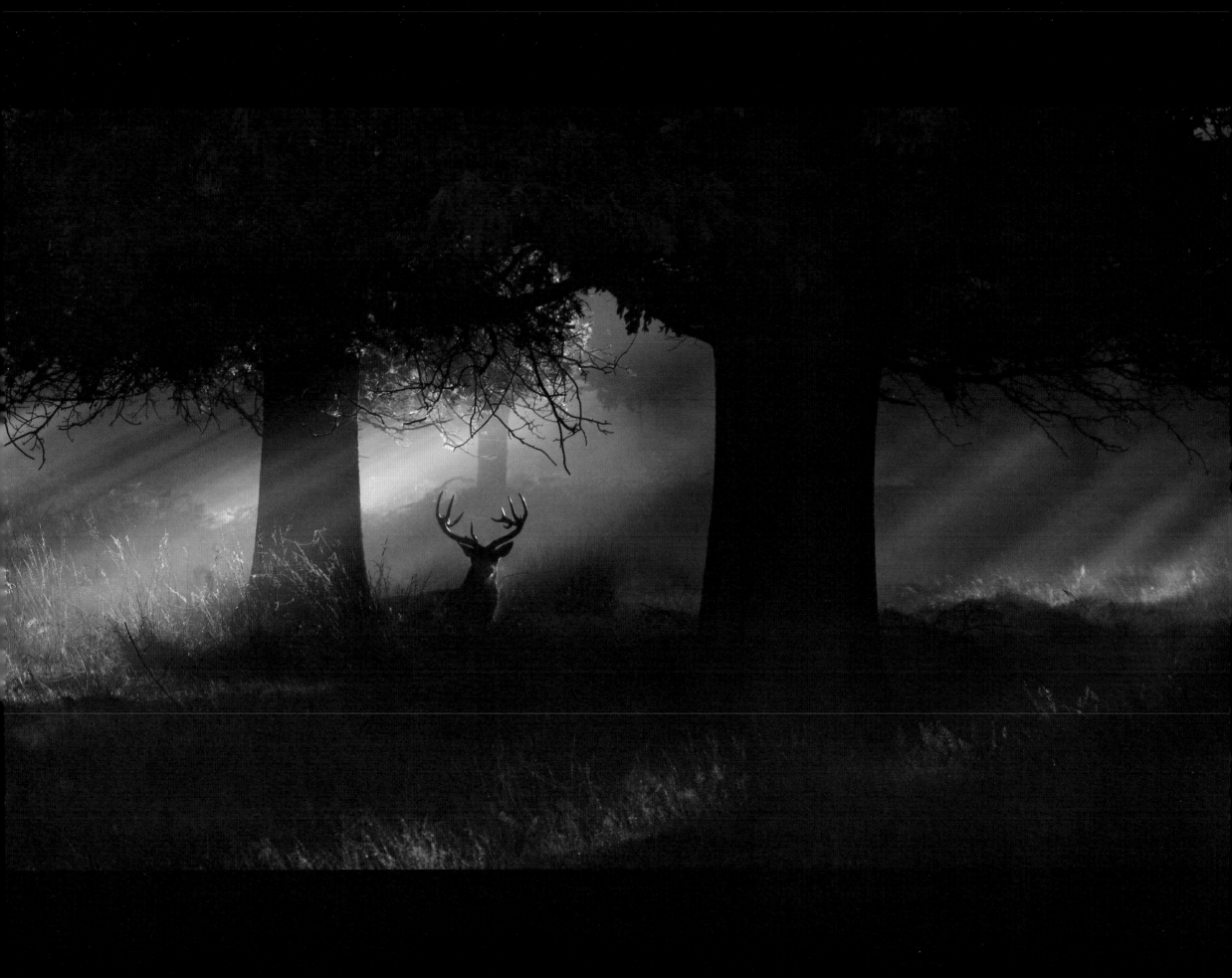

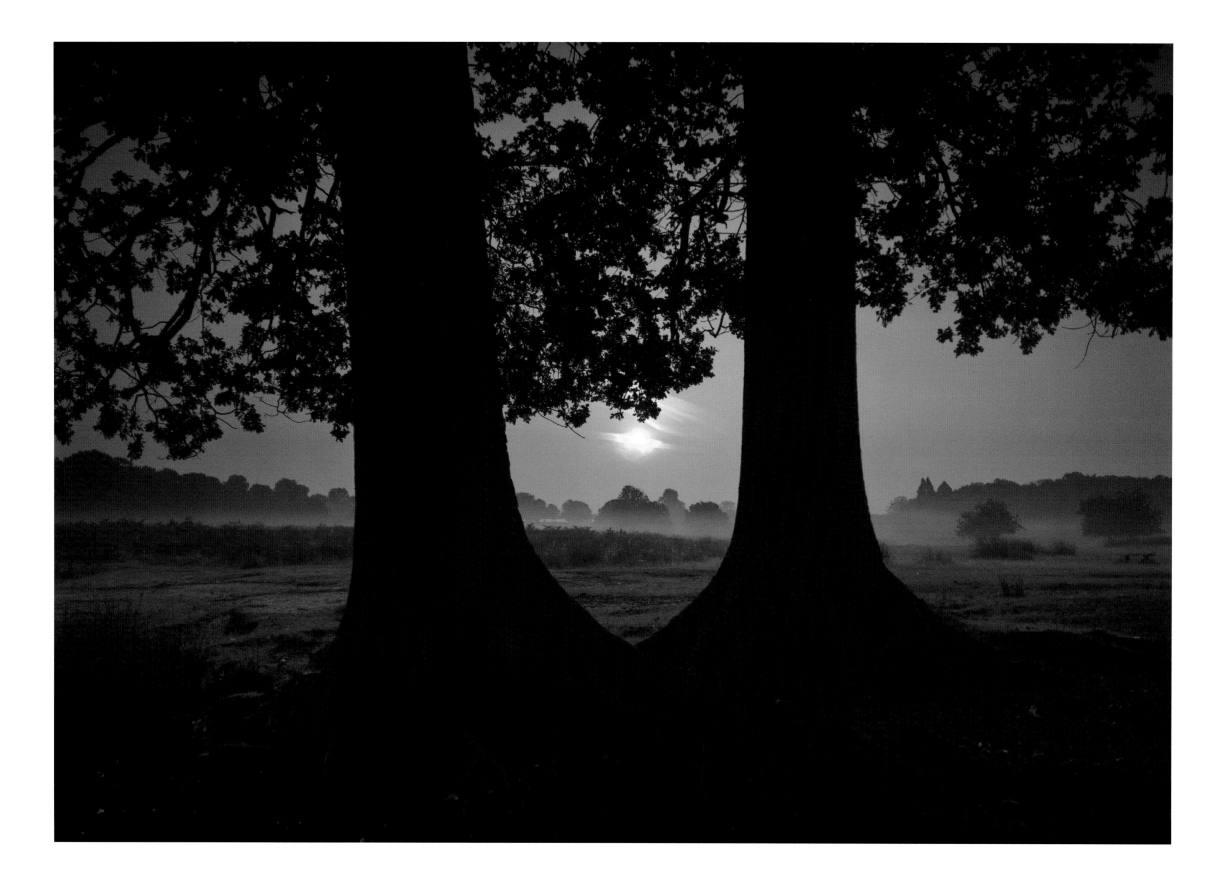

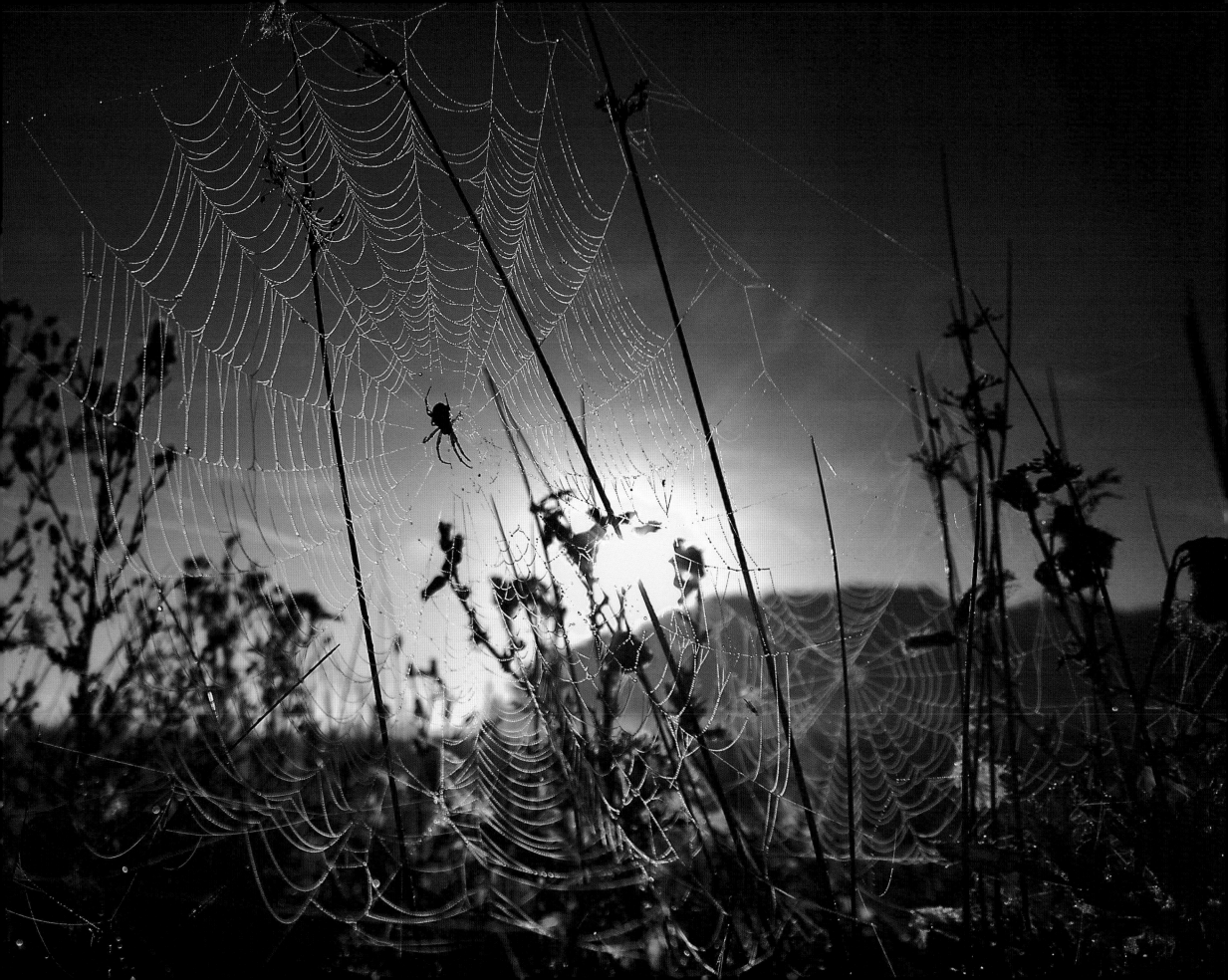

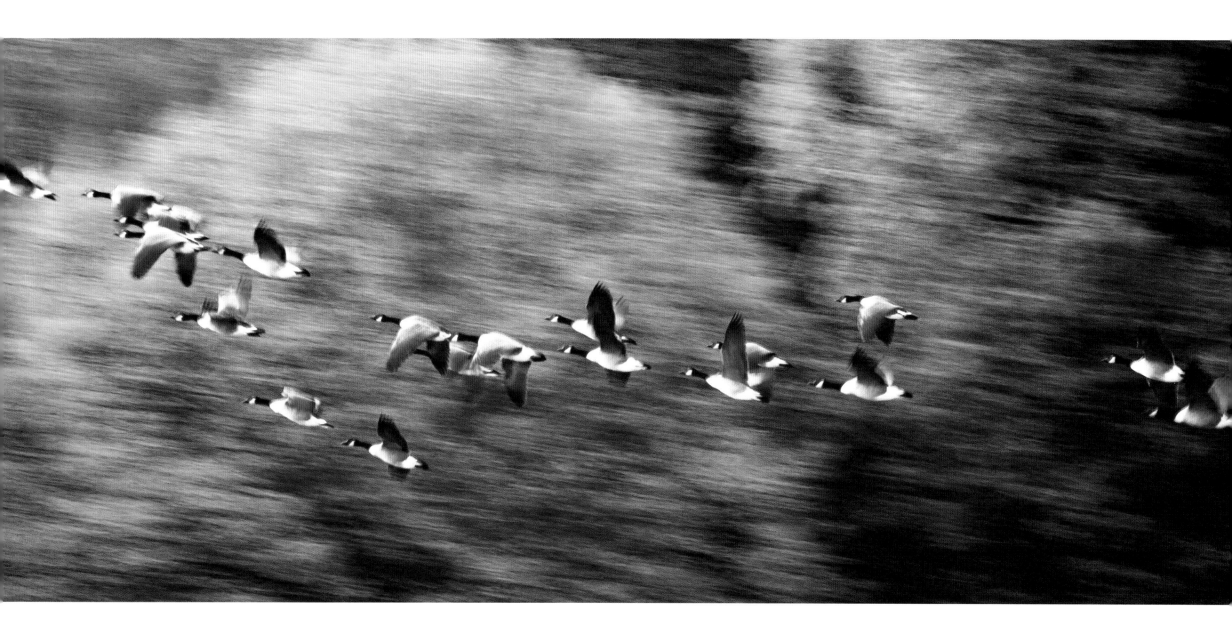

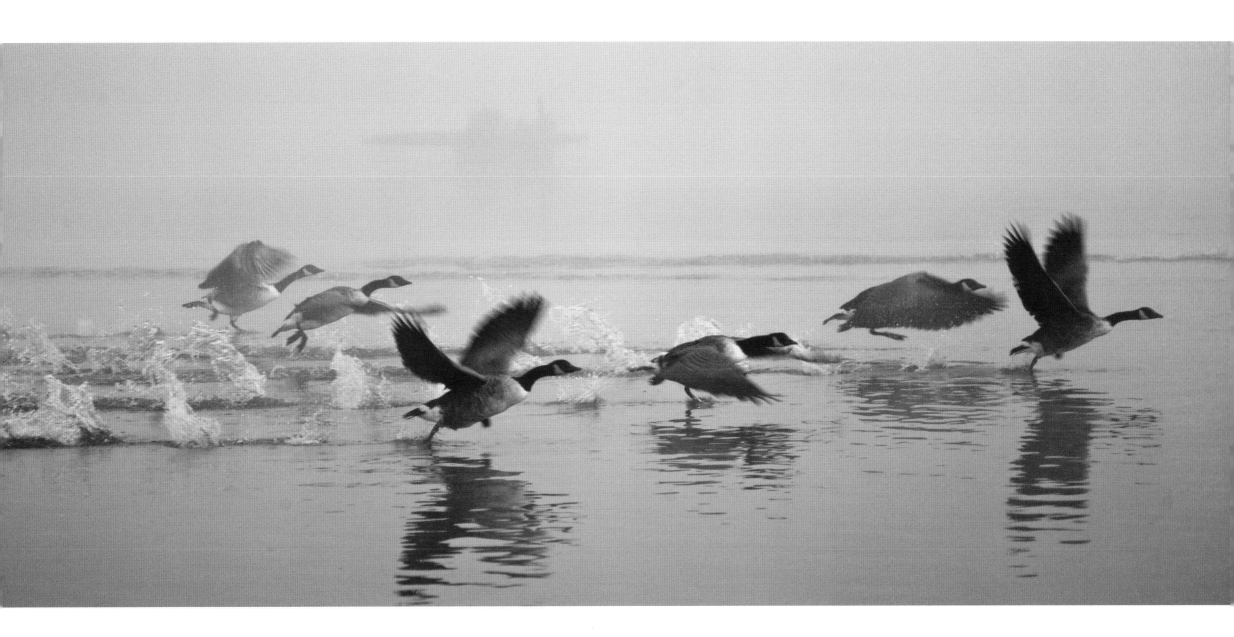

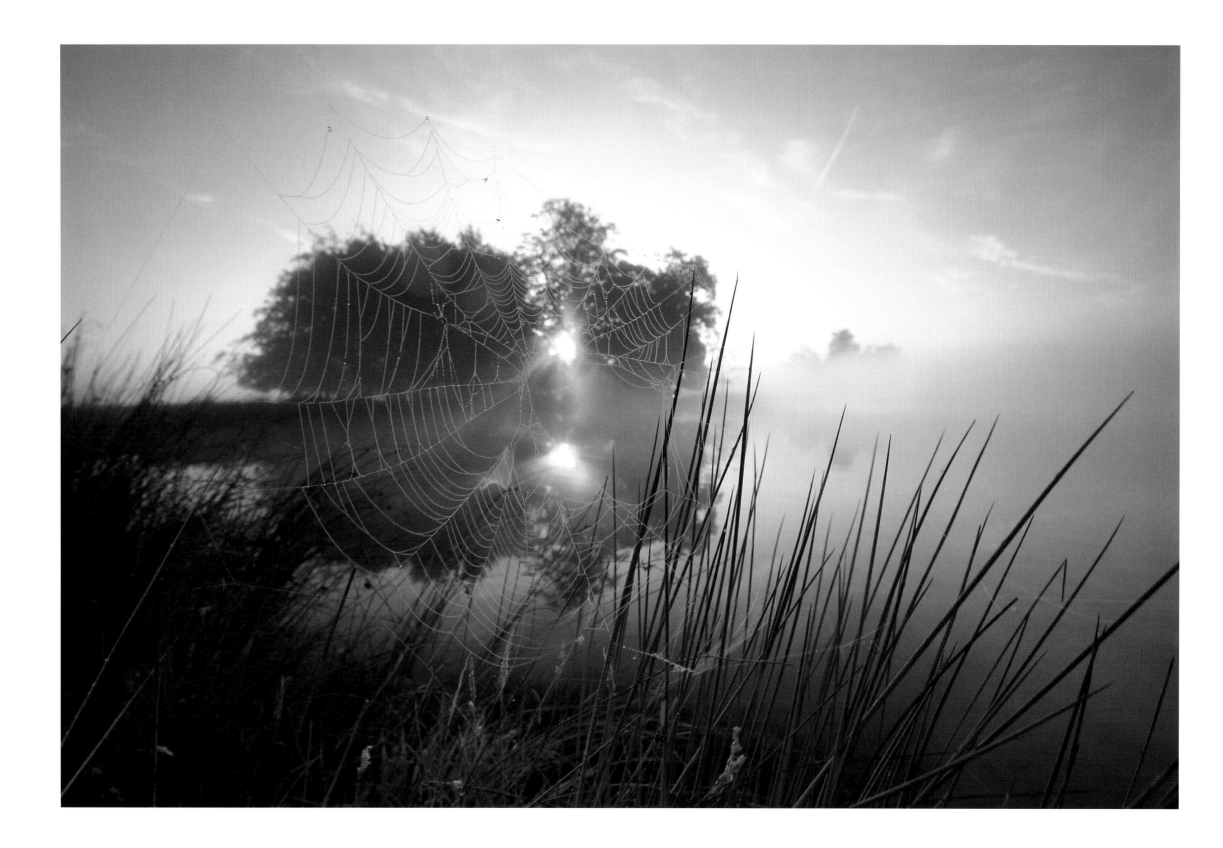

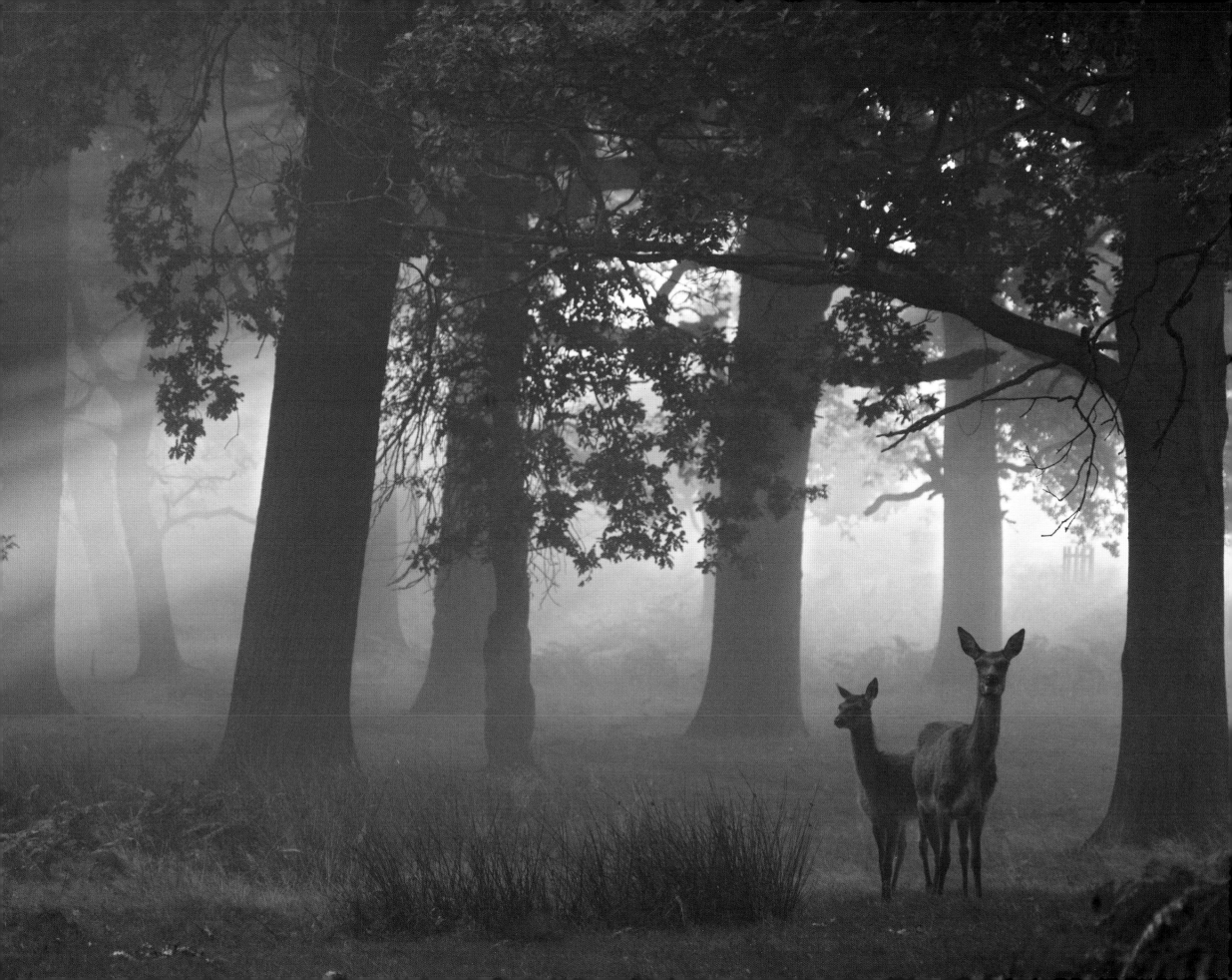

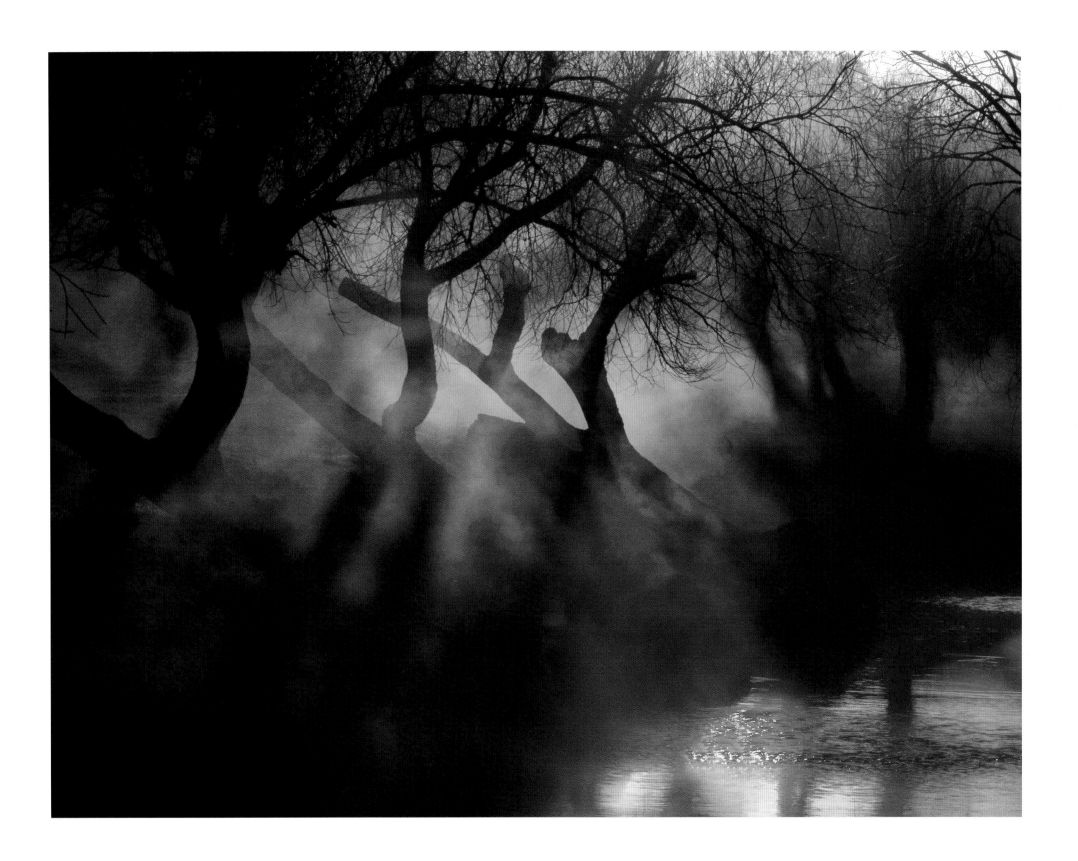

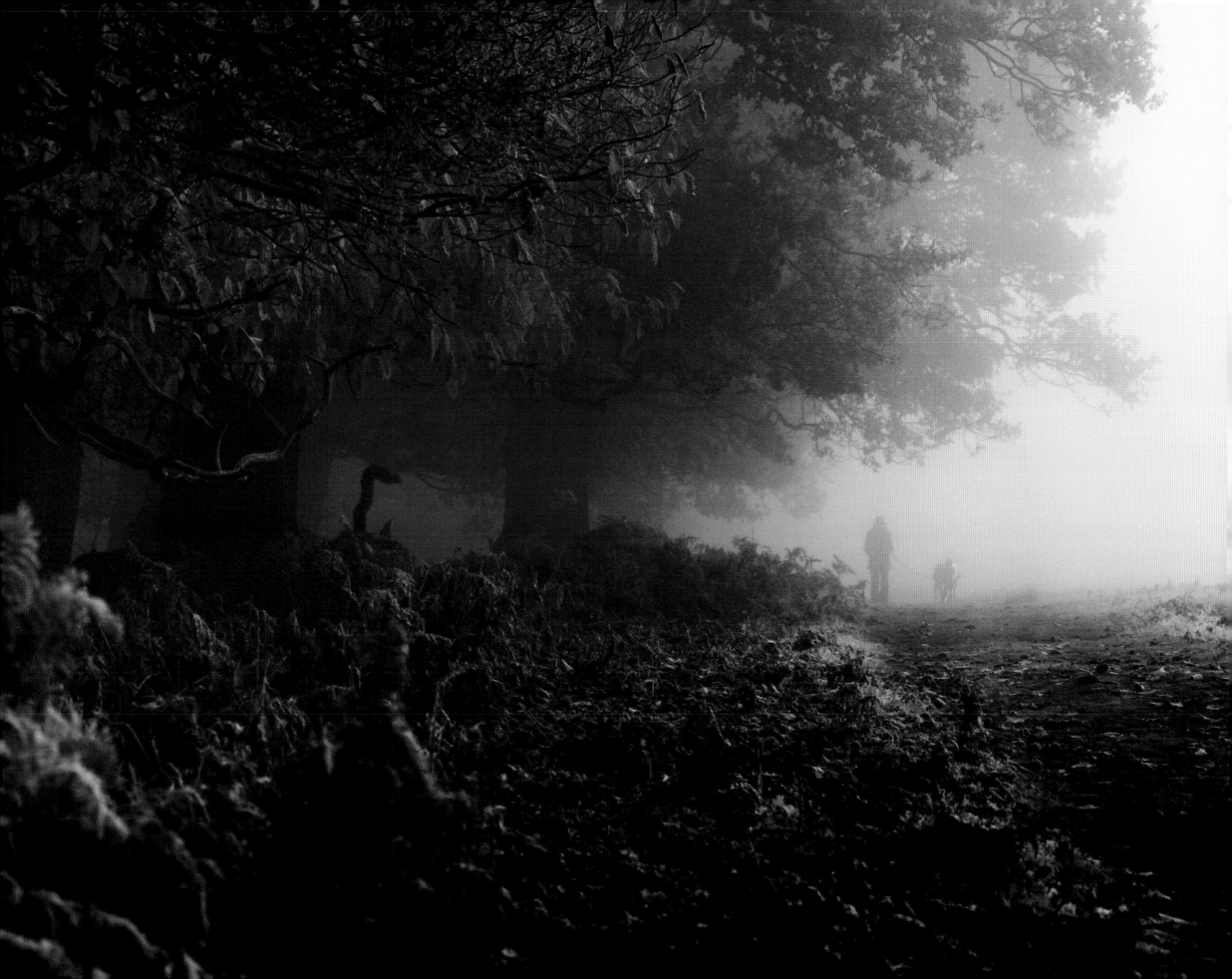

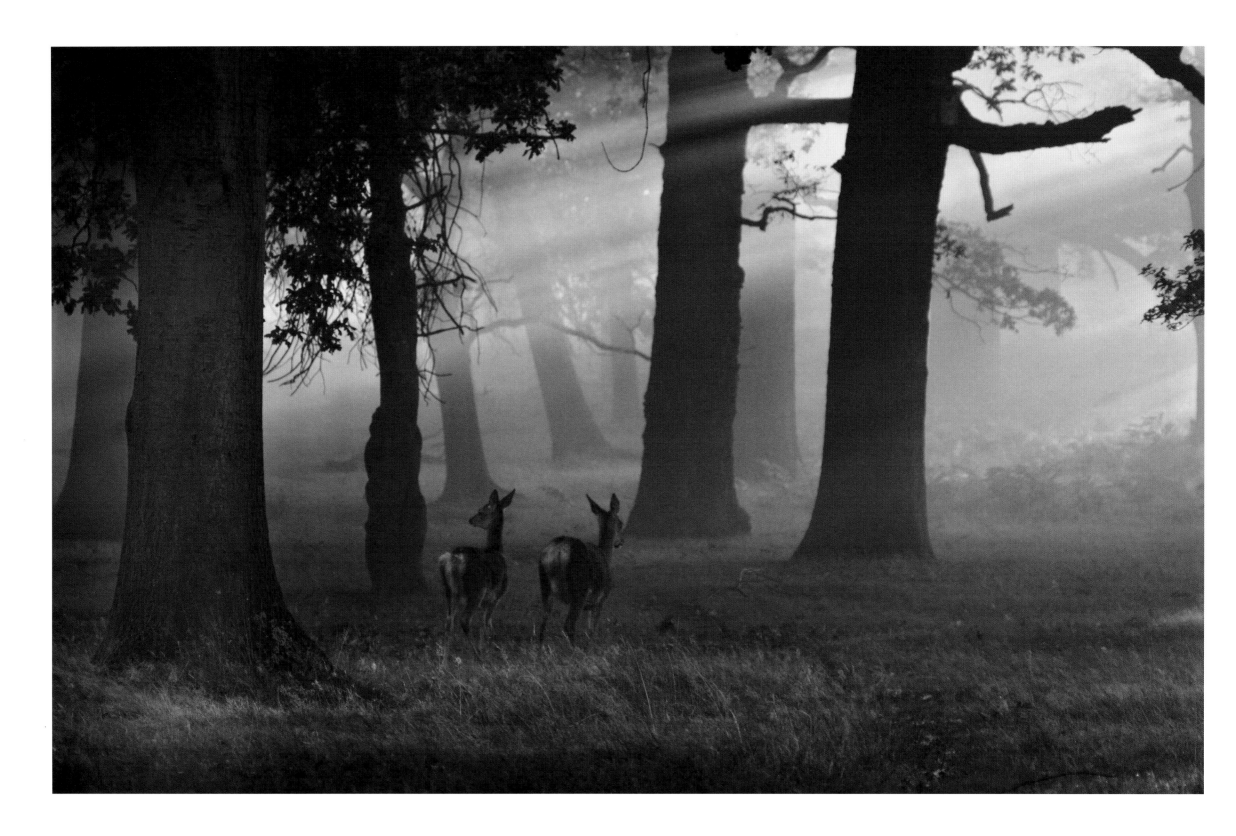

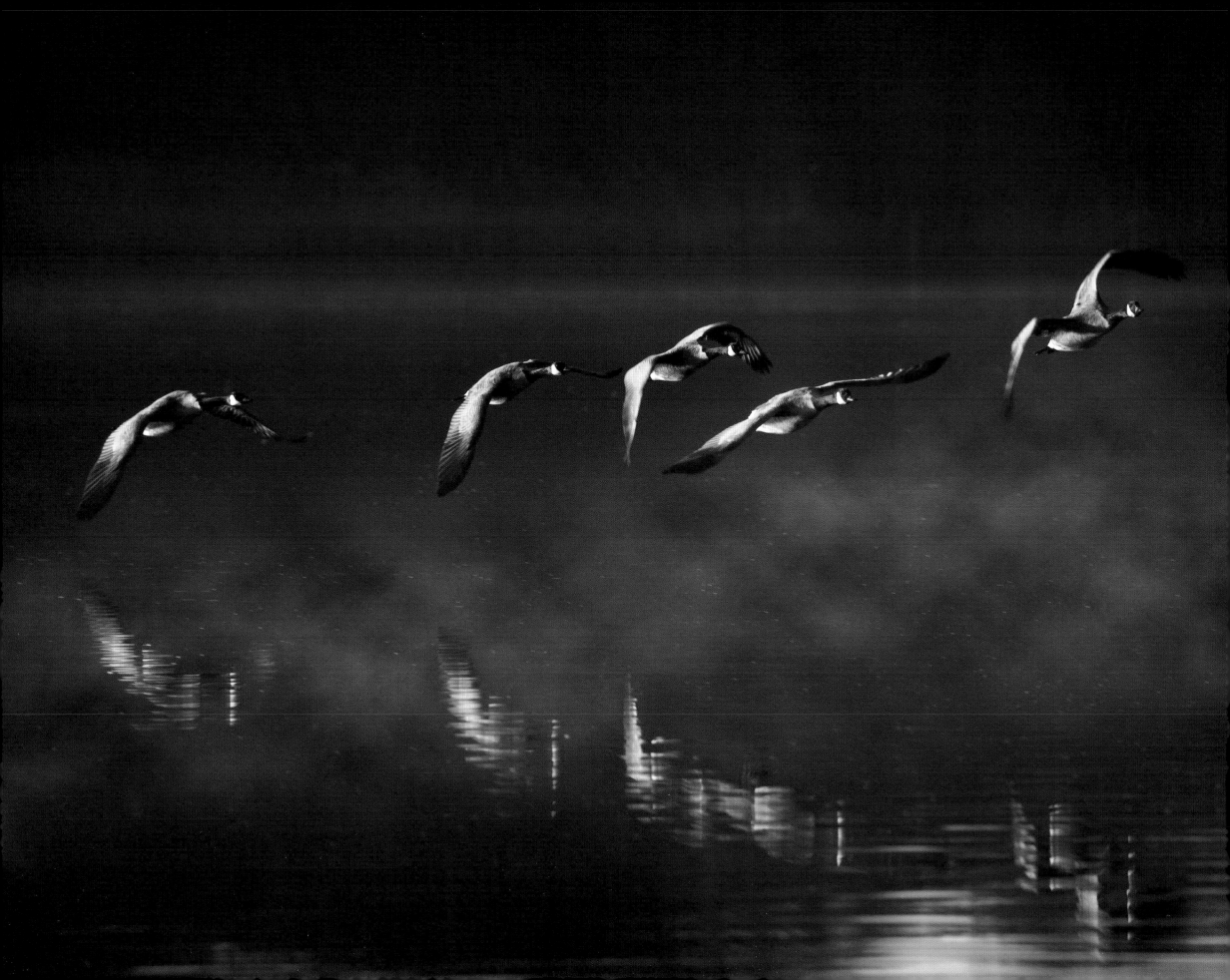

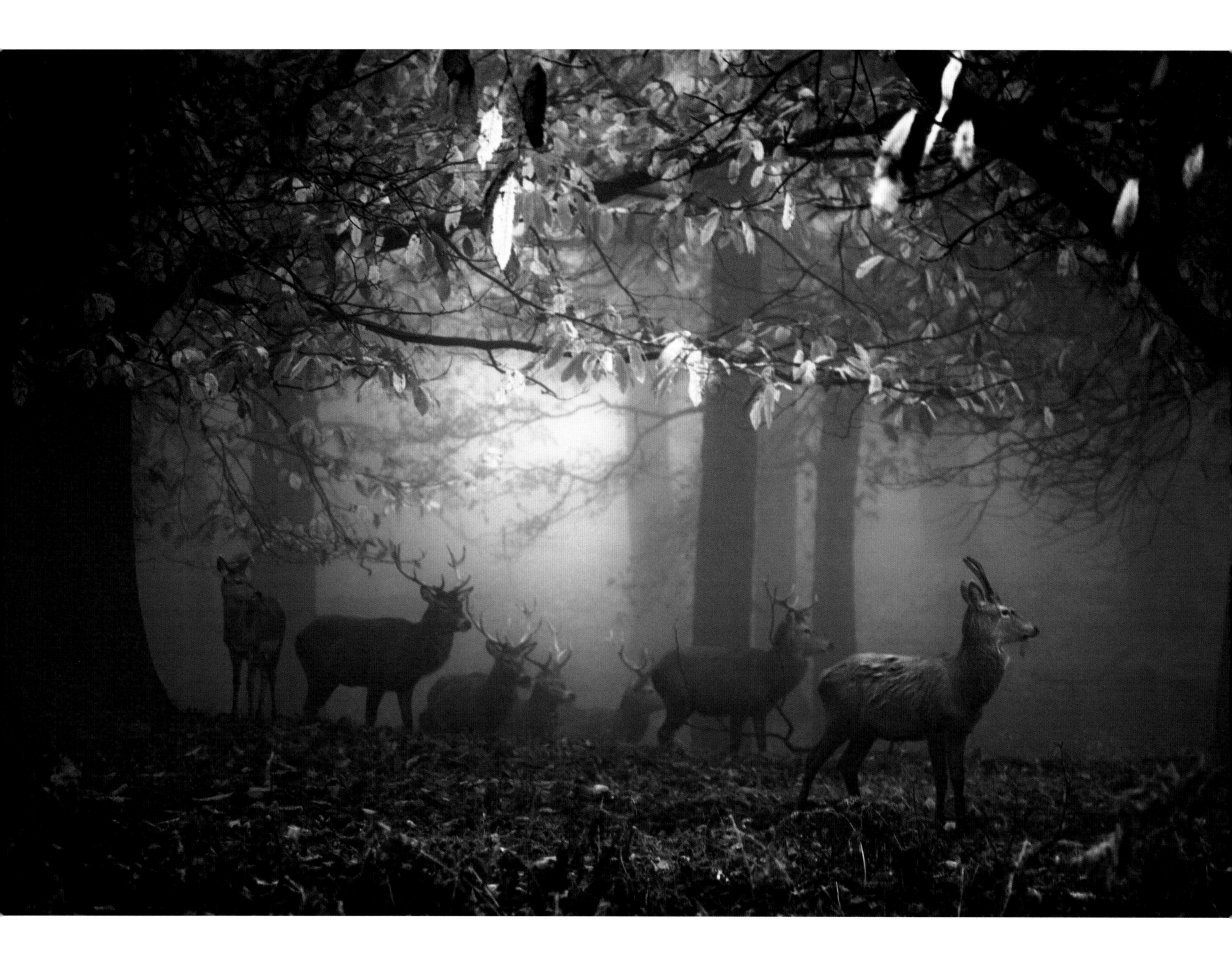

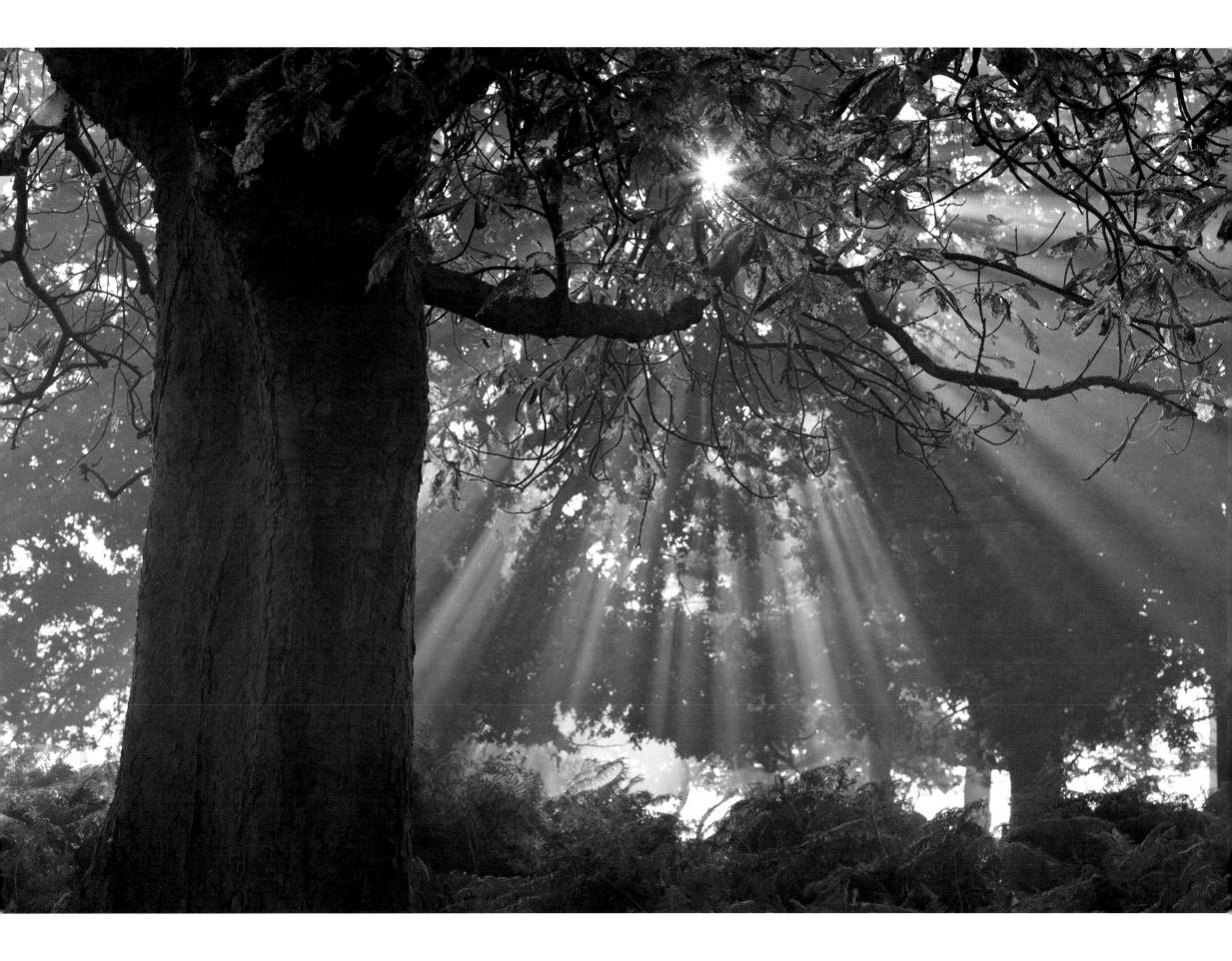

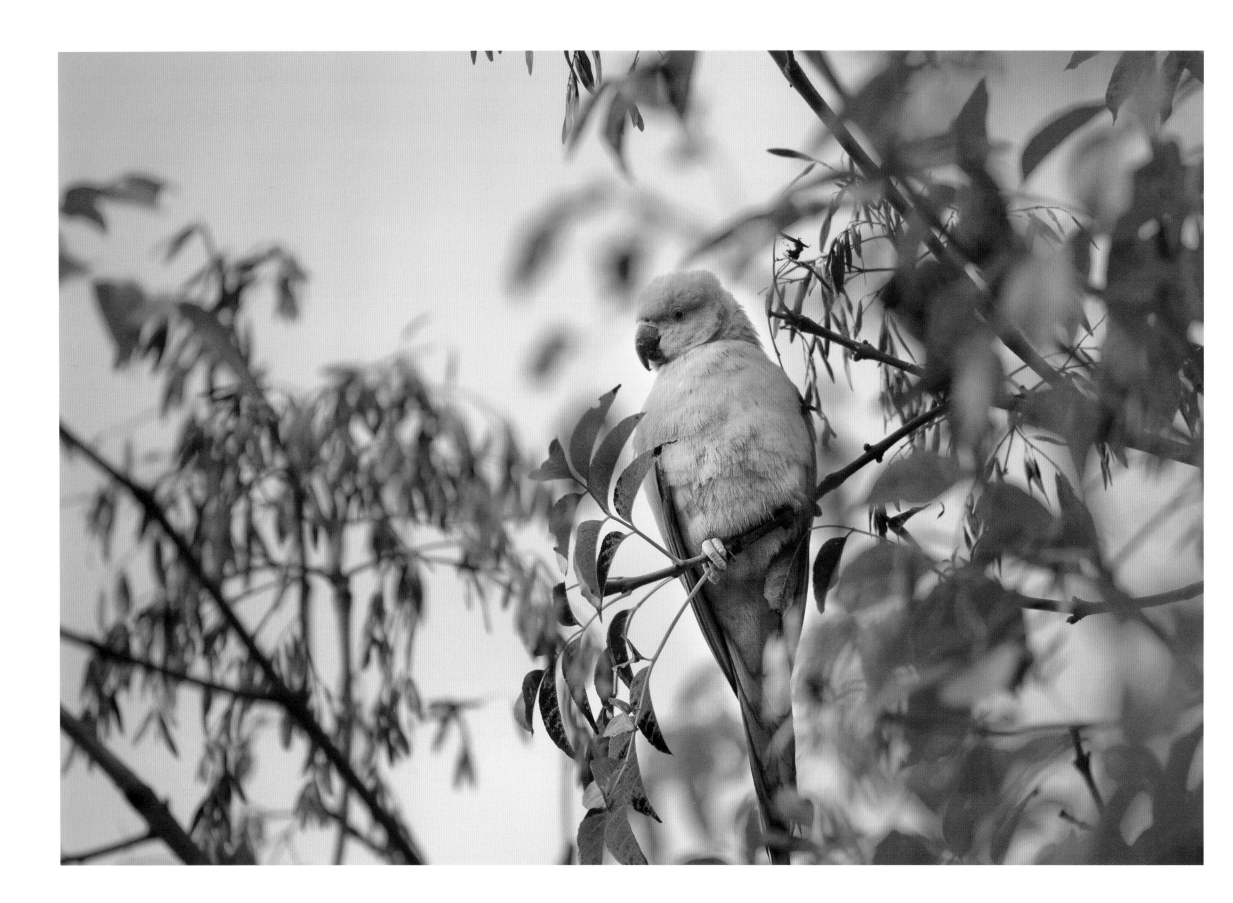

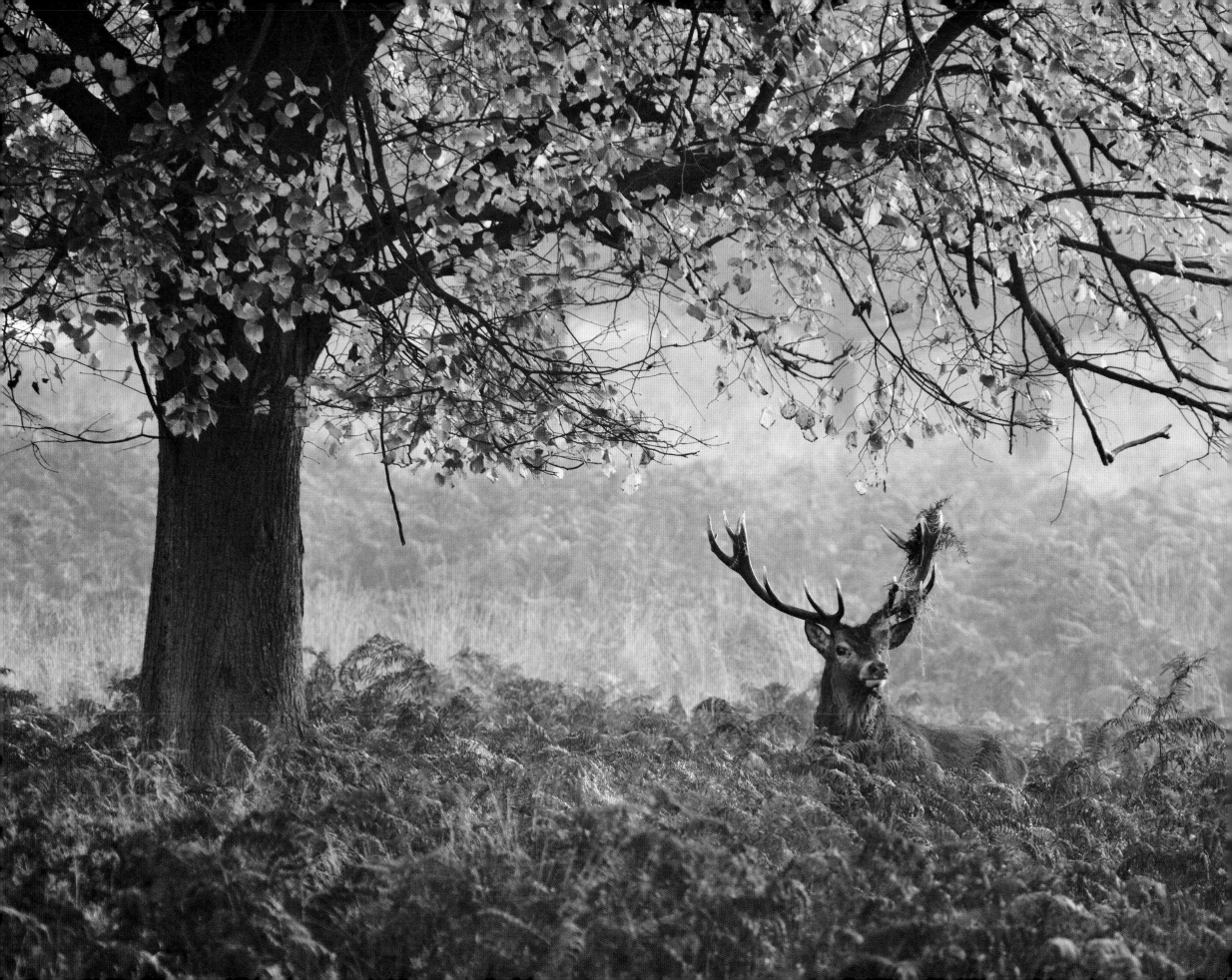

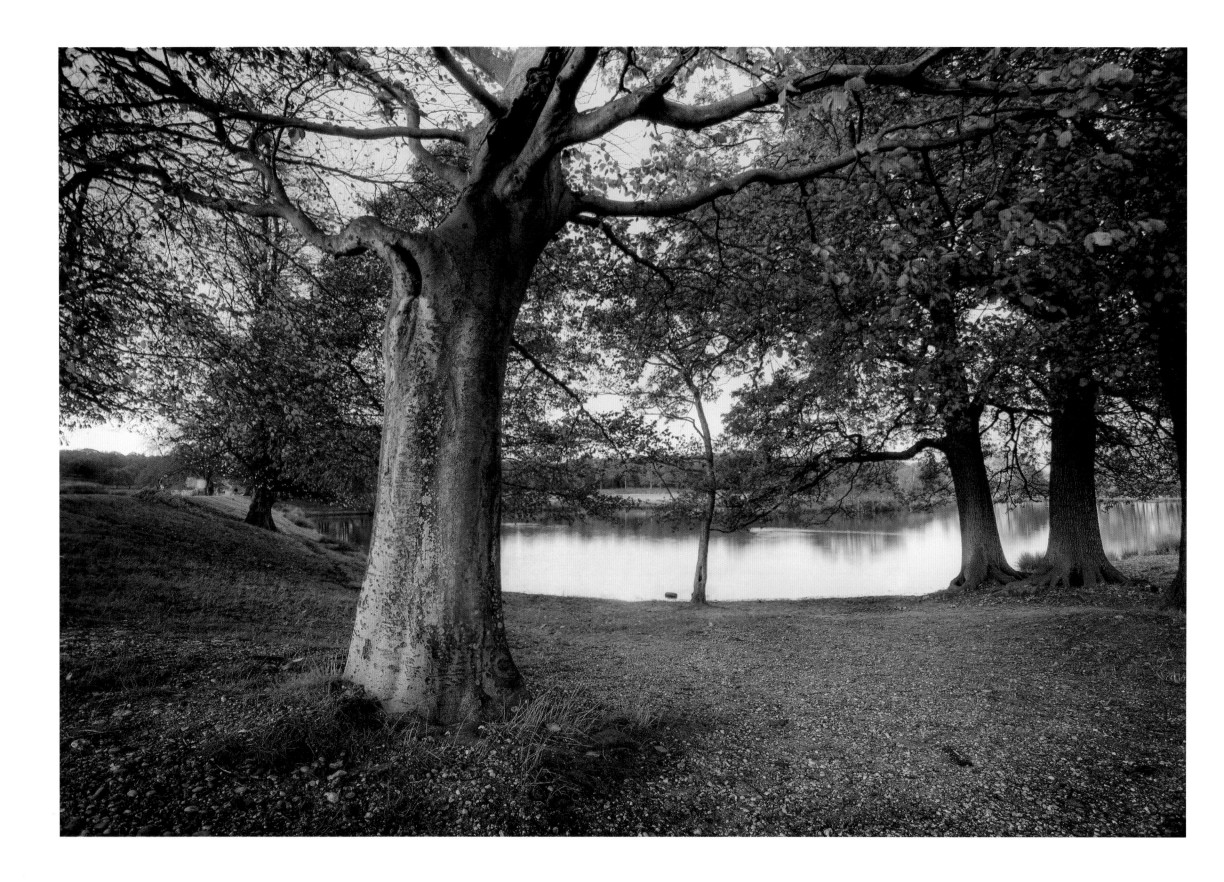

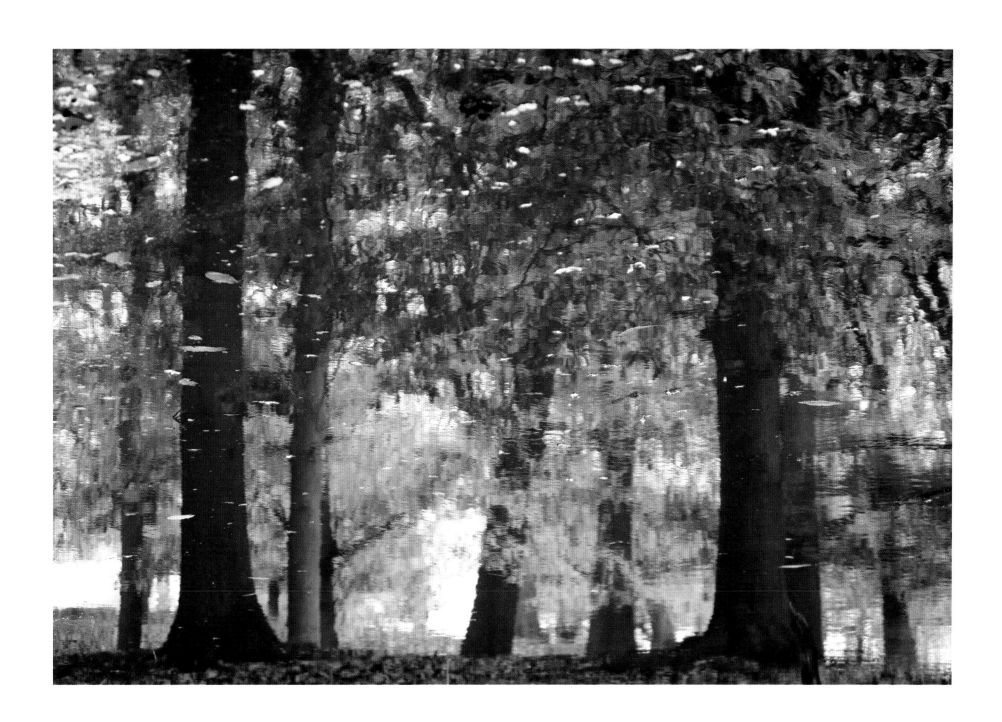

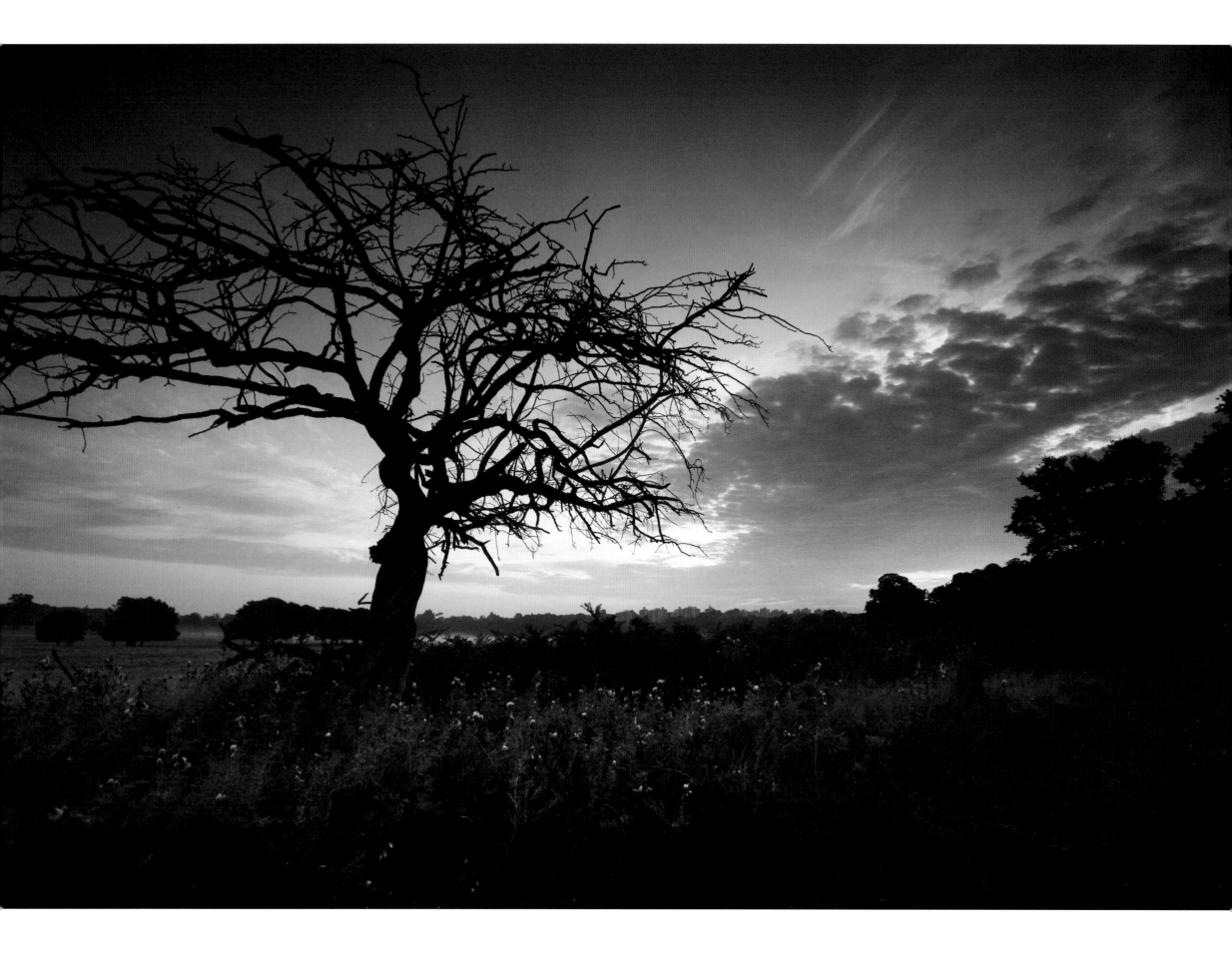

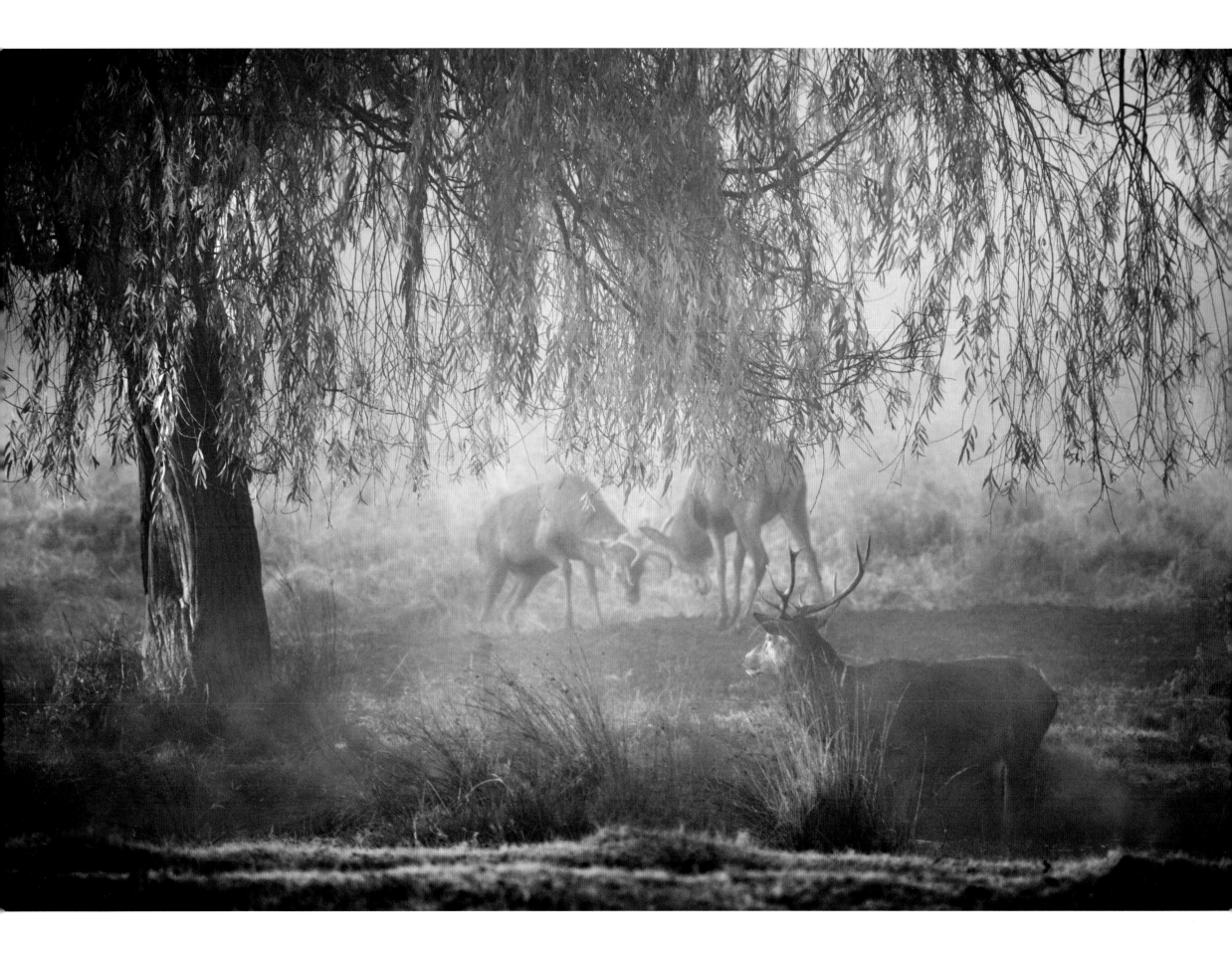

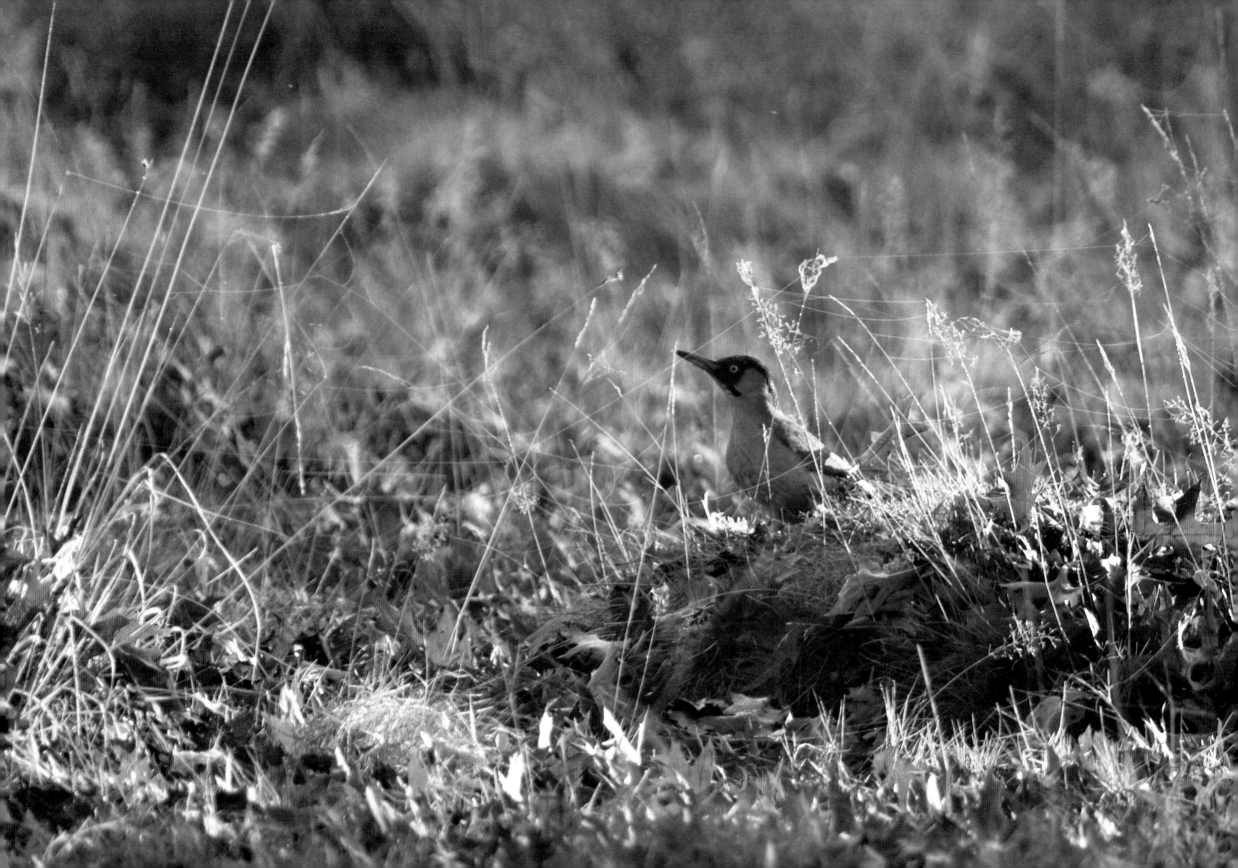

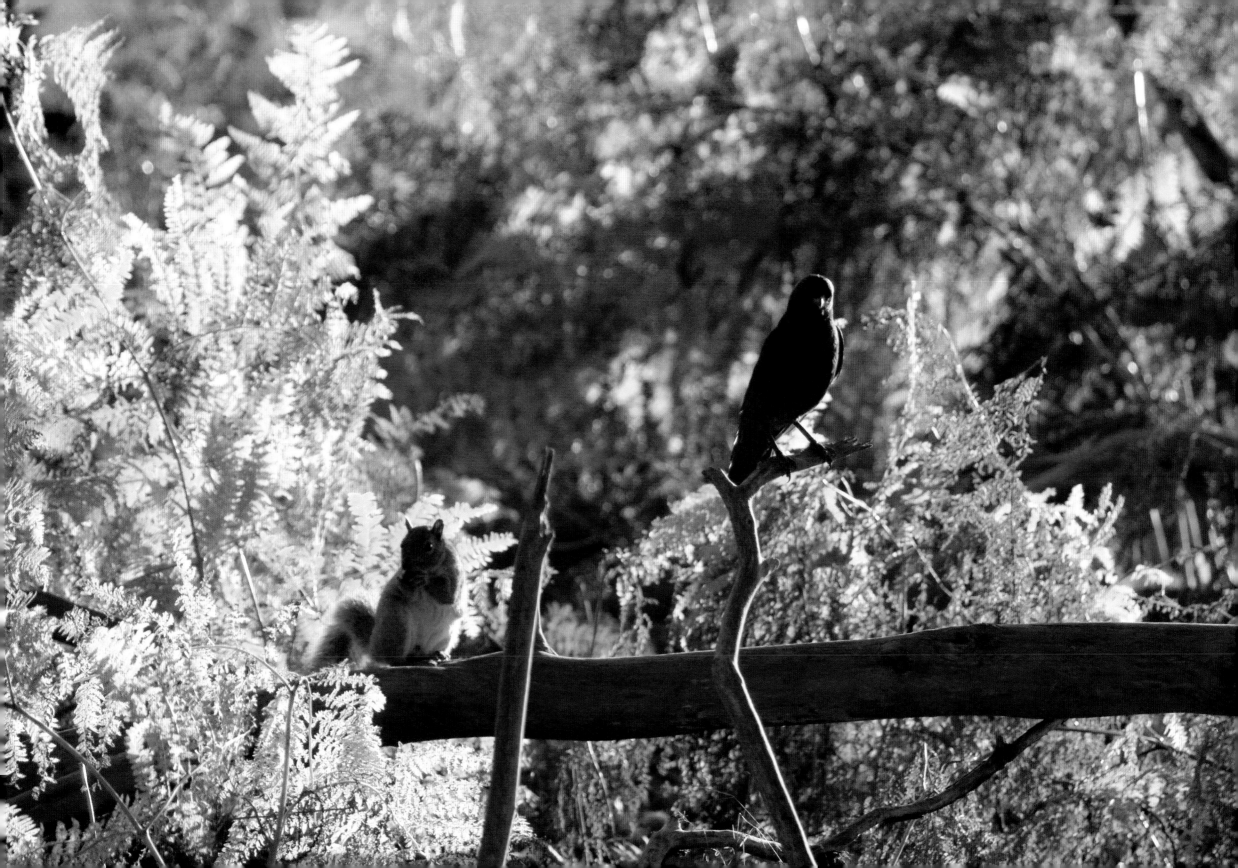

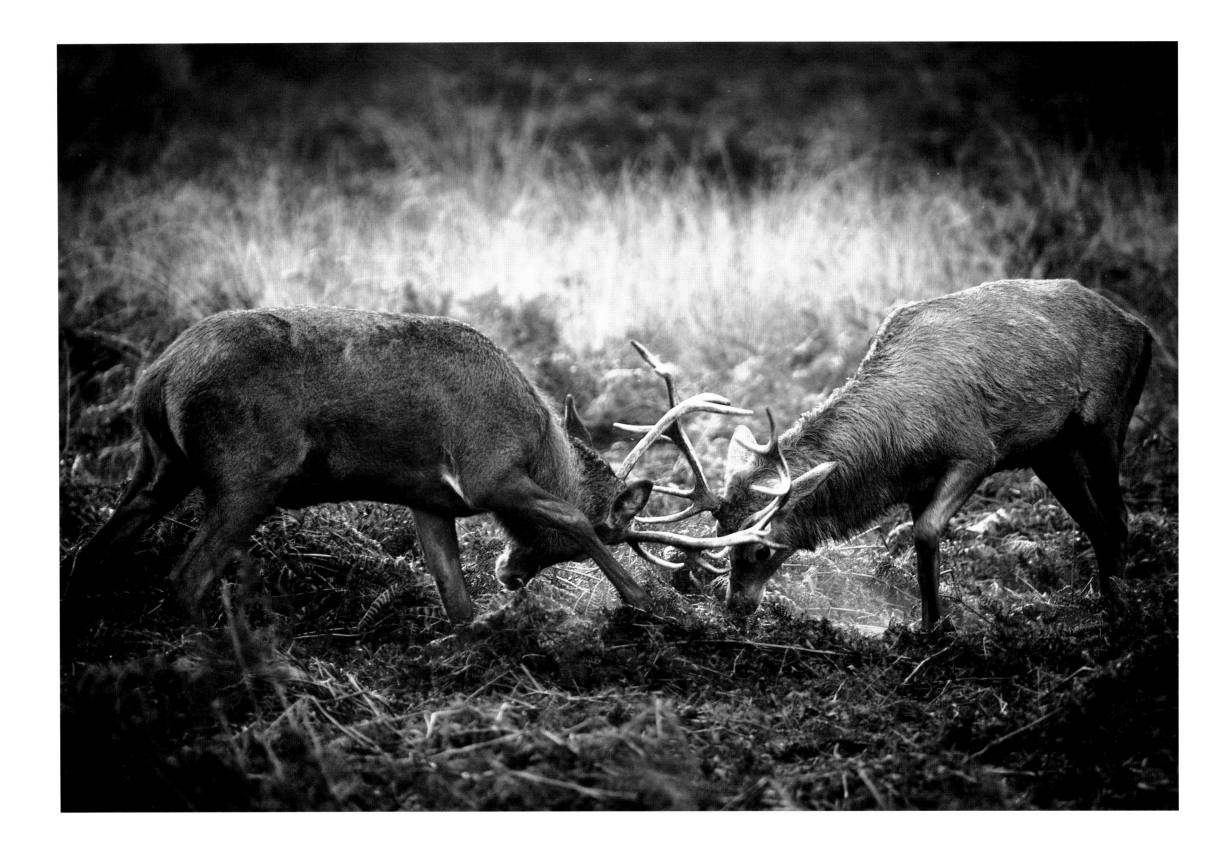

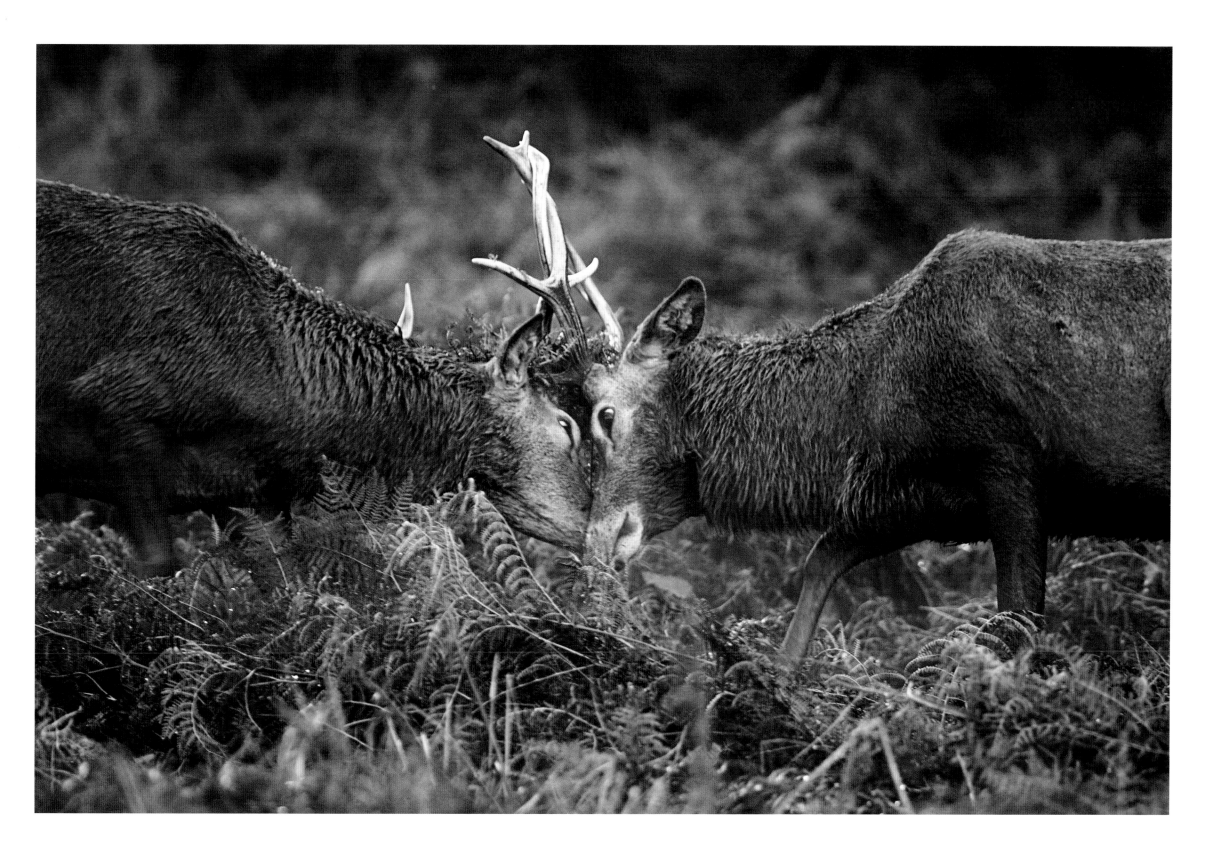

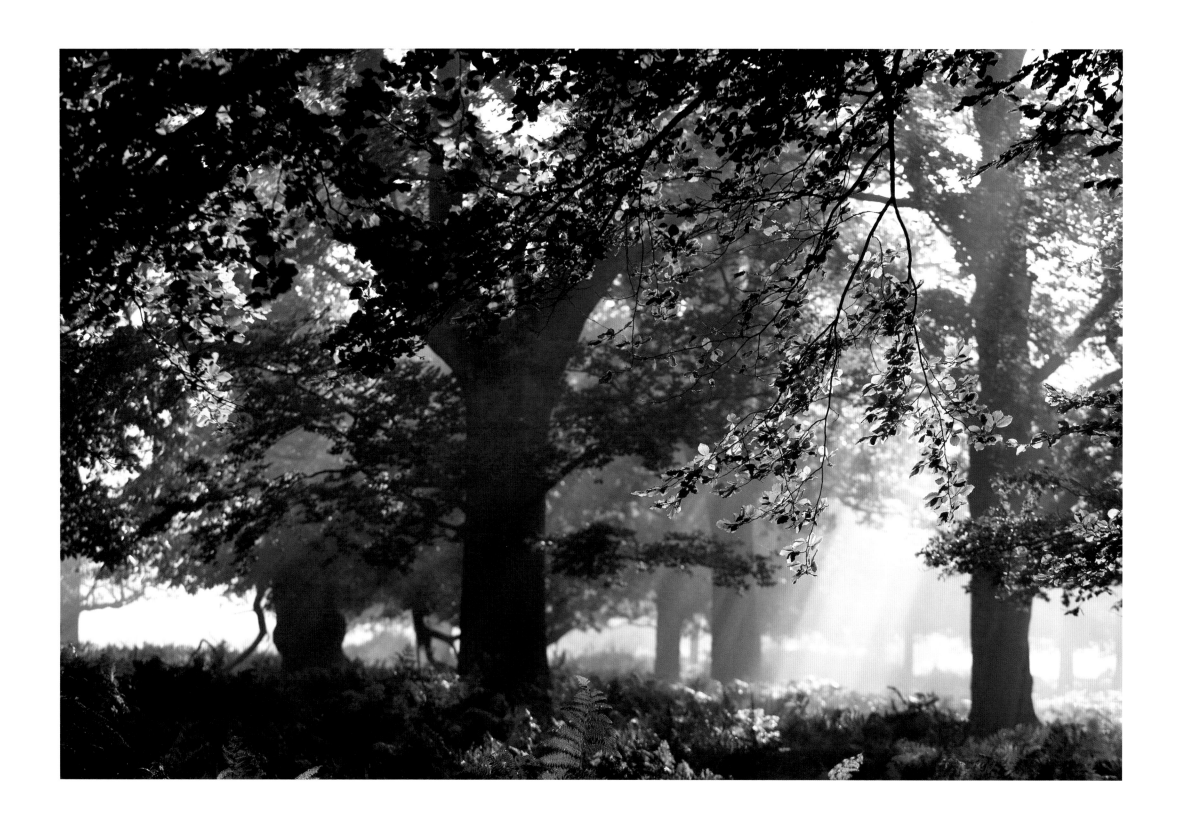

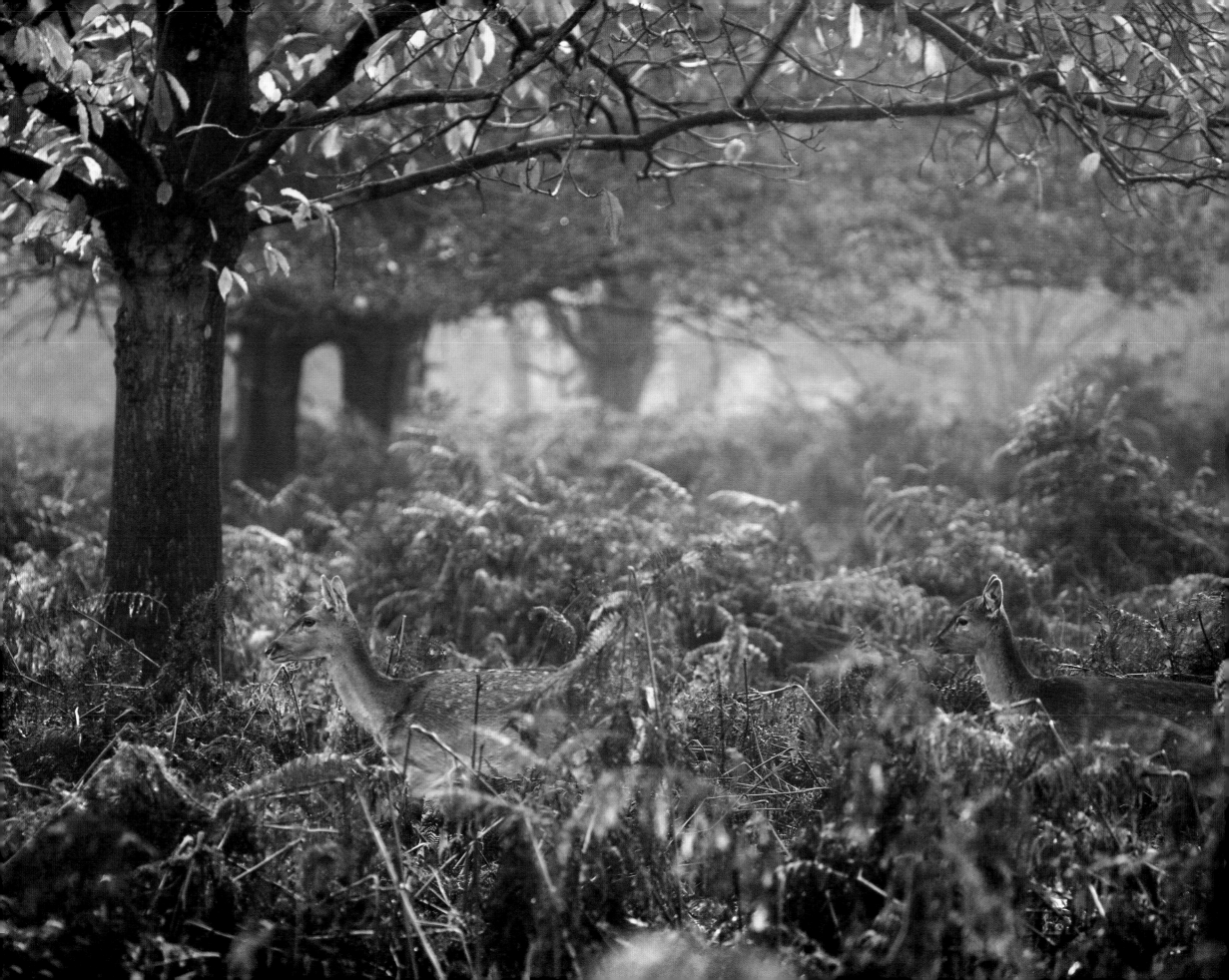

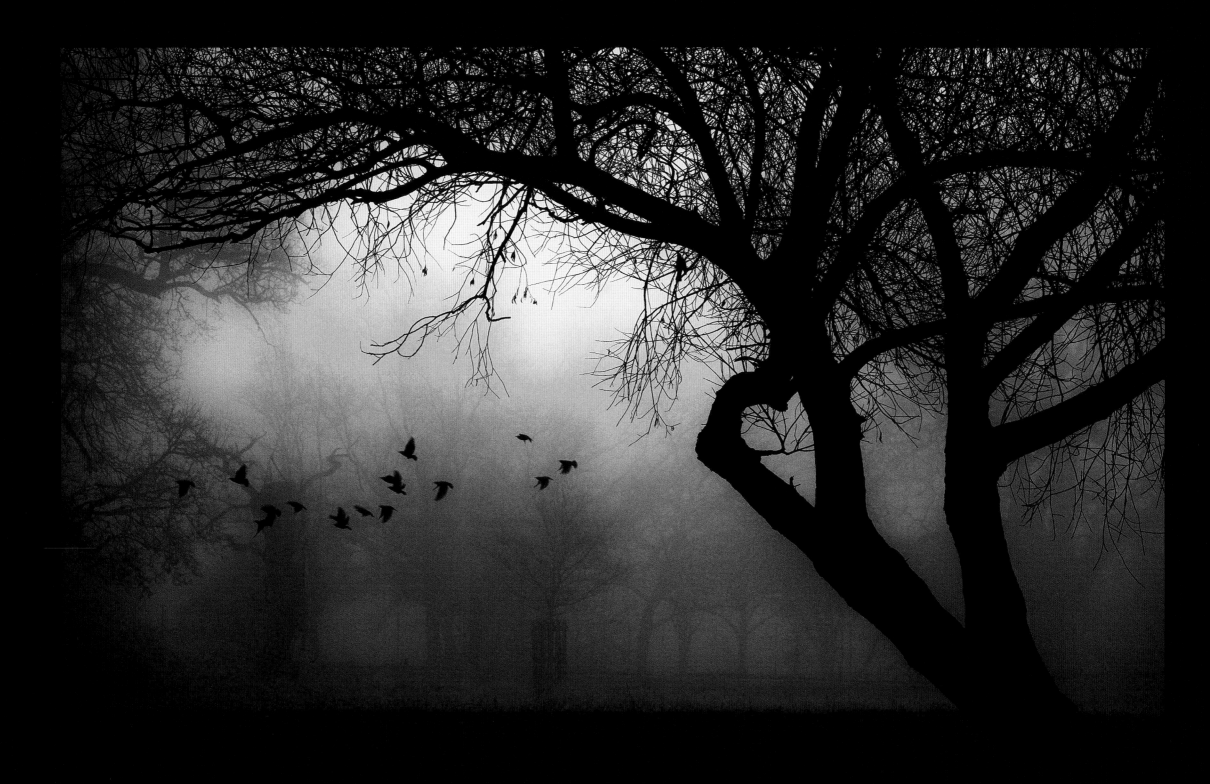

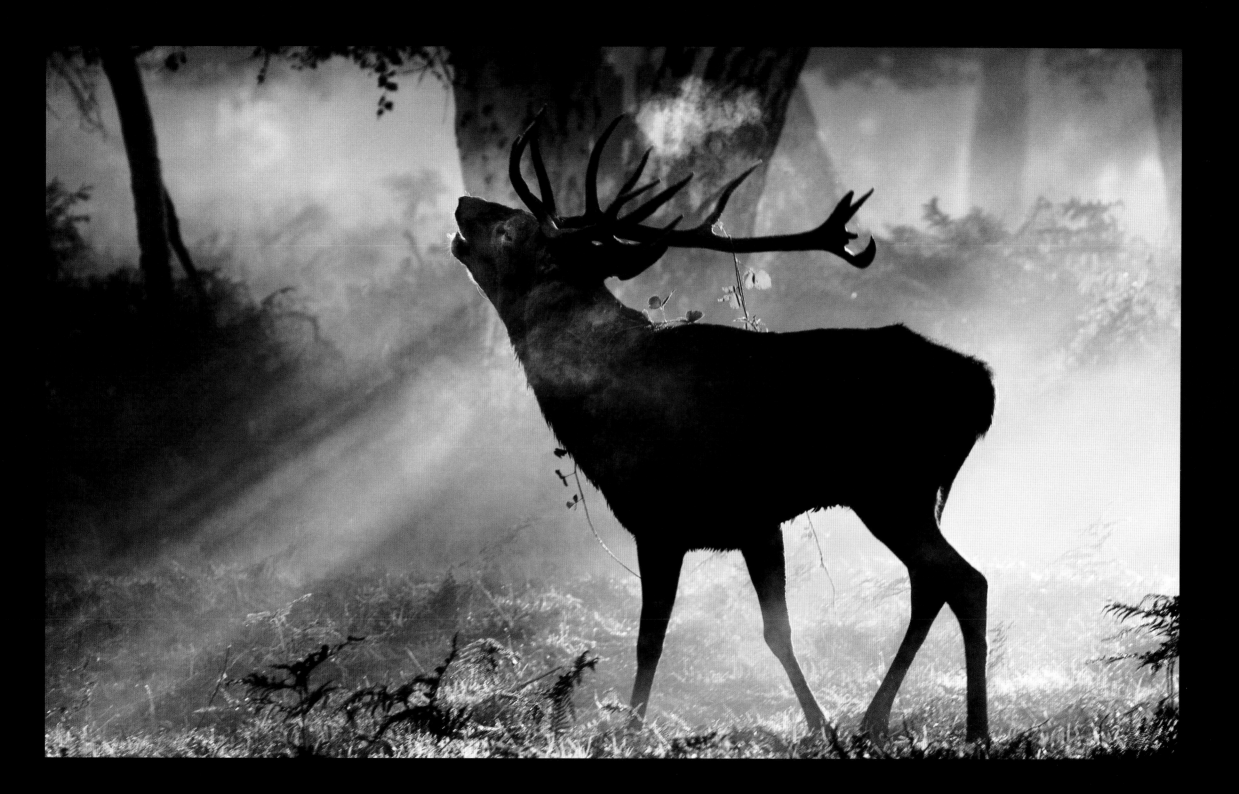

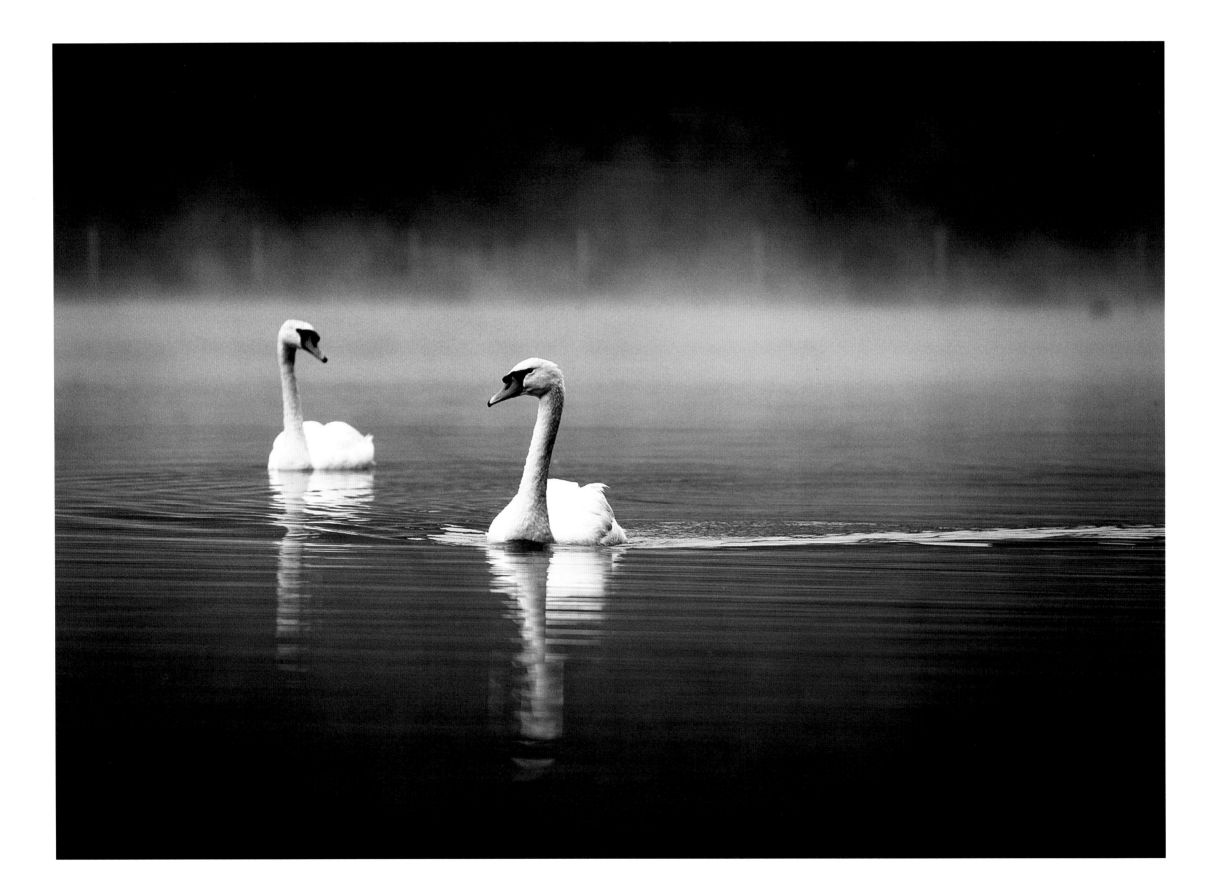

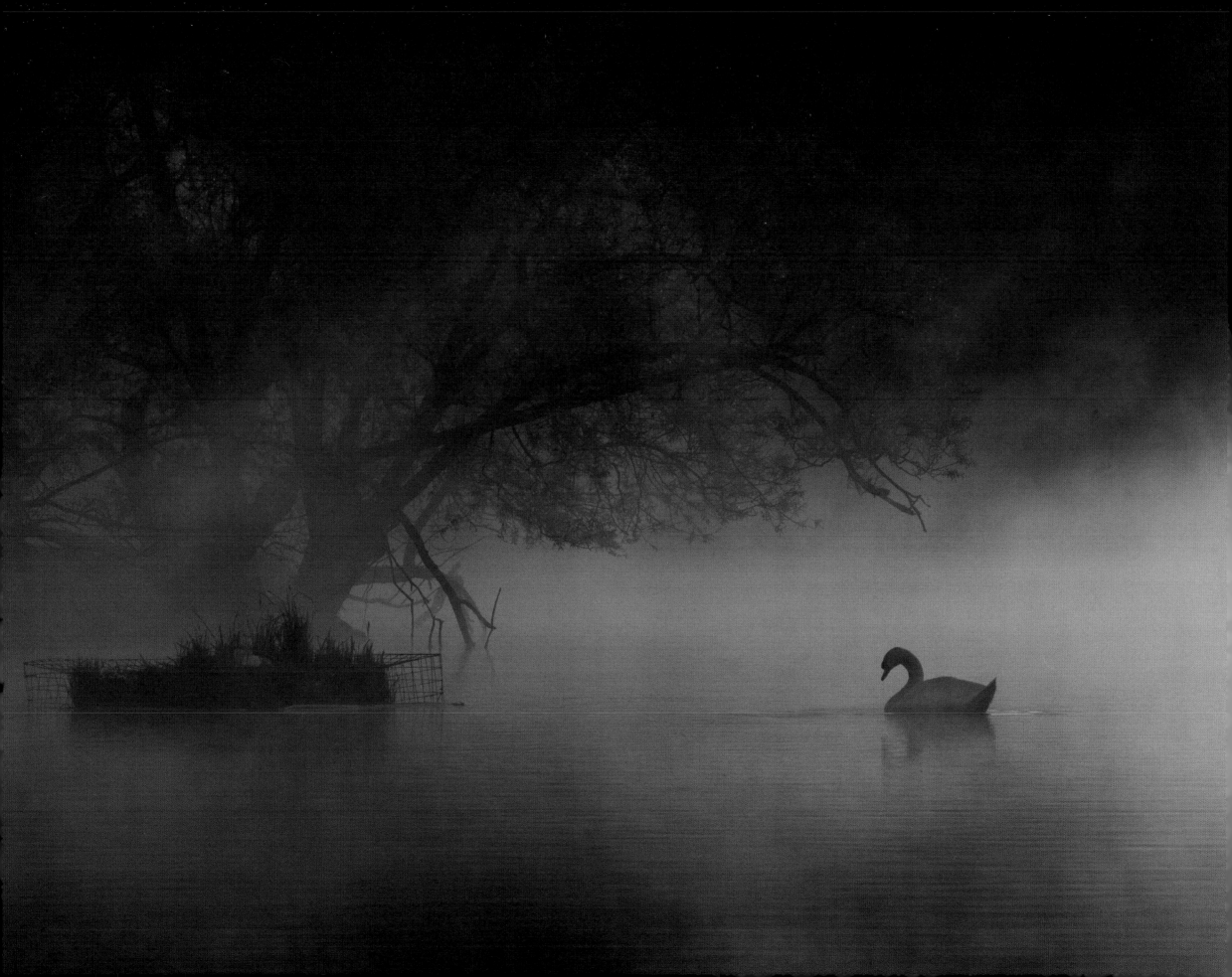

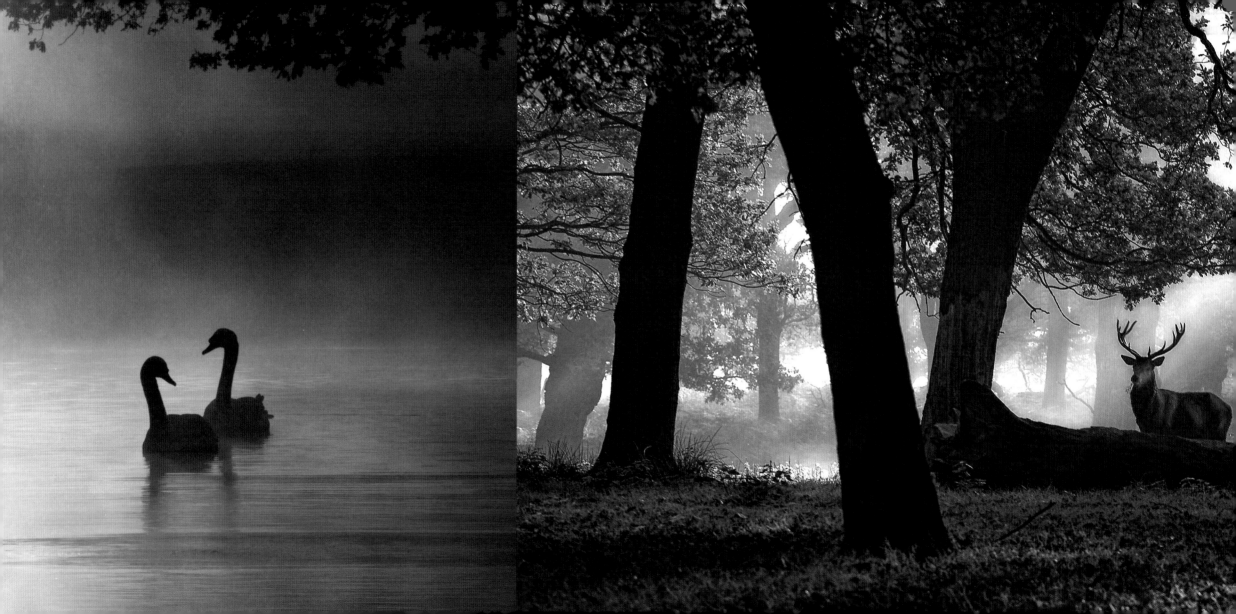

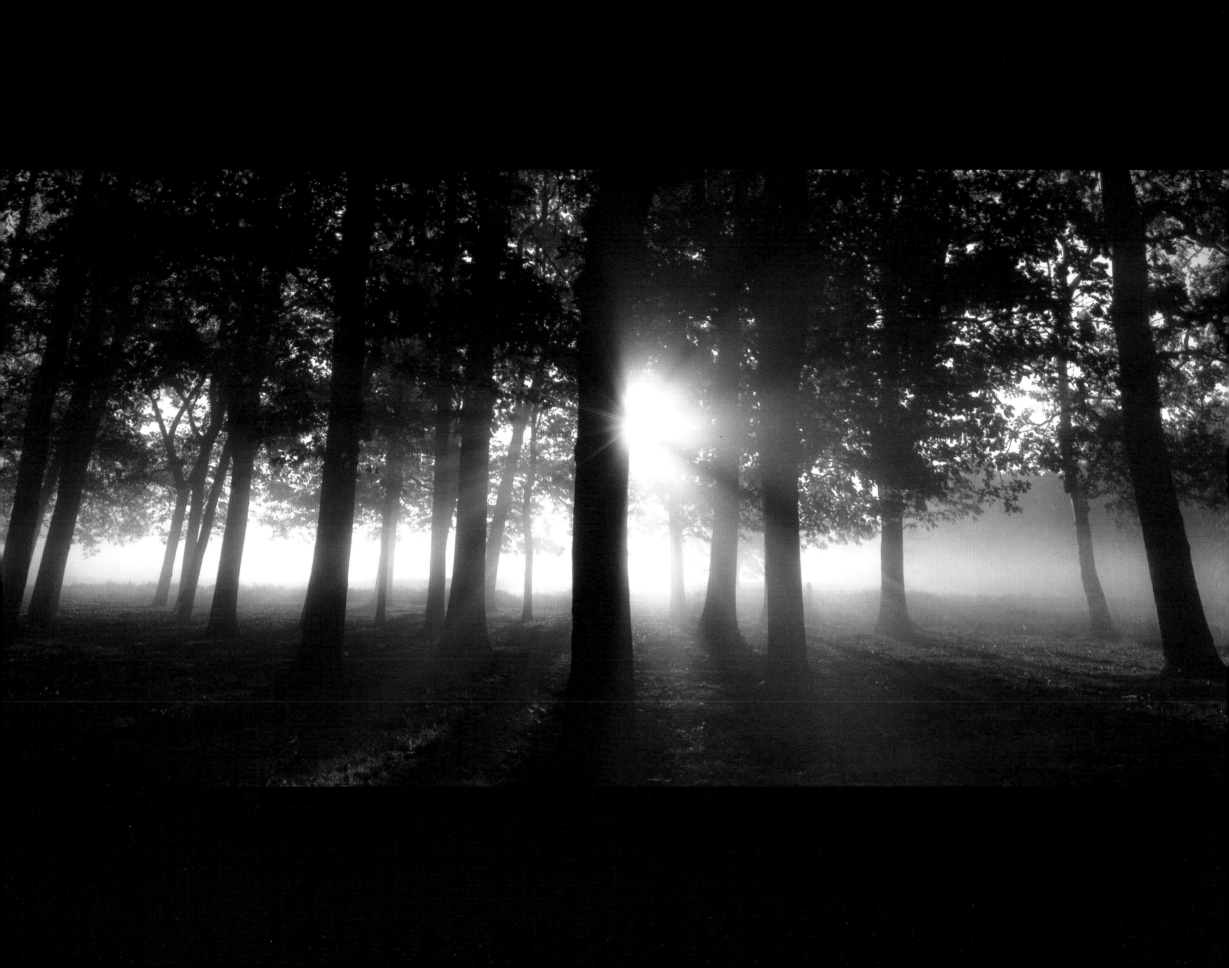

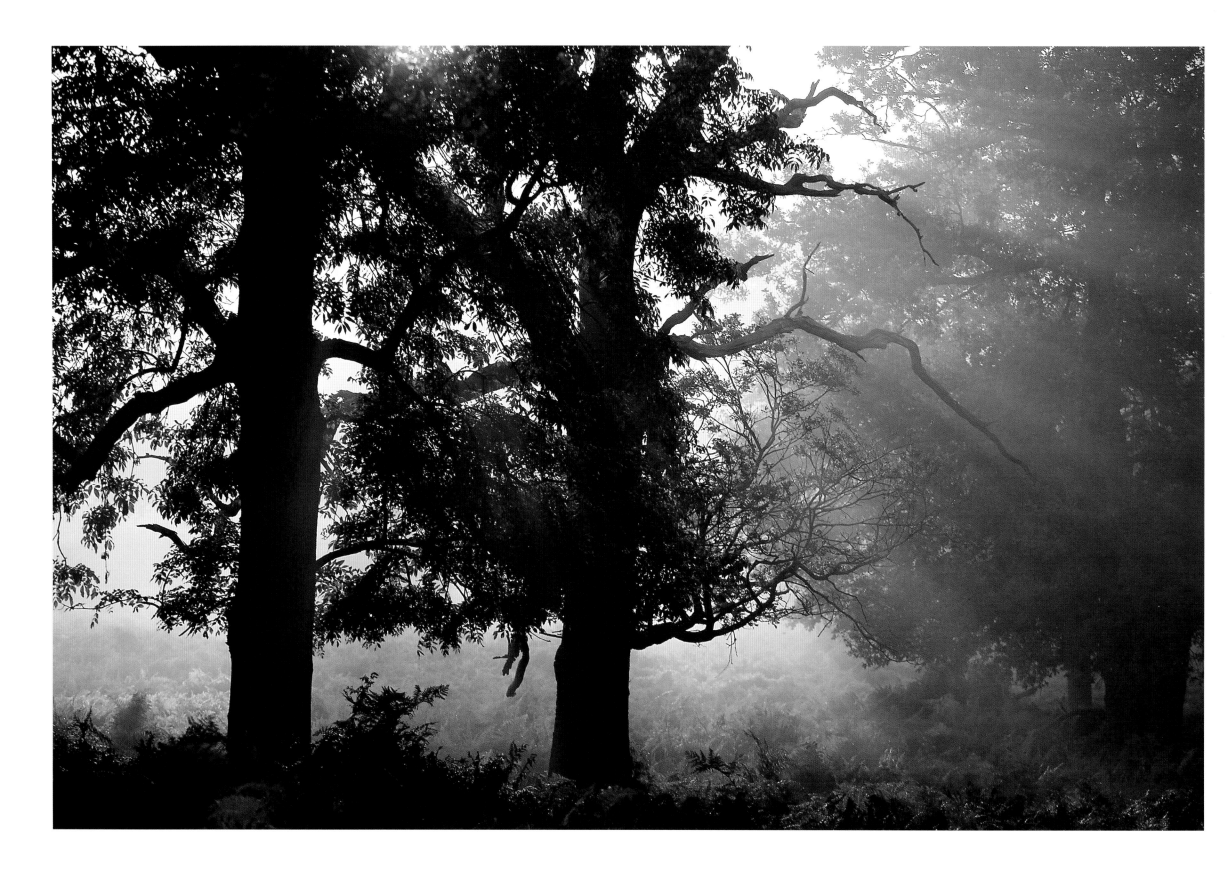

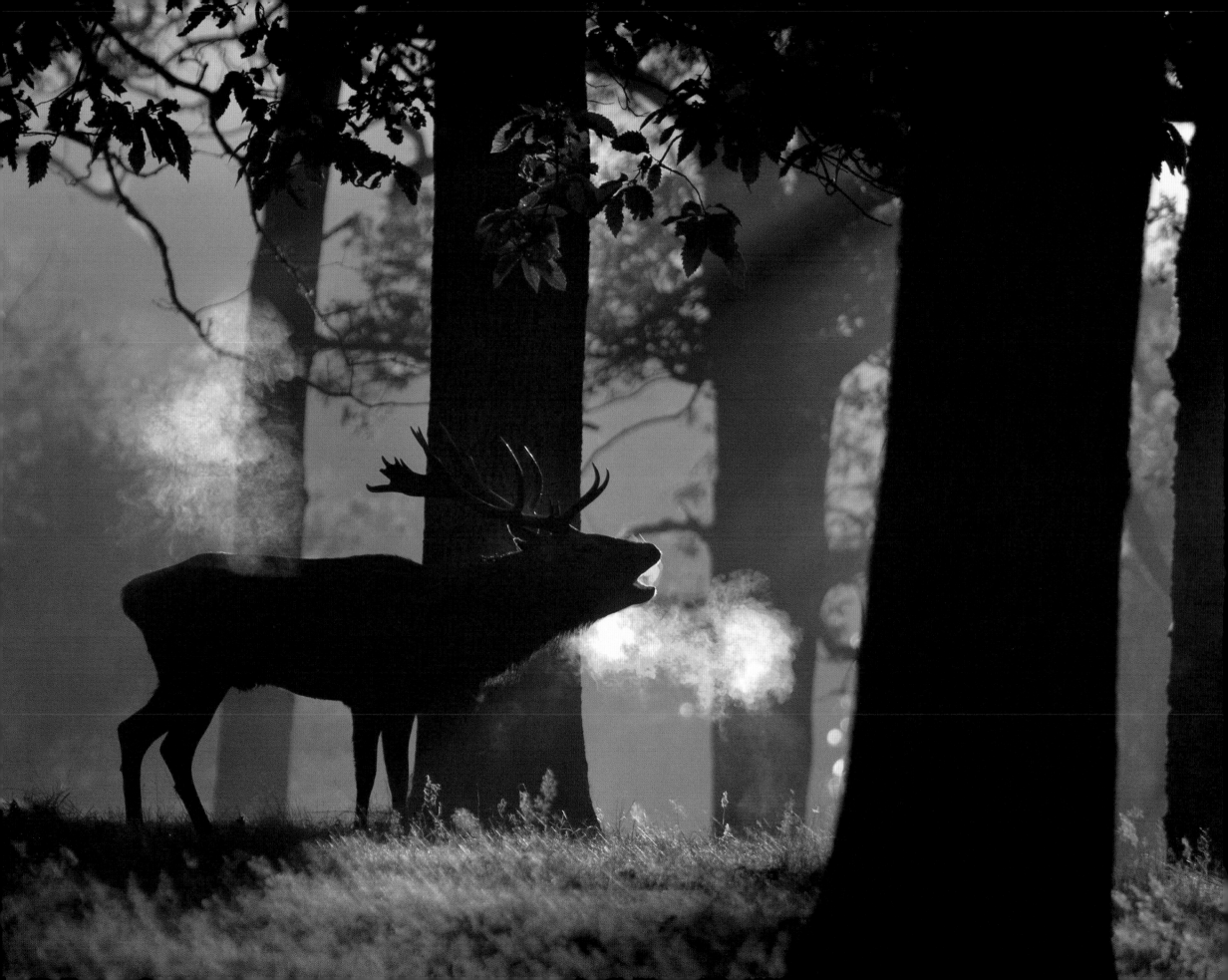

Winter

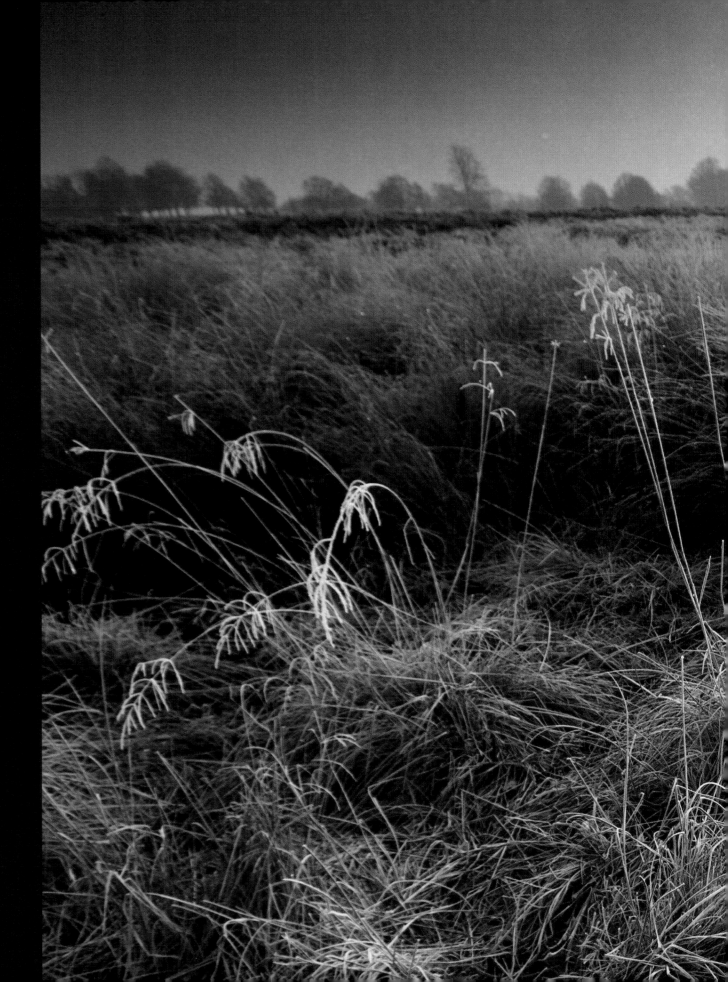

A time of dying, but it is a good death, with more than a hint of imminent re-birth. The trees are spindly and leafless, but catch them in the morning with frost decking their branches with strands of silver and they are gloriously transformed. When temperatures plunge there is a different kind of enchantment: the skies are a more intense shade of blue; the ground has a stunning cyan tinge; the mists are thicker and more forbidding; bracken fronds lie around like rusty corpses; and when the snow falls, white magic casts its spell everywhere.

With branches bare, birds are easier to spot now: robins with breast feathers looking a more vibrant shade of red; a fluffy little owl silhouetted against the night sky; parakeets a bizarre tropical contrast to the cold and damp. When the winds whistle across the grassland, deer huddle together like best friends lost in the wild; though a leopard might not lose his spots, as the year ebbs away, a fallow deer does. And when temperatures fall further and ponds freeze over, it is time for ducks, geese and swans to put on their ice skates and show humans how it's done.

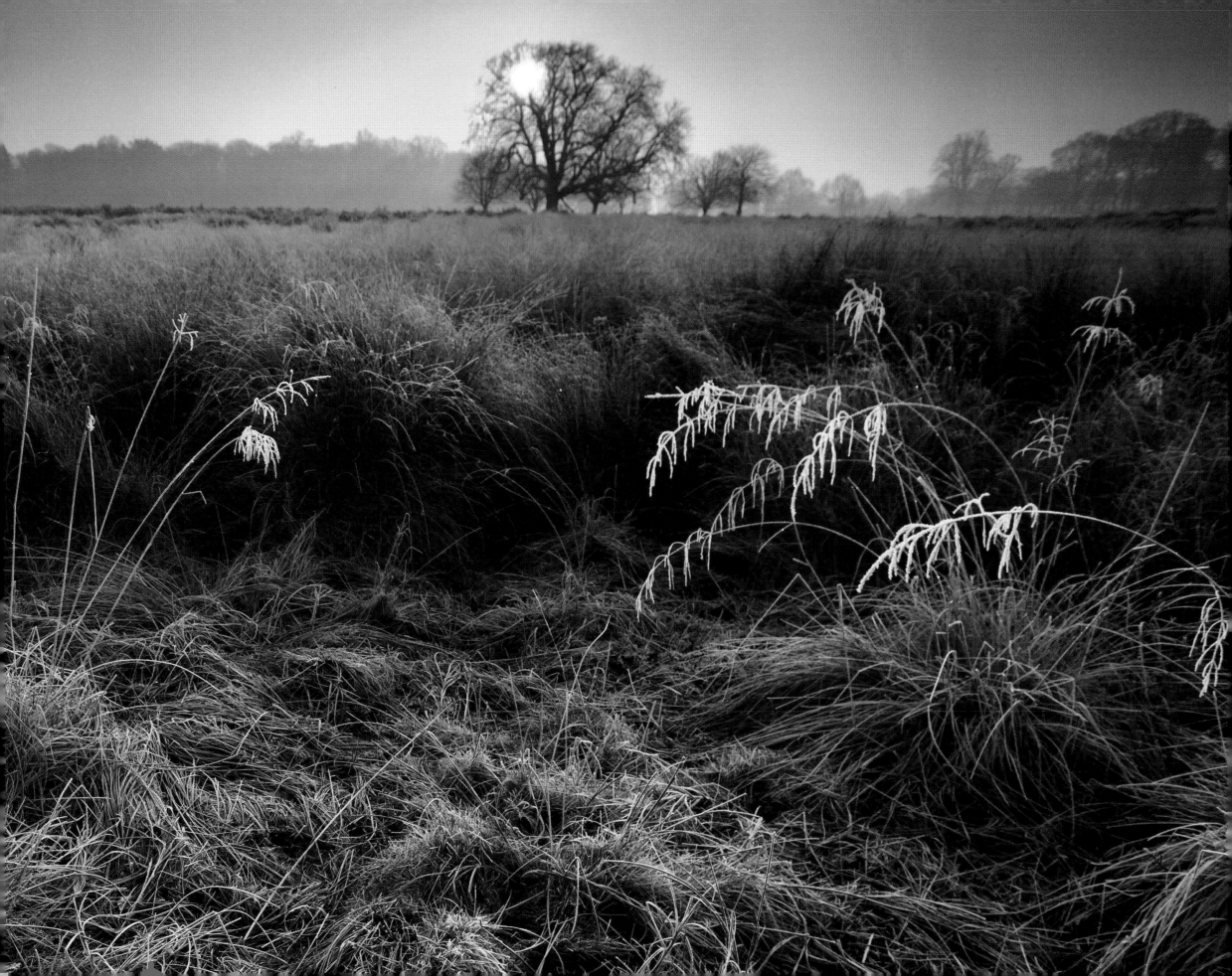

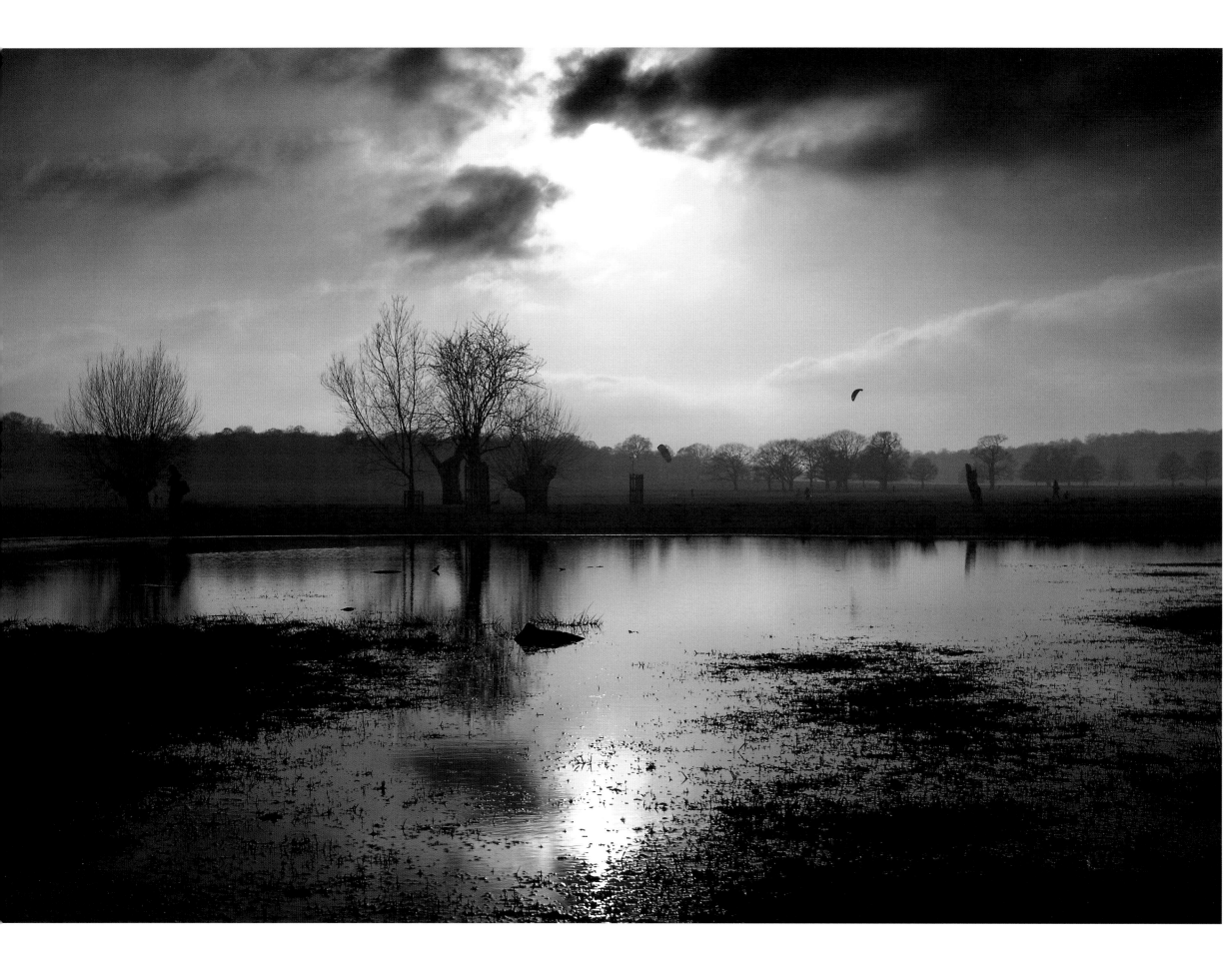

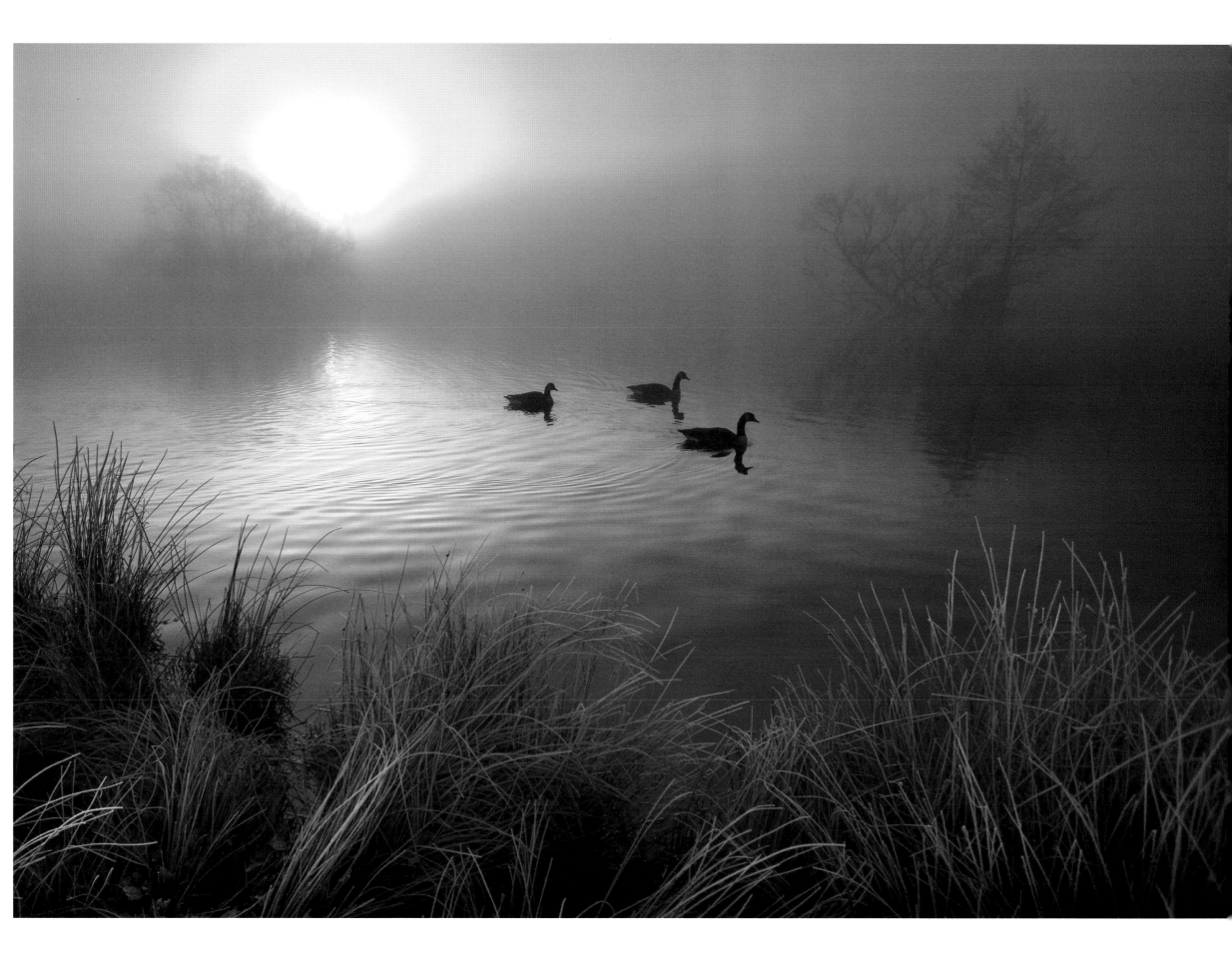

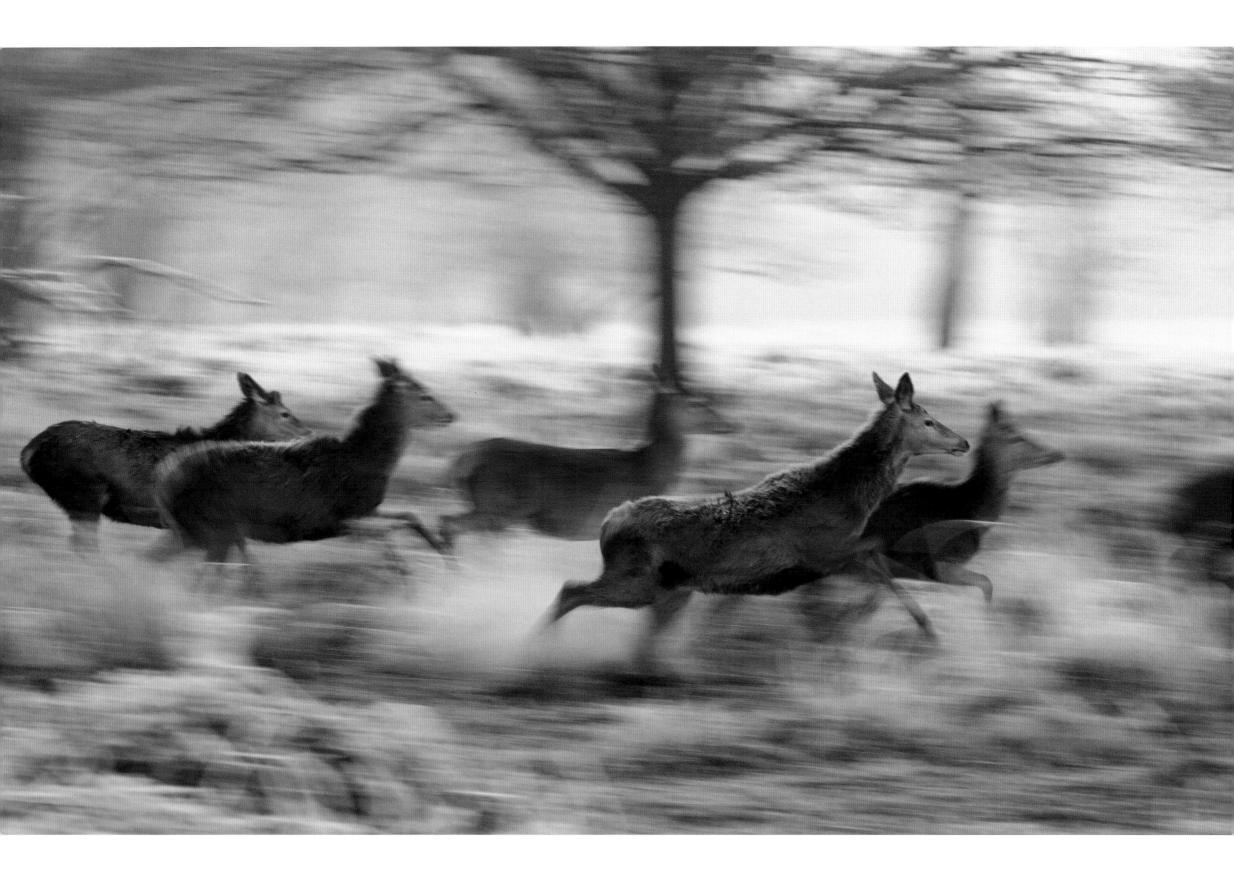

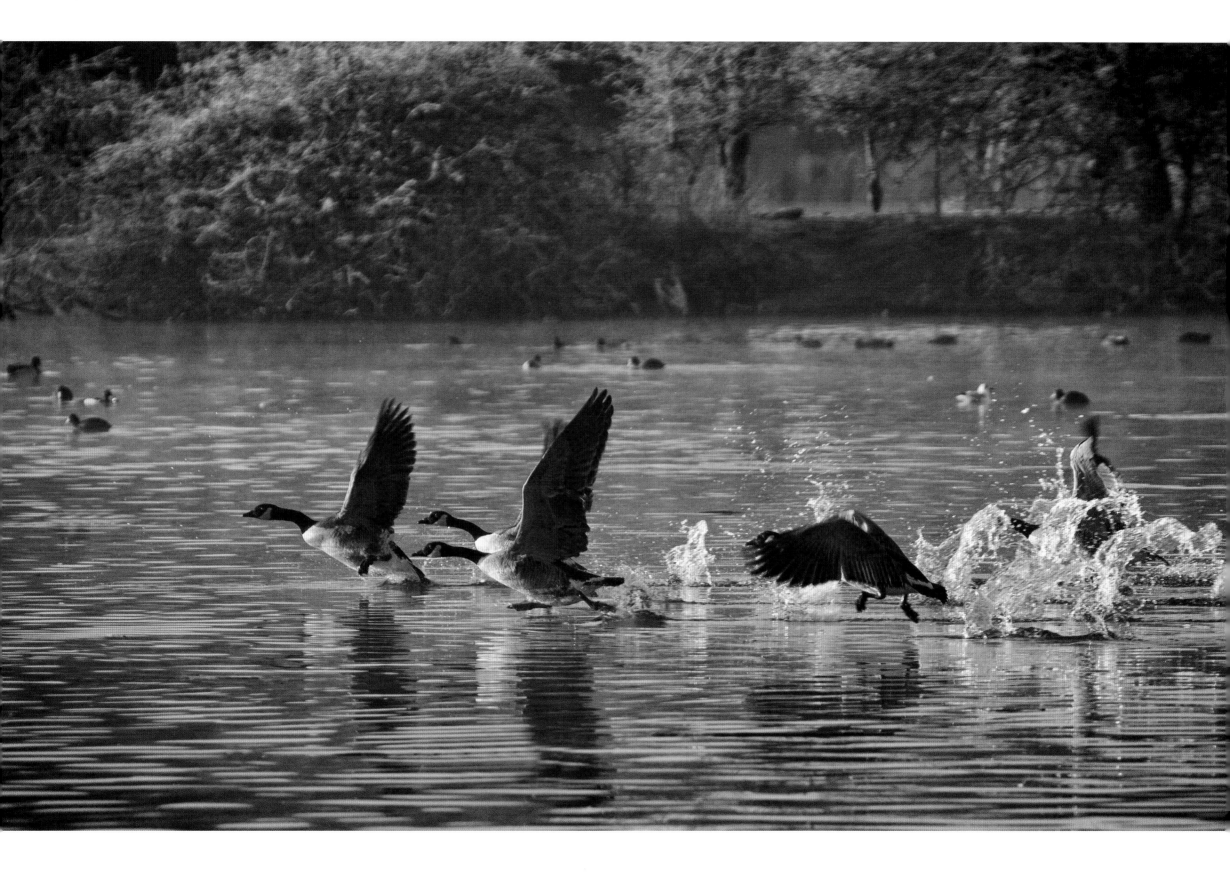

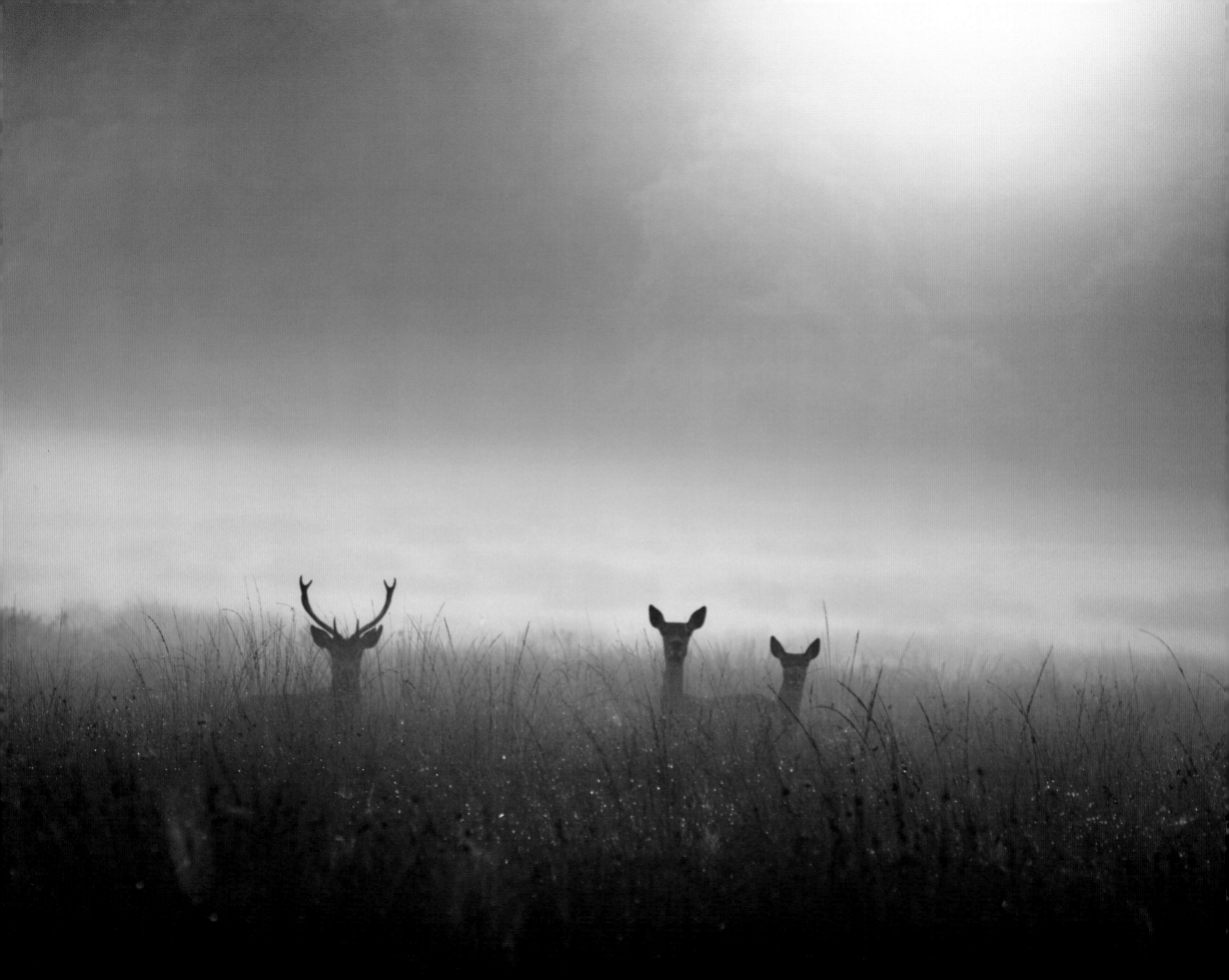

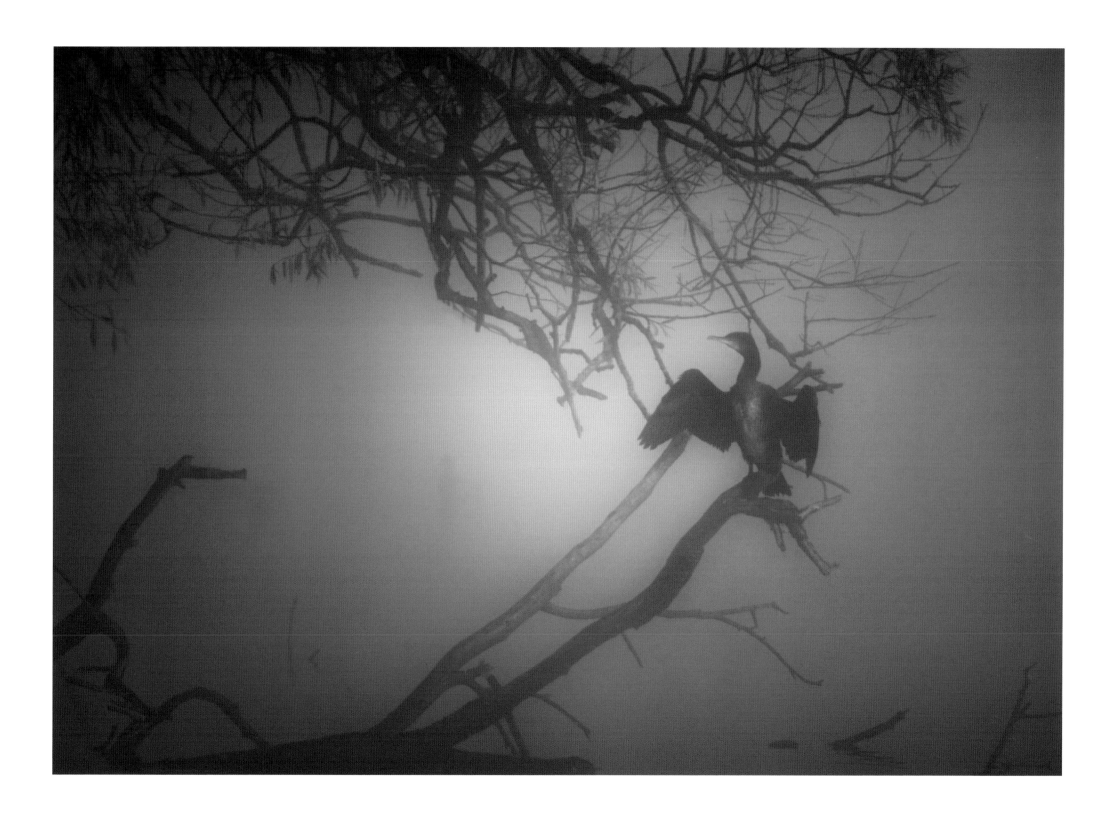

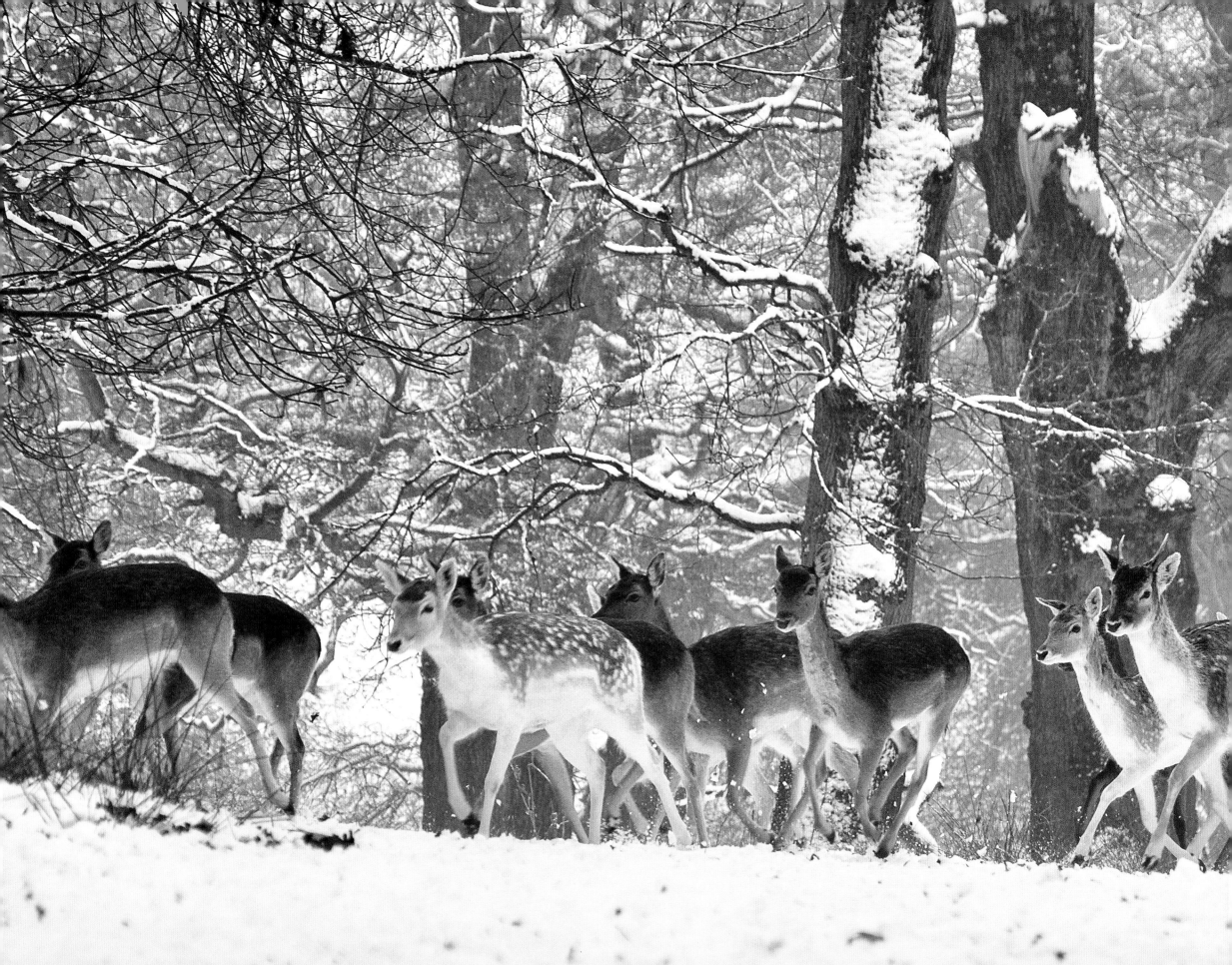

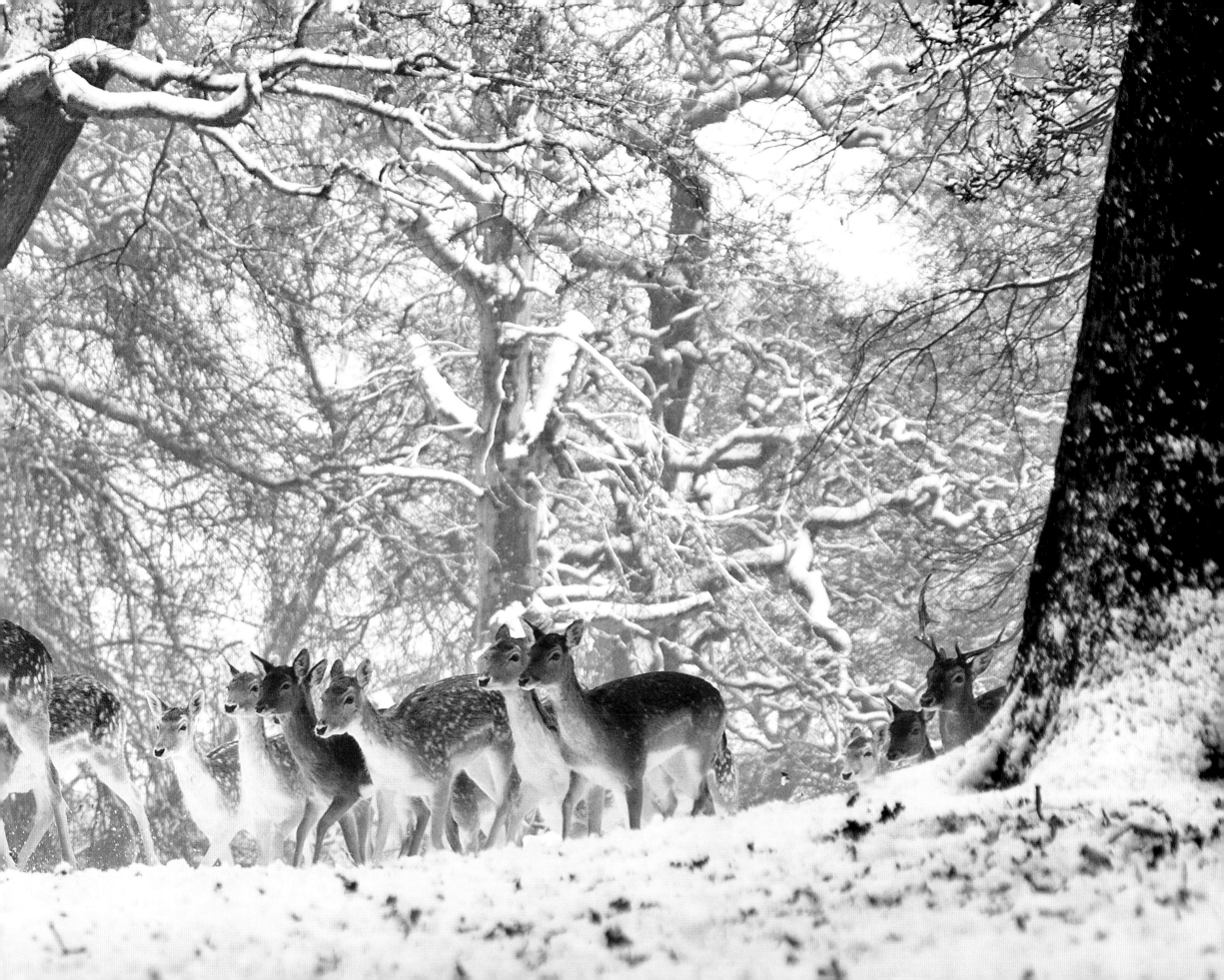

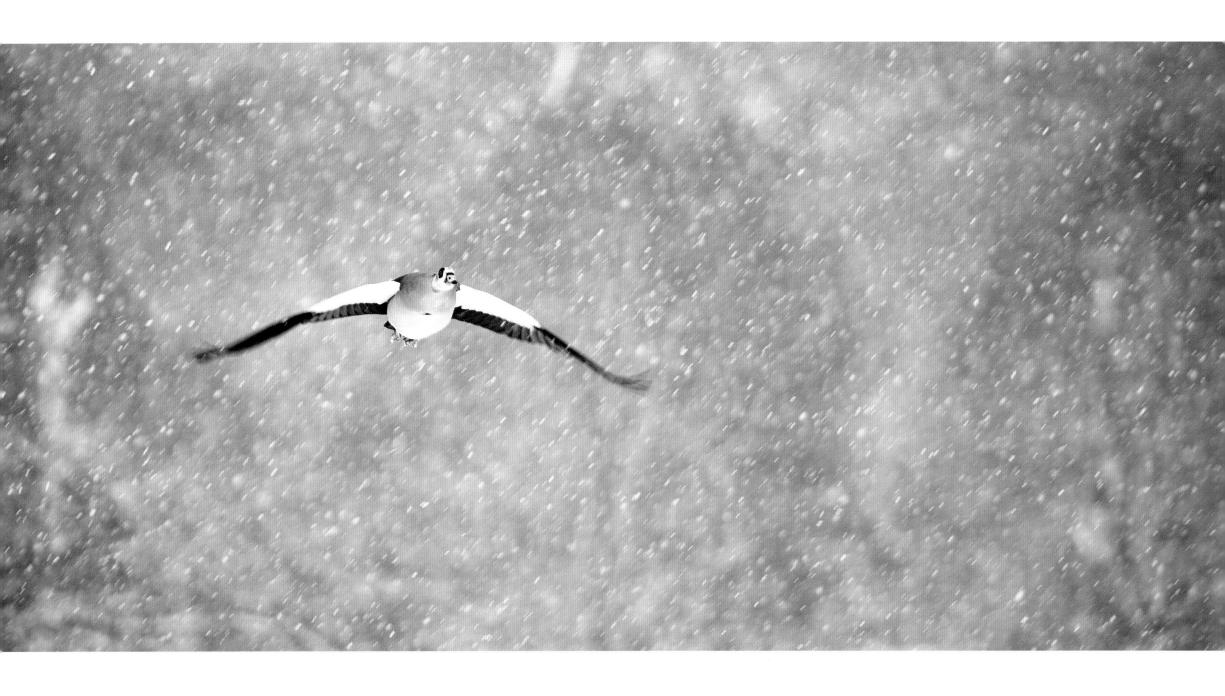

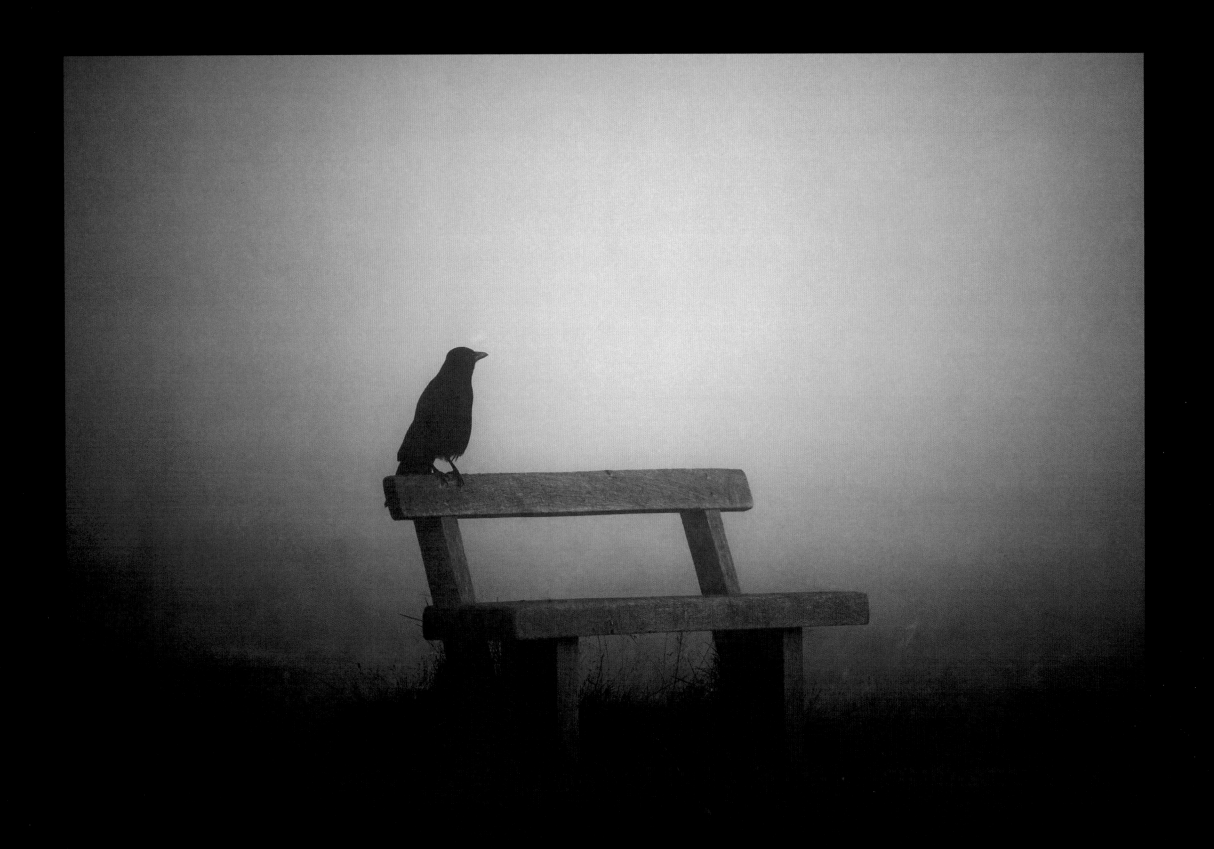

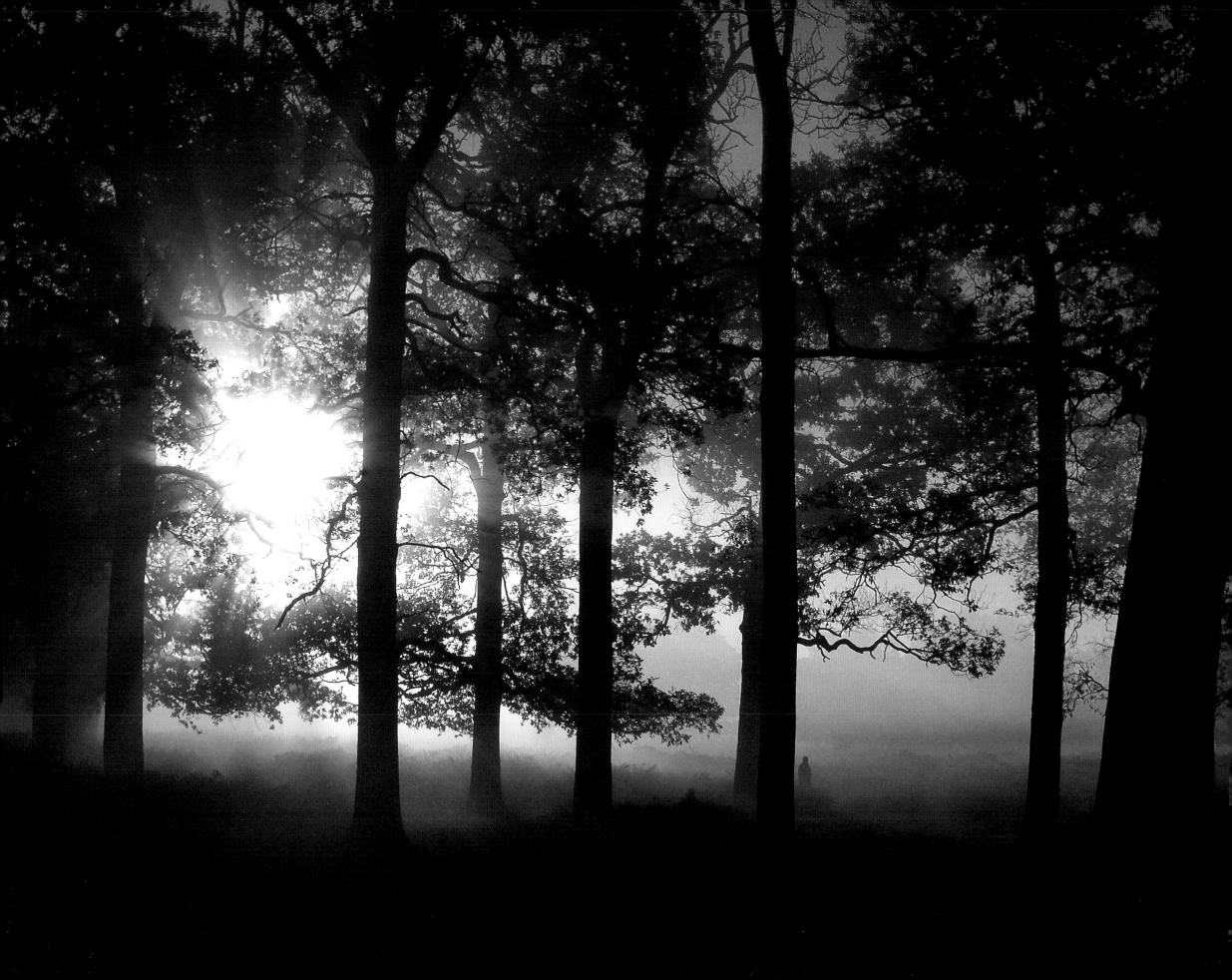

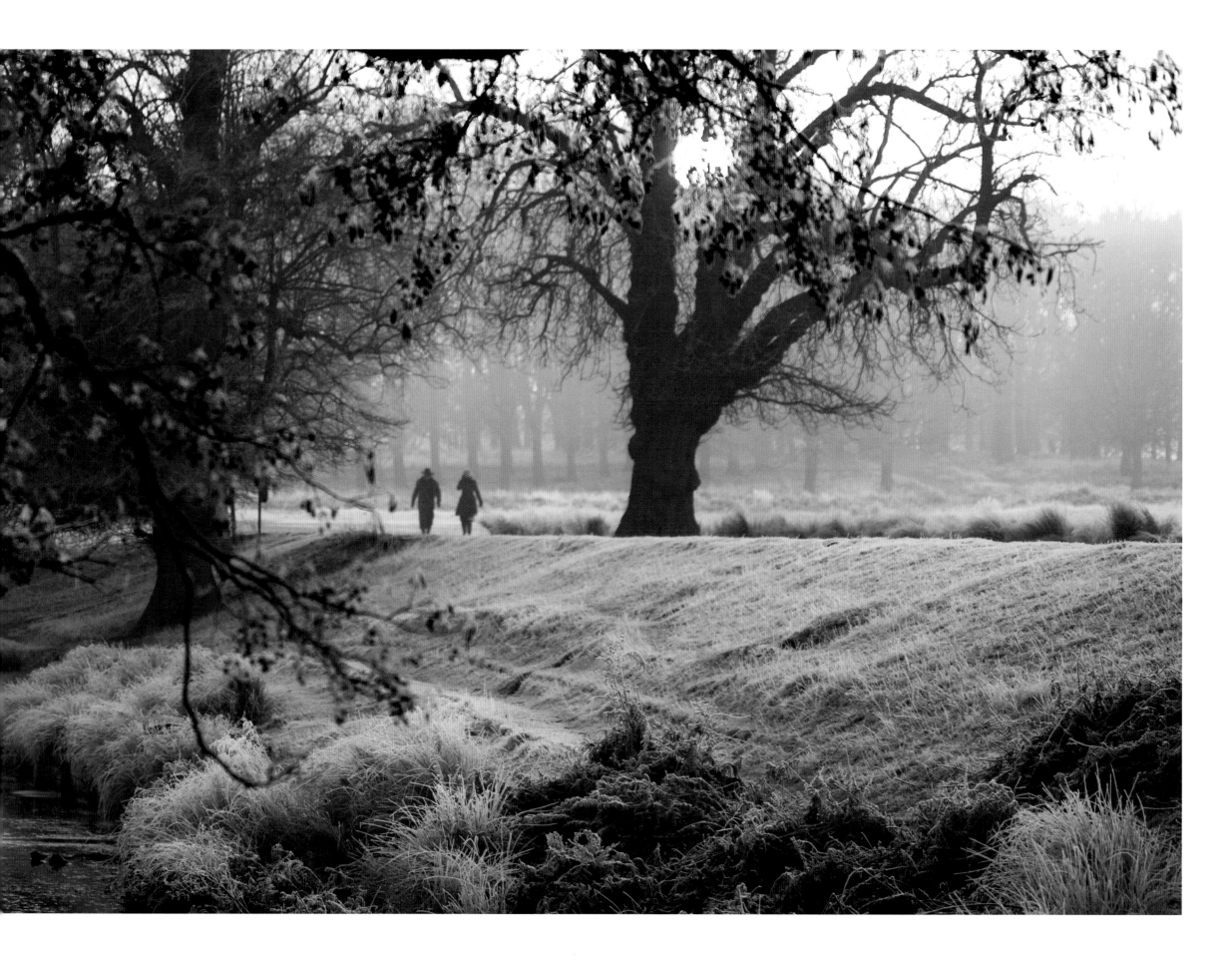

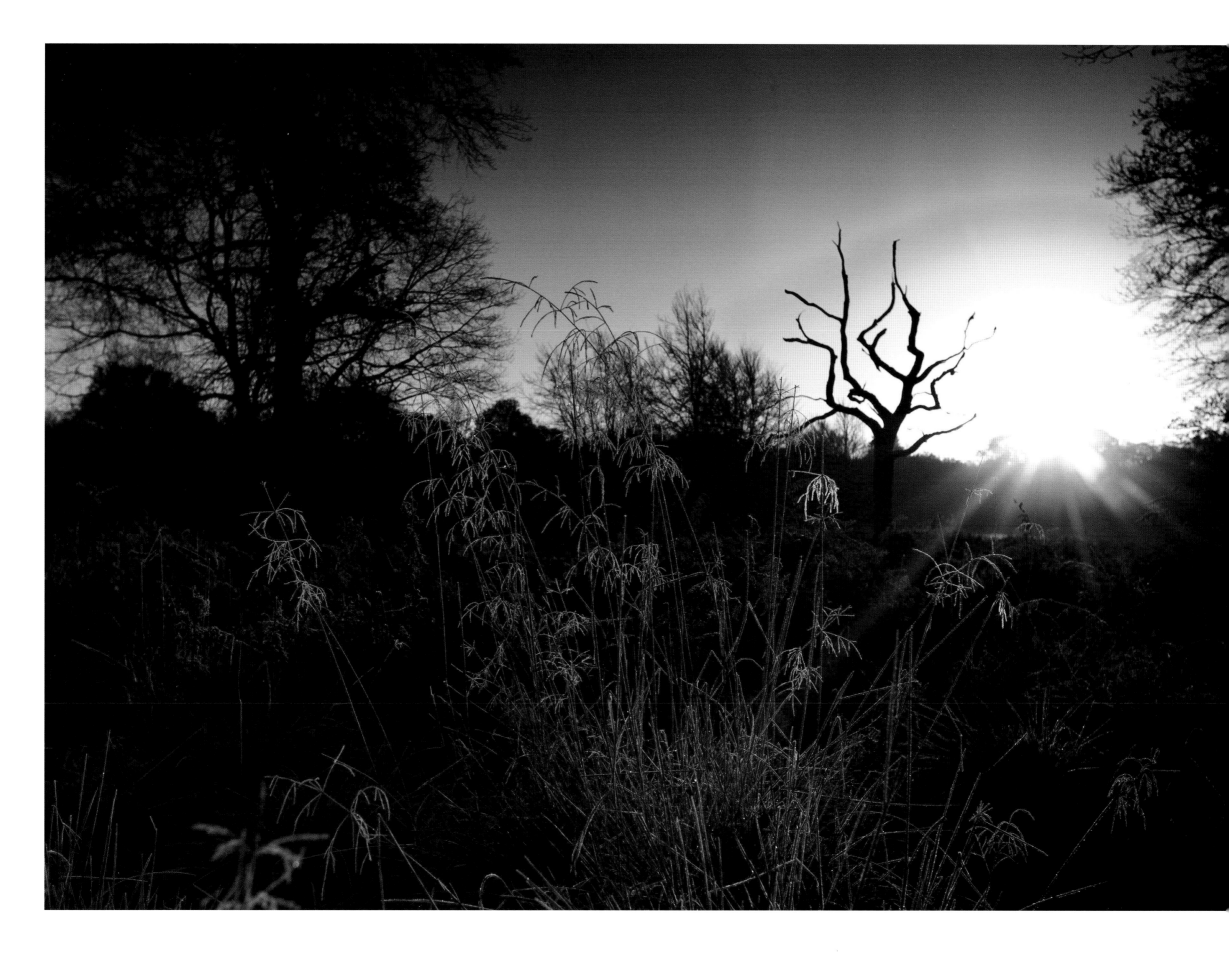

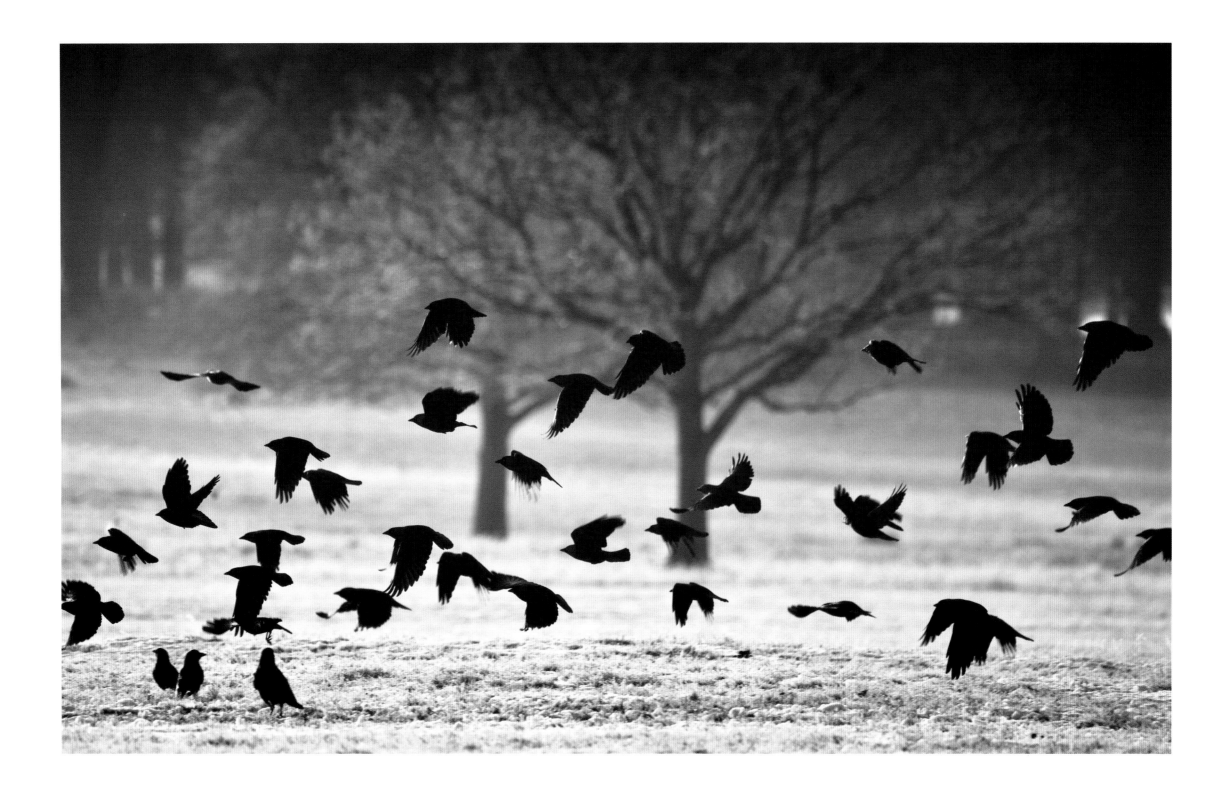

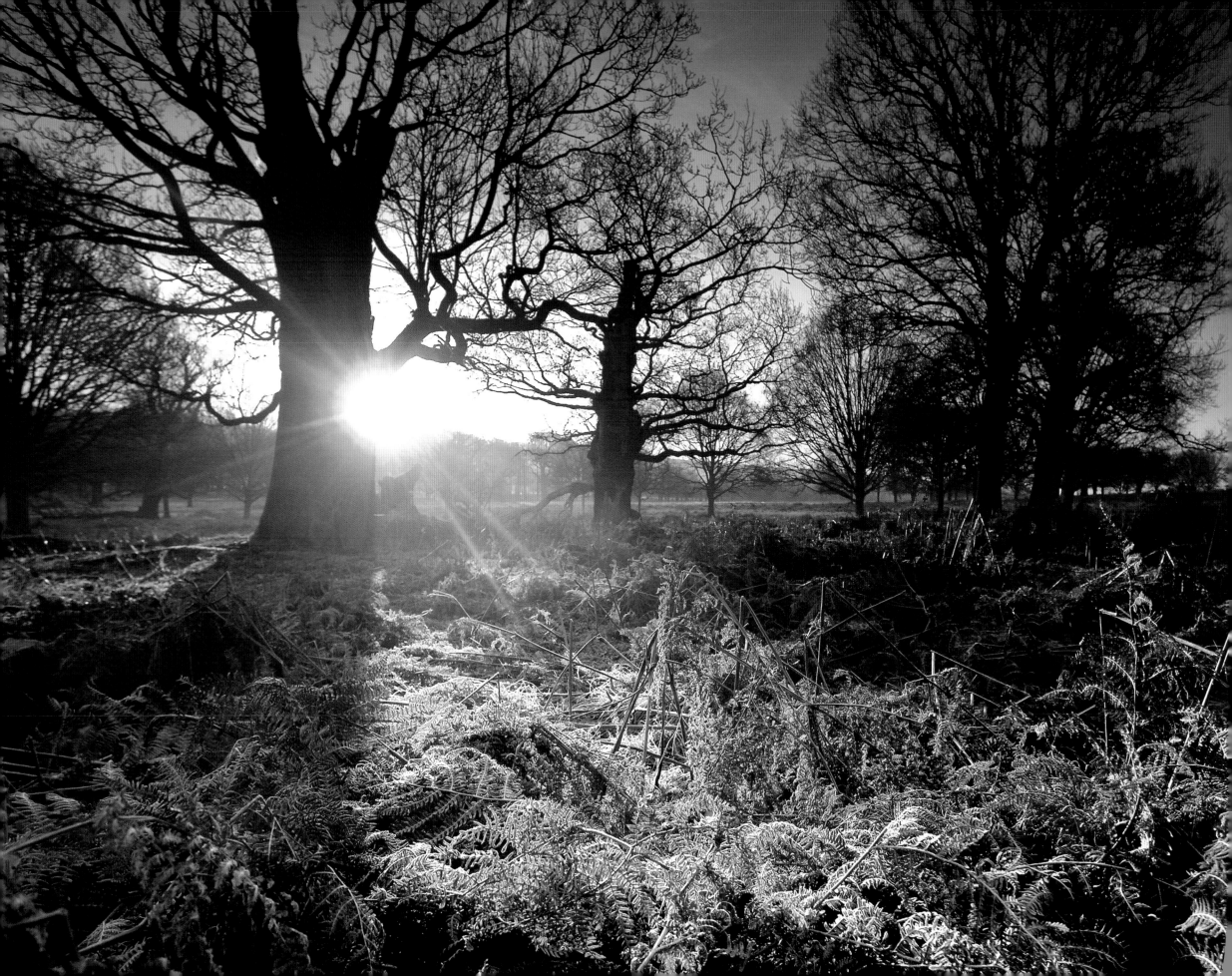

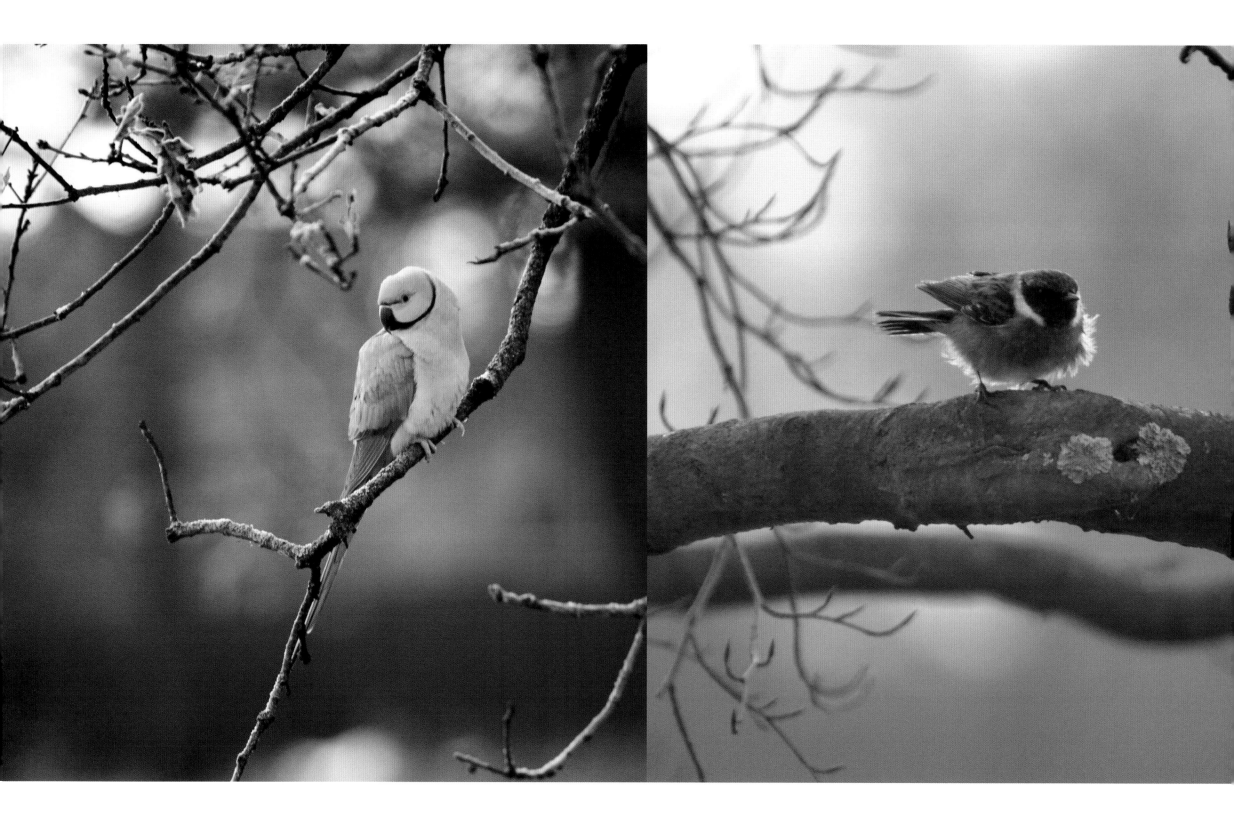

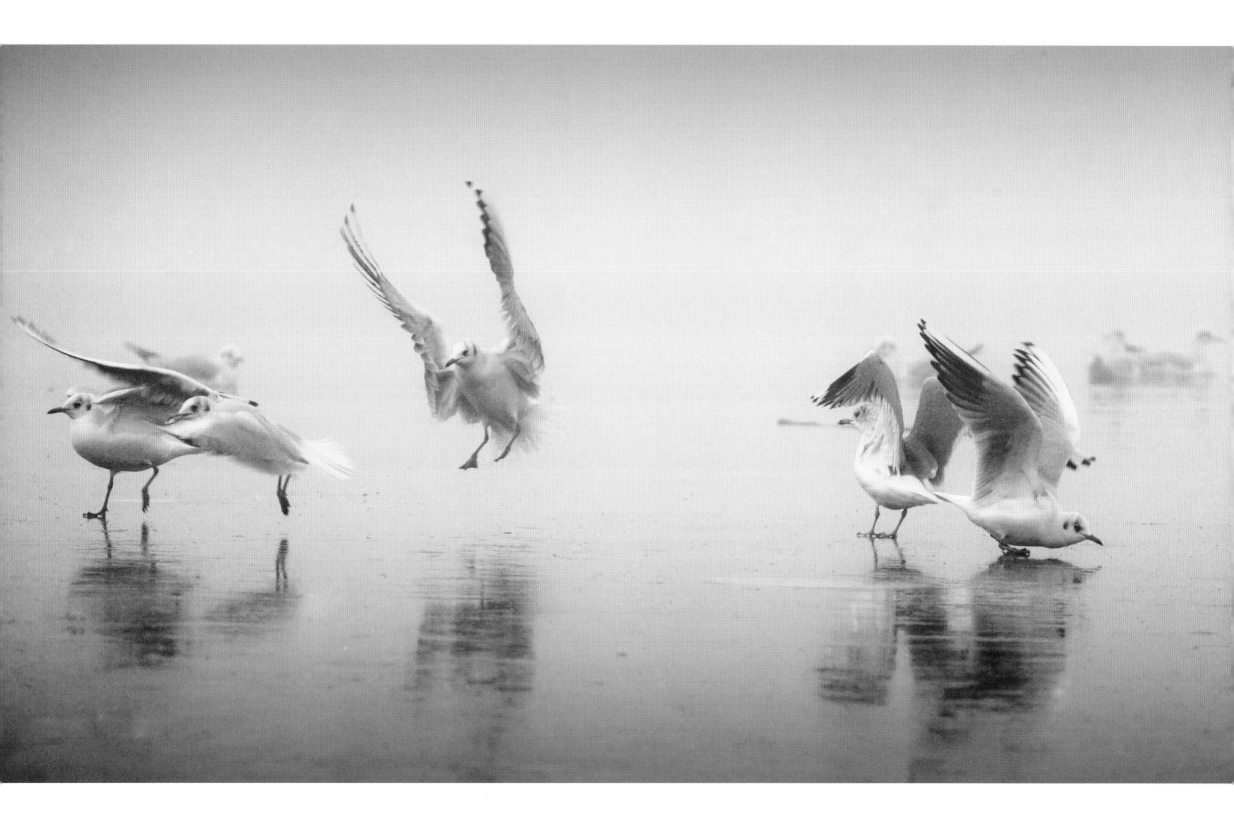

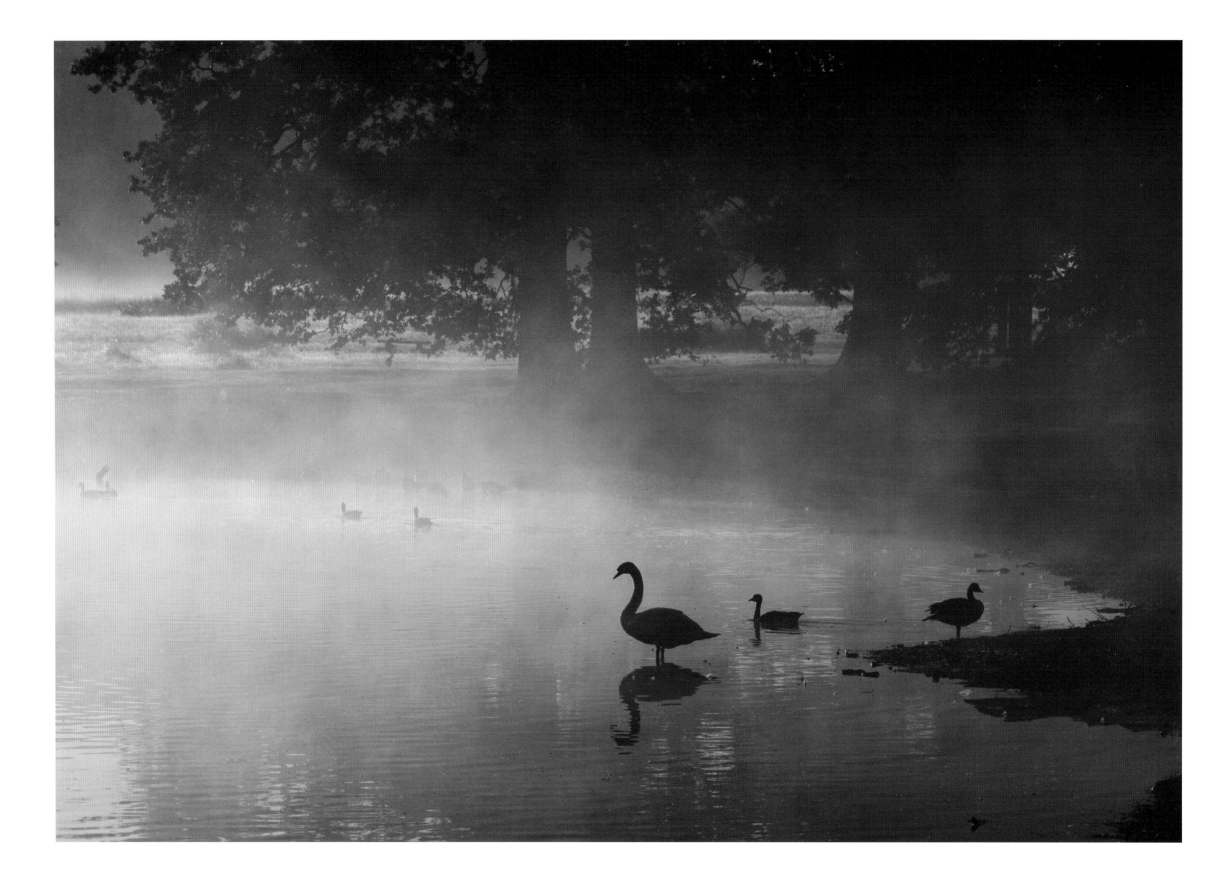

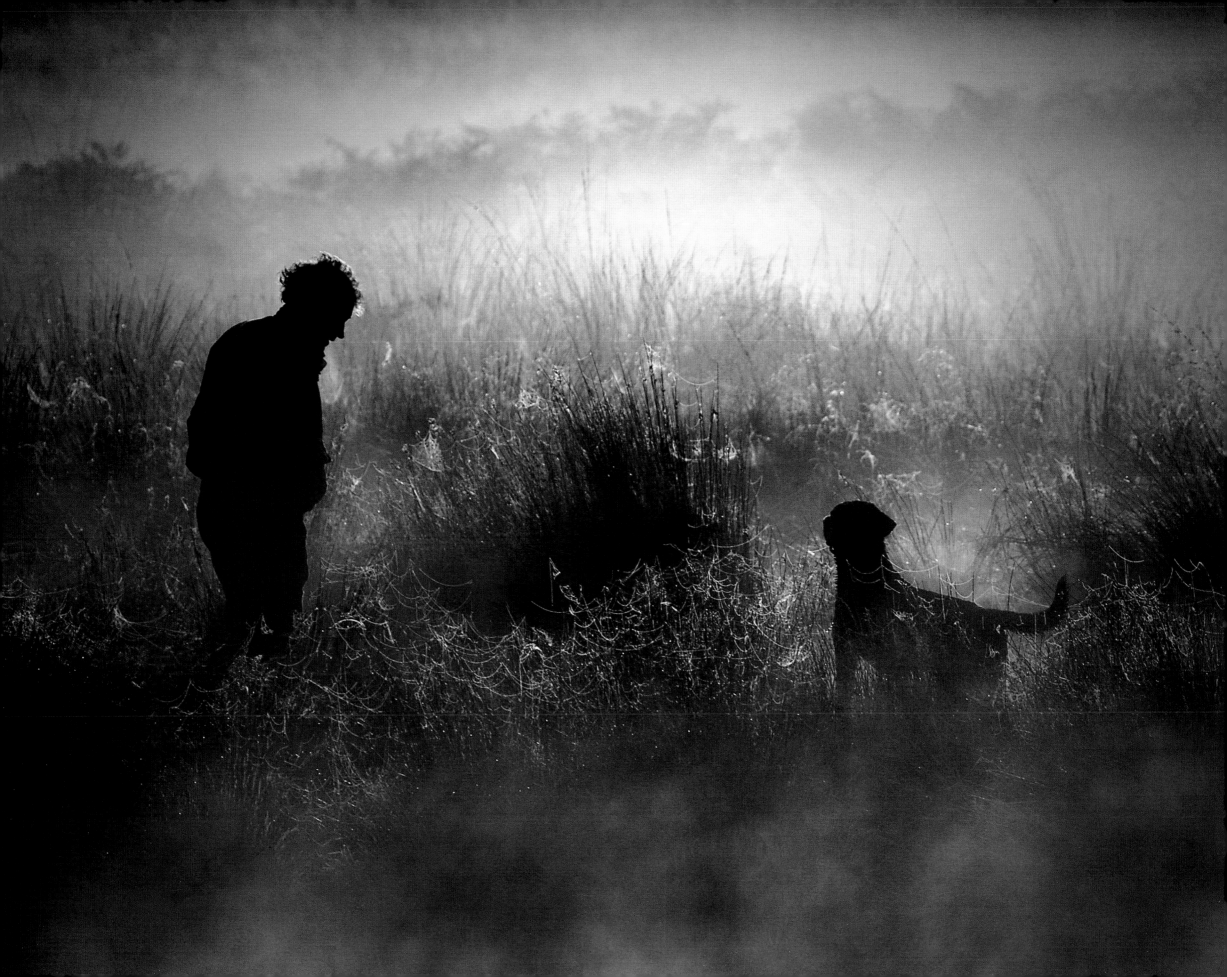

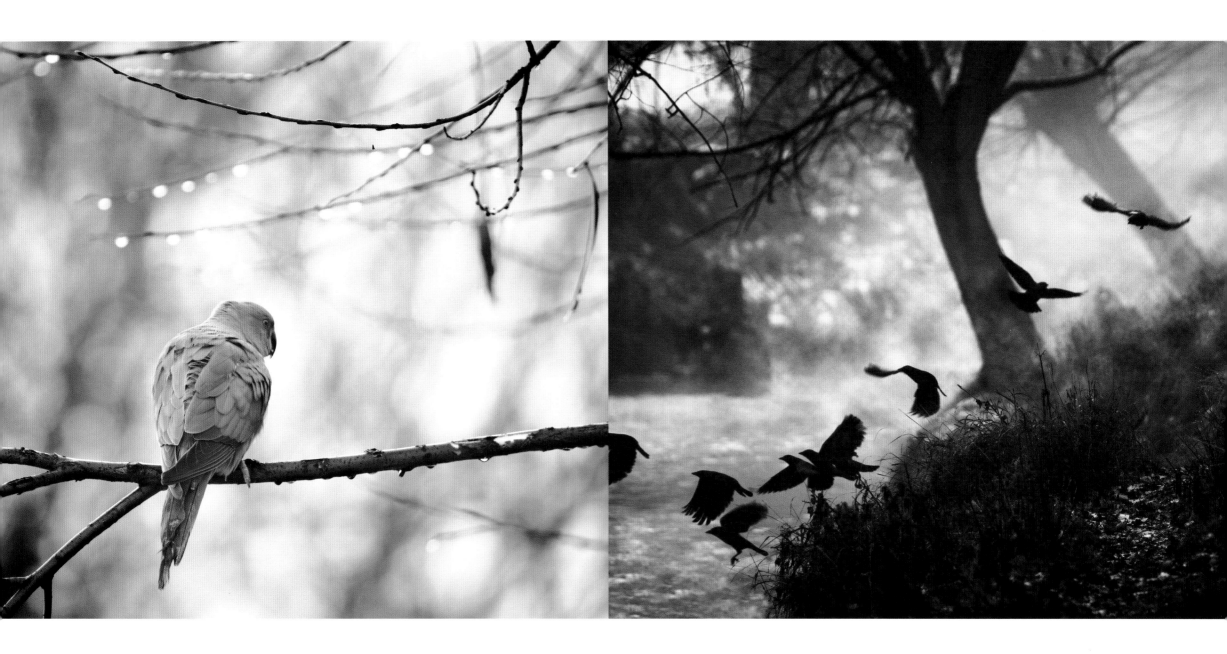

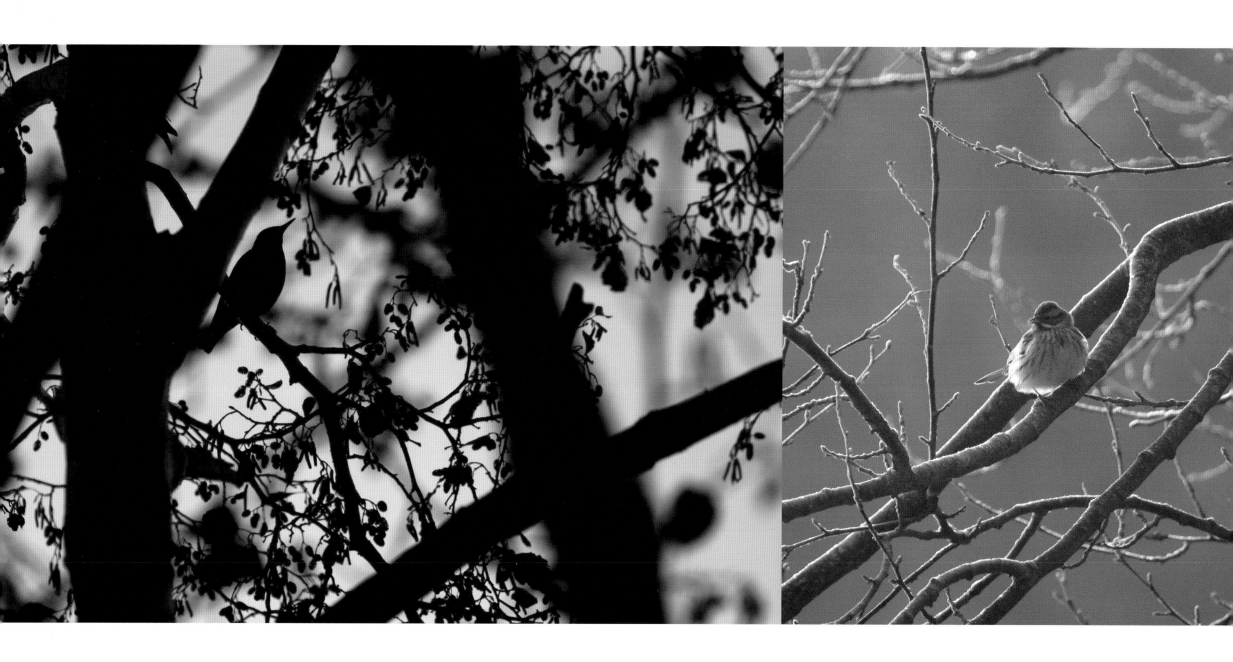

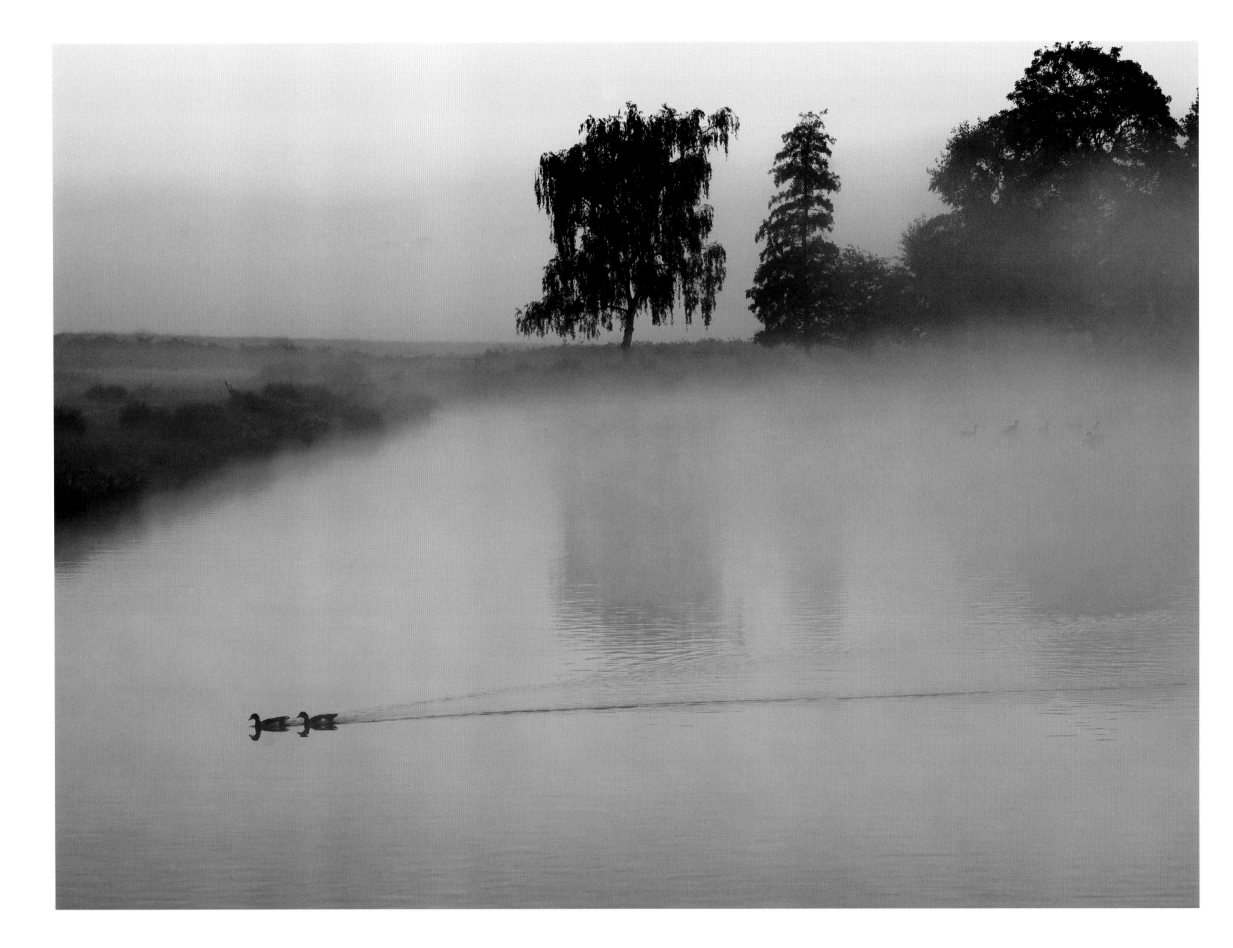

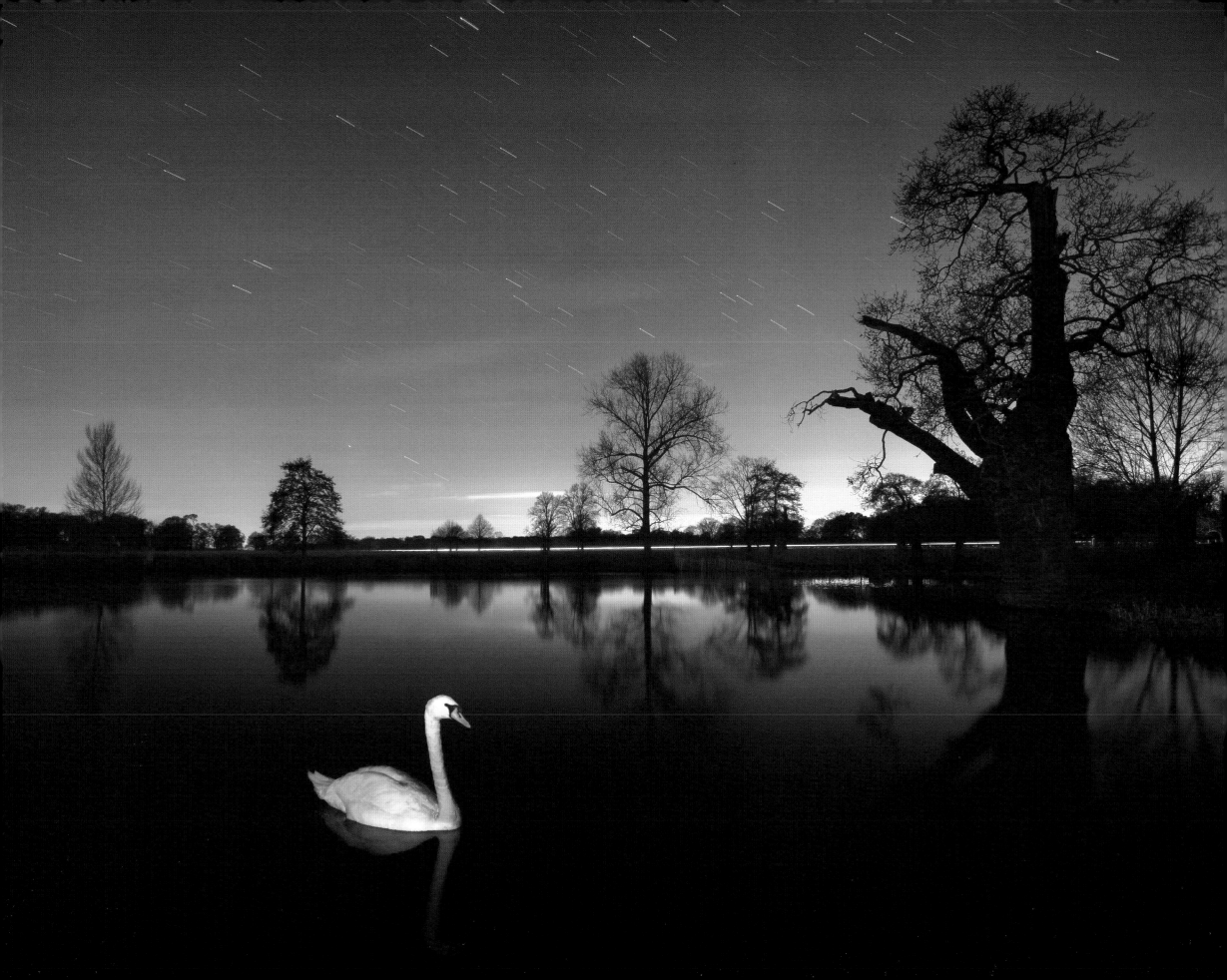

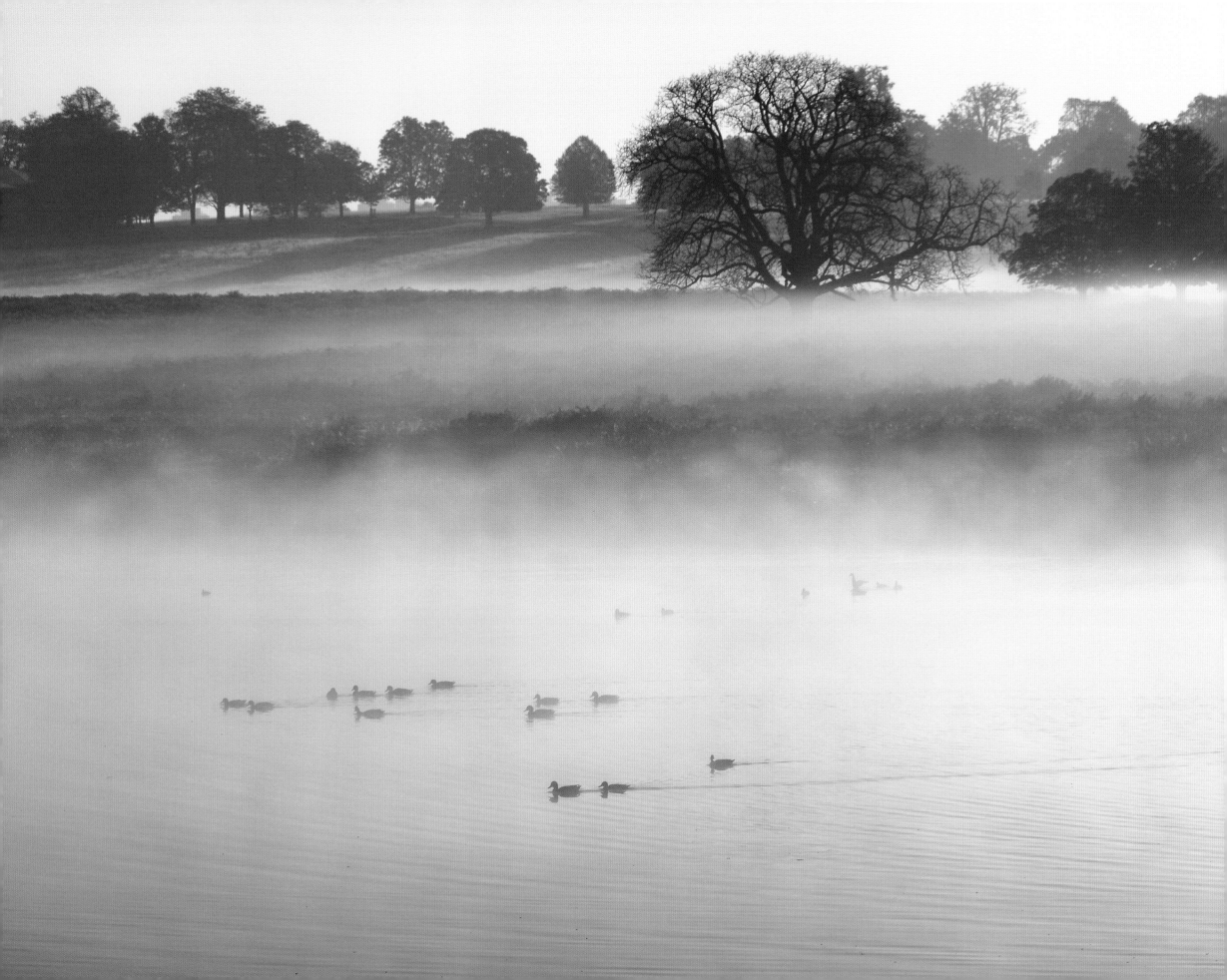

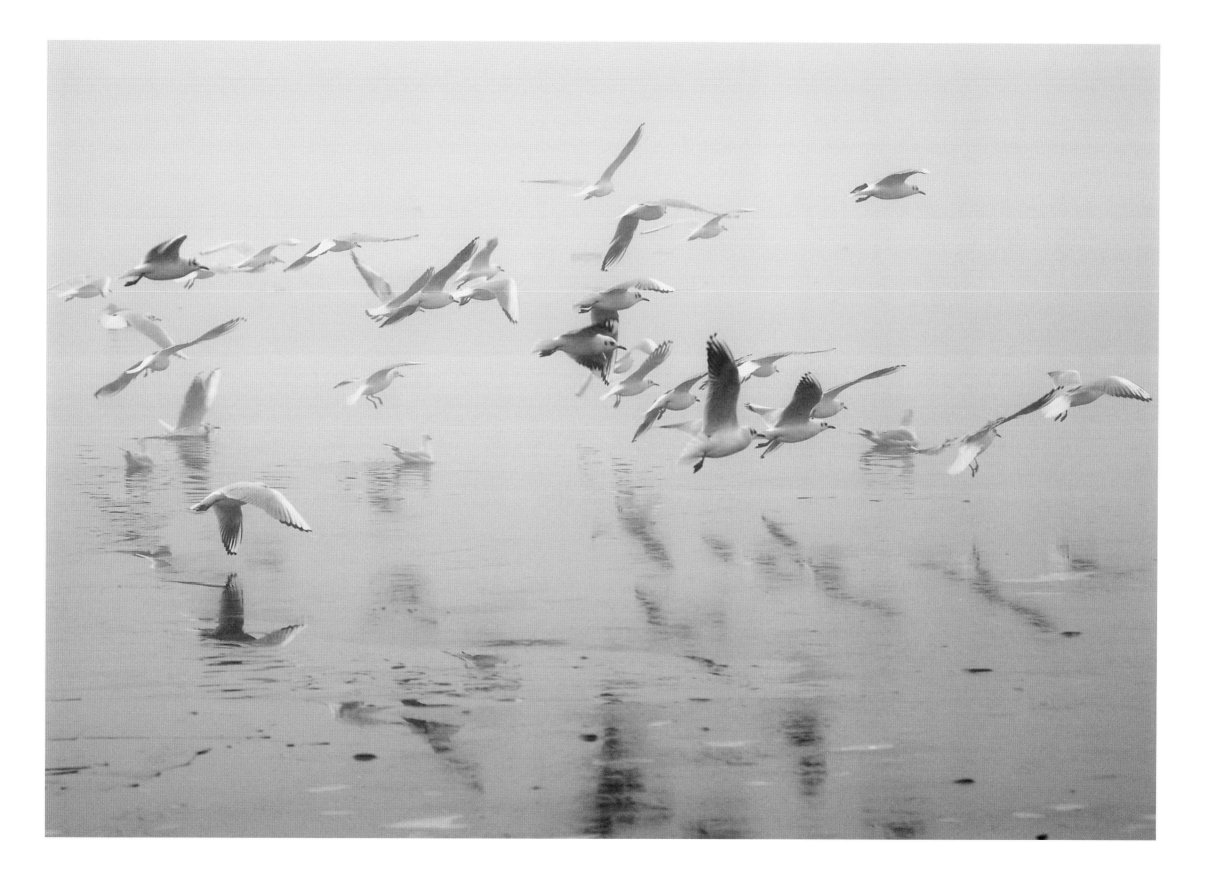

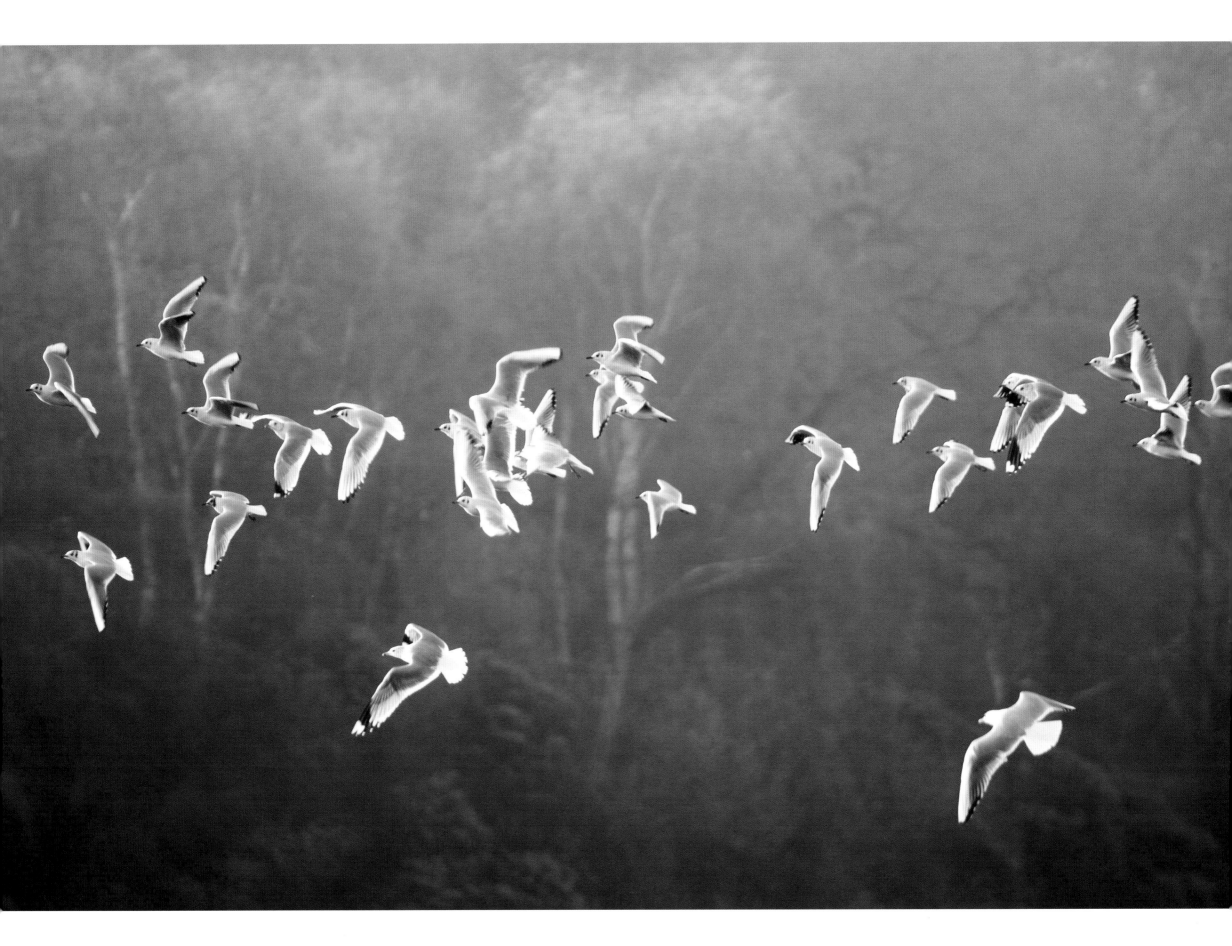

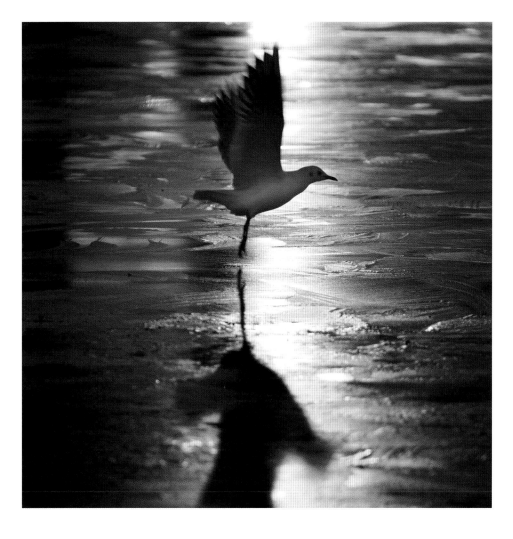
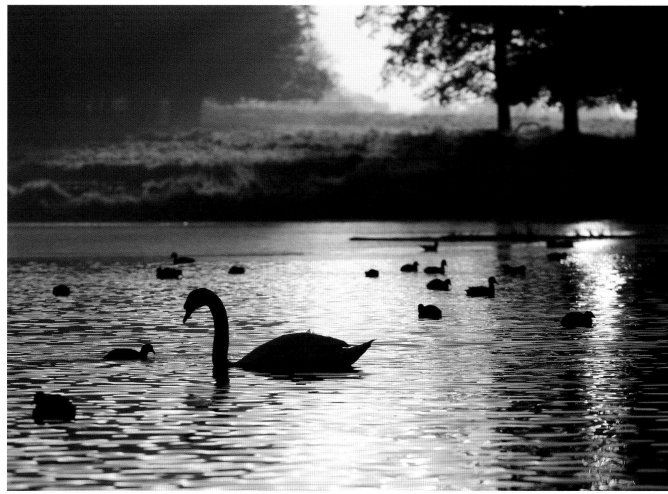

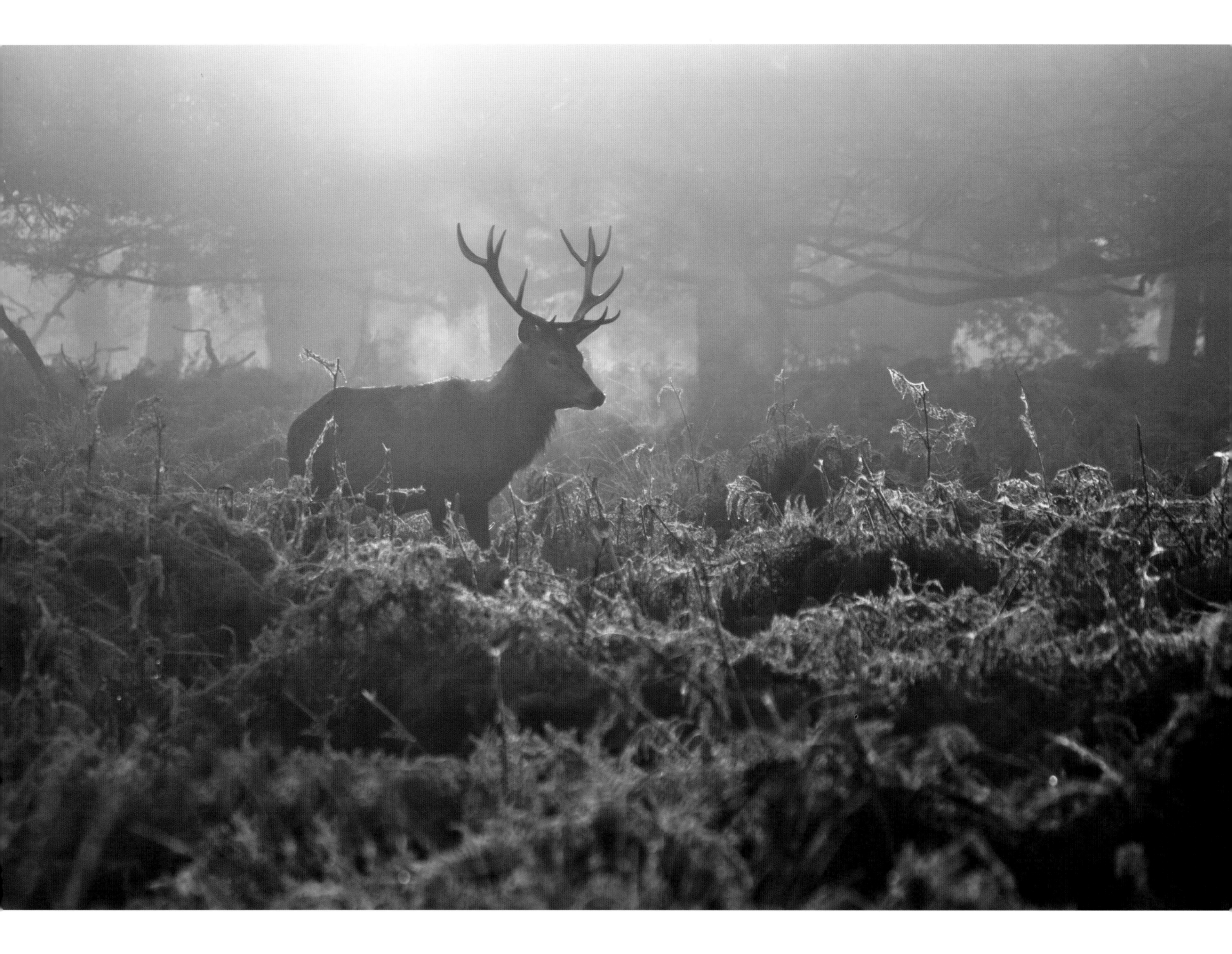

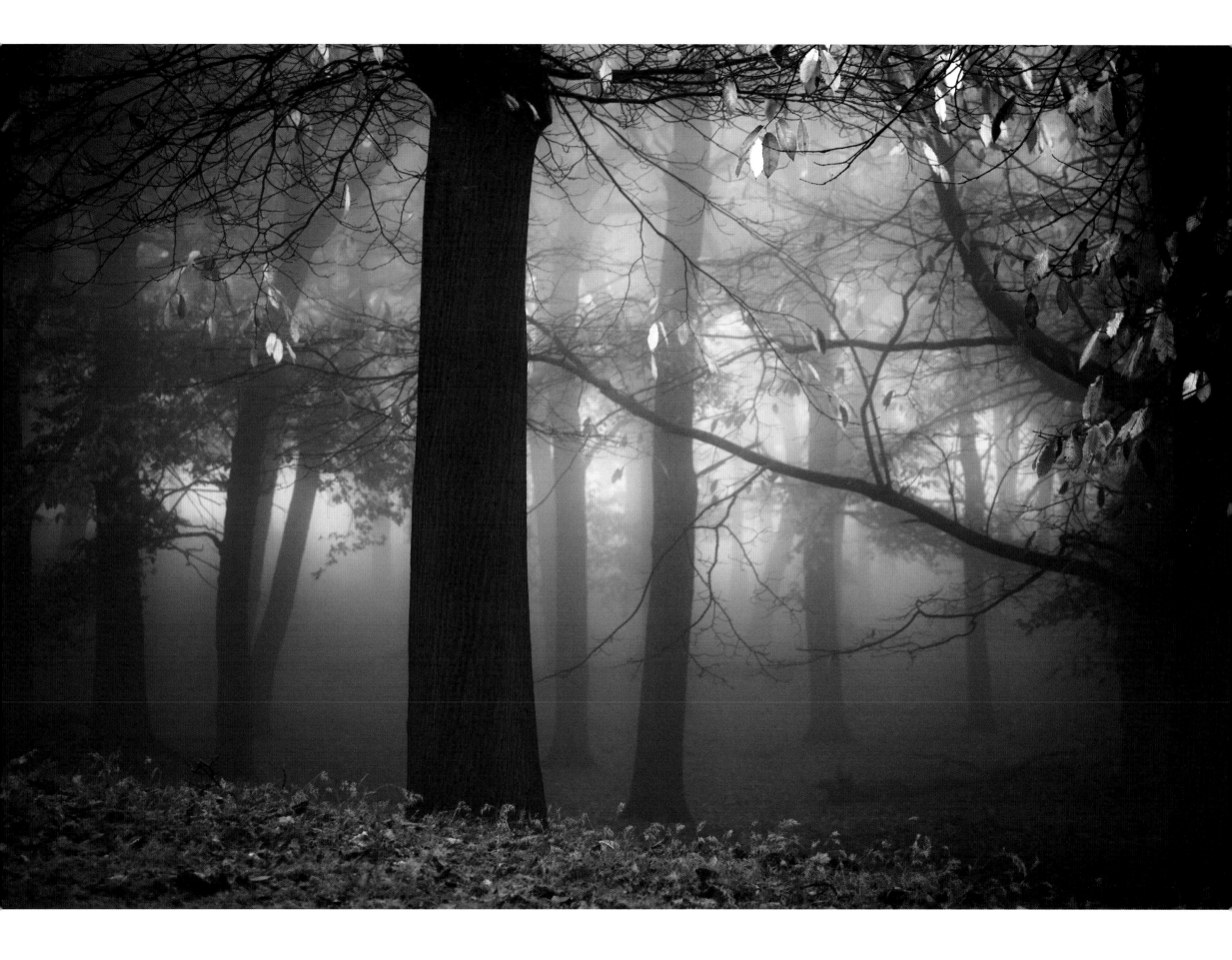

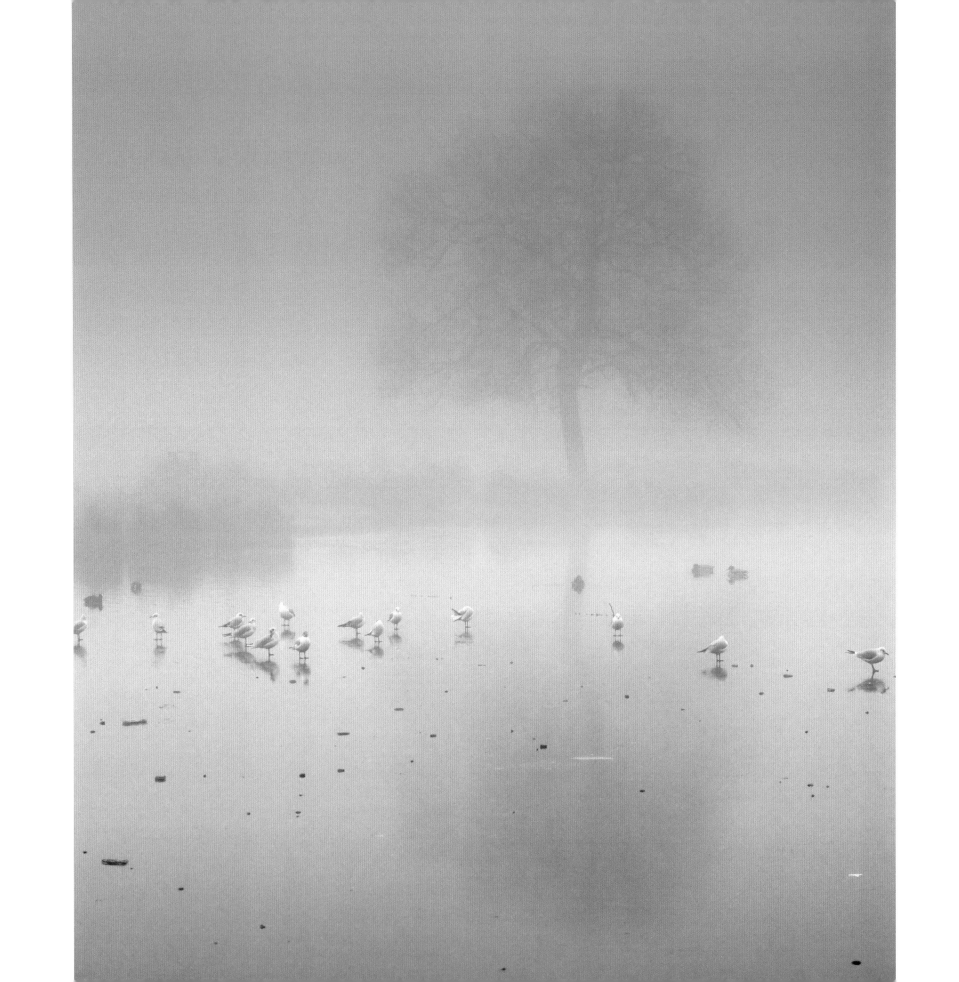

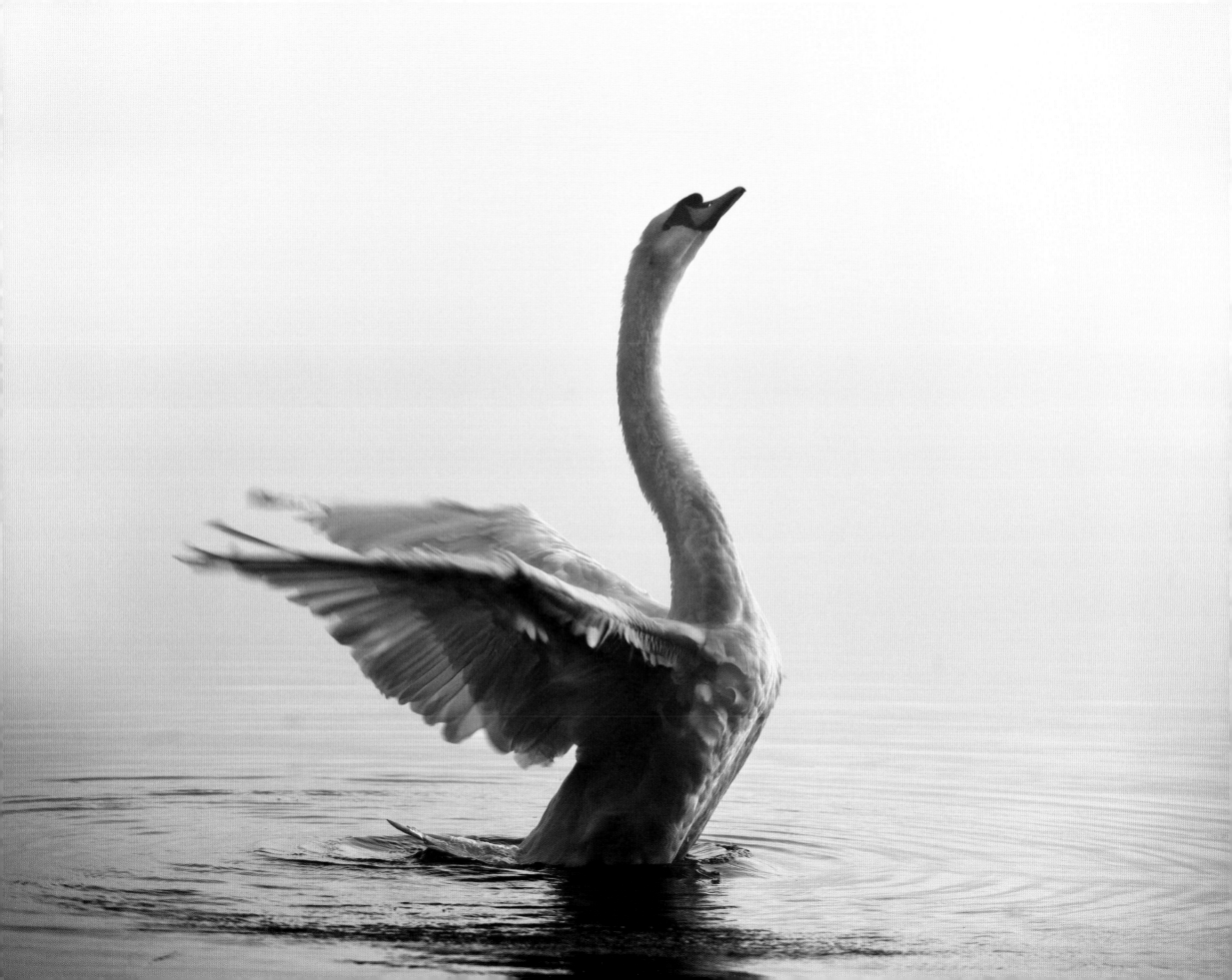

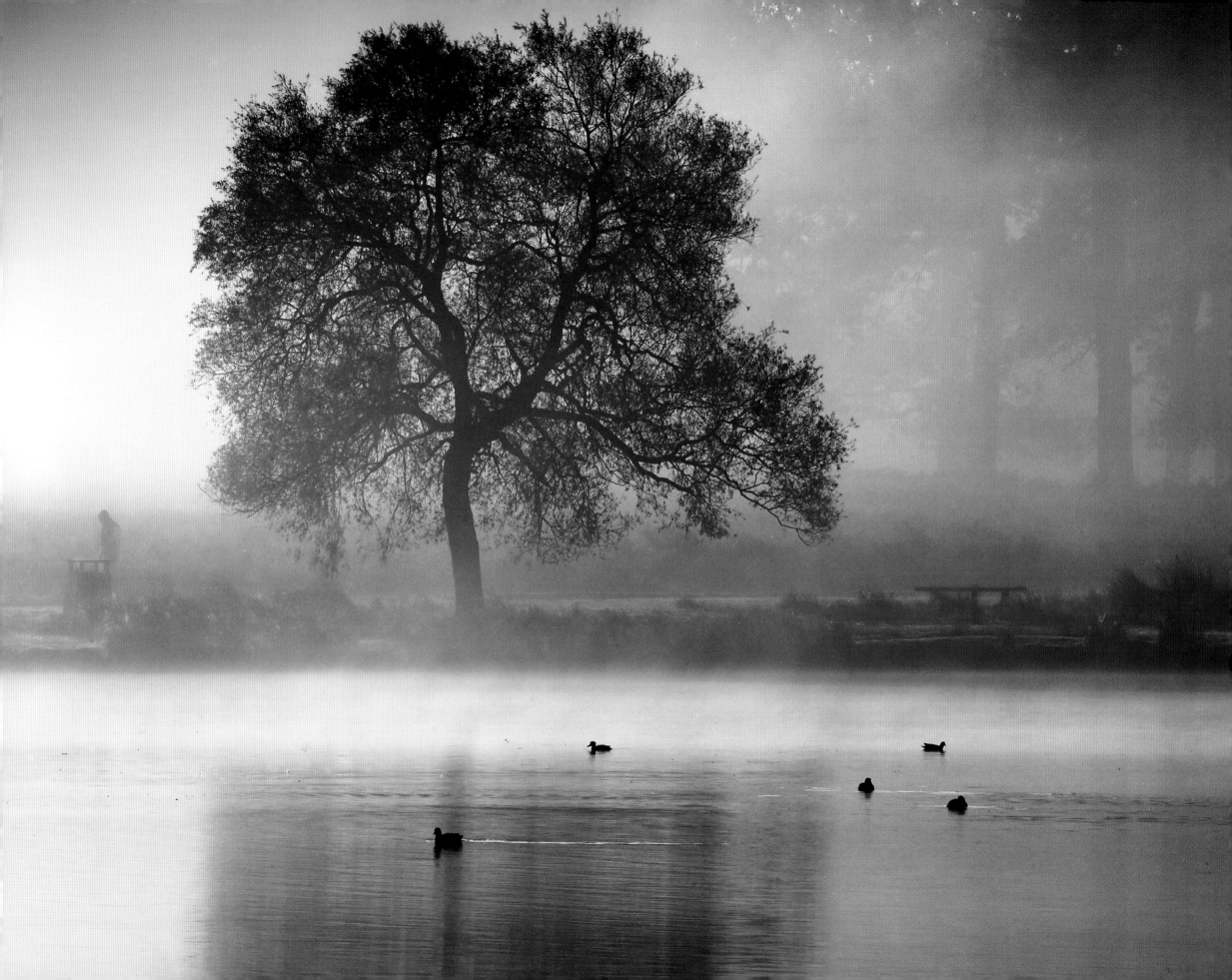

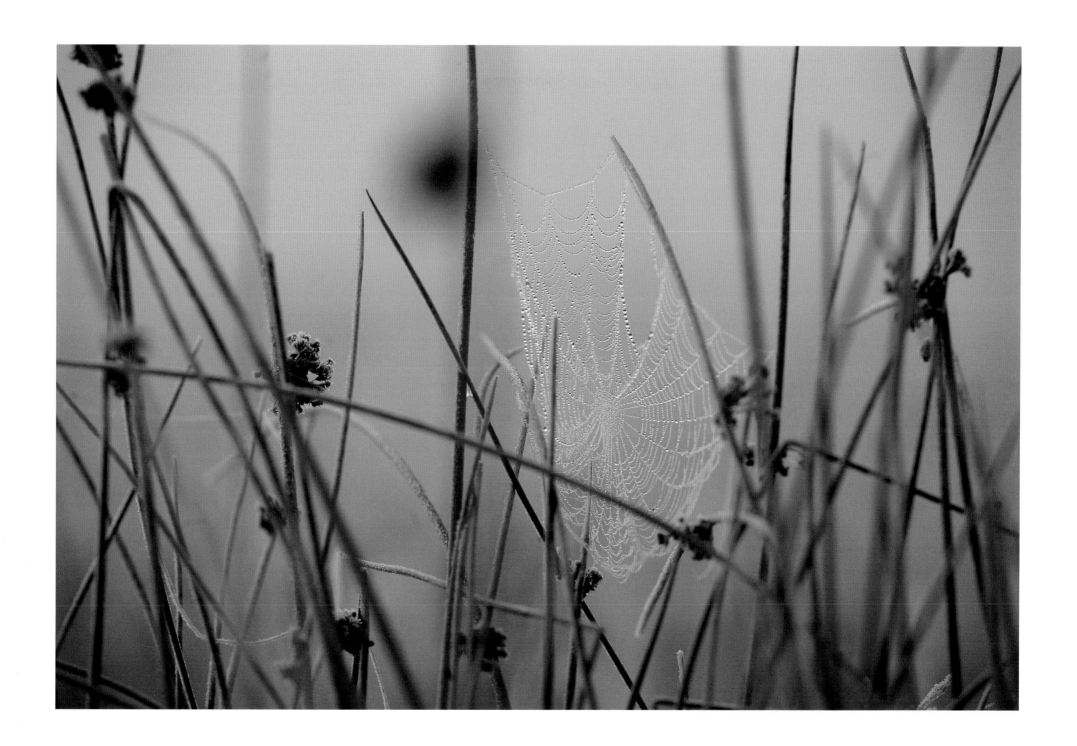

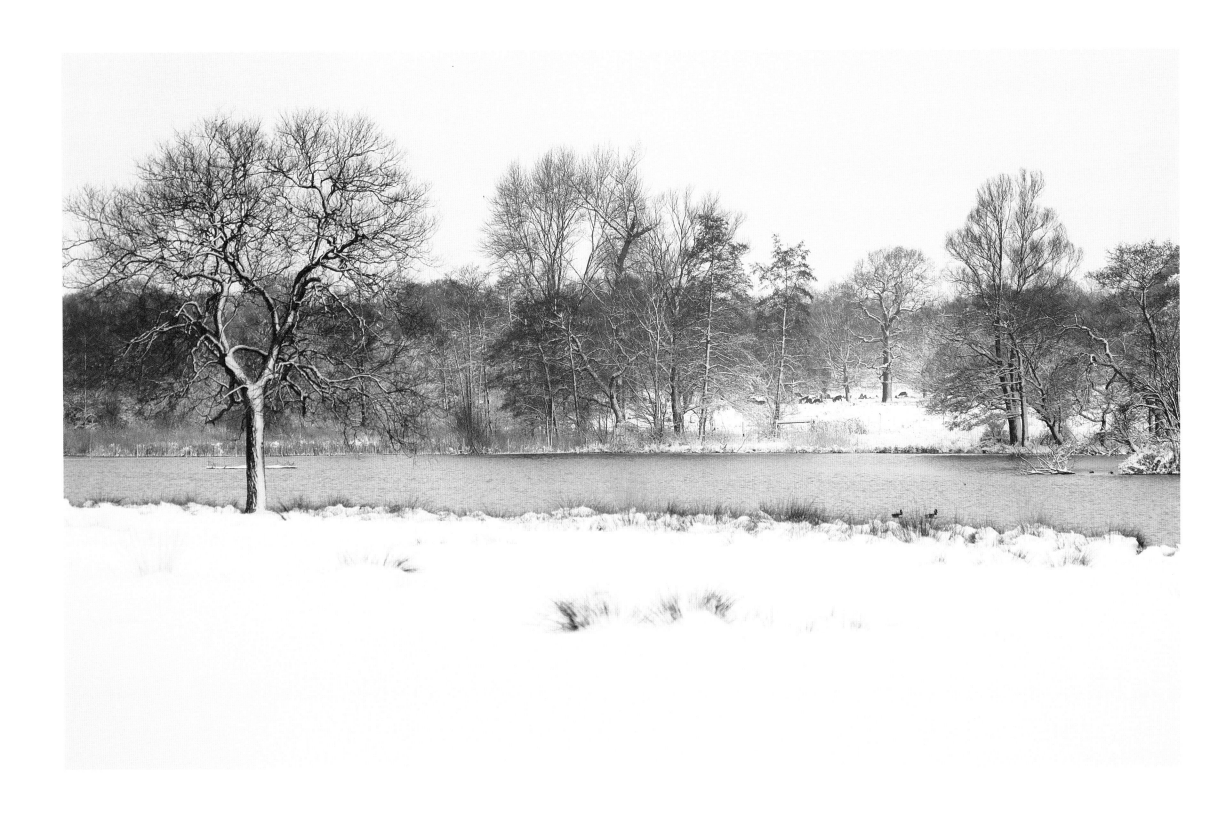

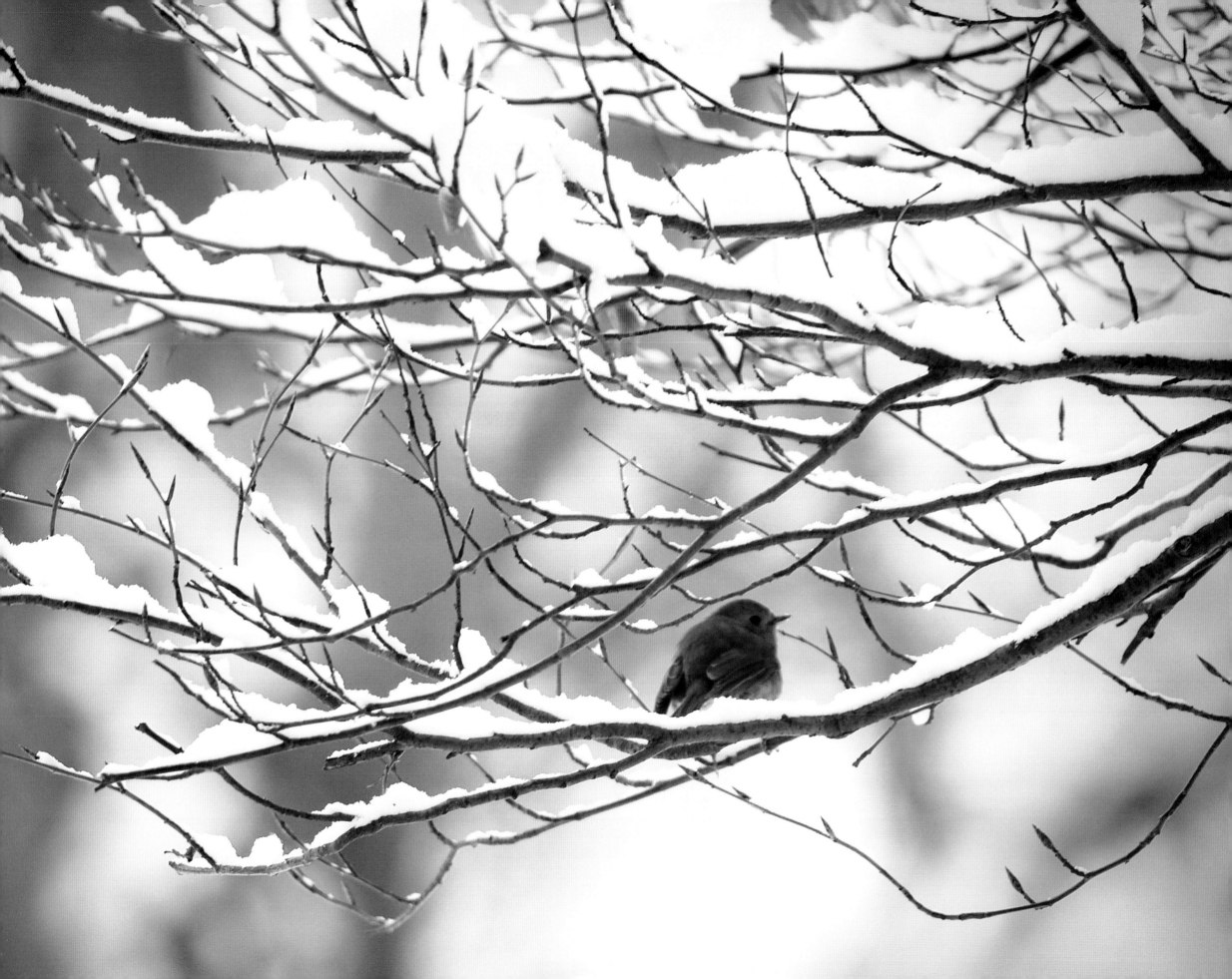

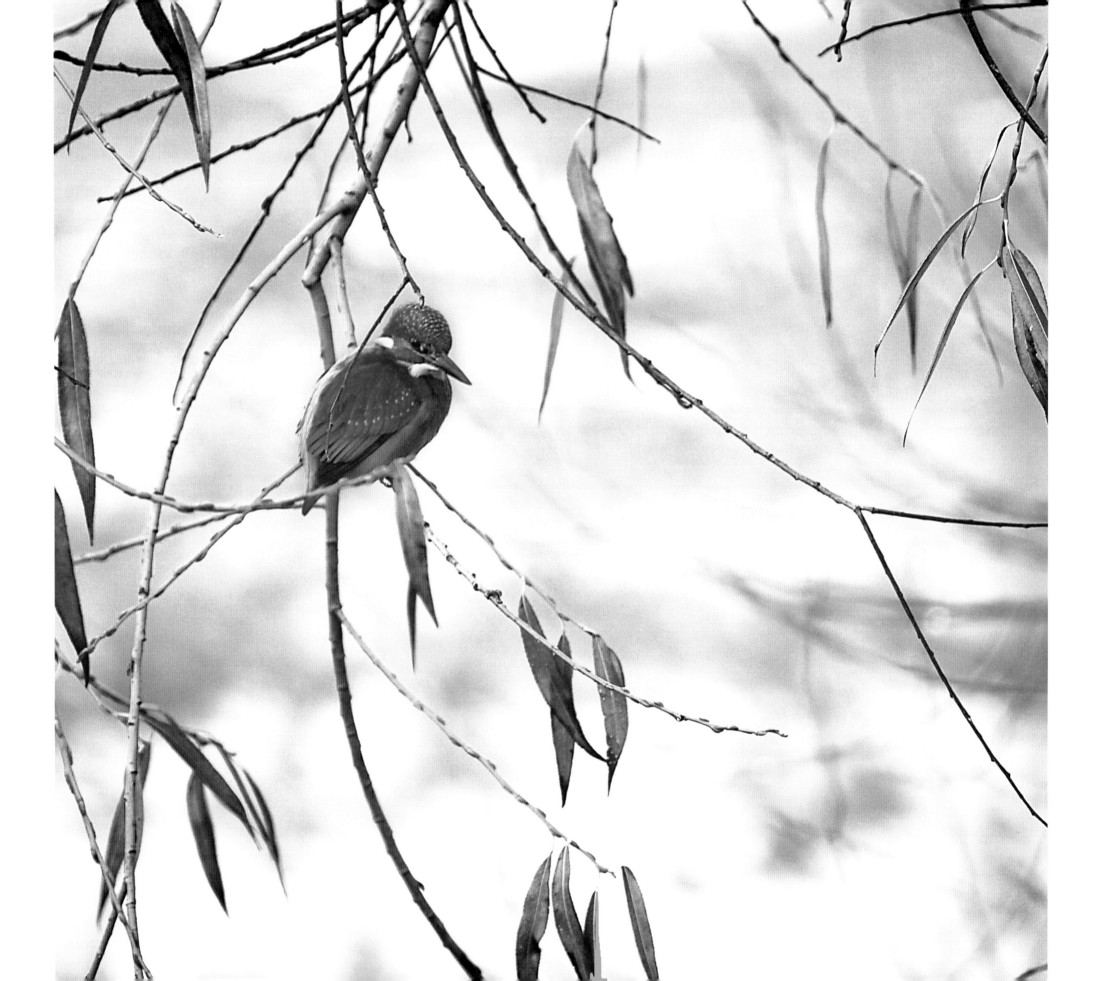

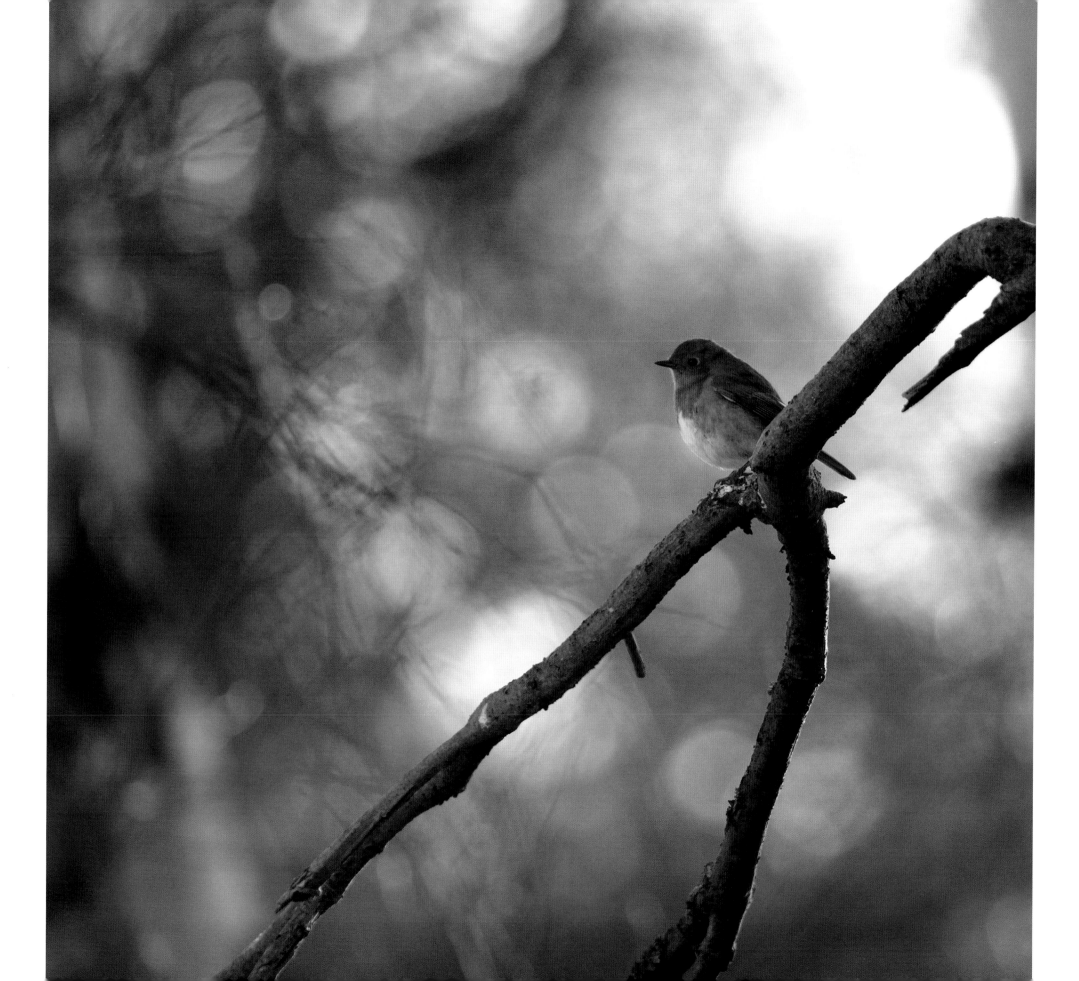

in memory of John and Hilda

Images © Alex Saberi 2012
Text © John Karter 2012
World copyright reserved

ISBN 978 185149 679 2

British Library Cataloguing-in-Publication Data
A catalogue record for this book is available from the British Library

Printed in China
for ACC Editions, an imprint of the Antique Collectors' Club Ltd., Woodbridge, Suffolk

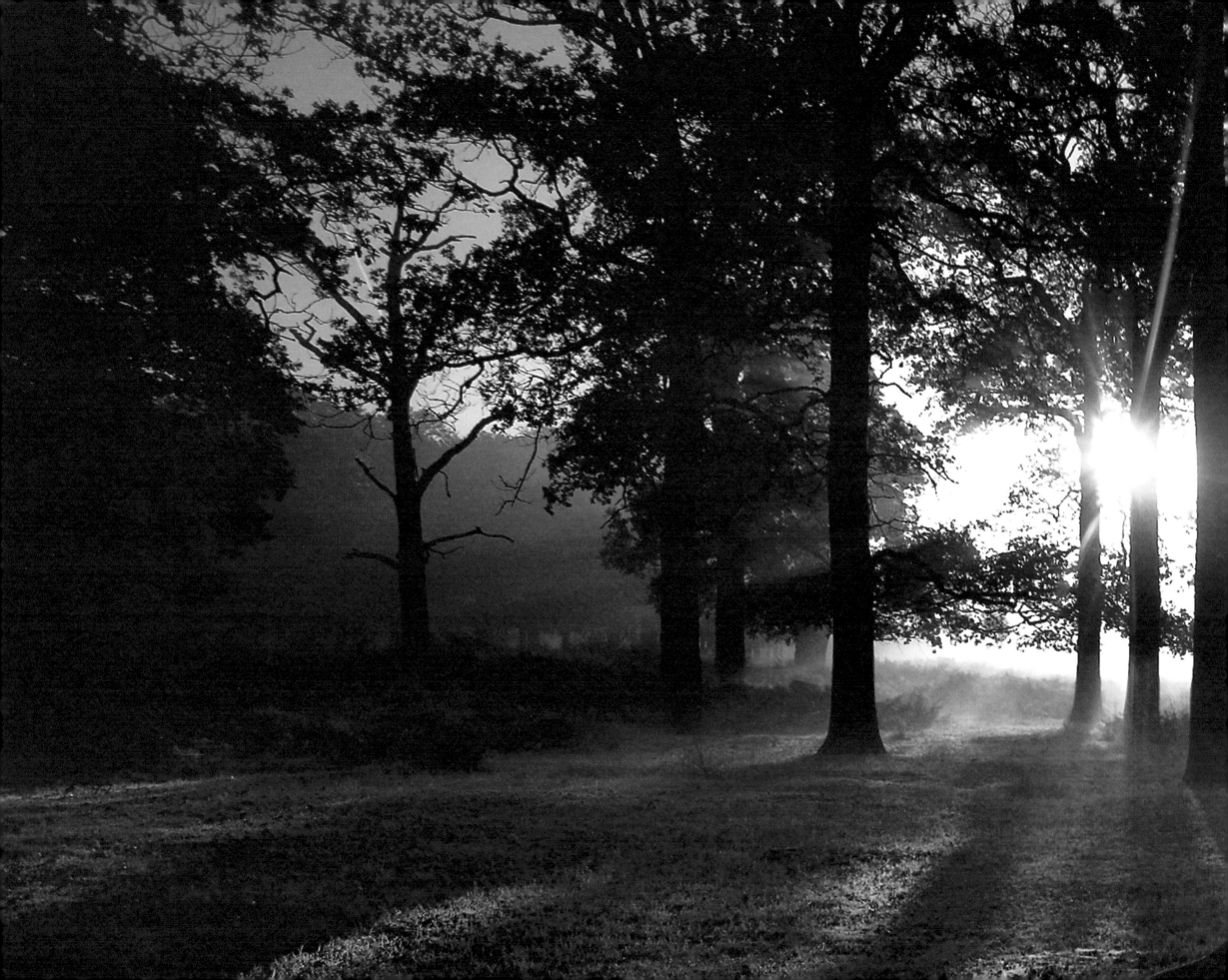